30. J
11. A

16

1.

*The*

# NATIONAL GALLERY

*of London and Its Paintings*

*Edited by*
MARINA ANZIL

*With a foreword by*
MICHAEL LEVEY

JOHN BARTHOLOMEW & SON LIMITED: Edinburgh

# Great Galleries of the World

*Collection directed by*
ETTORE CAMESASCA

*Editing and Graphics*
CLAUDIA GIAN FERRARI
SERGIO TRAGNI
GIANFRANCO CHIMINELLO

*Picture collection*
CARLA VIAZZOLI

*Secretaries*
VERA SALVAGO
MARISA CINGOLANI

*Graphic and Technical Adviser*
PIERO RAGGI

*Printing and Binding*
ALEX CAMBISSA
CARLO PRADA
LUCIO FOSSATI

*Color editing*
PIETRO VOLONTÈ

*Foreign editions*
FRANCESCO TATÒ
FRANCA SIRONI

*Editorial Committee*
MILTON GLADSTONE
DAVID GOODNOUGH
JOHN SHILLINGFORD
ANDREA RIZZOLI
MARIO SPAGNOL
J. A. NOGUER
JOSÉ PARDO

# Contents

## Photographic sources

Color plates: Archivio Rizzoli, Milan; Nimatallah, Milan; Publications Department of the National Gallery, London. Black and white illustrations: Publications Department of the National Gallery, London.

*First published in Great Britain 1974 by*
JOHN BARTHOLOMEW AND SON LTD.
*12 Duncan Street, Edinburgh, EH9 1TA*
*and at 216 High Street, Bromley, BR1 1PW*
*Copyright © by Rizzoli Editore, Milano, 1974*

ALL RIGHTS RESERVED
*ISBN 0-85152-929-1*

PRINTED IN ITALY

# National Gallery,
# a Temple of Aesthetic Enjoyment

The National Gallery was founded in 1824 and is now celebrating its one hundred and fiftieth anniversary. That impending occasion and the publication of this book provide an opportunity not only to glance over virtually a century and a half of acquisitions, but also to reflect briefly on the Gallery's origins and purpose. Its foundation came in a revolutionary decade of European history. Countries like Greece were struggling for their independence; in the Greek cause Byron died in the year of the Gallery's foundation. Elsewhere, notably in England, people struggled for a larger measure of liberty in the way they should be governed and altogether how they should be treated. Perhaps it seemed prudent to provide ordinary people with their own, "national" gallery of art.

It was not a totally novel concept in England that an art gallery should be provided for the nation, but by the standards of the Continent, England had been comparatively slow to act. It did not have the opportunity to provide the basis for a national collection of pictures by absorbing a local princely or royal collection (such as the Medici basis of the Uffizi and the French royal basis of the Louvre). Parliament brought the Gallery into existence, taking a truly democratic step in recognizing that those who cannot afford personally to own pictures may yet wish to enjoy access to them — and that by right, not favor. England was — indeed, still is — rich in private collections, already in the 19th century usually open to the polite visitor, thus privileged to gaze at the possessions of others. This point of ownership is more acute in the visual arts than in music or literature: to acquire a picture, or statue, is to possess it, with consequent power to prevent others deriving enjoyment from it in a way virtually impossible with a book or a piece of music.

The National Gallery was founded as, and has remained, a collection of paintings only. Far from being planned as a museum in the antiquarian sense of displaying historical objects for their own sake, it was from the first concerned with aesthetic quality. Indeed, so strong was this sense (as understood by connoisseurship at the beginning of the 19th century) that there was some opposition among older men when the Gallery purchased its first Italian primitive pictures which seemed to them mere "curiosities."

How the Gallery began is profoundly relevant to how it has gone on, and to what it has become. Perhaps because it inherited no long-established local collection, it was remarkably free from any bias towards the national school (rather too free, for even now we do not exhibit such a fine British painter as Stubbs at his best). It inevitably mirrored in its beginnings contemporary concepts of a typically good but not vast private collection, one more middle class than aristocratic. John Julius Angerstein, it must be remembered, was a merchant. And the Gallery, which has remained numerically small in its actual holding of pictures (today just about 2,000), continued throughout the 19th century to be shaped by the taste of the rising middle classes.

Victorian earnestness did not show merely in the policy of acquisitions but also in the stress rightly laid on the educative properties of art. This is highly relevant in the modern world, though we do not need to bring such moral fervor to our interpretation of education where art is concerned. But the Victorians took the National Gallery seriously. Today, when approximately one and three-quarter million people may visit the Gallery in a single year — as they did in 1971 — they too testify to a serious interest. What is the significance of the Gallery they are visiting and what is it doing, or should do, for that large number of visitors?

The Gallery's scope is twofold. It is a collection of rare masterpieces from all the great European schools of painting, but it is also a collection which offers a context for these masterpieces, providing some idea, for example, of secondary yet good Italian Renaissance painters, in addition to the great names from Masaccio to Tintoretto; as well as Rembrandt, it shows the rich variety of Dutch art in the century over which he presides. And this double function continues to be pursued throughout the collection; among our most recent purchases is a famous Titian mythology, "The Death of Actaeon," and there is also a fine painting by Solimena, one of the last Italian Baroque painters. This dual activity is part of the Gallery's living, evolving existence. In the course of a century and a half, it has come to be a wonderfully vivid, and never merely historically representative, crystallization of most great moments of European painting up to Cézanne. What has powered its growth is the belief that good pictures from the past deserve preservation, and study, because they can give so much pleasure. The Gallery is a temple based on hedonism, which does not mean that it is indifferent to knowledge: it may instruct, but it aims to please. In so doing it emphasizes the necessity of art for human beings. To derive pleasure from works of art is a serious, perhaps vital, activity if we are ever to be truly civilized.

If one attempts to sum up in a single word what the National Gallery will go on doing — with additional fervor — alongside acquiring, conserving, investigating and displaying paintings, that word must be welcoming. Visitors will, we hope, feel increasingly encouraged to look at the pictures not in awe but in affectionate comprehension. They are the world's property, on exhibition to the world. Yet whatever aids we may supply — books, catalogues, lectures, recorded talks, explanations in the exhibition rooms — it is ultimately on the visitor himself that the onus falls. A public gallery needs the support of the public, one that is as wide as possible.

For those who have visited the National Gallery, this book should provide a fascinating record of what they saw, telling them something also of how the Gallery was created. For others it may stimulate plans, hopes or dreams. All that the Gallery asks is that it should be used by being visited, if only through the medium of the printed page. No one should try to *tell* the visitor what he will find, because each person makes his own discoveries. What one may with sincerity *murmur* is that the visit is worthwhile.

MICHAEL LEVEY
*Keeper and Deputy Director*

5

# History of the Gallery and Its Paintings

**1768.** Formation of the Royal Academy. This was destined to act as a determining influence on the birth of a national British museum. To its first chairman, Joshua Reynolds, we owe the progressive suggestion of creating a public collection of art. The suggestion survived even after the death of Reynolds himself, often amidst heated controversy within the precincts of the same Academy. Many of those who opposed the idea felt that it would be more fitting to use the funds they had at their disposal in order to provide pensions for aged painters or to subsidize young artists. Moreover, they saw the old masters not only as admirable and precious examples, but also as awesome rivals. For many years, such considerations as these, even amidst other events, gained the upper hand on any other proposal.

**1777.** The opportunity for a practical re-examination of the problem presented itself when the rich art collection owned by Sir Robert Walpole was put on sale. The radical, John Wilkes, proposed that the government should acquire the collection in order to form a gallery, but public opinion still would not recognize the necessity for having one. The collection was lost to Russian buyers and is now exhibited in the Hermitage of Leningrad.

**1805.** The founding of the British Institution, the aim of which was to promote development of the arts throughout the country, constituted a new attempt to create a gallery. According to the plans of Thomas Bernard, the Institution was to exhibit permanently either recent works of art which had been acquired by the wealthier members of the association or older works. This, he hoped, would be a source of inspiration for the young. But despite the good intentions of those who had originated the idea, the experiment was a failure; those works which they had acquired were eventually donated to churches and public bodies.

**1823.** The deciding stimulus came from a positive move by Sir George Beaumont, Governor of the British Institution, when he promised to donate his own private collection as soon as a "national gallery" was formed. This offer was all the more generously given because the collection contained such highly important works as *The Château de Steen* by Rubens, *Venice: Campo San Vidal* by Canaletto, *Hagar and the Angel* by Claude Lorrain and *The Deposition* by Rembrandt.

Furthermore, John Julius Angerstein, a Russian emigré of modest background died in the same year, leaving an important collection of paintings. Among the more notable paintings in the collection were *Venus and Adonis* by Titian, *The Resurrection of Lazarus* by Sebastiano del Piombo, *The Rape of the Sabines* by Rubens, *A Hilly River Landscape with a Horseman talking to a Shepherdess* by Cuyp, *The Woman Taken in Adultery* and *The Adoration of the Shepherds* by Rembrandt. In addition, there were Reynolds' *Lord Heathfield, Governor of Gibraltar*, five works by Claude Lorrain and six paintings by Hogarth (the complete cycle of *Marriage à la Mode*). The threat that such masterpieces might leave the country combined with faith in the promise made by Beaumont added up to two sufficiently convincing reasons for Parliament finally to grant the necessary funds for the purchase of the collection. And so, the first nucleus of the National Gallery was formed, not from collections owned by members of Royalty, as was the case with other great European galleries, but from private collections owned by British citizens.

**1824.** The doors of the National Gallery were opened to the public on the 10th of May. While preparations for a site worthy of the Gallery were being completed, the exhibition was housed in the Angerstein Gallery, 100 Pall Mall, where the paintings had already been exhibited by the deceased owner and where they were to remain for another ten years.

Care of the new museum was assigned to a curator named William Seguier who, together with his brother, had already done restoration work and had been involved in the valuation of works of art. He was assisted by Colonel G. S. Thwaites. In addition, a Board of Directors consisting of six members was set up to deal with the administration side of the Gallery; those involved were Beaumont, Lawrence the artist, Lord Liverpool then Prime Minister, the Chancellor of the Exchequer F. J. Robinson, Lord Aberdeen the future Prime Minister, and Lord Farnborough.

**1825.** Among the first acquisitions was Correggio's *Madonna of the Basket*.

**1826.** Bought during this year were Titian's *Bacchus and Ariadne* and Poussin's *Bacchanalian Revel before a Term of Pan*. George Beaumont honored his promise and had his collection transferred to the Gallery.

**1827.** Sir Robert Peel, Home Secretary and an important collector of Dutch and Flemish works of art, was welcomed by the National Gallery as a seventh member of the Board of Directors.

**1828.** The Duke of Sutherland donated *Peace and War* by Rubens to the Gallery.

**1831.** A site for the National Gallery was eventually chosen. It was then wholly occupied by the Royal stables and looked over on to Trafalgar Square, which had only recently been built. Arrangements were made for the demolition of the existing stables and the plans for the new building proposed by William Wilkins were adopted.

Also this year, the noteworthy bequest of Sir William Holwell Carr passed into the Gallery. He was a very wealthy art collector and connoisseur and his collection contained such works as Titian's *Holy Family*, Tintoretto's *St. George and the Dragon*, Claude Lorrain's *Landscape: David at the Cave of Adullam* and *A Woman Bathing in a Stream* by Rembrandt.

**1834.** A number of changes were undertaken in Pall Mall and among these was the demolition of the temporary seat of the Gallery. Since the new building which was to be the National Gallery was not yet ready, the paintings were transferred for a short time to 105 Pall Mall, which was just next door to the Angerstein Gallery.

Two new acquisitions came to the Gallery from Lord Londonderry's collection; these were *Mercury Instructing Cupid before Venus* and *Ecce Homo*, both by Correggio.

**1836.** A contribution was received from Buckingham Palace. William IV presented the Gallery with some paintings which included *The Toilet of Venus* from the workshop of Guido Reni and a portrait *John Julius Angerstein* 129 painted by Lawrence.

**1837.** Some important acquisitions were made this year. These were *The Two Trinities* by Murillo, *Four Ages of Man* by Lancret, Reynolds' *Three Ladies Adorning a Term of Hymen* (left by Lord Blessington in 1823 for the "national gallery" to be built in London) and, thanks to the subscription opened by William Beechey, Constable's *The Cornfield*. This was the first of Constable's works to be exhibited in the Gallery.

**1838.** The National Gallery collections were transferred from Pall Mall to their new home in Trafalgar Square, and the rooms in the west wing of the building were officially opened to the public on the 9th of April in the same year. The rules of opening to the public were questionable and summary. The Gallery was, in fact, open for six days of the week (remaining closed on Sundays) and, on two of those days, it was open only to students to allow them to work there in privacy. Because no system of artificial lighting was yet in operation, the hours it was open varied according to the time of year. Furthermore, during the autumn season, a six-week period was set aside during which the Gallery would be thoroughly cleaned and any alterations to the building made.

The last wing of the building was given over to the Royal Academy. This arrangement pleased neither party, because from the start both were confined to inadequate accommodations owing to the shortage of space.

**1839.** The collections were enriched by the valuable additions of *Sunset Landscape* by Rubens, which had been bequeathed by Lord Farnborough, and Raphael's *St. Catherine of Alexandria*, acquired from the British market.

**1842.** The Gallery bought one of Jan Van Eyck's masterpieces, *The Marriage of Giovanni Arnolfini and Giovanna Cenami*, on the advice of Seguier.

**1843.** On the death of Seguier, the responsibility of curator of the Gallery fell on Charles Lock Eastlake. He was a dedicated painter of historical subjects and an expert on art history.

**1844.** Eastlake published an "open letter to Lord Peel" in which he denounced publicly the deficiencies of the National Gallery: the inappropriate arrangement of the paintings, the inadequate space for both the works on exhibition and for the patrons of the Gallery, the lack of accommodations for administrative offices, and the inferior system of ventilation and heating. He declares it expedient that the Gallery should be extended and its organization improved without delay. The situation was further aggravated by the tendency of passers-by to use the Gallery merely as a place of shelter in bad weather.

Among the more notable qualities of the new director was his determined effort to establish a policy whereby the choice of new acquisitions would be based on critical opinion and would not, as had been the case up till then, be a slave to the prevailing and undiscerned taste for the Italian painters from Raphael onwards. This effort was not always successful and in the same year the Gallery bought Guido Reni's *Christ Embracing St. John*, *Lot and his Daughters Leaving Sodom*, and *Susannah and the Elders*, which is now thought to be a copy. From the same sale, probably, came two other works of outstanding value; these were *The Judgment of Paris* by Rubens and *The Doge Leonardo Loredan Full-Face* by Giovanni Bellini.

**1845.** Great uproar and indignation was aroused by the acquisition of *A*

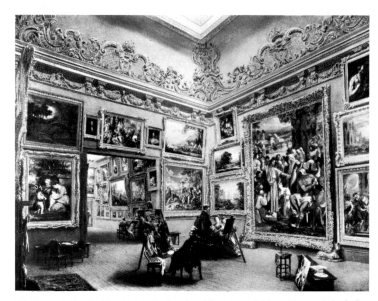

*This is a painting by W. Mackenzie (London, Victoria and Albert Museum) depicting John Julius Angerstein's gallery, first provisional seat of the National Gallery, located at 100 Pall Mall.*

*Man with a Skull* bearing a forged signature. At first it was attributed to Holbein but is now thought to be in the style of Nicolas de Neufchâtel.

**1846.** The steps taken by Eastlake to have the paintings cleaned caused discussions which were even more heated than those of the previous year. In order to protect the paintings from the adverse effects of the London air, William Seguier had treated them with a mixture of resin and linseed oil. The paintings had at first acquired a golden tone, but this had progressively darkened and had altered the timbre of the colors.

John Ruskin joined in the controversy. Like Eastlake, he was a believer in, among other things, the necessity of building up a representative collection in the National Gallery of very early works.

**1847.** Probably embittered by the biting criticism to which he had been subjected, Eastlake resigned and Thomas Unwins, inspector of the collections in the Royal household, was designated to take his place.

An official catalogue of the collections was published, compiled by Eastlake and the portrait painter, Ralph N. Wornum.

The Gallery was offered the Robert Vernon collection of 157 paintings of the British School. The paintings, however, could not be housed in the Gallery because of the lack of sufficient space and the collection remained for some time in the hands of the owner. It was then housed for a short time in Marlborough House.

Another acquisition is *Vision of a Knight* 213 by Raphael.

**1851.** Another new acquisition: *Portrait of the Painter in Old Age; in a Red Jacket with a Fur Collar, His Hands Clasped*, a self-portrait done by Rembrandt when he was 63 years old.

**1852.** The Gallery acquired *The Tribute Money* by Titian.

**1853.** The unresolved controversy over the acquisitions to be made by the National Gallery and, above all, the cleaning of the paintings, finally led to the setting up of an extensive enquiry, chaired by William Mure, a humanist. It lasted for four months, examining the many complicated problems concerning the Gallery. The cleaning of the paintings (a subject which had aroused much protest) was not, however, discontinued but was made subject to certain regulations. Furthermore, in order to eliminate the main causes of deterioration of the paintings (which were the lack of ventilation and space), the decision was made to erect a new building for the National Gallery, leaving the one in Trafalgar Square entirely to the Royal Academy. This decision was never, in fact, implemented. As for the policy on acquisitions, a new approach was worked out which had, as its end, a complete panorama of the history of art. Particular emphasis was placed on the necessity of building up a good collection of early works, something which had, up until then, been neglected.

The enquiry also proposed an innovation in the responsibilities of the director of the Gallery. He was to be given full control over the acquisitions and was to be fully supported in this by a yearly grant from the state. And so began a particularly happy period for the National Gallery because the intelligent suggestions of individuals, now no longer completely exposed to uninformed criticism (as had befallen Eastlake), were reinforced and corroborated by a firm organizational structure based on enlightened and well-defined directives.

**1854.** The post of director was offered to Eastlake who, after some hesitation, accepted and remained in this appointment until his death some ten years

later. Leaving the administrative duties to the curator, Ralph N. Wornum, Eastlake dedicated his time almost entirely to the question of acquisitions. He was assisted in this by a traveling art agent named Otto Mündler, an eminent critic and collector.

The Krüger collection was acquired by the Gallery, probably on the advice of William Dyce, a painter and precursor of the pre-Raphaelites. This collection is entirely made up of very early German works.

**1855.** Ten Northern Italian Renaissance works were bought from Baron Galvagna of Venice, among them, Giovanni Bellini's *The Virgin and Child* 280.

**1856.** The highly important bequest by Turner who was so little esteemed by his contemporaries, comprising all the works in the painter's possession (hundreds of oil paintings and approximately 19,000 water colors) was, like other donations before it (see 1847 above), temporarily placed in Marlborough House.

**1857.** The most important of Eastlake's acquisitions were undoubtedly the 22 paintings of the Lombardi-Baldi collection, bought for the considerable but suitable sum of 7,000 guineas. This greatly expanded the old Italian masters section of the Gallery. The works included the Margarito di Arezzo altarpiece (perhaps still the oldest work in the Gallery), the triptych of *The Virgin and Child with Six Angels*, which was then thought to be by Cimabue and is now attributed to a follower of Duccio, *The Coronation of the Virgin* ascribed to Agnolo Gaddi, *Niccolò Maurizi da Tolentino at the Battle of San Romano* by Paolo Uccello and Botticelli's *The Adoration of the Kings* 592.

After a long and painstaking period of trying to persuade Count Victor Pisani to sell *The Family of Darius before Alexander* by Veronese, Eastlake succeeded. The price agreed on was extremely high for that time, amounting to 13,000 guineas. There ensued an immediate protest to such a sum from Parliament and Mündler's immediate resignation was demanded.

Another acquisition during this year was Van Eyck's *Portrait of a Young Man*.

**1860.** The space provided for the Gallery was enlarged owing to an alteration made on the large entrance hall. This was bisected horizontally, thus creating a very large upper room.

In Paris, Eastlake bought from the Edmond Beaucousin collection 46 paintings for £ 9,205. Among the most noteworthy of the pieces were *An Allegory* by Bronzino, *Madonna and Child with St. John and St. Catherine* by Titian, *The Magdalen Reading* by Rogier van der Weyden and *A Man with a Rosary* by Gossaert. During the same year, Fra Angelico's *Christ Glorified in the Court of Heaven* was acquired.

**1861.** Acquired this year were part of an altarpiece, *The Baptism of Christ* by Piero della Francesca, and Filippo Lippi's *Seven Saints*. Eastlake presented the Gallery with Lippi's *The Annunciation*, a pendant to *Seven Saints*.

**1862.** Among numerous acquisitions were Piero di Cosimo's *A Mythological Subject* and Andrea del Sarto's *Portrait of a Young Man*.

**1863.** *The Agony in the Garden* by Giovanni Bellini was bought this year.

**1865.** Among Eastlake's last noteworthy acquisitions were *St. John the Baptist and St. Lawrence* by Memlinc, Raphael's *Madonna, Child and St. John* ("The Garvagh Raphael") and Velázquez's portrait *Philip IV of Spain* 745.

Eastlake died in the same year, leaving behind him a personal collection of paintings which, though not very large, had been of fine quality and had been lovingly gathered together during his frequent journeys abroad. In his will,

he stipulated that they be offered to the National Gallery at the same price he himself had paid for them. The Gallery chose *St. Michael* by Piero della Francesca (a panel from a polyptych) and *The Virgin and Child Enthroned* by Cosmé Tura (the central panel from an altarpiece), and in addition, in memory of her husband, Lady Eastlake presented Pisanello's *The Virgin and Child with St. George and St. Anthony Abbot* to the Gallery.

**1866.** Eastlake's successor, William Boxall, continued to carry out the recommendations of the enquiry by enriching the Italian section of the Gallery. One of the first works added by him was *Portrait of a Lady in Yellow* by Alesso Baldovinetti.

**1868.** Acquisition of *The Entombment* by Michelangelo.

**1868-69.** With the passing of the years, the problem of the need for more space had become increasingly urgent and the issue could now no longer be shelved. It was, therefore, decided to transfer the Royal Academy somewhere else and this was done without delay. The Gallery occupied the east wing of the building while plans for the extension of the wing were being made (see 1876 below).

**1869.** If Italian art was now as well represented in the Gallery as was the work of Rubens and Rembrandt, the Dutch and the Flemish schools were still under-represented. And it is because of this that the acquisition of one of Pieter de Hoogh's masterpieces *A Woman and her Maid in a Courtyard* is so important at the time.

**1870.** A new addition to the collection: *Madonna and Child with St. John and Angels* attributed to Michelangelo.

**1871.** Robert Peel sold his father's very rich collection to the National Gallery. It contained 77 paintings, mainly of the Dutch and Flemish schools. Peel's price was £ 75,000, and while the government accepted what was the most important bargain in the history of the Gallery, it suspended the Gallery's annual grant for the time being. And so, an area of the collection in the Gallery which had been, up until then, poorly catered to, now achieved a considerable balance. It had acquired works of such worth as *Le Chapeau de Paille* by Rubens, two paintings by Pieter de Hoogh, four by Hobbema, three landscapes by Cuyp, *An Extensive Landscape with a Hawking Party* by Koninck and *A Young Woman Playing a Theorbo to Two Men* by Gerard Ter Borch. At the same time, Sir Richard Wallace made a donation of *The Swearing of the Oath of Ratification of the Treaty of Munster, May 15, 1648* by the same artist.

**1873.** Though the annual state grant was still suspended, an extraordinarily large allowance was made to the Gallery by the state, so that Mantegna's *The Introduction of the Cult of Cybele at Rome* ("The Triumph of Scipio") could be purchased.

**1874.** Frederick William Burton was appointed director of the Gallery this year; although not very highly gifted as an artist, he was an excellent organizer. Thanks to the support of his curator Eastlake (grandson of Lord Eastlake), he managed to obtain a special grant from the government in order to acquire 14 Italian Renaissance works at the Alexander Barker sale. These works included *The Nativity* by Piero della Francesca, *Venus and Mars* by Botticelli, and two frescoes from Palazzo Petrucci (the palace of Lorenzo dei Medici) in Siena painted by Signorelli and Pintoricchio.

**1875.** The bequest left to the Gallery by Thomas Denison Lewis, amounting to £ 10,000 which had been put aside and kept in reserve for a time when it might be needed, was used to buy

*Cornard Wood* by Gainsborough and *The Mill at Norwick* by John Crome (now to be seen in the Tate Gallery).

**1876.** The series of extensions made to the rear part of the east wing by the architect E. M. Barry were now complete, resolving at least for the time being the perennial problem of shortage of space. At the same time, other important changes also took place; a system of central heating was installed in the building and an attempt was made to improve lighting in the Gallery; but the system still relied upon was that provided by Nature.

*Portrait of a Middle-Aged Woman with Hands Folded* by Frans Hals was bought (with the help of the Lewis funds), as were paintings by Moretto and Moroni, for which a special grant was received.

The Gallery received another important bequest, this time from Wynn Ellis. It contained 94 works, predominantly of the Dutch School. Included in the collection were: Dieric Bouts, *Portrait of a Man*, works by Cuyp, van de Cappelle, Hobbema, Jacob van Ruisdael, three scenes by Canaletto, and *Apollo and Daphne*, ascribed to Pollaiuolo.

**1878.** The annual state grant was restored but the Gallery was only given half of the original sum. Botticelli's *Adoration of the Kings* 1033 and *Mystic Nativity* were bought this year.

**1880.** The state granted the full sum of the yearly subsidy and da Vinci's *Virgin of the Rocks* was bought.

**1882.** From the Hamilton sale in London, the Gallery acquired *The Assumption of the Virgin*, which is now ascribed to Botticini but which at that time was thought to be by Botticelli, *The Circumcision* by Signorelli, *St. Jerome in a Landscape* by Cima da Conegliano, and *Philip IV of Spain in Brown and Silver* by Velázquez. With the £ 24,000 left by Francis Clarke, the

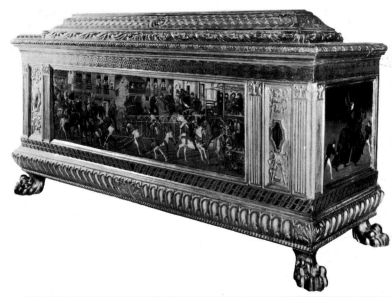

"Cassone with a Tournament Scene." A fifteenth century chest of the Florentine School with rich pastiglia ornamentation.

Gallery was able to buy *Joseph in Egypt* by Pontormo and *Christ Washing His Disciples' Feet* by Tintoretto.

**1883.** Two predella panels from Duccio's altarpiece the *Maestà* from the Cathedral of Siena were bought, again with money from the Clark fund. These were *The Annunciation* and *Jesus Opens the Eyes of a Man Born Blind.* Besides these, the Gallery bought Antonello's *Portrait of a Man* and Mantegna's *Samson and Delilah.*

**1884.** This year there were some more important acquisitions. These were *The Assumption of the Virgin* by Matteo di Giovanni and *Adoration of the Magi* by Giorgione.

**1885.** The Gallery acquired two more paintings which were as valuable as they were controversial: *The Ansidei Madonna* by Raphael and van Dyck's portrait *Charles I on Horseback.* They were part of a group of 12 paintings in the Duke of Marlborough's personal collection which had been selected by the directors of the Gallery, but the sum asked for by the owner, £ 400,000, was judged by the government to be extremely excessive. Even £ 165,000, the price of five of the paintings, was felt to be too high. It was only after pressure had been brought to bear on the government by various groups of people, including many well-known figures and 64 members of Parliament, that at least two works of the utmost importance were not lost. These were

The *Ansidei Madonna*, which was bought for £ 70,000, and the portrait of Charles I, bought for £ 17,500.

**1886.** *The Hay-Wain* by Constable was donated to the Gallery by Henry Vaughan.

**1887.** Numerous extensions were made to the building this year.

**1888.** Constable's daughter, Isabelle, made a substantial donation of some of her father's work to the Gallery.

**1890.** New state opposition was aroused by the proposed purchase of three paintings from the Count of Radnor, who refused to sell them individually. The paintings concerned were *The Ambassadors* by Holbein the Younger, *A Nobleman* 1316 by Moroni, and *Don Adrián Pulido Pareja* with the unauthenticated signature of Velázquez. This painting is now attributed to Juan Bautista del Mazo. The purchase of the works was eventually made possible, however, thanks to the generous offers to contribute £ 10,000 each, made by Sir Edward Guinness and Charles Cotes, on condition that the state provide the remaining £ 25,000, which the state did.

The annual state grant was used to buy *The Origin of the Milky Way* by Tintoretto and *Unfaithfulness* by Veronese, one of four paintings which comprise the *Allegory of Love* cycle.

**1891.** The other three paintings of the cycle, *Scorn, Respect,* and *Happy*

*Union* were acquired this year. They belonged to Lord Darnley who made a gift of one of them to the Gallery.

**1892.** At the sale of the Thoré-Bürger collection in Paris, the Gallery bought *A Young Woman Standing at a Virginal* by Vermeer for £ 2,400.

**1894.** Burton goes into retirement and a directive from the government revokes the full powers of decision which had been given to the director of the Gallery in 1853. This function now became the prerogative of the board of directors. This course of action was not altogether justified, if one is to judge by the successful results during the former term of office.

To the new director, E. J. Poynter, lecturer at University College and later President of the Royal Academy, is owed the acquisition of such important works as *The Agony in the Garden* by Mantegna, *St. Jerome in His Study* by Antonello da Messina, and *St. Giles and the Hind* by the Master of St. Giles.

**1896.** Acquisition of three Goya canvases: *A Picnic, A Scene from "El Hechizado por Fuerza"* and the portrait *Doña Isabel Cobos de Porcel.*

**1897.** The director of the National Gallery was also given responsibility for the Tate Gallery, which was to act as a kind of complement to the National, housing only those more recent works.

**1899.** During this year, two great paintings by Rembrandt were bought by the Gallery. These were *Portrait of Jacob Trip* and the *Portrait of Margaretha de Geer, Wife of Jacob Trip* 1675.

**1900.** The Henry Vaughan bequest brought to the Gallery an outstanding group of works of the British School, among them Gainsborough's *The Painter's Daughter Chasing a Butterfly* and some paintings by Constable.

**1901.** The St. George military barracks which lay to the north of the National Gallery were demolished and the building was subsequently extended by the addition of new rooms to the west wing (see 1876 above).

**1903.** In order to counter any attempt by foreigners (and especially Americans) to invade the English market for works of art, the National Art-Collections Fund was instituted.

**1904.** Titian's *Portrait of a Man* 1944 was acquired this year. However the board of directors in its new role of authority raised so many difficulties against its purchase that Poynter resigned. Furthermore, the loss of Titian's *Rape of Europa*, a painting offered to the Gallery by Lord Darnley, to the

United States can also be attributed to the Board.

**1909.** The Duke of Norfolk, who owned *Christina of Denmark, Duchess of Milan* by Hans Holbein the Younger, a painting which had for a long time been on exhibition in the Gallery, decided to sell it for £ 72,000. The public appeal launched by the National Art-Collections Fund, which was strongly supported by the press, achieved a reasonable response, but the figure reached with the help of contributions amounted only to £ 32,000. The precious work was, however, saved from being shipped out of the country by the generous intervention of an Englishwoman who insisted on remaining nameless.

**1910.** The George Salting bequest consisting of 192 paintings enriched the collection in the Gallery with some precious works by Constable, some very worthwhile pieces from various sources such as *The Virgin and Child before a Fire Screen* by Campin, *An Extensive Landscape with Ruins* 2561 by Jacob van Ruisdael, and a few character studies by Jan Steen.

**1911.** The new rooms added to the north side of the Gallery (see 1901 above) were opened to the public.

**1916.** Sir Henry Layard's bequest brought to the Gallery some interesting works of the Venetian School which had originally come from the Palazzo Cappello in Venice.

With the help of private funds, *The Virgin and Child* by Masaccio was bought by the Gallery.

**1917.** The bequest containing nineteenth-century French works left by Sir Henry Lane was put on exhibition in the Tate Gallery; only much later (see 1935, 1950-53-56 and 1961) were some of the paintings transferred to the National Gallery.

This bequest, however, had caused a dispute to arise between the National Gallery of London and the National Gallery of Ireland in Dublin. According to Lane's will, the collection was to go to the London Gallery; but the Gallery in Dublin also claimed possession, as a result of a later codicil to the will, a codicil of disputable legal validity (see 1959 below). At this time, the controversy remained still unresolved.

**1924.** Among the most important donations of the 20th century was the Mond bequest, a collection made up almost entirely of Italian works, among which are: *The Crucifixion* by Raphael, two panels from *Four Scenes from the Early Life of St. Zenobius* by Botticelli, *Pietà* by Giovanni Bellini and Titian's *Madonna and Child.*

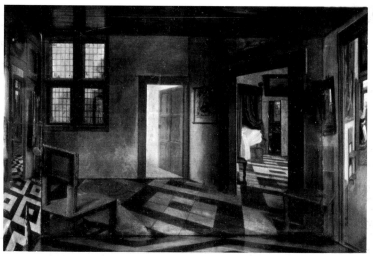

"Peepshow with Views of the Interior of a Dutch House." This is the work of the Dutchman Samuel van Hoogstraten. When viewed from the exterior, it is a cube-shaped structure bearing allegorical-mythological figures (left). The figures on the upper part of the cube have been considerably shortened so as to create the effect of perspective (right). The interior (center) with all the atmosphere of a Dutch household, can be viewed by means of two holes set in such a way that the onlooker has the impression of actually being inside a room with doors corresponding to other rooms of the house in which members of a Dutch family are going about their daily lives. The whole effect is achieved by the artist's painting the six inner walls of the cube as if he had been standing in the middle of the room.

**1935.** *Les Parapluies* by Renoir was transferred from the Tate to the National Gallery (see 1917 above).

**1939-45.** When the Second World War broke out, all the paintings from the National Gallery had already been moved to a safe place in Wales. This consisted of a hollow in the side of a mountain which had been specially prepared with air-conditioning for this purpose. Obviously, however, no such measures could be taken as regards the building itself, which suffered substantial bomb-damage, some rooms being entirely destroyed. Despite this, the paintings were quickly brought back and put in their rightful places in time for the re-opening of the Gallery before the armistice was signed. Because of the shortage of space, many works of the British School were transferred to the Tate Gallery, the National retaining only those belonging to the period from Hogarth to Turner.

**1942.** *Pentecost*, one panel from a series attributed to Giotto, which came from the Coningham bequest, provided an unexpected contribution to an already rich collection of Italian works.

**c. 1946.** During the complicated post-war reorganization energetically undertaken by the new director, Philip Hendy, a start was made on extensive internal alterations of the Gallery. The reconstruction of the building was to include numerous extensions and the installation of air-conditioning; an integrated program for the cleaning of the paintings was established; new administrative departments were created, including a special department to deal with the conservation of paintings and restoration work; a science laboratory to carry out research into restoration methods and to find new and more effective ways of dealing with the task; and, finally, a Publications Department to provide for the public illustrated material on the Gallery itself, such as photographs and guides.

**1950.** Acquisition of part of an altarpiece by Masolino, *St. John the Baptist and St. Jerome*, on the back of it, another painting by Masolino, *A Pope and St. Mathias*. These two paintings have now been separated and the second one is now shown as the pendant of the first.

The first room with air-conditioning is opened to the public.

**1950-53.** Several French Impressionist works were transferred from the Tate to the National Gallery. These included *Lavacourt (?), Winter* by Monet, five paintings by Manet, and three by Pissarro.

Thanks to the fund instituted by Samuel Courtauld which guaranteed the National Gallery the right to choose any paintings bought by him, the Gallery acquired two works by Degas, *Petites Filles Spartiates Provoquant des Garçons* and *La La at the Cirque Fernando, Paris*.

**1953.** Acquisition of Cézanne's *La Vieille au Chapelet*.

**1954.** The autonomy of the Tate (as opposed to the National Gallery) was ratified by a statute of law as were the different natures of the two collections so that all contemporary works were to go to the Tate Gallery.

**1955.** A special allowance was granted by the state so that El Greco's sketch for *The Adoration of the Name of Jesus* at the Escorial could be bought.

**1956-57.** Since the extremely high price paid for works of art on the open market rendered increasingly more difficult the enrichment of the general public's cultural heritage, the state, to encourage this enrichment, introduced the Finance-Act which accepted payment of taxes in the form of works of art. As a result of this, the Gallery fell heir to numerous paintings, these

# GENERAL INFORMATION

**Organization** – The Gallery has a Director General, a Keeper and a Deputy Director, a Deputy Keeper and three Assistant Keepers, who form the staff of the Art Historians. There is also an official Lecturer. A Board of Directors and an honorary advisory Scientific Committee oversee the interests of the Gallery.

**Institutions Connected with the Gallery** – The Gallery is provided with a Scientific Department to carry out chemical and X-ray researches with the help of the most up-to-date equipment in the field. There is also a very efficient Photographic Department and a Publications Department to provide for the public illustrated material in the Gallery itself, such as yearly reports, updated catalogues of the various schools, pamphlets on certain pictures.

**Lighting and Air-conditioning** – Most rooms have fully automatic lighting controlled to the strength of the outside light. The whole reserve collection and a good part of the exhibition rooms are air-conditioned. Automatic lighting and air-conditioning are expected to be extended to all the rooms. Relative humidity is held at 54% ± 4%.

**Security Services** – In addition to unarmed attendants, there is an anti-fire service and a system of alarms.

**Admission** – The rooms on the first floor are open to visitors from 10 a.m. to 6 p.m. on weekdays; from 2 p.m. to 6 p.m. on Sundays and on the Feast of St. Stephen, and from 10 a.m. to 9 p.m. on Tuesdays and Thursdays from June through September. The rooms of the Reserve Collection are open from 10 a.m. to 5.45 p.m. on weekdays. The Gallery is closed on Christmas Eve, Christmas Day and Good Friday. On request, conducted tours are available.

**Cultural Services to the Public** – Lectures are given four days a week. A first class library is available, but it is primarily for the use of staff. However, applications from members of the public are considered. Catalogues, color and black-and-white postcards, large reproductions and other publications are on sale.

**Services to the Public** – The Gallery is provided with a restaurant with self-service.

**Subsidiary Exhibitions** – The Gallery, from time to time, organizes in the Board Room small exhibitions (of, for example, acquisitions and cleaned pictures).

## CHARACTERISTIC

1,950 paintings _____

## VISITORS

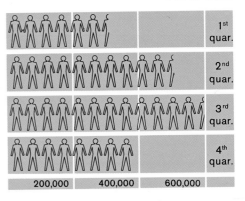

| | | | |
|---|---|---|---|
| | | | 1st quar. |
| | | | 2nd quar. |
| | | | 3rd quar. |
| | | | 4th quar. |
| 200,000 | 400,000 | 600,000 | |

9

# RELATIVE IMPORTANCE OF THE SCHOOLS REPRESENTED IN THE MUSEUM

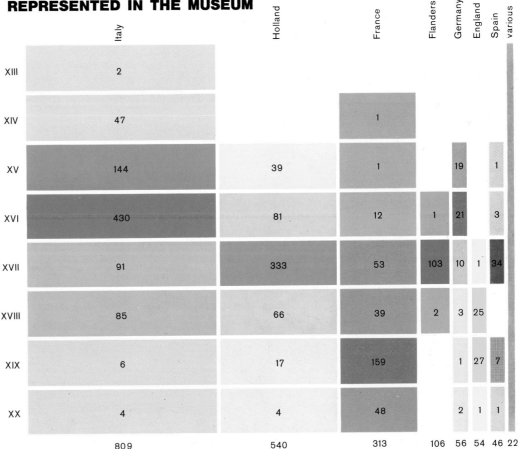

| | Italy | Holland | France | Flanders | Germany | England | Spain | various |
|---|---|---|---|---|---|---|---|---|
| XIII | 2 | | | | | | | |
| XIV | 47 | | 1 | | | | | |
| XV | 144 | 39 | 1 | | 19 | | 1 | |
| XVI | 430 | 81 | 12 | 1 | 21 | | 3 | |
| XVII | 91 | 333 | 53 | 103 | 10 | 1 | 34 | |
| XVIII | 85 | 66 | 39 | 2 | 3 | 25 | | |
| XIX | 6 | 17 | 159 | | 1 | 27 | 7 | |
| XX | 4 | 4 | 48 | | 2 | 1 | 1 | |
| | 809 | 540 | 313 | 106 | 56 | 54 | 46 | 22 |

*Sketch illustrating the importance of the various schools: each school is divided into centuries and indicated by a different color; the length of the strips is proportional to the number of paintings belonging to each school with regard to the other schools; the color intensity is proportional, within each school, to the importance of the paintings for each century. The figures referring to the paintings have been indicated with the nearest possible approximation.*

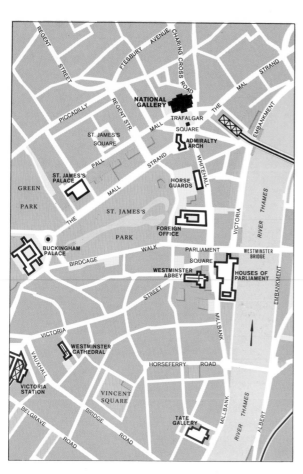

10

being *Pietà* by van der Weyden from the Powis collection, and later on, *The Virgin and Child with Saints, Angels and Donors* ("The Donne Triptych") by Memlinc from the Duke of Devonshire, *An Old Man in an Armchair, Leaning His Head on His Right Hand* by Rembrandt, and twin portraits by Jordaens. Also acquired was *Ovid among the Scythians* by Delacroix.

A large number of 19th century French paintings were transferred to the National Gallery from the Tate Gallery; these included canvases by Corot, Courbet, Daumier, Delacroix, and Rousseau.

**1958.** "Hamptonsite," an area lying to the west of the National Gallery became the property of the state. According to the scheme of development planned for the site of the National Gallery, this latest acquisition of property would permit wider expansion of the National, eventually taking in the actual site occupied by the National Portrait Gallery as well. The Portrait Gallery would ultimately be demolished and would then be rebuilt in "Hamptonsite." This development would give the National Gallery five or six new exhibition rooms on a site totaling an area of 1,400 square meters.

Eight of the ten frescoes by Domenichino were bought by the Gallery. These are pictorial illustrations of stories concerning Apollo which originally decorated Villa Aldobrandini in Frascati.

**1959.** The Gallery acquired Paolo Uccello's *St. George and the Dragon.*

The annual state grant to the Gallery was increased to £ 100,000.

In order to settle the question of the Lane bequest (see 1917 above), a tem-

porary arrangement was made whereby the collection was to be divided in two and each half exhibited alternately at the London and Dublin galleries for a period of five years each.

**1960.** A series of four canvases by Giovanni Battista Tiepolo were bought by the Gallery, which received at the same time the donation of a painting by Pompeo Batoni, presumed to be a portrait of *Mr. Scott of Banksfee.*

**1961.** The lengthy work of reconstruction of the Gallery after the damage done to it during the war was finally completed. Bringing with it a number of vast improvements to the building and the addition of two extra rooms, many parts of the Gallery were equipped with both air conditioning and fluorescent lighting.

Moreover, a system was set up whereby the paintings could be lent to smaller galleries throughout the country for a certain period of time.

Among the year's acquisitions were the two *Danseuses* paintings by Renoir, *Landscape with a Footbridge* by Altdorfer (one of the only two surviving landscapes by the artist, the other one being in the Alte Pinakothek in Munich) and the portrait painted by Goya, *The Duke of Wellington.* This last was stolen in August of that year and it was not found until four years later (see 1965 below).

Paintings by Cézanne, Degas, Gauguin, Monet, Pissarro, Renoir, Seurat, Sisley, Toulouse-Lautrec, and Van Gogh were removed from the Tate Gallery and housed in the National Gallery.

**1962.** The Leonardo cartoon, *The Virgin and Child with St. Anne and St. John the Baptist,* the auction of which

1  Italian Painting, 13th/14th c.
2  Italian Painting, 14th/15th c.
2a  Lombard and Venitian Painting, 15th/16th c.
3  Florentine Painting, 15th c.
4  Central Italian Painting, 15th c.
5  Leonardo
6  Italian Painting, 16th c.
7  Venetian Painting, 16th c.
8  Netherlandish Painting, 16th c.
8a  German Painting, 15th/16th c.
8b  North Italian Painting, 15th c.
8c  Florentine Painting, 15th c.
8d  Netherlandish Painting, 14th/15th c.
9  Venetian Painting, 16th c.
10  Dutch Painting, 17th c.
11  Dutch Painting, 18th c.
12  Rembrandt
13  North Italian Painting, 16th c.
13a  Domenichino Frescoes
13b  Italian Painting, 18th c.
13c  Carlo Crivelli
14  Flemish Painting, 17th c.
15  Flemish and Dutch Painting, 17th c.
16  British Painting, 18th c.
17  Canaletto
17a  Italian Painting, 17th c.
17b  Italian and French Painting, 17th c.
17c  Italian Painting, 17th c.
17d  Italian Painting, 18th c.
18  Spanish Painting, 16th/17th and 18th c.
19  French Painting, 18th c.
20  French Painting, 17th c.
21-23  French Painting, 19th c.

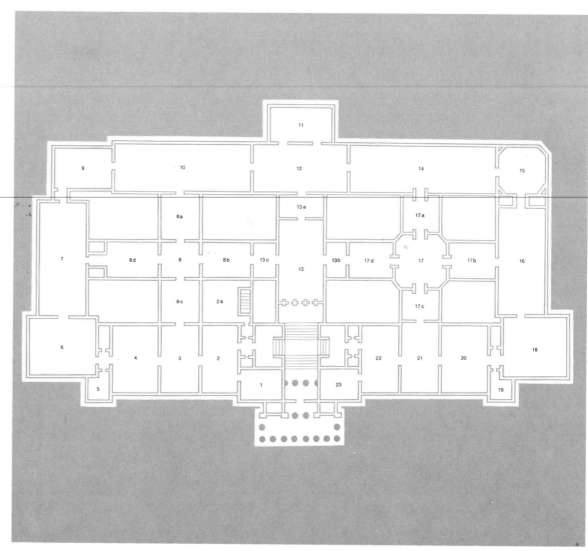

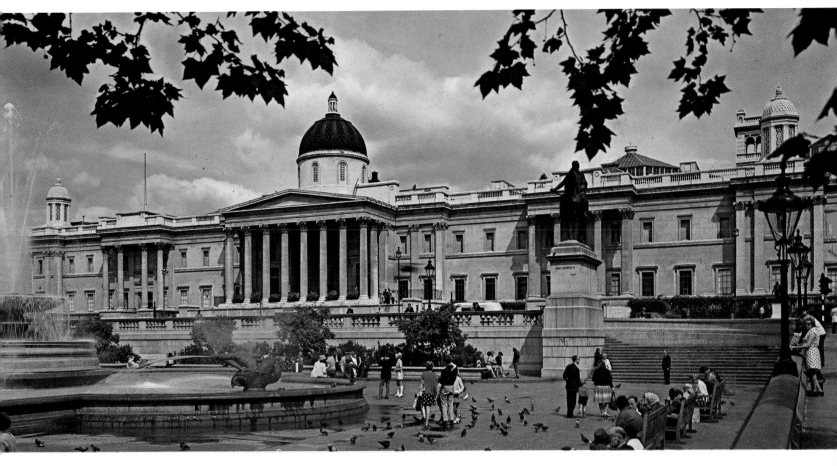

was announced in March by the Royal Academy, was, from the beginning, the cause of rivalry between the National Gallery and the British Museum as to which of them would eventually acquire it. The British Museum's claim to it was substantiated by the fact that, up until now, drawings had always been its own particular domain. The National Gallery was, however, better equipped to house the work (a whole room was eventually given over to it) and it was for this reason that preference was finally given to the National rather than to the British Museum.

Consequently, a public appeal was launched so that the £ 800,000 necessary to buy the work could be raised. Though by no means a small amount of money, this sum was much lower than the price it would fetch on an open market. And thanks to such a step as well as the substantial amount contributed by the state (£ 350,000), it was possible to buy the cartoon in August of that year.

Luca Giordano's *Martyrdom of St. Januarius* was bought with money from the Martin-Colnaghi Fund.

The Claude Rotch bequest brought to the Gallery Wtewael's *The Judgment of Paris* by Giuseppe Maria Crespi, *Rebecca at the Well* by Giovanni Antonio Pellegrini, and one work of particular interest to the Gallery, a *Portrait of Sir George Beaumont*, painted by Hoffner; Beaumont had been one of the first and most generous benefactors of the Gallery (see 1823 above).

The French School was still underrepresented in the Gallery and it was, therefore, with great pleasure that *The Adoration of the Shepherds* by Louis Le Nain was received from the Duke of Norfolk's collection.

The Brandt family donated *A View of Deventer* by Salomon van Ruysdael and two canvases by Corot, *Dardagny - un Chemin dans la Campagne, le Matin* and *La Charrette, Souvenir de Saintry*.

**1963.** The acquisitions for the year were Cranach the Elder's *Cupid Complaining to Venus*, *The Luteplayer* by

Ter Brugghen, *St. Jerome* by Giuseppe Maria Crespi, and *Dans le parc du Château Noir* by Cézanne.

The Gallery acquired its first Danish painting, which was *A Portrait of Joseph Greenway* by Juel. This was a gift from the de Paravicini family, who were descendants of Joseph Greenway.

Mrs. H. W. Rawlinson presented a small painting by Lépine entitled *Nuns and School Girls Walking in the Tuileries Gardens, Paris*.

Because of a special allowance given by the government to the Gallery, it was possible to buy a large Monet canvas from the Galerie Beyeler in Bâle; it was one of the artist's later works, and is entitled *Nymphéas*.

**1963-64.** New rooms were opened on the ground floor of the west wing and the Reserve Collection is on exhibition in these rooms. Because space is not lacking in this part of the Gallery, the paintings can be arranged in a way that is fitting. Besides these paintings, those works which have been lent out to provincial galleries can also be appropriately arranged when they return temporarily to the Gallery.

Air conditioning was installed in these new rooms and in the Conservation Department, while only 13 out of the 34 rooms on the main floor had it. It would take quite a few years work before it would eventually be installed.

**1964.** A special allowance of £ 41,000 was made to the Gallery, so that *Les Demoiselles des Bords de la Seine*, a composition sketch by Courbet, could be purchased. Then a few months later the Gallery received another grant of £ 125,000 which, together with a contribution from the Max Rayne Foundation amounting to £ 225,000, made possible the acquisition of *Les Grandes Baigneuses* by Cézanne.

The small room where two paintings by Giorgione had previously been exhibited was opened to the public after having been renovated especially to house the Leonardo cartoon (see 1962 above). A special system of air conditioning had been installed in the room,

and the entirely artificial lighting was so arranged as to focus fully on the masterpiece.

The state grant was fixed at a yearly allowance of £ 200,000 for five years.

The contribution made by National Art-Collections Fund was used to purchase Rembrandt's *Belshazzar's Feast* from the Earl of Derby's collection.

Viscount and Viscountess Radcliffe presented the Gallery with *Lower Norwood* by Pissarro.

Sir Ronald Storrs presented the Gallery with a painting by the so-called Master of Riglos, *The Crucifixion*.

**1965.** On the 22nd of May, the portrait of the *Duke of Wellington* by Goya was found (see 1961 above) in the left-luggage department at Birmingham station after a message had been received from the thief himself indicating where it was to be found.

With financial help given by the National Art-Collections Fund and by a generous individual who wished to remain anonymous, it was possible for the Gallery to buy *The Crucifixion*, a work done on wood by the Master of St. Francis, while the two canvases by Domenico Beccafumi, *Tanaquil* and *Marcia*, were bought by private transaction before they went to auction.

Government responsibility for the National Gallery was transferred from the Treasury to the Ministry of Education. Various improvements were made to many rooms of the Gallery. Some were redecorated; others were fitted with air conditioning or new lighting equipment. The artificial lighting system of the Gallery was readjusted so that it could be regulated according to the amount of natural light there was available. The skylights were fitted with sheets of plastic to exclude the penetration of ultraviolet rays into the rooms.

**1966.** *The Allegory of Prudence* by Titian came into the Gallery this year.

Many important acquisitions were made this year, these being: *A Man Holding a Scroll* by Campin, an important work of the early Dutch School, *The Madonna and Child with the Infant*

*St. John the Baptist* by Pontormo, *The Marriage at Cana* by Mattia Preti, *The Judgment of Paris* by Rubens (bought with the help of a benefactor whose identity is unknown), *The Archbishop Fernando de Valdés* by Velázquez, *Landscape with a Water-Mill* by François Boucher, and finally Vuillard's *Le Déjeuner à Villeneuve-sur-Yonne*.

**1967.** The acquisitions for this year were *Les Irises* by Monet, *St. Andrew and St. Thomas* by Gian Lorenzo Bernini and *St. Anthony Abbot and St. Francis of Assisi* by Andrea Sacchi.

**1968.** A very important acquisition this year and one which was very much criticized by the British public because of what was felt to be too high a price (360,000 dollars) was *The Virgin and Child with Four Saints* by Duccio. The painting had originally belonged to Julius H. Weitzner, Inc., and had then been sold to an American gallery, but an export licence could not be obtained for it. The painting eventually went to the National Gallery which was able to buy it—thanks to the generous contributions made by the National Art-Collections Fund and an individual who is not named.

The collection of works by Cézanne was enhanced by the addition of one of the painter's early works, a portrait of *The Painter's Father*.

The work of expanding the north side of the Gallery to include the site of the National Portrait Gallery was begun.

As previously mentioned, the government took over "Hamptonsite" in 1958. But work was started on the site only this year and the whole development scheme is to be completed by 1975. The ground floor of the Gallery will be almost entirely occupied by the Reserve Collection, which will take over that part of the Gallery at the moment belonging to the Scientific Department. The amount of space, therefore, allocated to the Reserve Collection will be doubled. Furthermore, since many rooms on the first floor (approximately six out of 35) are often closed to the public, more rooms are needed on the

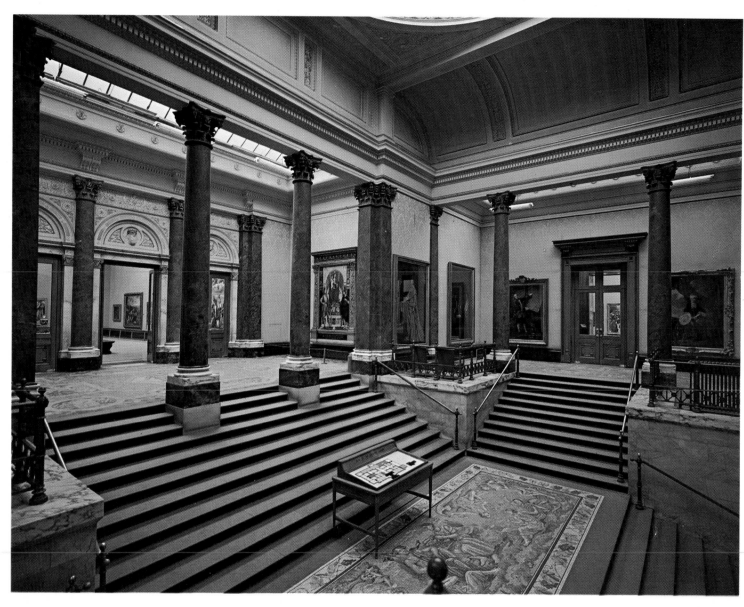

12

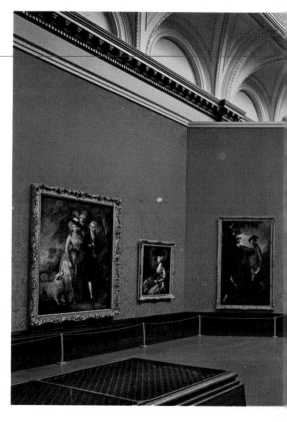

ground floor so that works can be exhibited there. At the far end of the north wing, a staircase and elevator is to be installed.

The first floor is to be given over entirely to exhibition rooms and this part of the Gallery will be accessible either by means of the stairway at the north end or else by the entrance to room X (Duveen).

There will be one or two changes made in the form and size of the rooms; for example, the ceilings of two rooms will be lowered and these rooms will be reserved exclusively for small paintings.

The space for exhibition purposes will be increased by 30 per cent with the new extensions.

The new rooms will all be air conditioned and a system of artificial lighting will be in operation whereby the lighting can be regulated according to the amount of daylight there is. As soon as the new construction is finished, this lighting system as well as air conditioning will be installed also in the east wing of the existing building.

The Scientific Department will be moved to the second floor of the new building.

M. Davies, previously curator of the Gallery, became director and his former post was filled by M. Levey.

**1969.** The annual state grant to the Gallery was fixed at £ 230,000, an amount thought by those responsible for the Gallery to be quite insufficient. The government was, therefore, asked to increase the grant to not less than £ 650,000. A further sum of £ 250,000 was requested which would be put aside to form a fund, managed by the Department of Education and Science, in order to prevent works of art from leaving the country.

Tiepolo's *Allegory: Venus and the Weather* was acquired by the Gallery. On the 1st of January, the Theft Act came into force. This guaranteed the highest possible security for works in the care of the Gallery.

**1970.** *Salomé*, a work ascribed to Caravaggio (and which had already been on loan to the Gallery since 1961), was eventually bought by the Gallery, together with two *Views in the Roman Campagna* by Poussin, a painting by

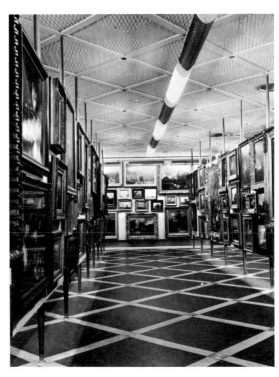

13

*(Above) The complicated framework which underlies the ceiling of the Gallery and into which a system of photoelectric cells has been installed so that the amount of artificial lighting can be varied according to the changing intensity of natural light. (Above right) An air-conditioned room of the Reserve Collection which is entirely open to the public. (Right) The plan of the new wing under construction. (On the page opposite) Entrance to the Gallery and (below) the exhibition rooms devoted respectively to sixteenth century Italian painting and to English painting.*

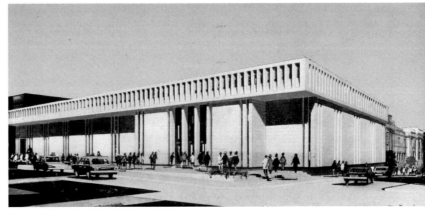

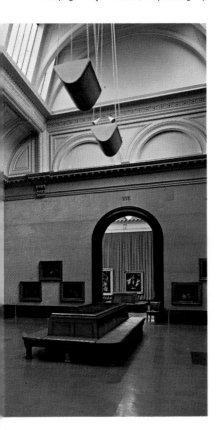

Rubens, *Portrait: Ludovico Nonnio*, and *The Adoration of the Magi* by Bartholomeus Spranger.

**1971.** Two paintings by Monet and one by Courbet were donated to the Gallery this year.

**1972.** Thanks to the contributions received from the National Art-Collections Fund, the Pilgrim Trust and a public association, the Gallery acquired *The Death of Actaeon* by Titian. Additional contributions were used to purchase the first of Henri Rousseau's paintings in the Gallery, *Tropical Storm, with a Tiger*, and the presumed *S. Ivo* by Rogier van der Weyden.

# Description of the Gallery

The National Gallery occupies the entire north side of the large expanse of ground that makes up Trafalgar Square, a focal point where some of the most famous streets in London—Charing Cross Road, the Strand, Whitehall, Pall Mall—all converge.

The Gallery was built in 1838 and was designed by an architect by the name of William Wilkins. It cannot claim to be one of his most inspired works, however. The building is in white stone because it was originally intended to be part of a much larger project of urban redevelopment planned by John Nash which aimed at

creating large thoroughfares to link up the important points of the city center.

The long solemn façade of the building is a clear example of the taste for the classical style of architecture which became popular in Britain between the end of the eighteenth century and the beginning of the nineteenth. In the center, there is an impressive Corinthian colonnade surmounted by a tympanum, in the style of a Greek temple, which divides the façade in two. The sides of the building bear two pairs of columns (these stand at either side of the lateral doorways) which are also Corinthian and which re-echo the decorative motif of the façade. These columns are modeled on those of Carlton House, one of John Nash's works (a few of the columns actually belonged to the building itself, which was demolished in 1820). Another decorative element is that of the pilaster strips which project dramatically from the top of the building, creating the effect of a markedly rhythmic scansion of the whole surface of the building.

At the center of the structure is a highly ornate dome which accords neither with the overall structure nor the architectural style of the building but which in itself characterizes the whole ensemble of the building.

The Gallery extends over two stories and includes, in addition to the main exhibition rooms on the first floor and those which belong to the Reserve Collection on the ground floor, a small cafeteria, offices, a library, a lecture theater, a science department with a

laboratory, a publications department with a photographic studio, and a workroom for restoration purposes.

The Gallery is entirely made up of collections of paintings, which are divided as follows:

a) Italian School

| | |
|---|---|
| Thirteenth and Fourteenth Centuries | 1-2 |
| Fifteenth Century | 2-4, 8 B-C |
| Leonardo | 5 |
| Crivelli | 13 C |
| Sixteenth Century | 2 A, 6, 7, 9, 13 |
| Seventeenth Century | 17 A-C |
| Domenichino | 13 A |
| Eighteenth Century | 13 B, 17 D |
| Canaletto | 17 |

b) Dutch and Flemish School

| | |
|---|---|
| Fifteenth Century | 8 D |
| Sixteenth Century | 8 |
| Seventeenth and Eighteenth Centuries | 10-15 |
| Rembrandt | 12 |

c) French School

| | |
|---|---|
| Seventeenth Century | 17 B, 20 |
| Eighteenth Century | 19 |
| Nineteenth Century | 21-23 |

d) British School

| | |
|---|---|
| Eighteenth and Nineteenth Centuries | 16 |

e) German School

| | |
|---|---|
| Fifteenth and Sixteenth Centuries | 8 A |

f) Spanish School

| | |
|---|---|
| Sixteenth, Seventeenth and Eighteenth Centuries | 18 |

# Masterpieces of Painting in the National Gallery

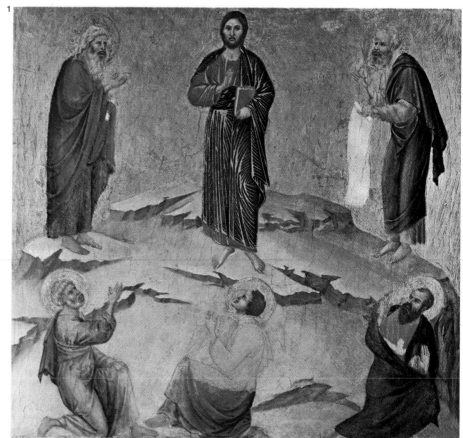

DUCCIO  The Transfiguration

**1.** The most important of **Duccio**'s work is the *Maestà* altarpiece which he painted for Siena Cathedral in 1308-11. *The Transfiguration*, one of the three predella panels from the altarpiece in the National Gallery (the other two being *The Annunciation* and *Jesus Opens the Eyes of a Man Born Blind*) is a work in which the figurative elements are reduced to essentials which are wonderfully serene and balanced. The painting shows Christ in the company of the prophets Moses and Elijah on Mount Tabor and beneath them are the Apostles Peter, John, and James. The classical tone of the noblest of Byzantine tradition is revived in the warm humanity shown by the artist, which he acquired when in his youth he frequented the studio of Cimabue, the Florentine painter.

**2.** There is no general agreement as to the attribution to Pietro **Lorenzetti** of this part of a predella panel which depicts the vain attempt by the Roman Governor of Tuscany to compel the holy bishop of Assisi to fall down and worship an effigy of Jove. The happy fusion of Duccionian elements with the broad spaciousness of Giotto and features of transalpine gothic makes this attribution very feasible, however.

**3.** **Sassetta**, while remaining attentive to Florentine masters, especially to Fra Angelico whose wise perspective rigor he translated into fanciful artifices, painted, between 1437 and 1444, an altarpiece for the church of St. Francesco di Sansepolcro; on the sides of it he had depicted, along with seven other anecdotes from the life of Saint Francis, the story of *The Legend of the Wolf of Gubbio*. In this scene Francis is portrayed in the act of concluding a pact with the fierce animal (whose last victims can be seen just behind him) in front of a gate of the town of Gubbio. While this is going on, a notary is recording the incident.

**4 – 5.** Taking the solid Giottesque forms which had become established in Tuscany and Venetia, Antonio **Pisanello** imbued them with some subtle elements from the International Gothic style, with splendidly rich and pungent results. In *The Virgin and Child with St. George and St. Anthony Abbot* the halo of the saintly group is perhaps a reference to the woman "clothed with the sun" and the child in the book of the Apocalypse (12:1); as for the other painting, the subject could well be Saint Hubert but in general it is held to be Saint Eustace. A reason for this is that both saints are said to have been converted to Christianity as a result of a vision of Christ crucified which they each had while out hunting one day.

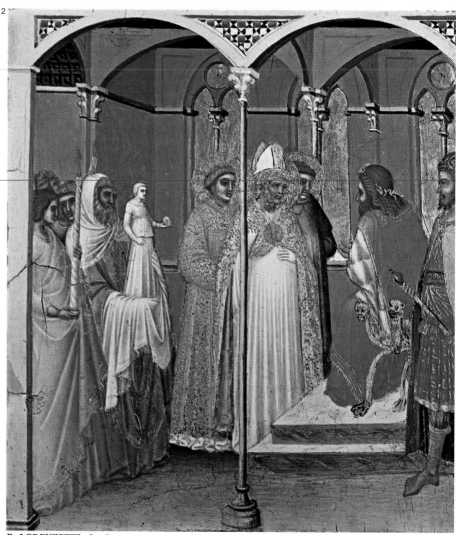

P. LORENZETTI  St. Sabinus before the Governor (?)

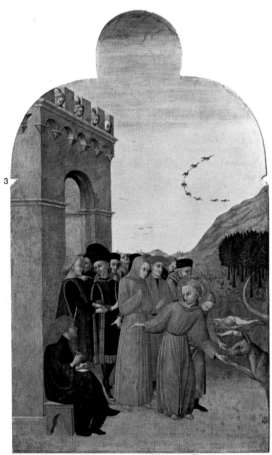

SASSETTA  The Legend of the Wolf of Gubbio

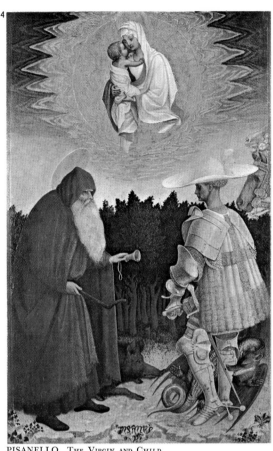

PISANELLO  The Virgin and Child
with SS. George and Anthony

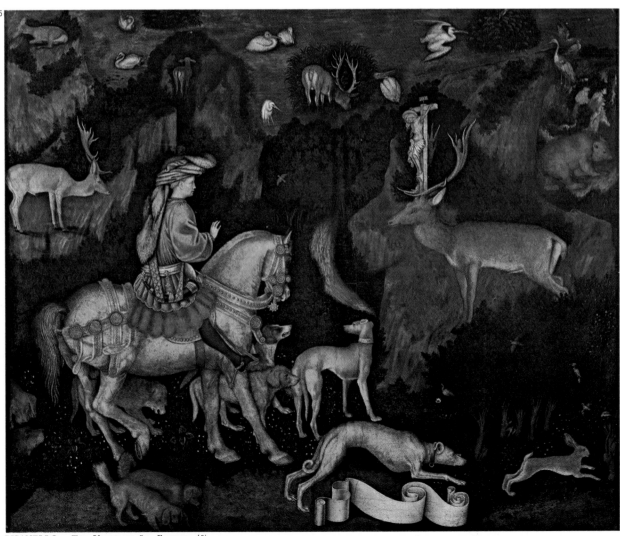

PISANELLO  The Vision of St. Eustace (?)

**16**

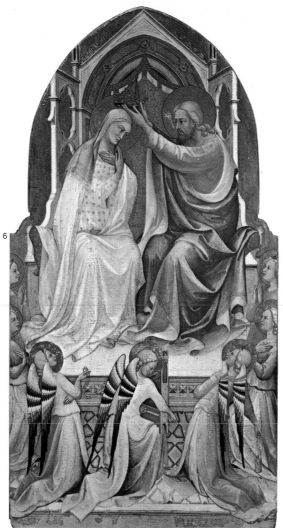

LORENZO MONACO  The Coronation of the Virgin

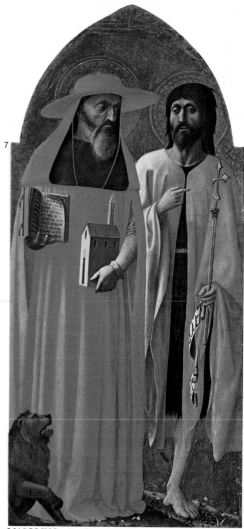

MASOLINO  St. John the Baptist and St. Jerome

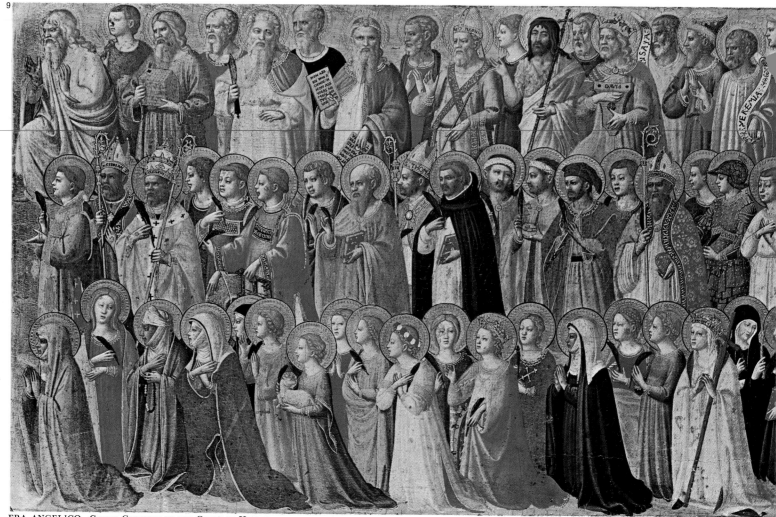

FRA ANGELICO  Christ Glorified in the Court of Heaven

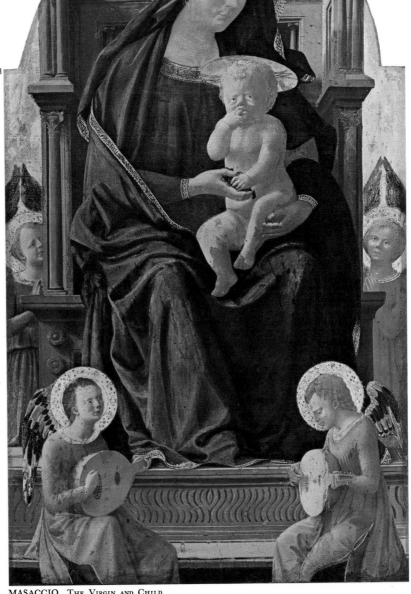

MASACCIO THE VIRGIN AND CHILD

6. Although surrounded by the Giottesque atmosphere of Florence where he lived, it was Siena, where **Lorenzo Monaco** was born and educated, that exerted the stronger influence, conditioning him into an awareness of linear sensitivity and the lyrical light-filled colors which are characteristic of the International Gothic style.

7. It is the cardinal's vestments and the existence of a lion (more than the inscription on the book of the first two lines of Genesis) which point to the fact that the figure on the left is Saint Jerome. The identity of the other figure as being that of John the Baptist is revealed by the inscription «Ecce [agn]us Dei.» on the scroll. Together with another similar painting also in the National Gallery, this work formed part of a triptych which is in Santa Maria Maggiore in Rome. Apart from the part shown here often ascribed to Masaccio, the whole triptych is generally attributed to **Masolino**.

8. This is the main panel of a large polyptych executed by **Masaccio** for the Carmine Church in Pisa. The concepts of space which were formulated by those "fathers" of the Renaissance are here realized by Masaccio in a superb plasticity of form.

9. This is one of the five panels (they are all in the Gallery) which make up the predella of a large polyptych painted for the church of San Domenico in Fiesole by **Fra Angelico**. Even at this stage, young as he was, he expressed fully that firm dignified mysticism which was peculiar to his vision.

PAOLO UCCELLO   Niccolò Mauruzi da Tolentino at the Battle of San Romano

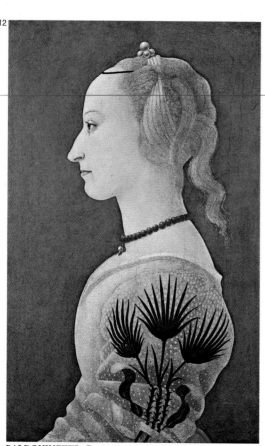

BALDOVINETTI   Portrait of a Lady in Yellow

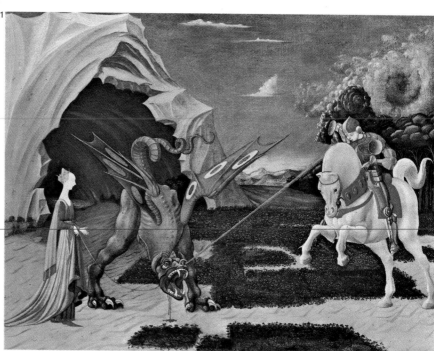

PAOLO UCCELLO   St. George and the Dragon

**10 – 11.** The first traces of the *Battle* painted by **Paolo Uccello** go as far back as 1492 when together with two twin paintings, one of which belongs to the Uffizi Gallery and the other to the Louvre, it was housed in the Medici palace. Uccello combines preciosity of line and color, elements derived from International Gothic with a personal style of perspective which represents a delicate balance between the binocular perspective of ancient tradition and the more centralized form typical of the Renaissance. This causes the action to seem suspended in mid-air, thus forming an almost geometrical abstraction and giving the work a fairy-tale-like quality. The same applies to his *St. George and the Dragon*, which is thought to be an early work of Uccello's.

**12.** There have been various suggestions as to the authorship of the work; Domenico Veneziano, Pollaiolo, Uccello, etc., have been named in connection with it. However, it was **Baldovinetti** who was finally established as the artist responsible. He had been a pupil of Domenico Veneziano and had been greatly inspired by Piero della Francesca in his technique of abstracting various character types, something which he achieves through enameled chroma work and a sharp delineation of the contours.

13

19

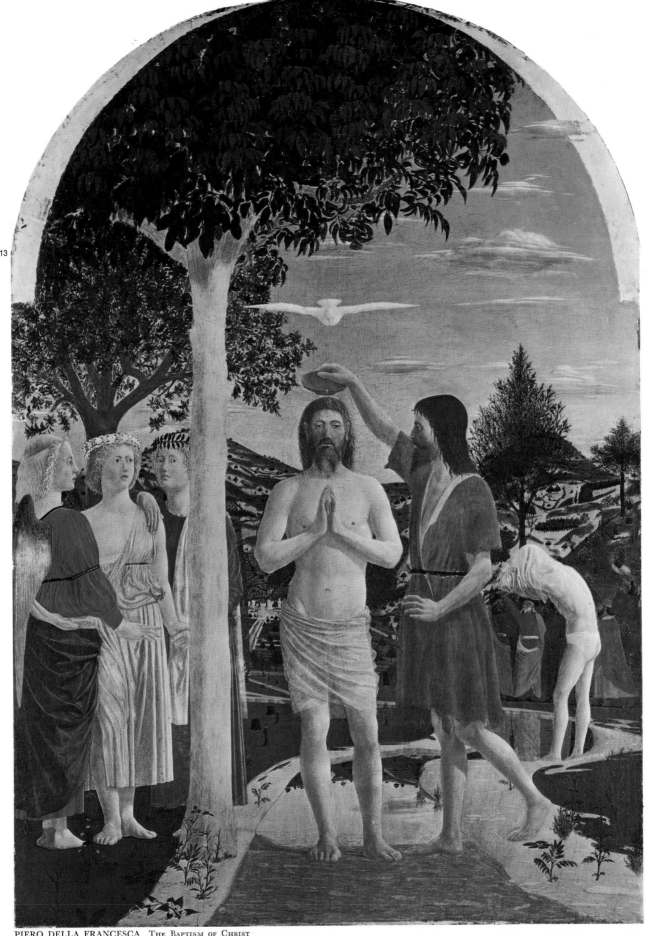

PIERO DELLA FRANCESCA The Baptism of Christ

**13.** *The Baptism of Christ*, probably painted for the priorship of the church of San Sepolcro, is considered to be the earliest surviving work by **Piero della Francesca** (even if there is no general agreement on the dating of the painting between 1440 and 1450). Features of Masaccio and Dome- nico Veneziano, the two greatest influences in the young painter's life, can be easily recognized in the work, but at the same time the painter also shows signs of the discipline of his own artistic vision in which both perspective and light are the true sources of space.

PIERO DI COSIMO The Death of Procris (?)

**14.** The absence of Cephalus and the presence of the satyr, besides smaller details of lesser importance, make it highly unlikely that what is being depicted is really *The Death of Procris*, while on the other hand, the imaginative fervor, the sensuous curve of the lines, and the burning passion inherent in the colors leave one in no doubt at all that **Piero di Cosimo** is indeed the author of the work. Roselli had been his teacher, while much of his inspiration came from Leonardo.

**15.** *The Adoration of the Kings* is so pregnant with technical allusions to Botticelli that it came to be thought of as originating from his imaginary alter ego, "Sandro's friend," as it was called. It was,

however, finally discovered that the painting had in fact been done by Filippino **Lippi** in his early years. Lippi had become a pupil of Botticelli's after the sudden death of his father, his first teacher.

**16 – 18.** In *Portrait of a Young Man* and *Venus and Mars* one is immediately aware of the efforts of **Botticelli** to subdue the linear energy which he had acquired from Filippo Lippi by giving it expression in the fullness of more classical forms which had inspired him during his stay in Rome (1481-2). As indicated by the wasps, *Venus and Mars* was probably painted for the Vespucci family. It is a work which may well be part of the Neo-Platonist culture of Florence,

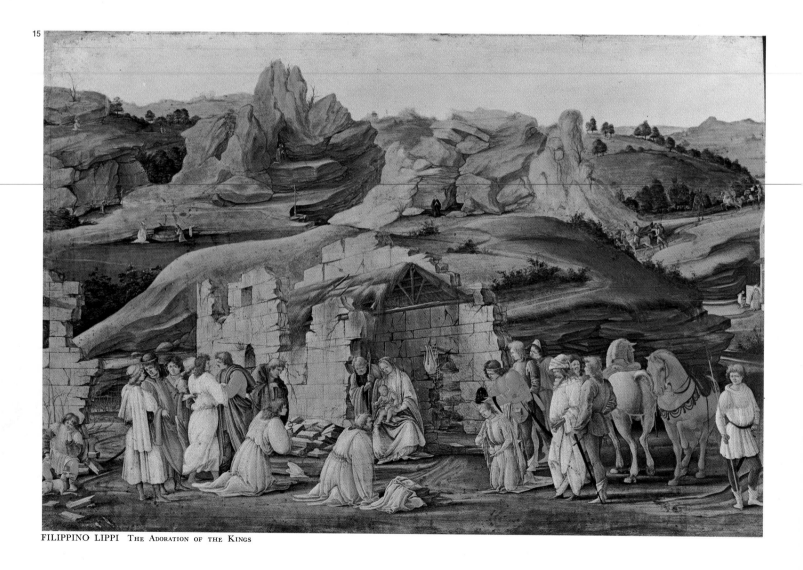

FILIPPINO LIPPI The Adoration of the Kings

portraying as it does the sharp contrast between Venus, symbol of love and harmony, and Mars, the symbol of hatred and disharmony. In *Mystic Nativity* a sharp change of register occurs; the smoothness of line is broken, colors become sharper and the calm balance seen in Botticelli's previous figures gives way to a dramatic suppleness. In other words, the artist is seen here as having turned his back on the refined ideals of Medicean humanism and embraced the severe spirituality of Savonarola. In the long inscription attached to the painting, the artist states that the work had been executed during the turmoil of the year 1501, a period, he says, when it was "the devil" who ruled the land. This is a remark which is very consistent with words spoken previously by Savonarola himself. It is a kind of exhortation, therefore, to men of good will to gather around the prophetic crib where Faith, Hope, and Charity (the colors of which are represented in the clothes worn by the angels on the roof of the stable) attend the Holy Family.

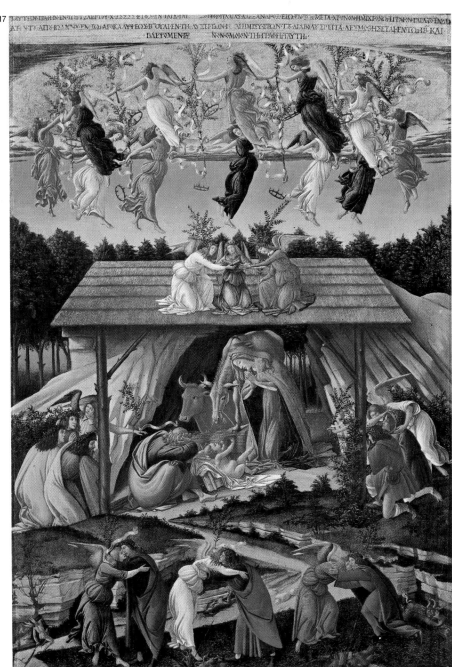

BOTTICELLI MYSTIC NATIVITY

BOTTICELLI PORTRAIT OF A YOUNG MAN

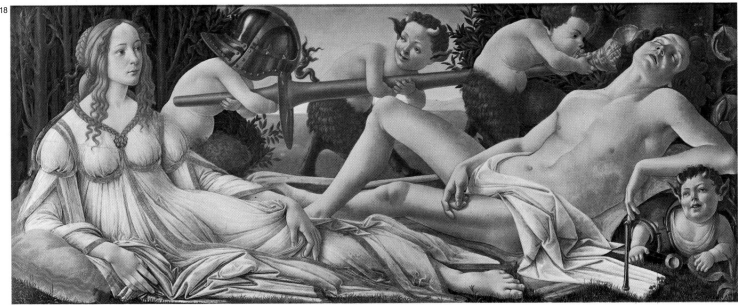

BOTTICELLI VENUS AND MARS

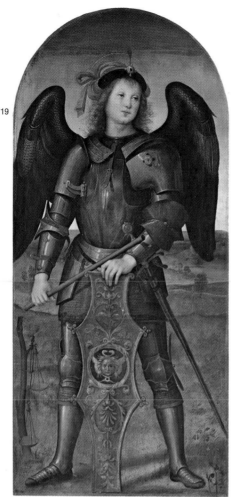

PERUGINO St. Michael

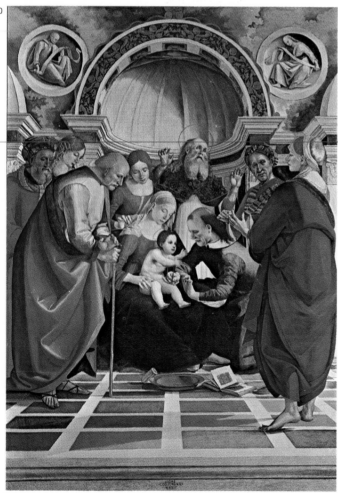

SIGNORELLI The Circumcision

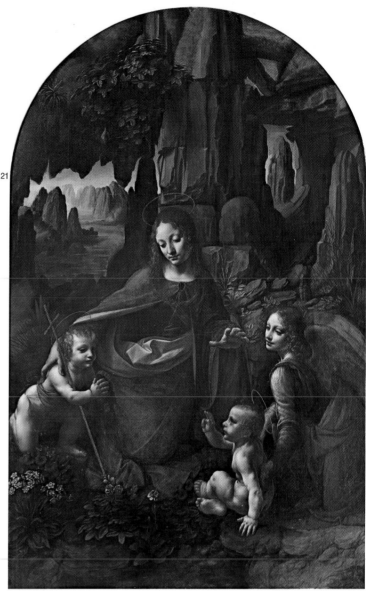

LEONARDO The Virgin of the Rocks

**19.** A fictitious triptych unites this work, *St. Michael*, with two elements of an altarpiece which had been commissioned from **Perugino** in 1496 for the Carthusian monastery in Pavia and where the other parts are still to be found. The whole complex was probably finished in 1499, but it is possible that it might have been finished later, in 1504. If the latter were true, one could perhaps postulate the intervention of the Umbrian master's talented pupil, Raphael. This hypothesis would explain the high quality of the work. The painting is, however, well worthy of Perugino who, after the experience of Piero della Francesca and his exposure to the work of Botticelli in his youth, turned to the Flemish School for inspiration and as a result made his color more precious and adapted it to form a beautifully luminous harmony between his figures and his landscapes.

**20.** Almost certainly the painting was formerly in the church of San Francesco of Volterra. Although restoration work on the painting, possibly carried out by Sodoma, has altered it, one is still aware that this is the work of **Signorelli**. He was yet another of Piero della Francesca's Umbrian pupils, but was later attracted to the linear dynamism of Pollaiolo, which he himself translates into a severe and epic magnificence already anticipating the style of Michelangelo.

**21 – 22.** It is a well-known fact that there are two versions of the *Virgin of the Rocks*; one is in the Gallery and the other in the Louvre in Paris. Both of them are thought to have been done, at least in part, by **Leonardo**. The first differs from the other both in its detail and in its more emotionally applied effects of chroma. Leonardo achieves this by means of his "sfumato" technique which unites the subjects, clothes, rocks, flowers, bushes, and water in solemn harmony. As for the famous cartoon, it is a work in which in the absolute coherence between all the elements of the composition is determined not so much by the mutual sympathy in the attitudes of the subjects as by the plastic potency of the whole.

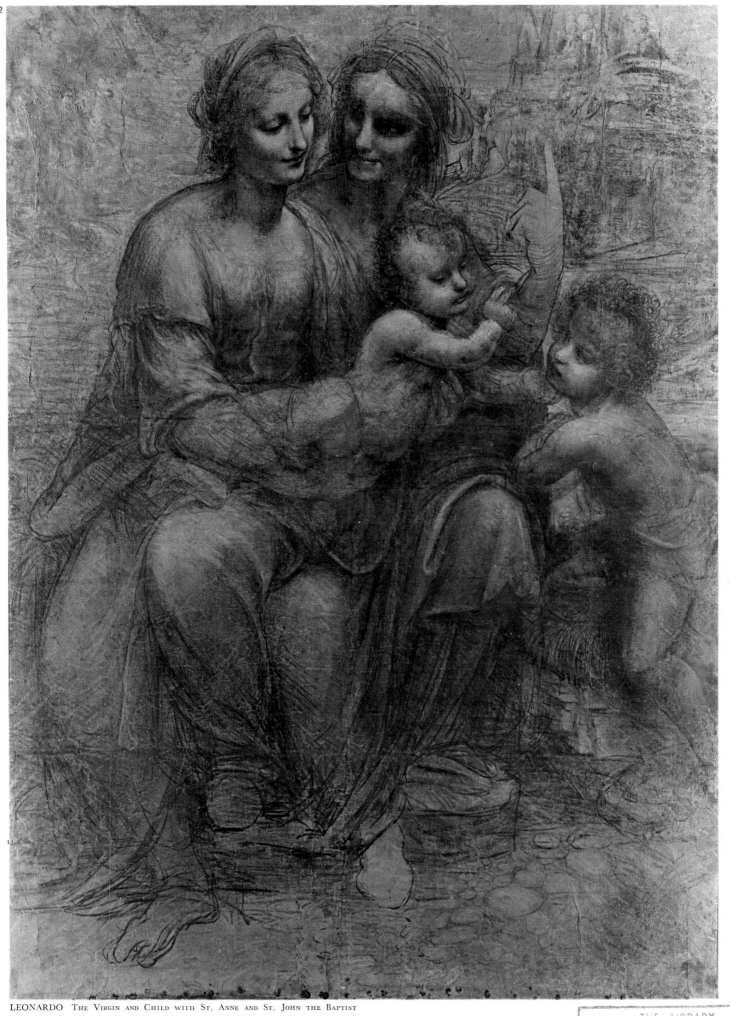

LEONARDO  The Virgin and Child with St. Anne and St. John the Baptist

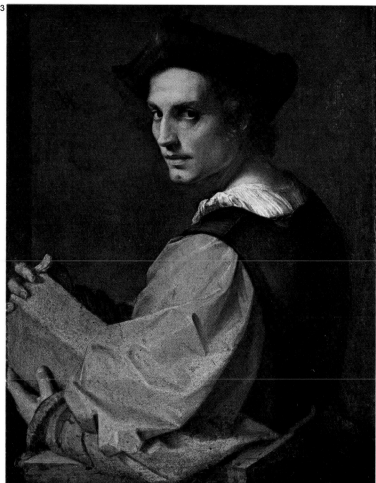

ANDREA DEL SARTO  Portrait of a Young Man

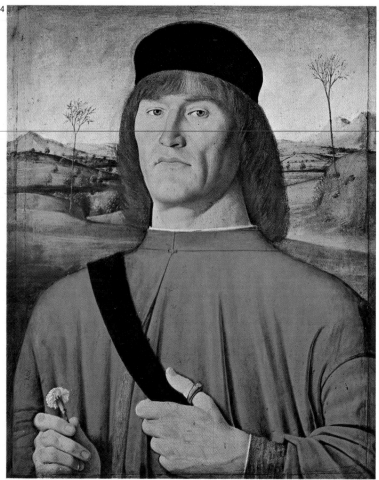

SOLARIO  A Man with a Pink

**23.** At the first, because of the direction in which the eyes of the subject are looking, this painting was understood to be a self-portrait. Then, because of the object in the subject's hands, it was thought to be the portrait of a sculptor, since he seemed to be holding what looked like stone or some kind of modeling material. However, since in the preliminary drawing which he did for the painting, and which can be seen in the Uffizi Gallery, Florence, the subject is holding a book, previous conjectures were found to be wrong and the present and more general title of *Portrait of a Young Man* is best. The temperament of **Andrea del Sarto**, a pupil of Piero di Cosimo, is unmistakeable in the painting, and he shows himself to be profoundly sensitive to the "sfumato" of Leonardo and to the serene magnificence of Raphael's work.

**24.** The example of Leonardo had a strong determining influence on Andrea **Solario**, the brother and pupil of Cristoforo and a famous sculptor and architect; but continual contact with Venetian and Flemish painting led him to adopt the "sfumato" technique in which he achieves a more vivid luminosity and creates forms more strongly defined than those found in Leonardo's work.

**25 – 28.** During the short-lived career of **Raphael**, these three works followed each other in the space of five or six years. They are *The Crucifixion, Vision of a Knight,* and *St. Catherine of Alexandria. The Crucifixion,* or "*Mond Crucifixion,*" which was named after the man who donated the work to the Gallery, is part of an altarpiece done in 1502-3 for the church of San Domenico in Città di Castello (the predella has been since split into various elements). The painting presents the artist as being still tied to his teacher, Perugino, but as having attained, through his own sensitivity, that luminosity of space characteristic of Piero della Francesca. In *Vision of a Knight* (the knight is possibly Scipio – which could refer to Scipione Borghese, for whom the work may have been destined – or else Hercules, faced with the choice of taking the road of earthly pleasures or that of pleasures of a superior kind) was done probably around 1504-5. The young artist can be seen to have achieved by this time a full naturalness – through the examples of Leonardo and the Florentine masters – and is striving to create a subtle correspondance between the figures he portrays and his settings by enveloping both in a mountain light, as he does in the equally famous pendant of the *Three Graces* at Chantilly. As well as possessing the painting of *The Vision,* the Gallery also owns the cartoon, together with all its perforations, which the artist had used for the purpose of transferring his rough outlines onto his canvas. Finally, in *St. Catherine of Alexandria* (1508), the slow circular motion of the body, which is suggested by the wheel, and the enamel effect of the colors reach a magnificence which easily parallels the frescoes done by the artist in Rome.

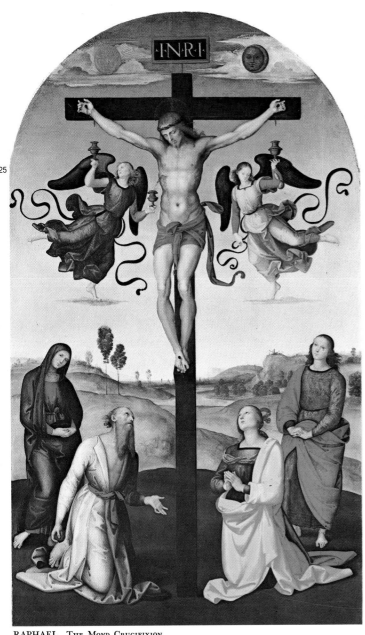

RAPHAEL  The Mond Crucifixion

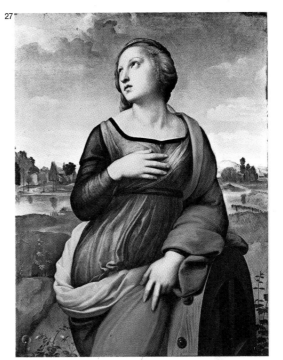

RAPHAEL  St. Catherine of Alexandria

RAPHAEL  Vision of a Knight

RAPHAEL  Vision of a Knight (cartoon)

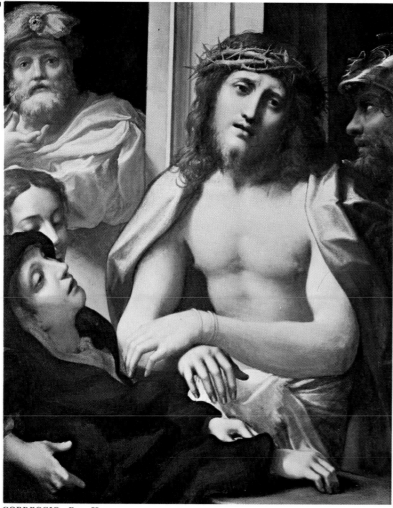

CORREGGIO  Ecce Homo

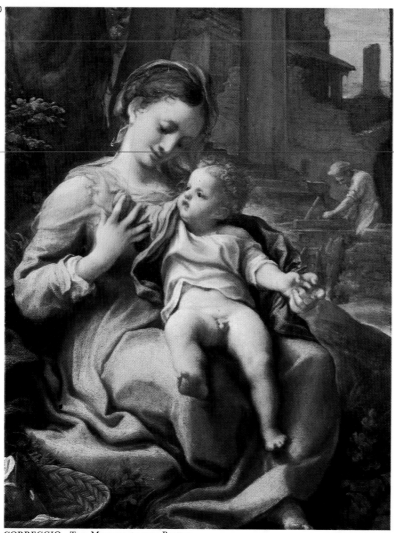

CORREGGIO  The Madonna of the Basket

**29 – 30. Correggio** was taught the rudiments of this art in his native land. But when he went to Mantua later, his first contact with the work of Mantegna constituted a profoundly moving experience for him, although he did not forget the valuable information he had gleaned from Costa. Then, influenced probably by the Leonardo "sfumato," or, more likely still, by Giorgione's tonalism and the early work of Titian, the harsh structures which he had copied from Mantegna underwent a radical transformation. Correggio added to them the main features of classicism expounded by Raphael and Michelangelo, which the artist had studied during a trip to Rome. (There is no record of such a trip, but critics have admitted it of necessity in order to explain this development of the Emilian painter.) Correggio always showed himself to be tireless in his research into technique, casting an inquisitive eye even on the innovations of the Mannerists in Florence. His second large mural, the cupola of the church of St. Giovanni in Parma, reveals his acute awareness of the serpentine transparencies achieved by Beccafumi, whose unmistakable typologies Correggio himself adopts, as can be seen in his depiction of an elderly man in a turban which is on the second story on the left side. Whatever the history of the painting, which is in fact not altogether clear, it seems to have been linked with the history of an ancient copy of the work, though critics have never expressed any doubt as to the authenticity of the painting.

Various analogous features come together in *The Madonna of the Basket*. The typology which was inspired by Beccafumi can be seen in the figure of St. Joseph intent on sawing wood, but otherwise the painting dates from the same period as the preceding work.

BECCAFUMI TANAQUIL

BRONZINO ALLEGORY OF LUST

**31.** Together with other similar works (one of which is to be found in the Gallery), a series of portraits of "famous women," all done in the same style, was painted for the Petrucci Palace in Siena (1519). The identification of the subject as Tanaquil, wife of King Tarquinius Priscus and authoress of the coronation of Servius Tullius, is based on the lines which are inscribed on the left panel and written in a Latin style complicated by the sophisticated elegance of the humanists of that time ("I am the foresighted Tanaquil who created two kings, the first being my husband and the second my servant"). The colors electrified by the extreme brightness of the light, the elongated figures, the soft delicate movement of the curving lines — all these elements betray without any doubt the touch of **Beccafumi**, the oldest of the first generation of Mannerists, born of the influence of Perugino and Sodoma.

**32.** According to the most accredited interpretation, this painting depicts the *Allegory of Lust* (Cupid ambiguously embracing his mother, Venus) and of its consequences. On the left can be seen the figure of Jealousy in the form of an old woman tearing at her hair; on the right, the figure of Pleasure carrying roses in his hand, and behind him a young girl, symbolizing Deception (perhaps the two masks concern her); in the background can be seen Time and the figure of Truth, who is engaged in pulling back the curtain. Vasari states that the work was executed for Francis I of France; that is, it was done no later than 1545, the period when **Bronzino** had readapted all he had learned from Pontormo and was in the process of forming a highly refined, clear-cut synthesis of it all.

**33.** *The Resurrection of Lazarus* was executed by **Sebastiano del Piombo** in 1517-9 for Narbonne Cathedral in competition with *The Transfiguration* by Raphael. The painting shows Sebastiano del Piombo at the time he had already left behind the tonalism of Giorgione and, under Michelangelo's influence, he was settling into a severe monumentalism, which he achieved mainly by the cold tones of his colors.

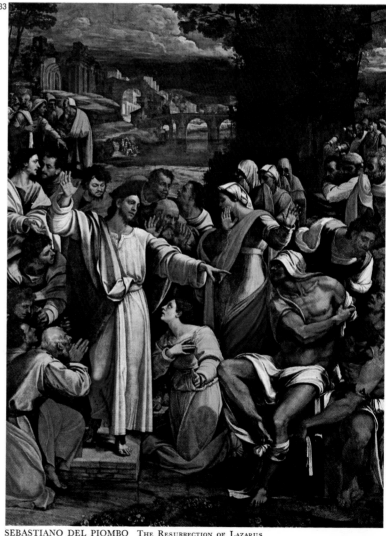

SEBASTIANO DEL PIOMBO THE RESURRECTION OF LAZARUS

CRIVELLI The Annunciation with St. Emidius

COSSA  St. Vincent Ferreri (?)

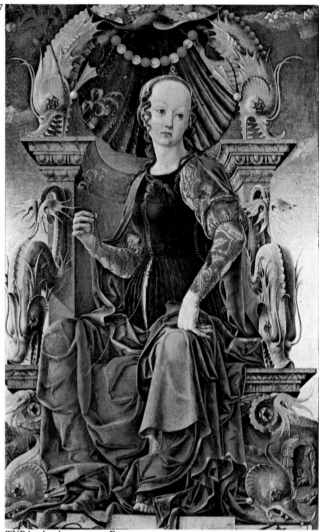

TURA  An Allegorical Figure

29

FOPPA  The Adoration of the Kings

**34.** The painting is signed and dated 1486. It is endowed with a richness of detail through which the various stages of **Crivelli**'s development can be reconstructed, going back to the artist's beginnings, when he was influenced by the linear energy of Vivarini and the School of Padua, up to the period of his admiration for the contrived elegance of the Ferrarese School and for the magnificent voluminousness of the German School. And it is a richness which is a part of the crystal-clear coherence of the Venetian artist which remains as yet unspoiled.

**35.** The art of **Foppa** took its origin from the International Gothic style. Foppa was a pupil of Bembo's in Brescia, his native land. He was then probably attracted to the vigorous structures of Mantegna's perspective and eventually came into contact with the Provençal and Flemish styles in the course of various journeys into Liguria after 1461. The final and ultimate influence on the artist was probably that of Da Vinci. The existence of so many strands of influence puts this painting into the beginning of the sixteenth century.

**36.** This is almost certainly the central partition of the Griffoni polyptych (it was painted in about 1475 and the panels have since been separated). Although both **Cossa** and Tura started from almost identical positions in their artistic careers, Cossa achieves a monumentalism which is quite different from that of Tura, one where light and perspective pulsate with a joyous vitality, and unite in perfect harmony.

**37.** The lack of realism in Squarcione, the early work of Mantegna, and especially of Donatello, the style of the Flemish painters and of Piero della Francesca — all these things had provided nourishment for the tough potency of **Tura**'s work. He had perfected this style when he returned permanently to his native Ferrara after having studied in Padua for a short while. It was in Ferrara that Tura painted (1460) one of the first of his works, *An Allegorical Figure*, which was perhaps destined for the Palazzo di Belfiore.

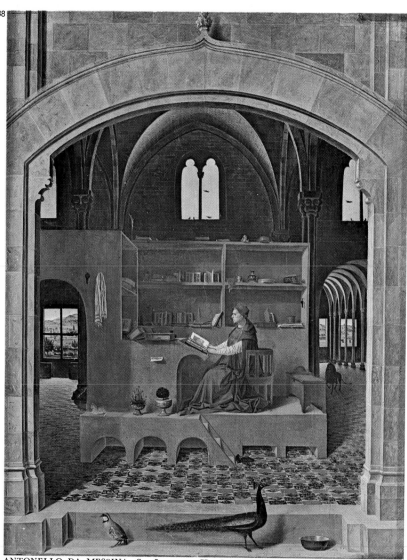

ANTONELLO DA MESSINA St. Jerome in His Study

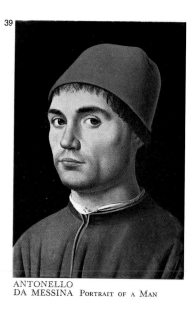

ANTONELLO
DA MESSINA Portrait of a Man

GIOVANNI BELLINI The Doge Loredan

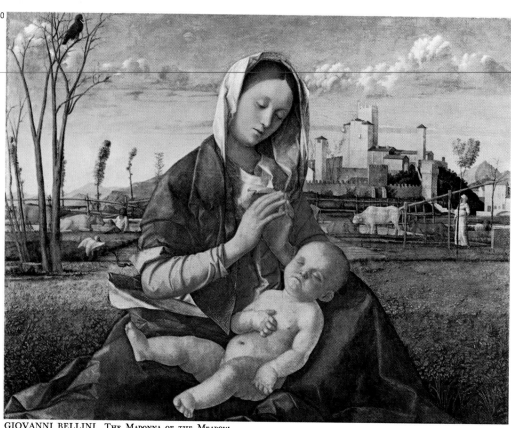

GIOVANNI BELLINI The Madonna of the Meadow

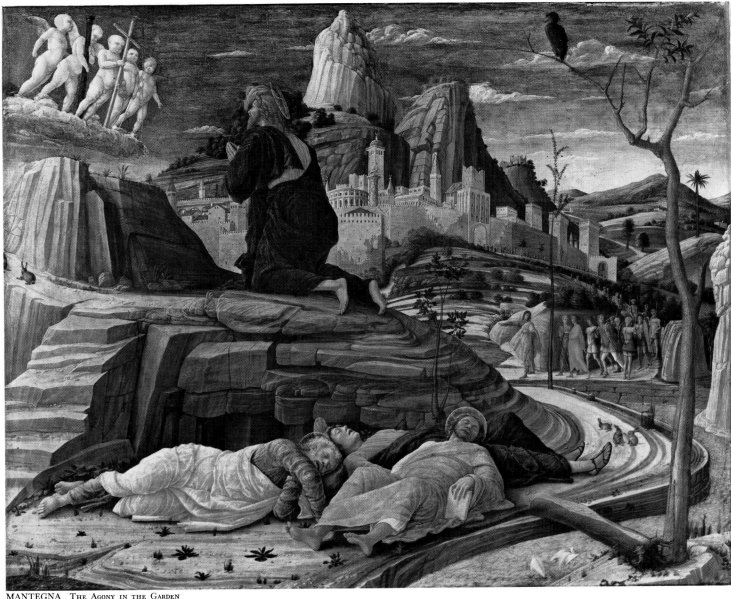

MANTEGNA   THE AGONY IN THE GARDEN

**38 — 39.** Rapidly following the example set by Piero della Francesca, **Antonello da Messina** suppresses the pungent realism of his detail and the intense brightness of his colors — elements suggested by Flemish painting during his stay in Naples, where he went to study as a youth — in favor of a personal coherence of perspective and luminosity, a coherence which had probably been energetically completed when, no later than 1460, he painted *St. Jerome in His Study*. For his model, he probably took a triptych done by Van Eyck in 1456 for the Parthenopean city. In the bust of the young man, dated around 1475, the lower part of which is very much reduced in size, many have claimed to see a self-portrait, an assertion which is quite unfounded.

**40 – 41.** According to the now classic definition given by R. Longhi, Giovanni **Bellini**, a pupil of his father Jacopo, and quickly attracted to Antonio Vivarini, was "first Byzantine and Gothic, then Mantegnesque and Paduan, then a follower of Piero and Antonello and finally Giorgionian, but he always remained true to himself." Bellini was one of the most potent of the poets of the Renaissance. This *Madonna* (c. 1505), although spoiled in parts, points this out very

well. The painting is the purest quintessence of several similar compositions executed prior to this one; the artist has infused its landscape with a realism of great fullness and lyricism. Even the portrait of the Doge (c. 1500) is executed with the skill of a goldsmith; at the same time it is rich in chromatic harmonies and contrast of volume. The painting is one of the most representative of its time.

**42.** On the left of the Redeemer, who is towering above the cliff, is a group of angels holding out not the customery chalice but symbols of the Passion; on the right is Judas arriving with officers of the law from the city, the walls of which have been patched up here and there. Opinion has differed as to when the painting was actually done, going from 1450 to 1475. The earlier chronology seems anyway more convincing due to the presence of elements which can be traced back to the time of **Mantegna**'s education in Padua, when he was in contact with examples of the work of Donatello and his followers, along with elements taken from Giambellino, and especially due to the highly dramatic urgency which makes itself felt in the work and which by 1465 had already established itself in his painting.

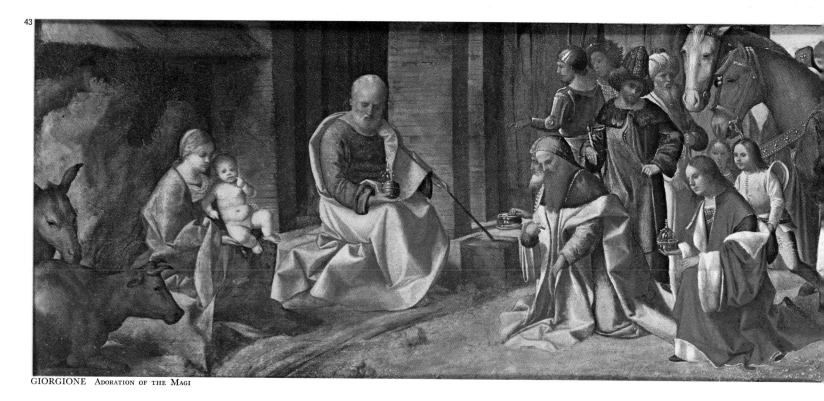

GIORGIONE  Adoration of the Magi

**43.** As has been the case with most of **Giorgione**'s work, the establishing of its artistic paternity has often been an arduous task; critics are, however, now all in agreement on the subject of the early work of the artist from Castelfranco, who was still under the influence of Giambellino, not to mention Carpaccio. The painter's personality has not of course appeared fully defined as yet, but the first shoots of that tonalism which will manifest itself within a year or two in *The Storm* are already evident. Gradations in the intensity of light and color is one example of this, as well as a coming together of the lines of the work into an increasingly more intimate harmony between his figures and the natural environment into which Giorgione sets them.

**44 – 45.** The initials inscribed on the parapet are thought to be

those of the artist ("T V") and the woman portrayed, called "La Schiavona," has been identified as Caterina Cornaro. We are aware of the same energetic human "presence" in this portrait as that which we find in **Titian**'s supposed portrait of Ariosto; furthermore, both the works are virtually contemporaneous with one another, having both been produced by the artist in his youth (c. 1510). At that time Titian was developing entirely under the influence of Giorgione, whose balanced tenderness he translated into a plastic humanity which was forced willy-nilly into space.

**46 – 49.** Here are gathered four Venetian Masters (Brescia and Bergamo being at the time under the same rule) who were essentially independent of the various streams running through Venetian painting

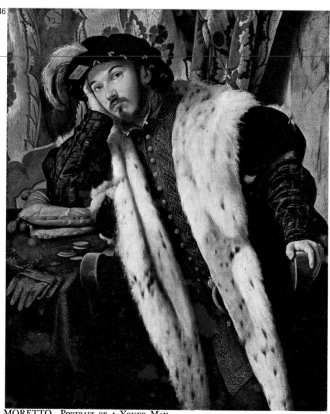

MORETTO  Portrait of a Young Man

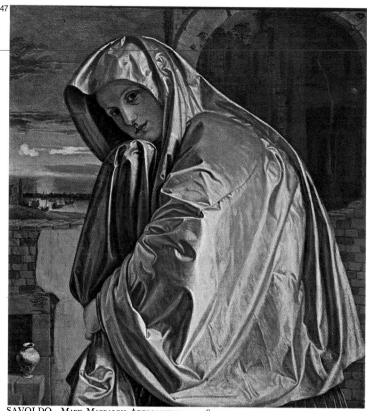

SAVOLDO  Mary Magdalen Approaching the Sepulchre

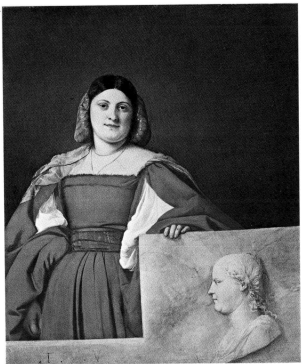

TITIAN "LA SCHIAVONA"

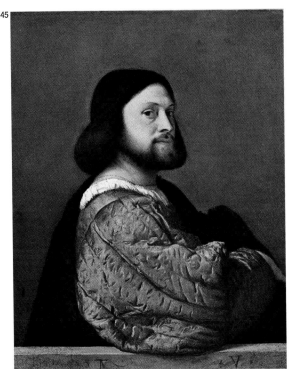

TITIAN PORTRAIT OF A MAN

of that era. **Moretto**, from Brescia, filters his Venetian style through the Lombardian tradition typified by Foppa. He salvages, however, a cold grey tone which he co-ordinates with a monumentalism of form going back through Lotto to Titian and Raphael. Moretto's forms, however, speak of a realism which distinguishes the artist even from those who were his source of inspiration. **Savoldo** interprets Giorgione with a chromatic richness which is fully exalted by the play on light and shade, which leads to visual effects which are streaked with pathetic undertones. Thirdly, there is **Lotto** who formed his style in the Antonellian tradition of Alvise Vivarini. Lotto was a painter who showed a great sensitivity to the Lombardian and Germanic culture as well as to the early Mannerists and to Raphael. Finally, the Bergamasque painter **Moroni**, who was a pupil of Moretto's and a renowned portraitist, confers on his paintings a truthfulness subtly underlined with a melancholy which distinguishes him from the epic transfigurations in the work of Titian.

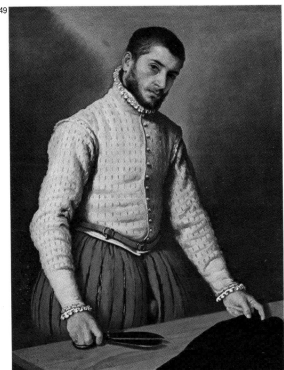

MORONI THE TAILOR

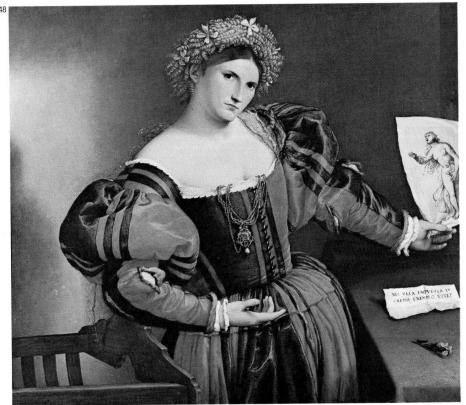

LOTTO A LADY AS LUCRETIA

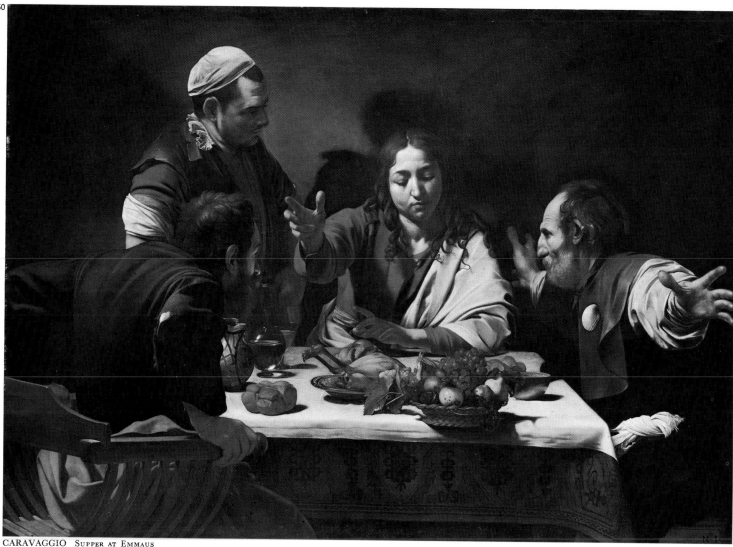

CARAVAGGIO SUPPER AT EMMAUS

**50.** Of the two depictions of the *Supper at Emmaus* by **Caravaggio** (the other is to be found in the Brera Gallery, Milan) this one is the earlier (1596-8). Having acquired the tools of his trade in his native land after the examples of Lombardian painters who represented various branches of the Venetian School of art (Moretto, Savoldo, Moroni, etc.), Caravaggio comes to put on his canvas at this stage his theories on true "realism," which he does by seeking in everyday situations material for poetic meditation and artistic transformation. He achieves this by the use of increasingly sonorous, dark colors which endow his figures with a dramatic presence.

**51.** The luminosity and "realism" of Caravaggio interest even **Strozzi**, who, having developed in an ambience of Ligurian-Lombardian Mannerism, and being open to hints of Rubens and Van Dyck, interprets these elements with a fluidity which becomes increasingly more liquid through the way the "impasto" is applied.

**52.** Founder, together with his elder brother Agostino and his cousin Ludovico, of the Accademia degli Incamminati in Bologna, a center which helped to renew interest in "realism" with the spirit of the anti-Mannerists, Annibale **Carracci** represented on canvas several times the scene of *The Dead Christ Mourned*. This version seems to be later than the one in the Kunsthistorisches Museum in Vienna, which can be dated at about 1603, and is probably earlier than the *Pietà* in the Louvre, which was painted about 1607.

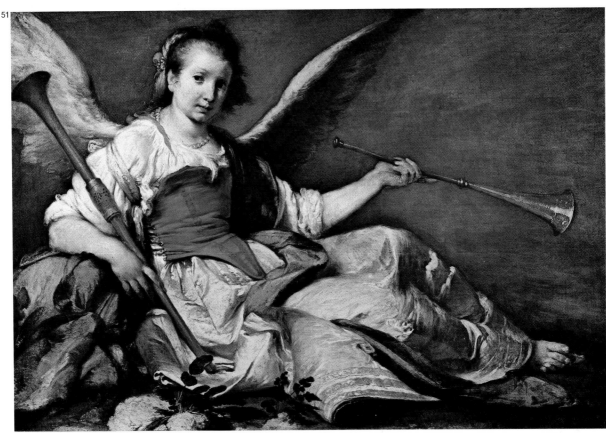

STROZZI  An Allegory of Fame

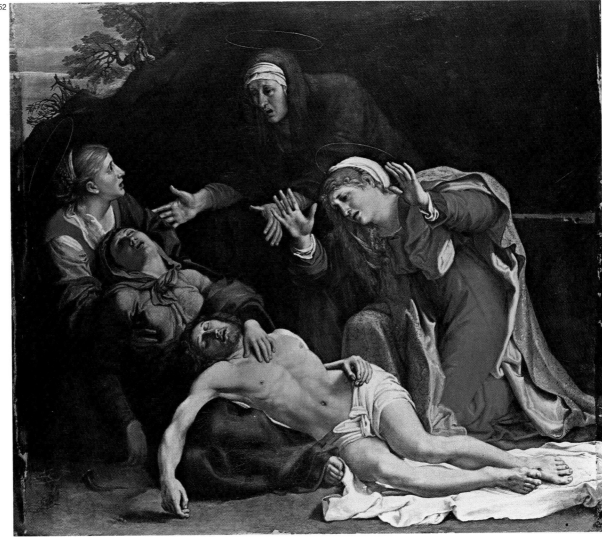

ANNIBALE CARRACCI  The Dead Christ Mourned

VERONESE The Allegory of Love: Unfaithfulness

53 – 54. *Unfaithfulness*, was part of an ornamental complex which was painted for the ceiling of some nobleman's house (like the following work, it dates back to 1570), and was perhaps dedicated to the theme of the joys and sorrows of love. **Veronese's** style is given full expression in the juxtaposition of colors magnificently reflected in a warm luminosity which ever increasingly diminishes the forms and aspires to the timbre of an aristocratic Arcadia. In *The Family of Darius before Alexander*, members of the Pisani family, who at one time bought the painting, have perhaps lent some of their physical features to the figures.

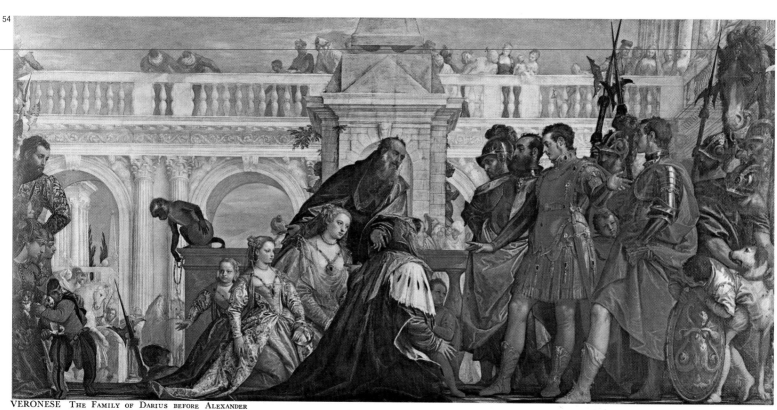

VERONESE The Family of Darius before Alexander

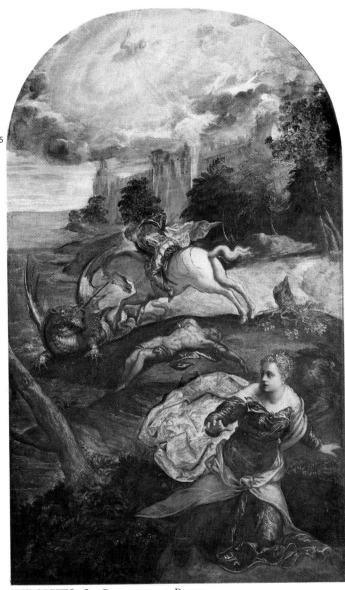

TINTORETTO St. George and the Dragon

TINTORETTO The Origin of the Milky Way

**55 – 56.** *St. George and the Dragon* is a work which was produced by **Tintoretto** during the height of his period of artistic maturity (c. 1560), when through astonishing ideations of composition and magnificent color-light effects he overcame the hard task of combining the cromia technique of Titian with the skill in drawing of Michelangelo. He managed to achieve a fantastic disintegration of forms while at the same time taking into account the Mannerism of Central Italy. The same hesitations mark *The Origin of the Milky Way* (c. 1570). The subject is that of the newlyborn Hercules, whose mother was the mortal Alcmene. Jupiter wishing to immortalize him held him to the breasts of Juno: the milk which spilled upwards was the origin of the Milky Way.

**57.** **Bassano**, another artist who was able to transform matter into luminous substance, began his career under Titian after having spent some time with Bonifacio de' Pitati. He was even more sympathetic than Tintoretto to Mannerism as interpreted by Pordenone.

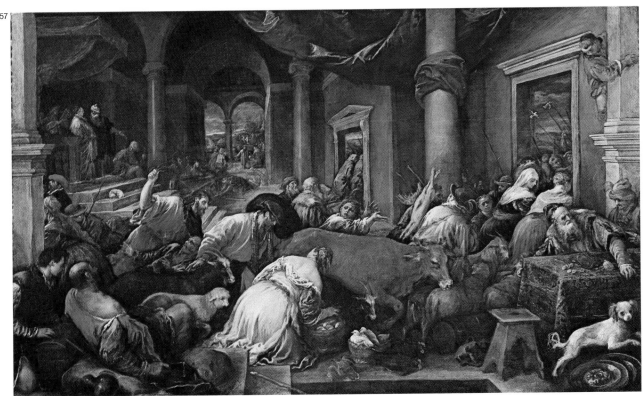

J. BASSANO The Purification of the Temple

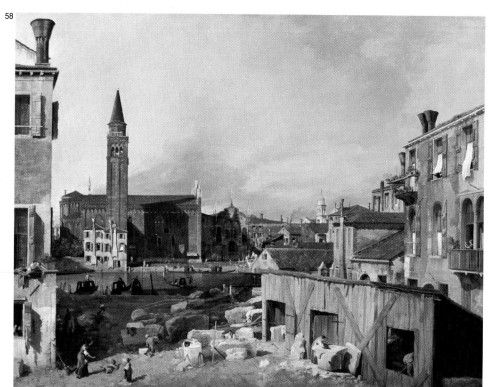

CANALETTO  VENICE: CAMPO SAN VIDAL AND S. MARIA DELLA CARITÀ

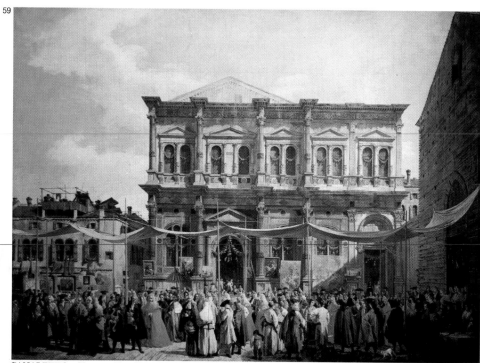

CANALETTO  VENICE: THE FEAST DAY OF ST. ROCH

**58 – 59.** Having been initiated into scene painting by his father, **Canaletto** soon ceased this type of work and devoted himself to painting following the examples of view painters such as Vanvitelli and Carlevaris. He discovered from them his own preference for bright colors, which he later shrouded in atmospheres increasingly more golden and melancholy in tone, where the clear discipline of broad perspective is transformed into the purest poetry. *Venice: Campo San Vidal* is such a transformation. It is the climax of his early work, portraying the "school" of Charity and the marble laboratory (1726-7). As for *Venice: The Feast Day of St. Roch*, the identification of the figure of the Doge (who is paying a visit to the church, accompanied by senators, on the occasion of the feast day of the saint) as Alvise Vivarini, elected in 1735, fixes the chronology of the work at a date soon after that year.

**60.** This is a painting of a lagoon by **Guardi** in the full explosion of his inventive freedom, of his vital touch, of his full awareness of light; by means of these elements, everything seems bathed in a humidity which is continually changing according to the variations in the reflections.

**61.** The subject of this painting is a rhinoceros which at that time had become quite famous. It had been imported in about 1741 and had been to all the main European cities, which had received it with enthusiastic interest. During the carnival in 1751, it was put on show in Venice and **Longhi** was commissioned by G. Grimani to paint its portrait, the result of which is to be found in Ca' Rezzonico in Venice. The painting which is shown here is a replica of that; it dates from the same time and bears some slight variations. The artist expresses his inspiration not only by means of the subtle humor which runs through the scene, but also in the tasteful choice of color, which he subdues in order to achieve a rigorously thought-out balance of composition.

**62.** This little model, of which there are three surviving versions (in Bergamo, Carrara, and the Drey Collection in New York), was probably done for an unknown altarpiece, and is typical of the style of **Tiepolo**. The artist was initiated into a superb "chiaroscuro" technique by Piazzetta and then, being sympathetic to the fantastic impetus of Bencovich, he followed the example of Ricci and turned to the clear luminosity of Veronese, which he used as an inexhaustible decorative source.

GUARDI  View on the Venetian Lagoon with the Tower of Malghera

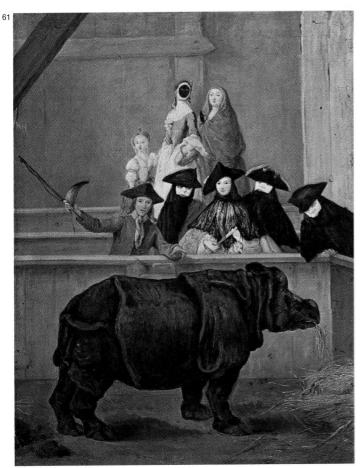

P. LONGHI  Exhibition of a Rhinoceros at Venice

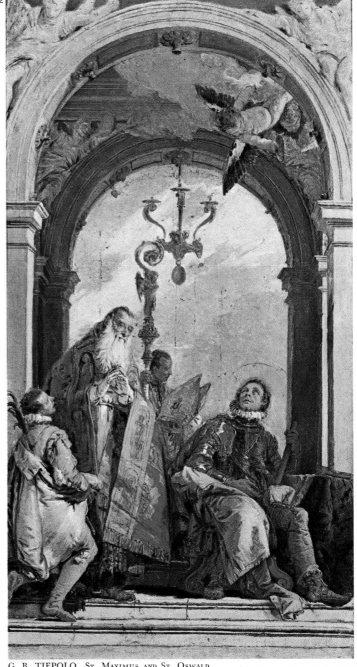

G. B. TIEPOLO  St. Maximus and St. Oswald

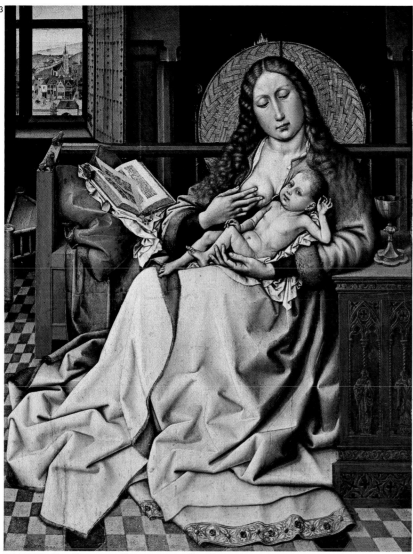

CAMPIN  THE VIRGIN AND CHILD BEFORE A FIRE SCREEN

**63.** The identity of the painter of this Madonna — whose halo has been replaced by a large circular firescreen — is based on a hypothesis which is above all a consistent one. For a time, it had become the practice to gather together under one name some works which were similar to the early paintings of Rogier van der Weyden. The name was a conventional one, being "Master à la Souricière," "of Flémalle," or even "of Mérode," and it was discovered recently that the unidentified painter could well be **Campin**, who had been called in various documents the Master of Rogelet de la Pasture, the latter being often identified with Van der Weyden.

**64 – 66.** The inscription "Johannes de eyck fuit hic. 1434," in the center of the composition leaves no doubt at all as to the identity of the painter of the famous Arnolfini couple, in the *Marriage of Giovanni Arnolfini and Giovanna Cenami*: Jan **van Eyck**, an innovator in Flemish painting, who by throwing light on numerous small details manages to achieve in his work an irresistible impression of spaciousness. The mirror shows that not only is there a couple present in the room, which is in a style typical of Flanders, but two other people standing in front of them and their dog; -these are probably the witnesses to the marriage (and one of them is probably the painter himself) which really did take place between Giovanni Arnolfini, a merchant from Lucca living in Bruges, and Giovanna Cenami, who was the daughter of a fellow-citizen and colleague of his working in Paris. The same attempt at an imperceptible realism animates a painting which is supposed to be the portrait of the musician *Timoteo da Mileto*. (The inscription "TYMOTHEOS," is above another inscription, "LEAL SOUVENIR," the date 1432, and the signature of the artist.) The *Man in a Turban*, because of a slight resemblance which he bears to the wife of Van Eyck, is probably the artist's brother-in-law.

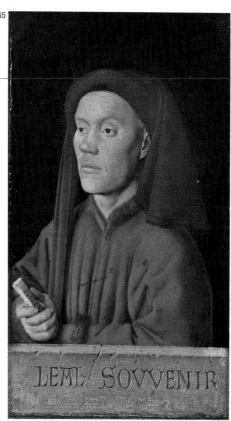

VAN EYCK  PORTRAIT OF A YOUNG MAN

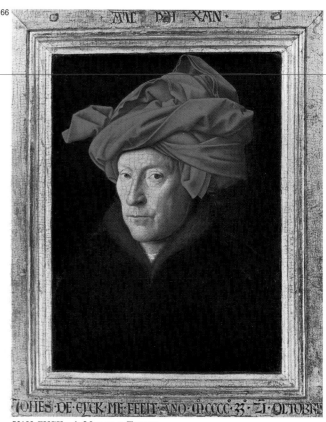

VAN. EYCK  A MAN IN A TURBAN

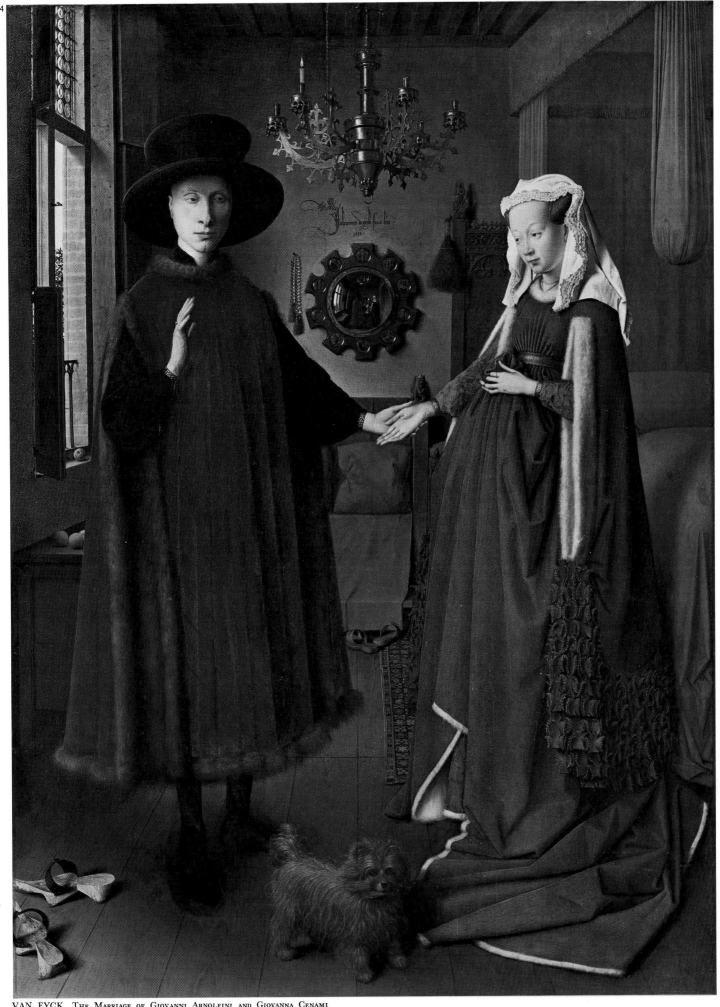

VAN EYCK  THE MARRIAGE OF GIOVANNI ARNOLFINI AND GIOVANNA CENAMI

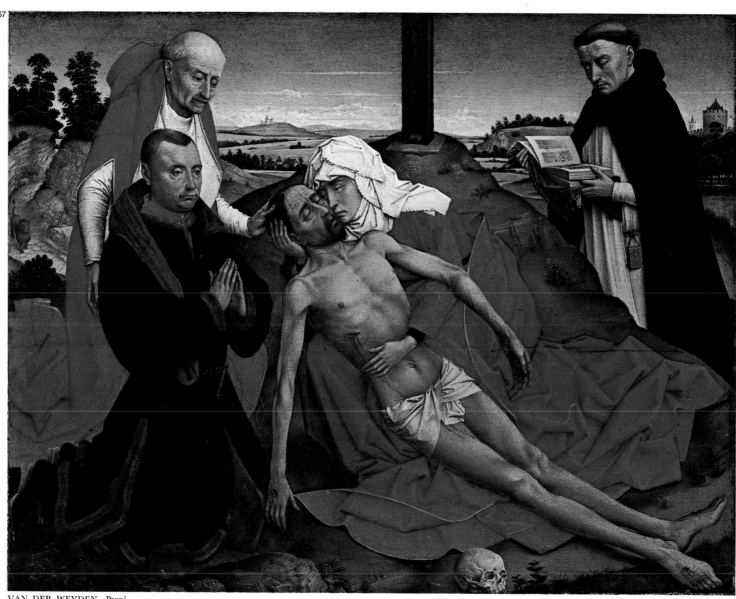

VAN DER WEYDEN Pietà

68

69

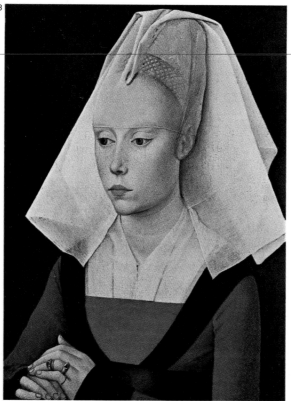

VAN DER WEYDEN Portrait of a Lady

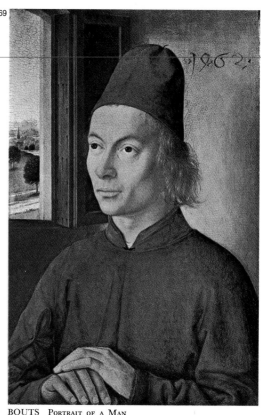

BOUTS Portrait of a Man

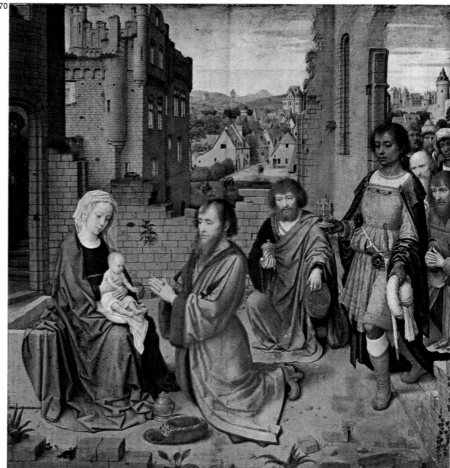

**67 – 68.** Whatever the influence Campin had on **Van der Weyden** one thing is certain, he was also greatly impressed by Van Eyck, whose intense dramaticism he deepened even more by the use of an energetic sketching technique, a more emotion-filled plasticism, and by crowding his subjects and detail into a more confined space. This still achieved the same results of clarity and monumentalism. In this sense his *Pietà* is emblematic and the large number of copies and elaborations on the theme of the work are sure signs of its success. The slight softening of the artist's approach to his themes, as revealed in the *Portrait of a Lady*, is due to his renewed interest in the work of Van Eyck.

**69.** The stylistic content of the *Portrait of a Lady*, which has already been examined above, is re-echoed in the *Portrait of a Man* by **Bouts** who was, for a time, a pupil of Van der Weyden.

**70. David,** a pupil of Van der Goes, depicts the immediate mutual sympathy between people and their environment. He displays this fully in *The Adoration of the Kings*, where the letters "AW" (?) which are inscribed on the purse hanging from the belt of the Moorish king, were taken to be the initials of a painter named Arend Winne, known only for a few archival maps.

**71.** Another of Van der Weyden's pupils, **Memlinc**, also subdues the dramatism which was passed on to him by his teacher. This he does by means of enshrouding his sculptural forms with a serene undulating light, by idealizing them, and softening the outlines, with the result of a serene intimacy which is shown here in the figures of the donors of the triptych, Sir John Donne and his wife. They are recognizable by their coat-of-arms and are respectively supported by the presence of St. Catherine and St. Elisabeth.

DAVID   THE ADORATION OF THE KINGS

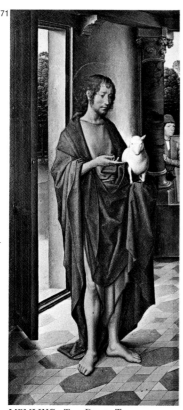
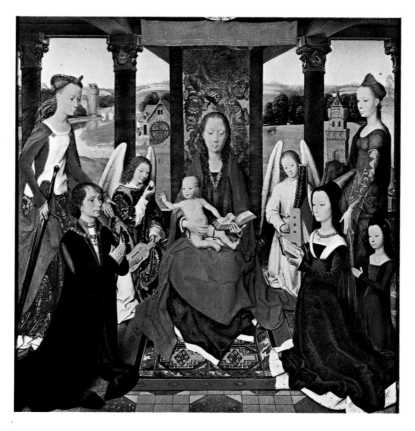
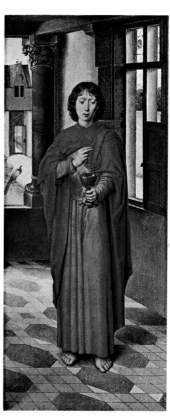

MEMLINC   THE DONNE TRIPTYCH

**72.** This is not **Bosch** the intellectual, gathering together natural forms and creating with them an effect of monstrosity, but Bosch the highly original draftsman, again with his characteristic preference for the grotesque, including both humor and hallucination. This can be seen especially in the figure on the lower left of the painting, which probably alludes to the Sinagogue and is most certainly laden with magical references because of the dipiction of the star and the half-moon on the cloth covering its head. This is above all Bosch the precious master of color, who toward the end of his career achieved such refinement in his work that he left his many imitators well behind him.

**73.** The letters which appear on the armillary sphere give no indication as to the identity of the woman portrayed. And this is still something which eludes even the art historians of today. The work dates from about 1520 and in the painting **Gossaert** subjects the analytical style which he derived from Van Eyck to a strong import of Italianization. This is evident in the fullness of his forms and in his overt desire to infuse the picture with intimacy of movement.

**74.** Another giant of "pure" painting is Pieter **Bruegel** the Elder. Like Bosch, he is often regarded as no more than a painter of pleasing little scenes, because of the meticulous care with which he represents the peasant costumes of his native Flanders. In reality, however, like his colleague, he infuses everyday situations with a vitality which is achieved by means of his simple, highly animated forms which are immersed in scenes of an airy fullness which marks the beginnings of the modern landscape. In *The Adoration of the Kings*, besides the detailing of the costume there occurs a confrontation between the typologies; this is a pungent reminder of Bosch himself and of his characteristic combination of the satirical and the grotesque.

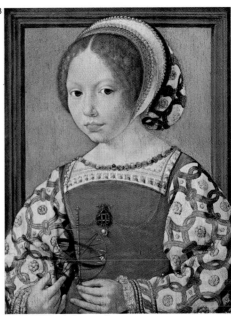

GOSSAERT  A LITTLE GIRL

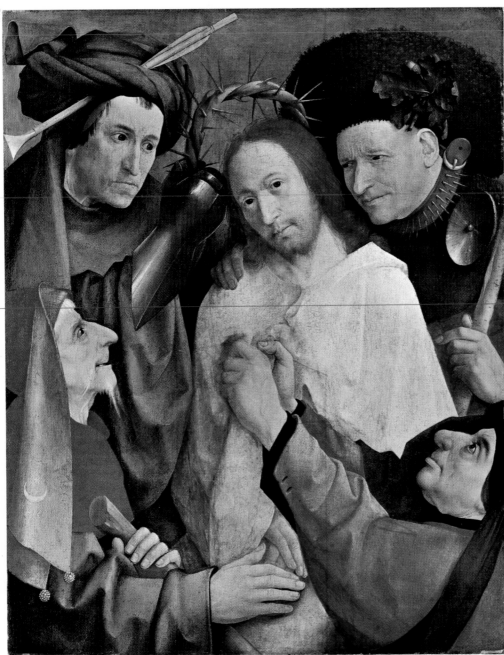

BOSCH  CHRIST MOCKED

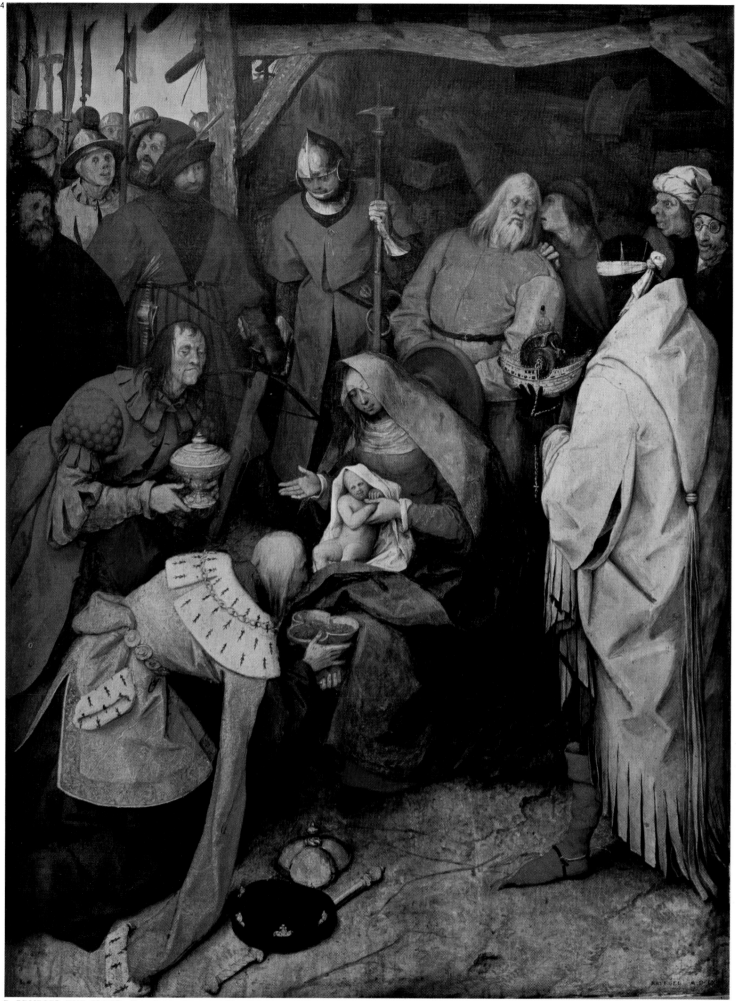

45

P. BRUEGEL THE ELDER The Adoration of the Kings

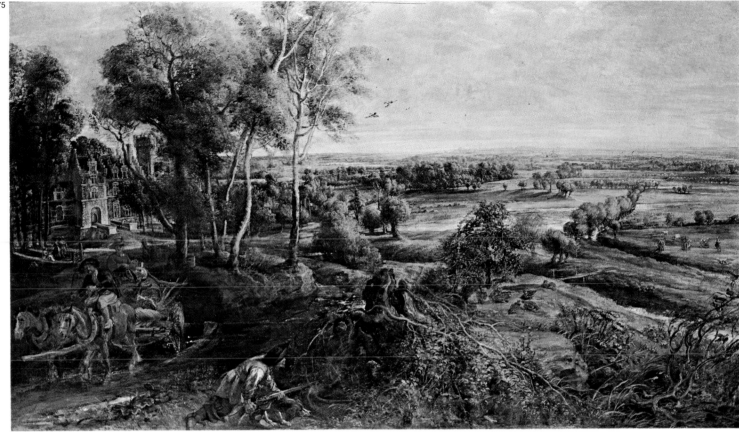

RUBENS Château de Steen

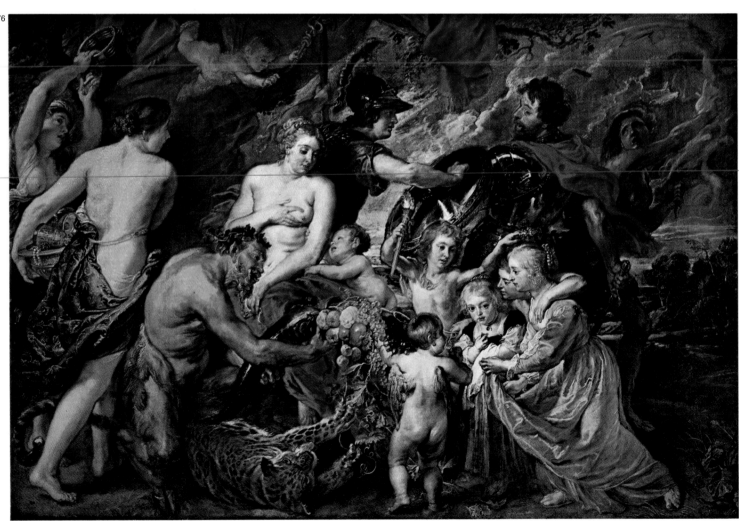

RUBENS Peace and War

**75 – 77. Rubens**, the incomparable interpreter of Baroque, appears here in a few of his different guises. As the historically outstanding landscape painter in *Château de Steen*, which is the artist's own castle on the outskirts of Malines; as the mythologist in *Peace and War*, with Peace standing in the center between a satyr and various children, and to the left of her, Happiness and Health, while nearer the right of the picture, the figures of Discord and Pestilence, and Minerva driving away War and all his attendants; and finally as the exuberant portrait painter. In this portrait he is seen as being inextricably linked with the subject of his portrait. *Le Chapeau de Paille*, is a tribute to his sister-in-law Susannah, the wife of Daniel Fourment. Rubens' brush strokes, here as always, arouse in the beholder a comfortable feeling of security.

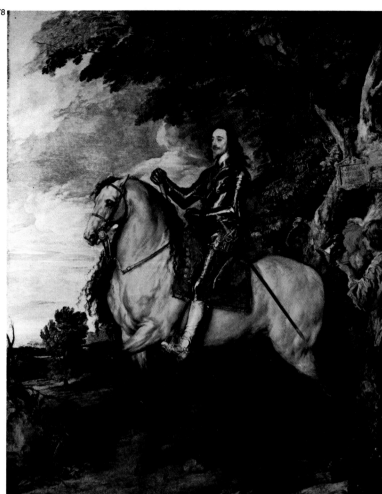

VAN DYCK Charles I on Horseback

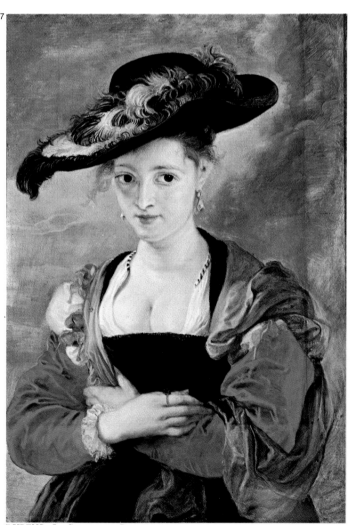

RUBENS Le Chapeau de Paille

**78. Van Dyck** had been an extremely faithful pupil and collaborator of Ruben's until 1620, even though he later replaced the overwhelming vitality which he learned from him with a tense refinement of his forms, drawn in a dignified manner and which were filled with light and atmosphere. The best of the artist can be seen in the portraits in which he combines both an idealization of and psychological insight into his subjects, as in this portrayal of *Charles I on Horseback*.

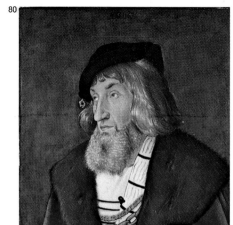

BALDUNG GRÜN PORTRAIT OF A MAN

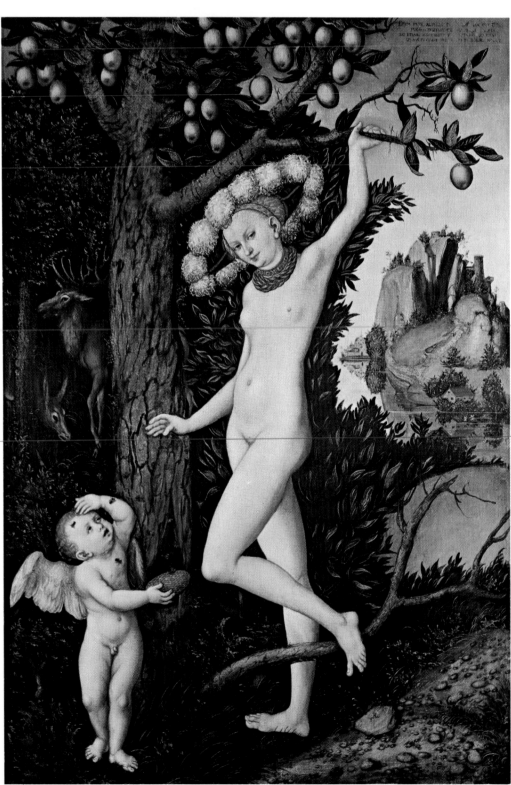

CRANACH THE ELDER CUPID COMPLAINING TO VENUS

**79.** The touch of **Cranach** the Elder is unmistakable here in the ironical depiction of Venus and Cupid with a honeycomb being pursued by bees. There is in the goddess the characteristic fluency of form which we associate with Cranach's female characters, and the elements of landscape exude a fanciful exuberance which accords very harmoniously with the human figures. The artist achieves this by means of thick enameling executed with virtuosity and craftsmanship – one might almost say with a self-conscious skill – but his enamels contribute at the same time to a formal structure full of pulsating vitality.

**80.** The noble subject of the portrait by **Baldung Grün**, with its incisiveness of line, caused by the great attention which the artist paid to Dürer's work, bears the insignia of the Order of Our Lady of the Sword; the identification of the subject as Margrave Baden Cristopher I, or a member of his household, is no longer consistent with the opinion of today's critics.

**81.** *The Two Ambassadors* by **Holbein** the Younger lean on a table where a magnificent collection of astronomical and musical instruments are on display and which is covered by one of those carpets which are correctly called today Holbein carpets. At the bottom of the work, between the two "Ambassadors," a skull has been placed. The skull is a "memento mori" which is unexpected, coming as it does in this magnificent display of refinement and knowledge. For the work to have the full impact that the artist intended, the beholder would first have to approach the painting from the front, where he would be highly impressed by the elegance of the work and the magnificent splendor of the two figures, both representing dignity and knowledge. After having feasted on this, the spectator would then have to leave the room via an exit just to the side of the work, and in casting a last glance on the painting, the sinister symbol of death would suddenly appear, recalling his attention to the realities of life. As for the aesthetic content of the painting, it bears a solemnity which, through the artist's technical skill in composition and color, becomes animated with slow, steady, but powerful, impulses.

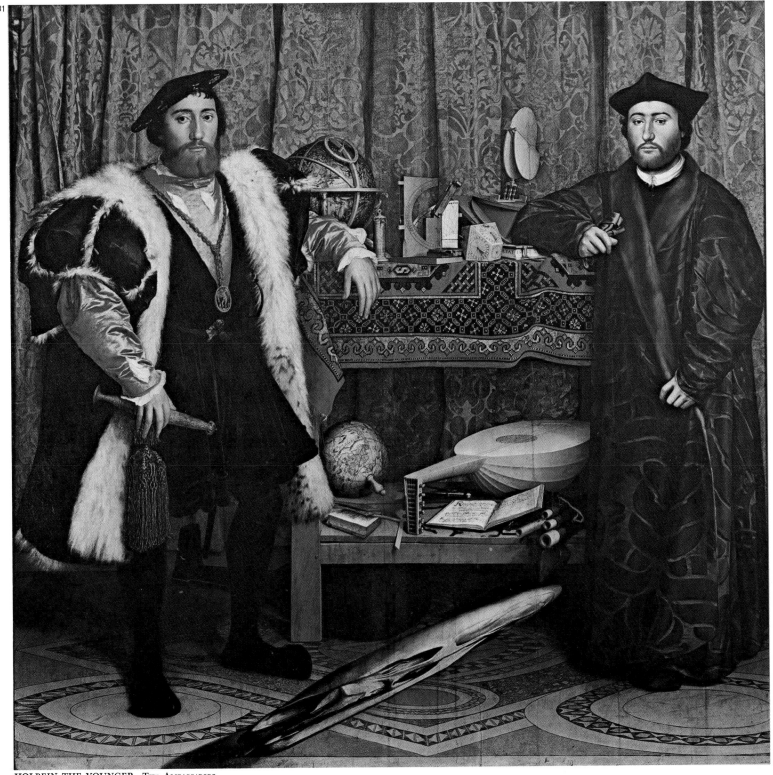

HOLBEIN THE YOUNGER THE AMBASSADORS

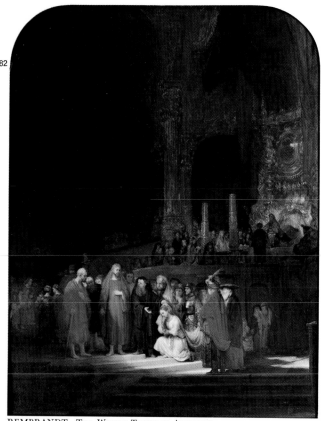

REMBRANDT  The Woman Taken in Adultery

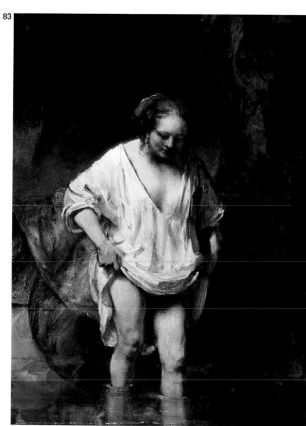

REMBRANDT  A Woman Bathing in a Stream

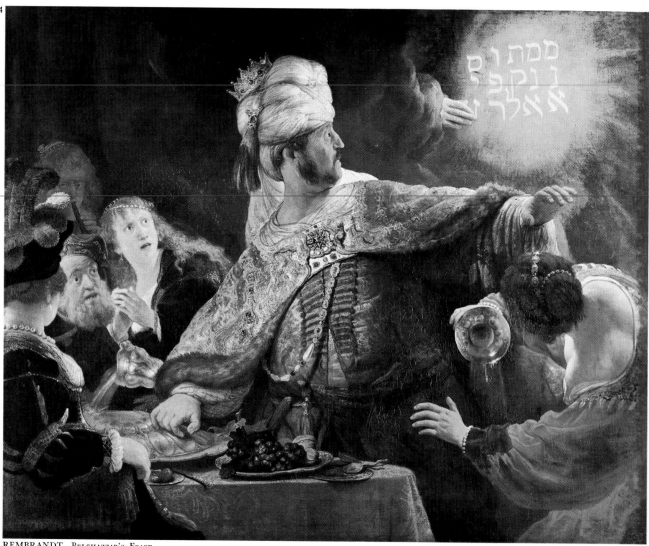

REMBRANDT  Belshazzar's Feast

REMBRANDT  Portrait of an 83-Year-Old Woman

**82 – 85.** In **Rembrandt**, the true protagonist is a light which magically transforms reality into a fairy-tale fantasy, as in *The Woman Taken in Adultery* (1644) and *Belshazzar's Feast* (1630-5). Here the artist's taste for clothes and precious objects is the starting point for the placing of very bold elements within the framework of a general atmosphere of luminosity. In this way, the iconography is completely transformed; while in *A Woman Bathing in a Stream* (often taken to be a portrait of his wife) and in the *Portrait of an 83-Year-Old Woman* (probably Françoise van Wassenhoven), the light conjures up enigmatic apparitions of a suffering humanity resigned to its destiny.

**86.** About 1630-5, when **Hals** probably painted *A Family Group in a Landscape*, he was just in the process of turning away from the style of his earlier years – a style which symbolized his opposition to Mannerism – towards which he had been guided by H. Goltzius, his teacher – and embracing a more open, terse style in which his frank realism, which was so typical of his approach, could eventually attain a bewitching evocation.

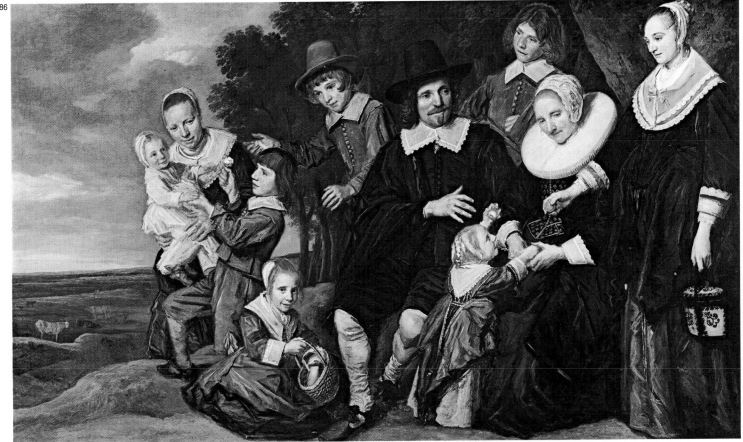

HALS  A Family Group in a Landscape

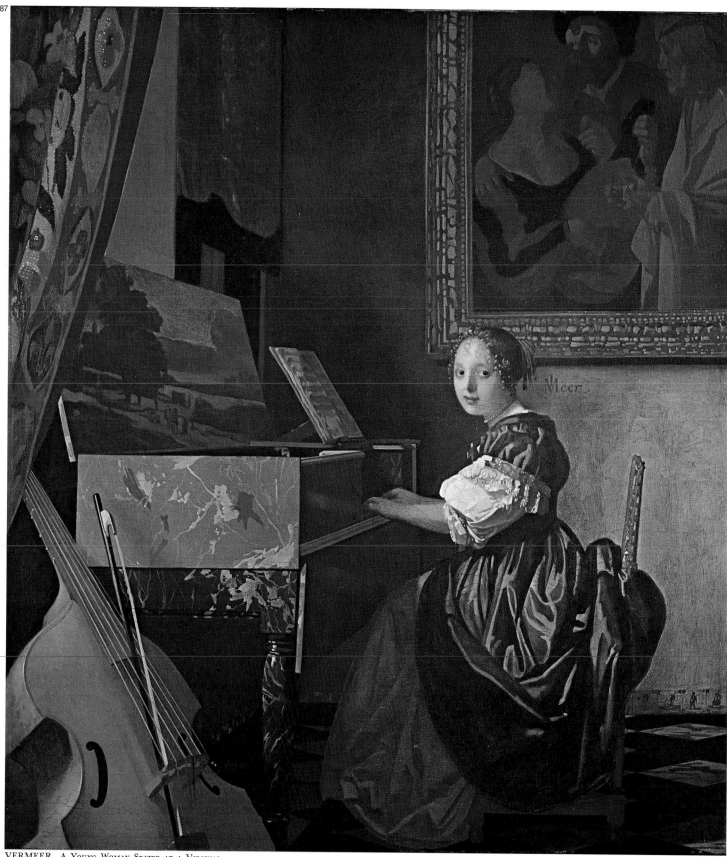

VERMEER  A Young Woman Seated at a Virginal

**87.**    While it has not been established if the landscape painted on the lid of the virginal is intended — as is probable — to be a reproduction of a work by some "specialist," the painting which is on the upper right of the work is a copy of the *Prostitute* by Dirck van Baburen, now in the Rijksmuseum in Amsterdam. This proves, along with other similar indications, that **Vermeer** was also an art-dealer, in order to be able to supplement his very small income. Furthermore, the floor is decorated by Delft tiles of such a beauty as to give joy to any collector. The whole is bathed in a light which Vermeer uses to cause the whites,

blues and yellows to vibrate against each other in this supremely serene world.

**88.**    This is thought to be a *Self-Portrait* of Carel **Fabritius** (despite the military dress). He was a follower of Rembrandt who translated the dramaticism of his master into a pulsating luminosity which was probably a determining factor for Vermeer's art.

**89.**    A follower of Fabritius, in his presentation of peaceful domestic interiors, is **De Hoogh**, who achieves here a happy lucidity of composition and of luminosity. The stone tablet which is placed above

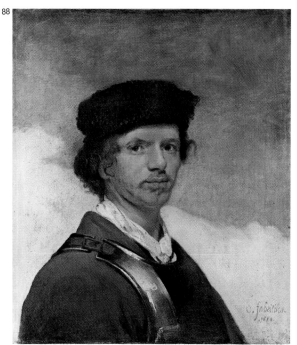

C. FABRITIUS  Self-Portrait (?)

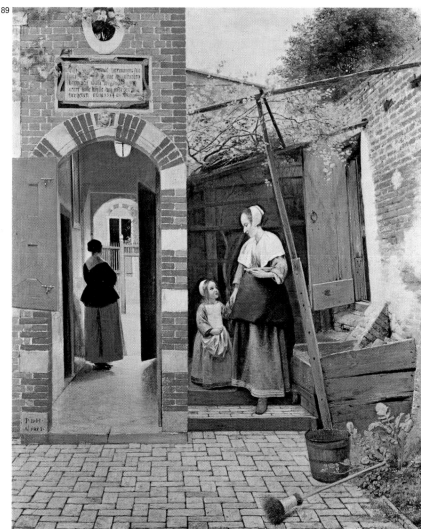

DE HOOGH  The Courtyard of a House in Delft

the arch (this was then to be found at the entrance of the Hieronymusdale Cloister in Delft) carries an edifying invitation: "If you wish to follow the road of patience and humility, this is the valley of St. Jerome into which you must descend before you can rise up again."

**90.** Even in Gerrit **Berckheyde**, who was an exponent of the airy spaciousness of E. de Witte, the serious documentation of a theme is translated into serene poetry. Apart from a few changes which took place after the work had been drafted, the interior of the Grote Kerk of Haarlem is still recognizable as such today.

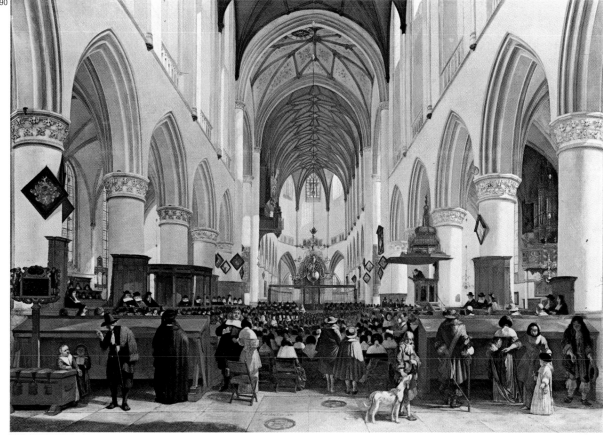

BERCKHEYDE  The Interior of the Grote Kerk at Haarlem

KONINCK  An Extensive Landscape with a Hawking Party

HOBBEMA  The Avenue, Middelharnis

**91.  Koninck**, another pupil of Rembrandt, was above everything else a painter of portraits and large-scale landscapes, where the light which filters through the large gaps in the clouds brings about a continual alternation of light and shade. As for the figures, the painter often availed himself of the assistance of J. Lingelbach, and the intervention of his colleague is quite probable here.

**92.**  The date which is inscribed on the **Hobbema** landscape should perhaps be read as 1689 rather than "1668." This would then help to explain the evident maturity reached by the painter in his confident brush strokes and in the structure of his perspective. Middleharnis (which is in the South of Holland) can be seen in the background; it is still recognizable today.

**93.**  In *A Windmill by a River*, **Van Goyen**, who painted it in 1642, is seen at the summit of his development; having left aside the episodic neatness learned from his teacher A. van Velde, he has achieved a synthesis in his composition which he then unites to a bland luminosity, thus intensifying the browns.

**94.**  Jacob **van Ruisdael**, a painter whose talents are many and varied, like his uncle, Salomon, interprets the Dutch countryside with a peculiar intensity of his own. Even here the scene, a *Shore* probably near Haarlem, is rendered with a simplicity of composition, and its solemn scenography lends itself well to effects of light and atmosphere.

**95.**  Winter landscapes, enlivened by caricatures and getting simpler with the advancing years, constitute in practical terms the only theme which **Avercamp** treated. The actual site of the scene is not known.

**96.**  The ruins of the castle on the left reveal immediately the identity of the countryside as being somewhere near Dordrecht; the scene is depicted with a crystal clarity which became one of the attributes of the style of **Cuyp** in his maturity, when he had already been seduced by the golden fusions achieved by Van Goyen.

**97.**  It is the lesson taught by Rembrandt which is at the root of **Van de Cappelle**'s interest in atmosphere and counterlight, and he bore besides a deep love for seascapes and ships. Here the collection of ships is quite remarkable; specialists have identified a ferryboat in the background, a passenger ship on the left, in the center a yacht, and in the foreground, a canoe, or small rowboat.

VAN GOYEN  A Windmill by a River

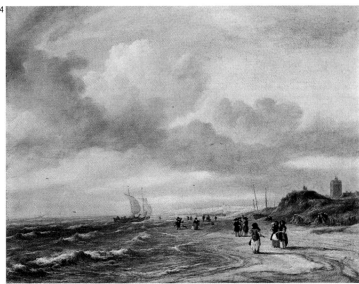

VAN RUISDAEL  The Shore at Egmond-aan-Zee

54

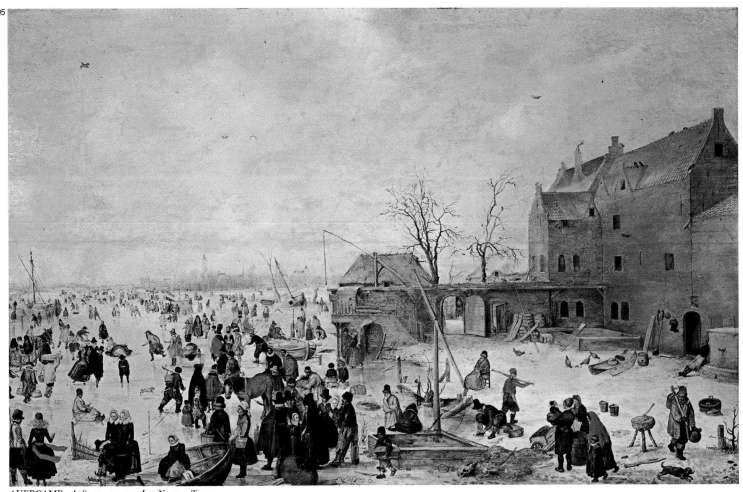

AVERCAMP  A Scene on the Ice Near a Town

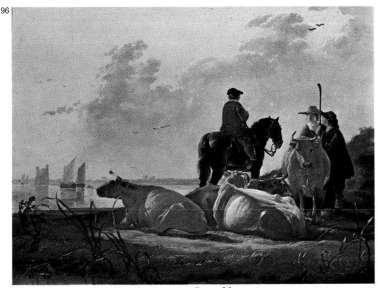

CUYP  Peasants with Four Cows by the River Merwede

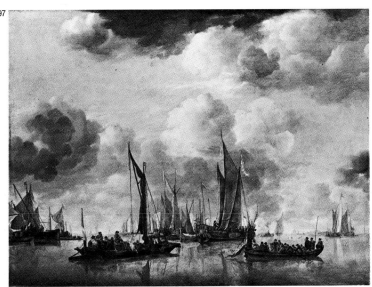

VAN DE CAPPELLE  A Dutch Yacht and many small Vessels at Anchor

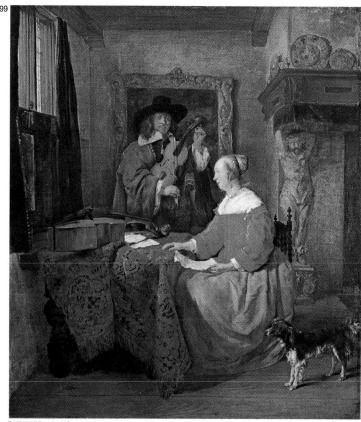

TER BORCH  A Young Woman Playing a Theorbo to Two Men

METSU  A Woman Seated at a Table and a Man Tuning a Violin

100

VAN OSTADE  An Alchemist

MOLENAER  Two Boys and a Girl Making Music

**98.** This theme of *A Young Woman Playing a Theorbo to Two Men* has been developed in several different versions. It was painted by the aristocratic **Ter Borch** who derives his preoccupation with the achievement of luminous effects from the example of Hals. Together with the three subjects of the painting, Ter Borch depicts a small spaniel dog which also appears in various other works by him; on the ground there is a playing card, the ace of spades.

**99.** Here **Metsu** is remodeling his style after Vermeer but at the same time drawing on a more overt realism.

**100.** The clear Latin inscription on the sheet of paper near the fireplace, "oleum et operam perdis," denotes the ironic scepticism of the painter towards alchemy. The work dates from 1661. For the previous twenty years, **Van Ostade** had frequented the atelier of Rembrandt, thus enriching his own ideas on luminosity and deriving a stimulus to acquire a much more synthetic form than that which he had hitherto sought.

**101.** **Molenaer** translates the style of Hals, who was probably his teacher, into an enameled aggressive realism, as can be seen in these musicians.

**102.** Humorous tones are not infrequent, even in the work of **Steen**; he was one of the pupils of his father-in-law, J. van Goyen. The humor is fed by an impeccable feeling for color, the liveliness of which always, or almost always, overrides any faults in the narrative of the scene portrayed. The date to be found on a copy of *Skittle Players Outside an Inn* is 1672, but this is due to a whim of the imitator, since the style of the original belongs to the period 1650-60.

STEEN  Skittle Players Outside an Inn

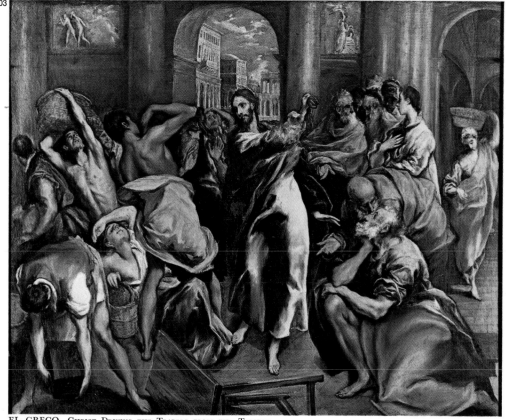

103

EL GRECO  Christ Driving the Traders from the Temple

104

VELÁZQUEZ  Philip IV in Brown and Silver

105

VELÁZQUEZ  The Toilet of Venus

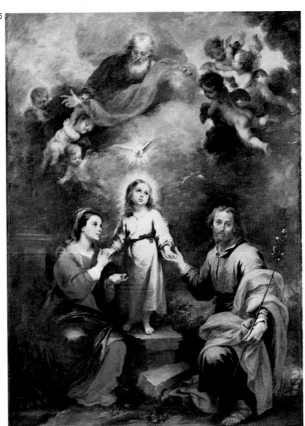

MURILLO  The Two Trinities

**103.** The dramatic ardor of Titian and Tintoretto which **El Greco** had admired in Italian art, especially because of the threads of cold light which twist and turn in-between the pure colors, is seen here to be fading into that hallucinatory realism of the last years, which the artist spent at Toledo. The painting can be traced back to the end of the Cinquecento.

**104 – 105.** There are overtones of Italian influence even in **Velázquez**, notably of Caravaggio and Titian. They are re-expressed, however, with a meticulous devotion to realism where the intrusion of color, which is becoming increasingly soaked in light, anticipates the detachment of the Impressionists. In his *Toilet of Venus* (which was the victim of the protest of a suffragette, who seriously damaged it in 1914) even the vague reference to classical examples vanishes into nothing and the spectator is left with the sensation of witnessing an absolutely new form of expression. Thus his *Philip IV of Spain in Brown and Silver*, which although a show-piece – because of the wondrous silvery whites heightened by blacks and greys – becomes the purest form of poetic art.

**106.** Caravaggio, or better still, the Caravaggism of Ribera, spurs even **Murillo** on to interpret a holy scene in simple terms, immersing them in the irridescence of an increasingly golden, increasingly soft cromia, which becomes almost academic in its application.

**107 – 108.** The third of the "greats" in Spanish painting, **Goya**, concerns himself here with the magnificent *Doña Isabel Cobos de Porcel* (1806) and the extremely severe *Dr. Peral*, both of which bear the flourish of a lively brush stroke and a refinement which is characteristic of Goya.

**59**

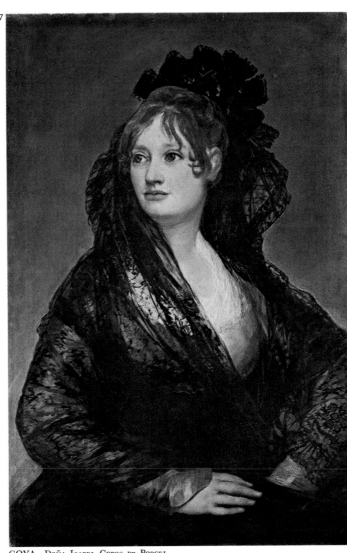

GOYA  Doña Isabel Cobos de Porcel

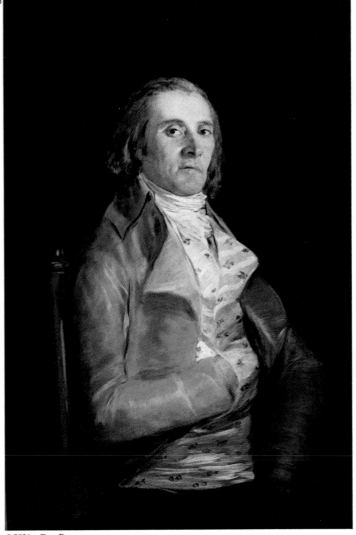

GOYA  Dr. Peral

109

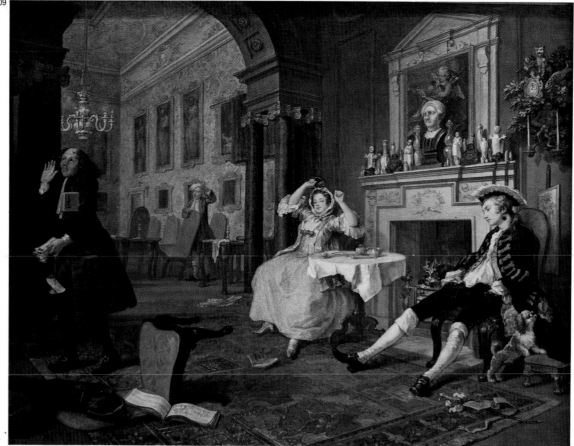

HOGARTH  Marriage à la Mode: The Countess's Morning Levée

110

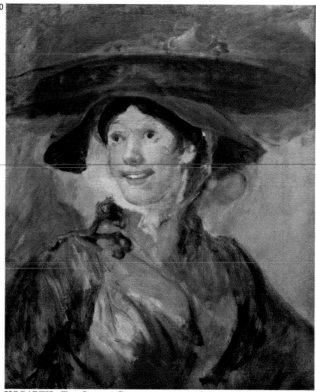

HOGARTH  The Shrimp Girl

111

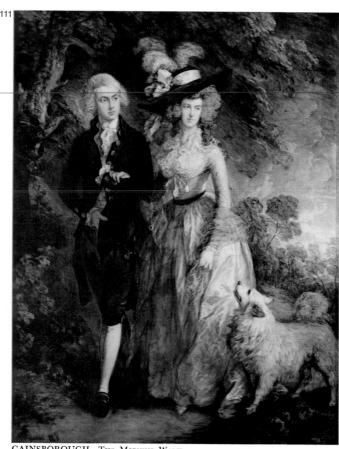

GAINSBOROUGH  The Morning Walk

**109 – 110.** The two striking aspects of **Hogarth**'s maturity are his extraordinarily fresh and vigorous touch, as in *The Shrimp Girl*, and his ruthless observation of life. The artist never, however, loses sight of the intimate tension between the structure of composition and the chromatic web of the narration, as in his *Shortly After the Marriage*, which is part of the series of six pictures forming the "Marriage à la Mode" (1744). The couple has spent a night of revelry, each in his own way: at her feet, a well-known handbook on whist; a little dog is sniffing at the unmistakable bonnet which is hanging out of his pocket; in the distance the butler is portrayed walking away with a pile of unpaid bills, except for one; the pseudo-antique rubbish on the mantlepiece indicates the bad taste of the owners of the house.

**111 – 112.**  **Gainsborough**'s admiration for Rubens and Van Dyck does not prevent him from keeping pace with the innovations of his times. This is very evident in his obvious understanding of the message conveyed by French painting of that time. It is from these things that his ever-growing stylistic freedom and the freshness of his portraits come – especially if they are set in the open air, as

is his *Morning Walk*, which portrays William Hallet and his wife Elisabeth (1786) and also the portrait of the Andrewses (c. 1750).

**113. Reynolds,** who during the course of a trip around Italy acquired a great admiration for the colors of the Venetian School, tends to dilute his perception as a portrait painter, preferring to achieve elegance of composition and a virtuosity of execution. In his portrait of Sir Banastre Tarleton, who distinguished himself in the American War of Independence, he alludes to his subject's courageous deeds by presenting in the background a cannon, horses and the smoke of battle.

**114.** Even more aware of exterior, without neglecting the exigencies of art, however, is **Lawrence,** who is shown as a court portraitist here. This is a portrait of Queen Charlotte with a miniature portrait of George III on her bracelet.

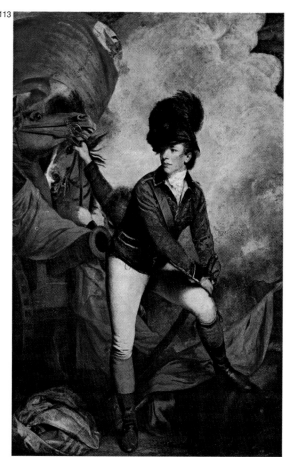

REYNOLDS  GENERAL SIR BANASTRE TARLETON

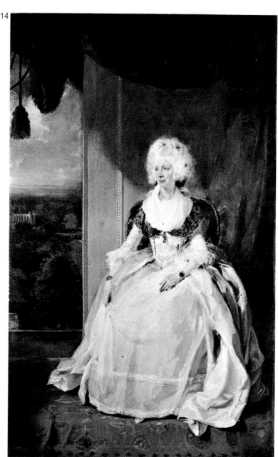

LAWRENCE  QUEEN CHARLOTTE

61

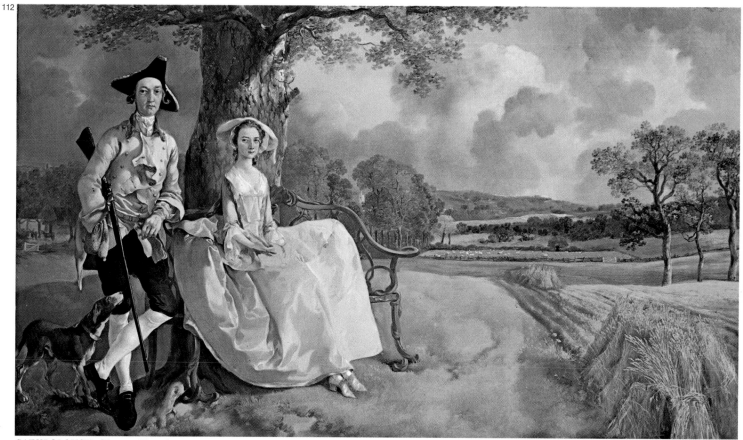

GAINSBOROUGH  MR. AND MRS. ANDREWS

62

115

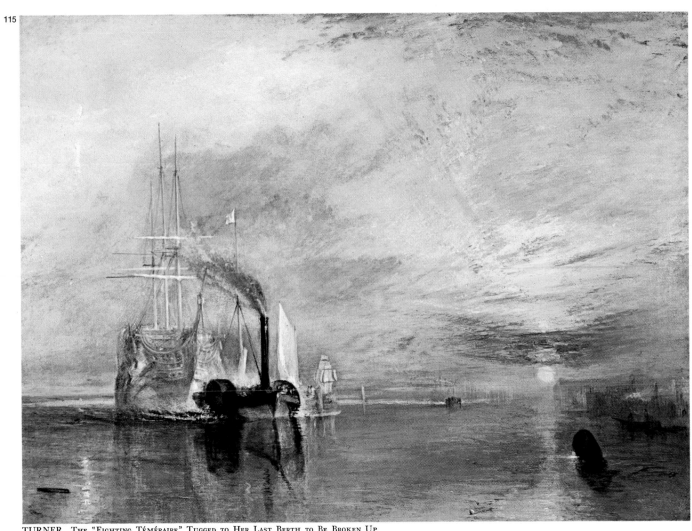

TURNER  The "Fighting Téméraire" Tugged to Her Last Berth to Be Broken Up

116

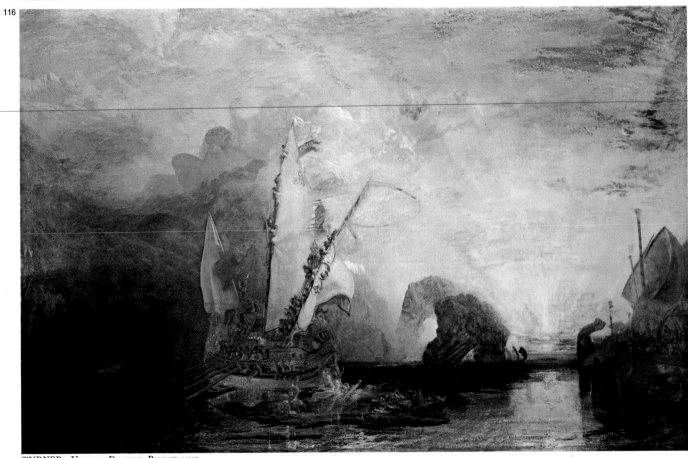

TURNER  Ulysses Deriding Polyphemus

CONSTABLE   Weymouth Bay

**115 – 116.**   From his initial admiration for painters of the Dutch School and the work of Claude Lorrain, **Turner** derived a personal style of his own which he achieved by applying transparent watercolors to oil. If in *The "Fighting Téméraire" Tugged to Her Last Berth to Be Broken Up* (1838) he still shows signs of his old preferences, traces of his later style can be seen in *Ulysses Deriding Polyphemus*, but this was done some ten years earlier. In this painting the forms are less well defined and are placed in a romantic, suggestive atmosphere shot through with dazzling light which the Impressionists were later to develop more fully.

**117 – 118.**   The course which the career of **Constable** took was not unlike that of the previous artist. He moved away from the influence of the Dutch artists and Gainsborough and, through the use of watercolor, achieved a lyrical transformation of his subjects. The sketch (c. 1816) of the Bay of Weymouth (unfinished but artistically complete) is a magnificent example of this. But even when he does "finish off" his work, as he does in *The Hay-Wain* (1821), he shows himself worthy of the title of "the father of landscape," as he was called by Delacroix.

63

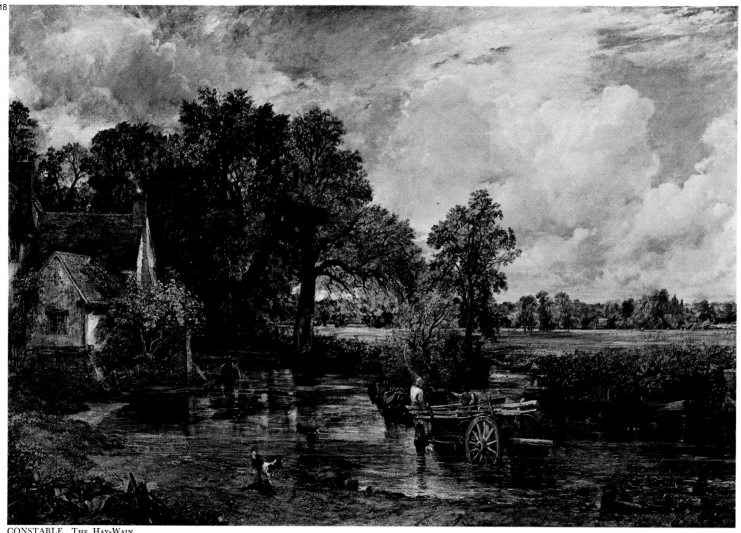

CONSTABLE   The Hay-Wain

**119.** The triple portrait of Cardinal Richelieu was painted by Philippe de **Champaigne** in his severe and brilliant style, to serve as a guide for the Italian sculptor Francesco Mochi; underneath the portraits on the right, an inscription in French affirms that of the two profiles, "this is the better one."

**120.** A work which was done before **Poussin**'s short return to France, *The Adoration of the Golden Calf*, presents the artist at the apex of his sensual tonalism, which was nourished by the classicists in Bologna and above all by the work of Titian. The dizziness portrayed in the adulators and in the young people who are doing a kind of dance is centered on the figure of Aaron; in the background, on the left, Moses is seen arriving with the tablets; he is accompanied by Joshua.

64

CHAMPAIGNE  Triple Portrait of Richelieu

POUSSIN  The Adoration of the Golden Calf

C. LORRAIN  Seaport: The Embarcation of St. Ursula

**121.** Claude **Lorrain** was another French painter to be influenced by the classicism of Bologna. He adopts some of their techniques especially to increase the play of light on trees and buildings, which he then breaks up into reflections on the water and softens into golden mists, as he does in this seascape, *The Embarcation of St. Ursula*. The theme goes almost unnoticed, being dominated by the more important theme of dazzling sunlight. The work carries an inscription which alludes to the martyr ("EMBARQUE ... ORS ...") and it is also signed and dated 1641, which at that time was read as 1646.

**122.** On the opposite pole, one could say, from the epic pompousness of Lorrain is **Chardin**, who, in the middle of the eighteenth century turns his attention to the domestic scenes of which the Flemish painters were so fond. But while appearing to look back into history, he at the same time gives them a newness, an unsurpassed elegance of chromatic harmonies, as in *The House of Cards*, which was perhaps put on exhibition by the painter himself in the Salon of 1741.

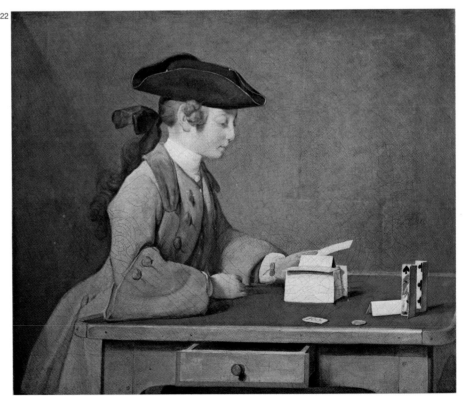

CHARDIN  The House of Cards

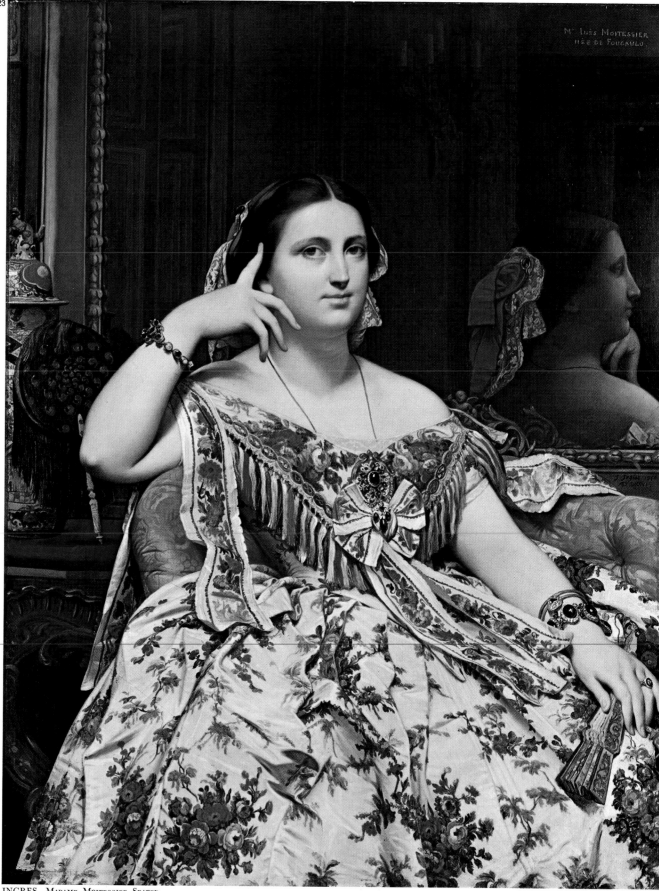

INGRES  MADAME MOITESSIER SEATED

**123.** As was the habit of **Ingres**, the portrait of *Madame Inès Moitessier née de Foucauld* – as it is stated in the inscription followed by the signature and date, 1856 – took a long time to be completed by the artist, since it was probably started in 1844-1845. The pose of the subject was probably borrowed from a painting from Ercolano in the Naples Gallery, which a pupil of Ingres photographed for him. So much for the majestic and noble naturalism of the work; he makes full use, however, of his talents in his masterful use of color, which can be seen in the costume and in the wonderful profile reflected in the mirror.

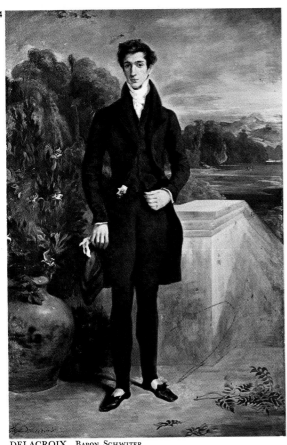

DELACROIX  Baron Schwiter

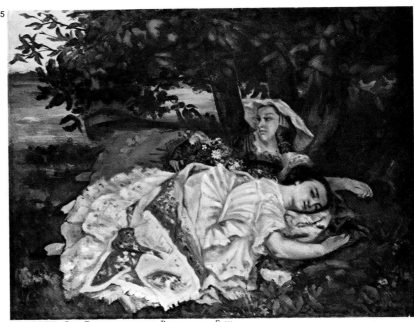

COURBET  Les Demoiselles des Bords de la Seine

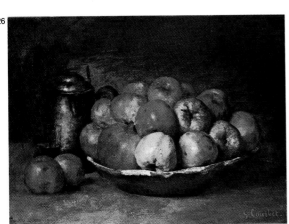

COURBET  Still Life: Apples and Pomegranate

**124.** The *Baron Schwiter* by **Delacroix** was refused by the Salon in 1827; this can be easily understood, because the artist's admiration for Rubens and Gros was leading into a style of uncontrolled freedom, of passionate movement in his colors and light, which was the very opposite of the neoclassical academic style which was acceptable at that time.

**125 – 126.** The example of the Dutch and Spanish painters of the seventeenth century is at the root of **Courbet**'s antirhetorical themes and of his synthetic realism, which he expressed by means of thick brush strokes in browns, relieved here and there by notes of magnificent intensity as exemplified in this *Still Life: Apples and Pomegranate*. *Les Demoiselles des Bords de la Seine* marks one of the first and major achievements of the painter in his search to find his own personal style; it is a study piece for his larger composition now in the Petit Palais, Paris.

**127.** This view of Avignon, seen from the western side or near it (c. 1836), represents one of the first landmarks in **Corot**'s process of liberating himself from his previous attempts at a classical style. This is an example of a solid, luminous technique heightened by the lyrical perception of the artist.

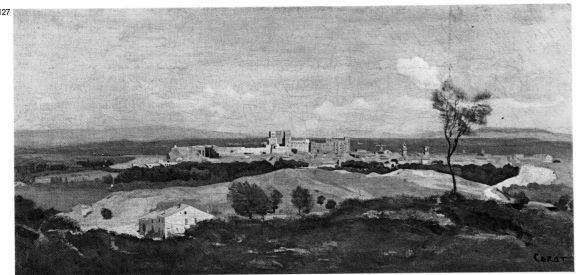

COROT  Avignon from the West

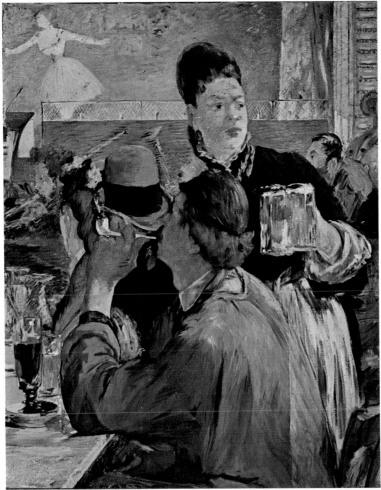

MANET The Waitress

**128.** *The Waitress* by **Manet** is a fragment (together with *Au Café* of the Reinhart Collection, Winterthur) from a vast composition the setting of which is the "brasserie" Reichsoffen, Boulevard Rochechouart. It is a painting which owes its intense vitality mostly to the way in which the colors contrast with and offset each other, there being no in-between tones. Its frank modernity, however, was a source of scandal at the time.

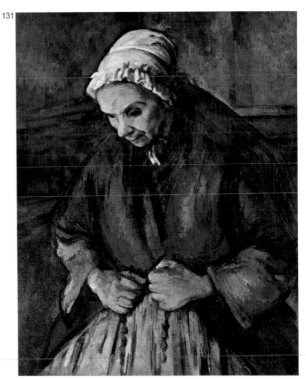

CÉZANNE La Vieille au Chapelet

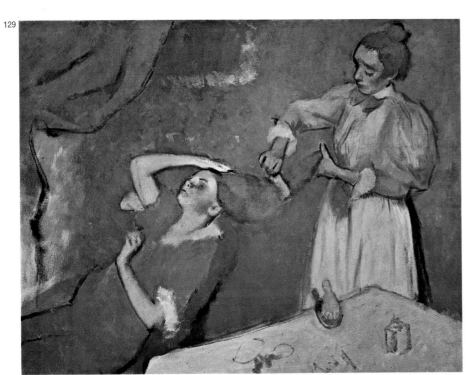

DEGAS Combing the Hair

DEGAS La La at the Cirque Fernando, Paris

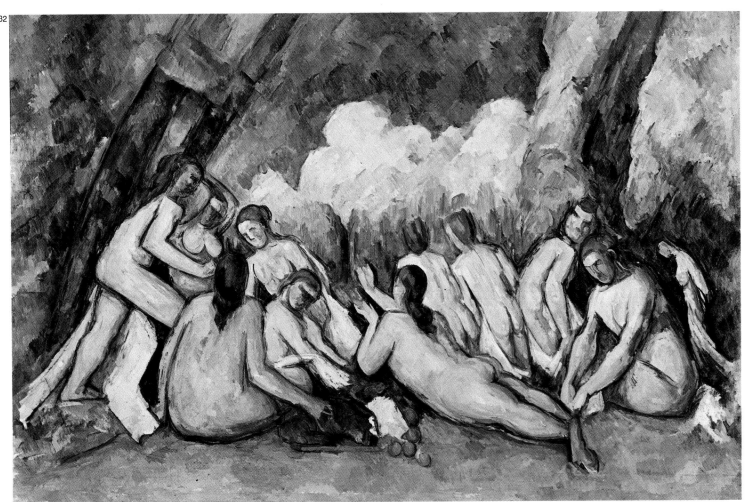

CÉZANNE   Les Grandes Baigneuses

**129 – 130.** It was an unfathomable artistic invention which led **Degas** to portray the female figure in such an infinite variety of poses. The woman, however, is only a means which the artist uses to explore the relationships between color, light, and form. And this is borne out in *Combing the Hair* (c. 1895). The painting is unfinished, and this heightens the flowing chromatic effect of the work. That the artist used the female figure in order to experiment can also be seen in *La La at the Cirque Fernando, Paris* (1879).

**131 – 132.** *La Vieille au Chapelet* (1900-4) occupied **Cézanne** for a full eighteen months while he worked to achieve that thickness of atmosphere which he called Flaubertian. Next is one of the numerous

oils which Cézanne dedicated to the theme of *Baigneuses* in his search for that geometric simplicity as yet unsurpassed by succeeding generations. In this painting (1904-5) the figures are enveloped in a faint blue halflight which seeps into even the moist, tender contours.

**133 – 134.** The scene depicted here is known to be the Côte des Bœufs near Pontoise. The work shows **Pissarro** preoccupied with finding a solution to the problems posed by light, and using means which put him alongside Seurat. The view of the Louvre in the snow is, on the other hand, part of a series of canvases which the artist painted during the last years of his life and in which the theme never varied, although environmental circumstances and the point of view did.

PISSARRO   The Côte des Bœufs at L'Hermitage

PISSARRO   Le Louvre, matin, effet de neige, 2ᵉ série

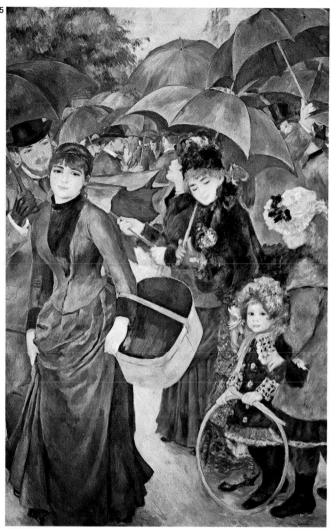

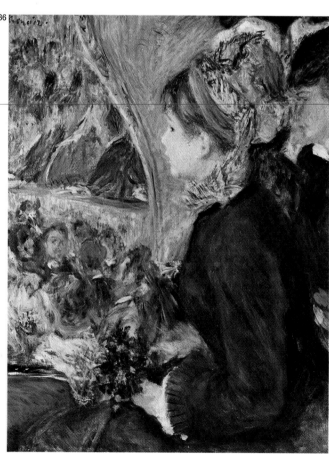

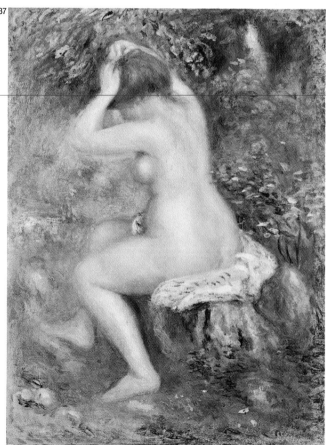

135

RENOIR Parapluies

136

RENOIR Première Sortie

137

RENOIR Baigneuse se Coiffant

**135 – 137.** Here is **Renoir** in three stages in his artistic career. In *Parapluies* of about 1885 (though it was perhaps started some years earlier), we see traces of a style which was re-embracing a classical outlook. This was reinforced by Renoir's admiration for Ingres and his knowledge of the work of Raphael, which had become fashionable in Italy. Although it was a looking-back, his previous experiences prevented this from becoming a decline. This is better understood in another work of around the same period, *Baigneuse se Coiffant* which is a clear prelude to the fine synthesis of a soft plasticity and luminous vibration of later nudes in which Renoir reached the height of his artistic talent. *Première Sortie*, painted in 1875-6, is the only surviving work from a period of experimentation with realism, which, since Renoir had been for some years engaged in research with Monet, betrays an Impressionistic style in the figures.

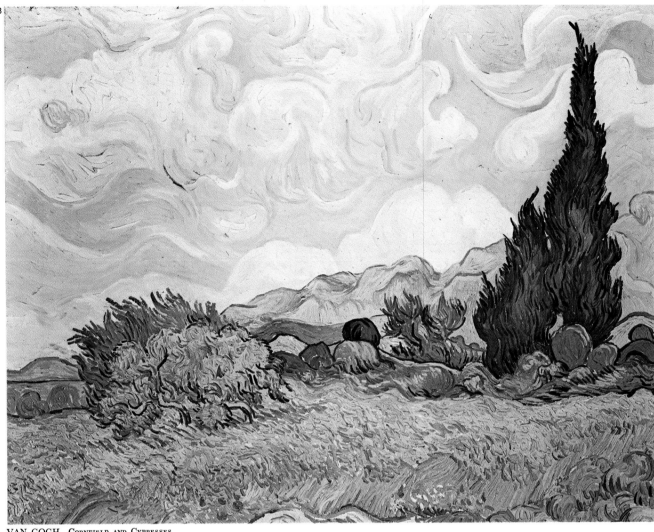

VAN GOGH CORNFIELD AND CYPRESSES

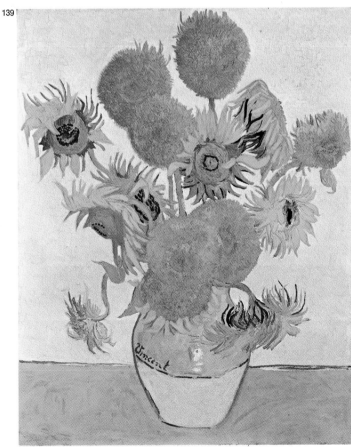

**138 – 139.** As is well known, **Van Gogh**'s artistic career was very short lived; some critics have recently undertaken the recovery of some of his very early paintings which were greatly influenced by the realism of Israels and Millet, but the full blossoming of the artist's career only lasted four years in all. It began with his moving to Paris (1886) where, under the influence of the Impressionists, his work takes on clear, shrill tones in which predominate those sunlike yellows which became a characteristic of his palette during his stay in Arles (1888). There then began to appear, as in *Cornfield and Cypresses* and *Sunflowers*, those moral and metaphysical anxieties which were to drive the artist to madness and which are at the root of the trancelike urgency of his tough brush strokes, of the "arabesque of passion" in which the Expressionists might have recognized themselves.

**140.** The step from the lessons he had learned from Ingres to the "scientific" application of the principles of Impressionism was for **Seurat** less extraordinary than might appear, since it did not work out in an episodic, luminous naturalism but in a structural logic, extending – from the example of Piero della Francesca – to the purity of geometrical forms which were poetically infused into Impressionistic landscapes. The *Baignade*, set in Asnières, is one of the best proofs of this.

VAN GOGH SUNFLOWERS

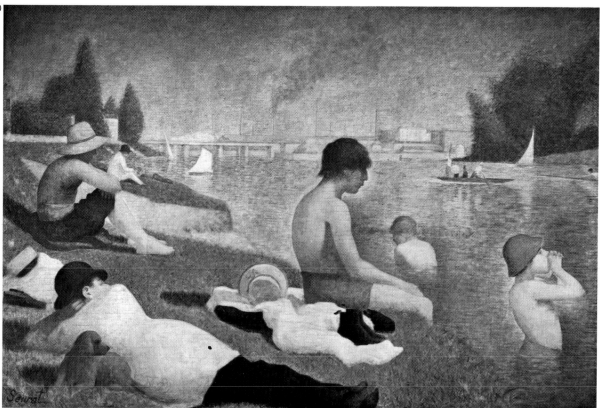

SEURAT Une Baignade, Asnières

**141 – 142.** The two canvases originally formed one painting, which was commissioned in 1902 from **Vuillard** by the short story writer Claude Auet. When, in 1935, the writer's widow moved, she asked the painter of the work to split the canvas because it was too large to fit into her new flat. Vuillard obliged and almost entirely redid the two halves of the painting. The work has as its subject a country festival which is set in the garden of the house of Misia, one of the most popular meeting places in Paris for the intellectuals of the time. The painting features some well-known figures from the world of art and literature. In the group on the right, one can identify the painter Bonnard with Mme. Auet, while her husband Claude can be seen standing behind a table in the background; Vuillard has also portrayed himself in conversation with Misia in the center of the picture. On the left, the little girl in blue is Hélène, the daughter of the writer.

VUILLARD Le Déjeuner à Villeneuve-sur-Yonne

VUILLARD Le Déjeuner à Villeneuve-sur-Yonne

# Other Important Paintings
# in the National Gallery

JOHANNES VAN DER AACK
*An Old Woman Seated
Sewing*

ALBRECHT ALTDORFER
*Landscape with a Footbridge*

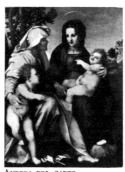

ANDREA DEL SARTO
*Madonna and Child with
SS. Elizabeth and John*

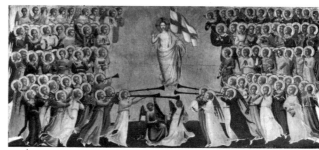

FRA ANGELICO
*Christ Glorified in the Court of Heaven*

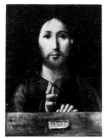

ANTONELLO DA MESSINA
*Salvator Mundi*

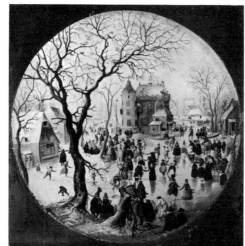

HENDRICK AVERCAMP
*A Winter Scene with Skaters Near a Castle*

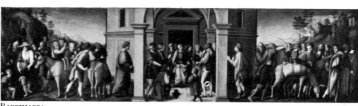

BACCHIACCA
*The History of Joseph (I)*

LUDOLF BAKHUIZEN
*Dutch Men-of-War and Small Vessels
in a Stiff Breeze Off Enkhuizen*

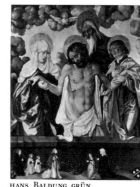

HANS BALDUNG GRÜN
*The Trinity and Mystic Pietà*

AUGSBURG SCHOOL (attr)
*Portrait of a Man*

JACOPO DE' BARBARI
*A Sparrowhawk*

BARNABA DA MODENA
*Pentecost*

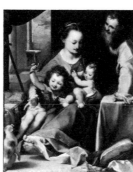

FEDERIGO BAROCCIO
*Madonna and Child with
S. Joseph and the Infant Baptist*

BARTOLOMEO VENETO
*Portrait of
Ludovico Martinengo*

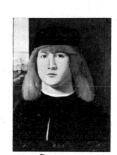

MARCO BASAITI
*Portrait of a Young Man*

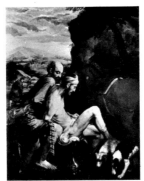

JACOPO BASSANO
*The Good Samaritan*

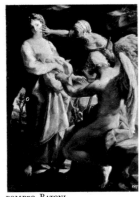

POMPEO BATONI
*Time Destroying Beauty*

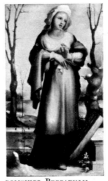

DOMENICO BECCAFUMI
*Marcia*

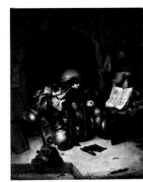

CORNELIS BEGA
*An Astrologer*

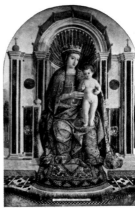

GENTILE BELLINI
*The Virgin and Child Enthroned*

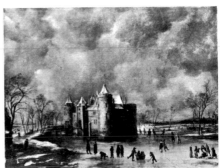

JAN BEERSTRAATEN
*The Castle of Muiden in Winter*

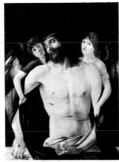

GIOVANNI BELLINI
*Pietà*

GIOVANNI BELLINI (attr)
*The Assassination of S. Peter Martyr*

NICOLAES BERCHEM
*Peasants with Four Oxen and a
Goat at a Ford
by a Ruined Aqueduct*

GERRIT BERCKHEYDE
*The Market Place and the Grote Kerk at Haarlem*

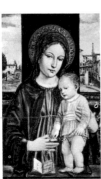

AMBROGIO BERGOGNONE
*The Virgin and Child*

AMBROGIO BERGOGNONE
*Christ Carrying the
Cross*

JAN VAN BIJLERT
*Portrait of an Elderly Man and
Woman, and a Younger Woman,
Outside a House*

FERDINAND BOL
*An Astronomer*

GIOVANNI BOLTRAFFIO
*A Man in Profile*

FRANCESCO BONSIGNORI
*Portrait of an Elderly
Man*

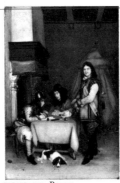

GERARD TER BORCH
*An Officer Dictating a Letter
While a Trumpeter Waits*

PARIS BORDONE
*Portrait of a Young Lady*

FRANÇOIS BOUCHER
*Pan and Syrinx*

JAN BOTH
*A View on the Tiber, Near the
Ripa Grande, Rome (?)*

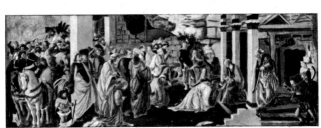

SANDRO BOTTICELLI
*The Adoration of the Kings 592*

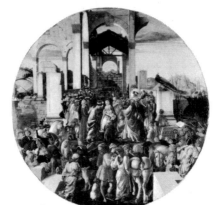

SANDRO BOTTICELLI
*Tondo: The Adoration of the Kings 1033*

LOUIS-EUGÈNE BOUDIN
*The Entrance to the Harbor of Trouville*

AELBRECHT BOUTS (style)
*Christ Crowned with Thorns*

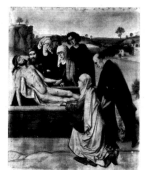

DIERIC BOUTS
*The Entombment*

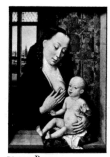

DIERIC BOUTS
*The Virgin and Child*
2595

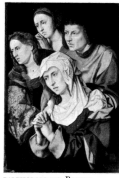

BARTHOLOMEUS BRUYN
THE ELDER
*The Virgin with Saints*

ROBERT CAMPIN
*A Man Holding a Scroll*

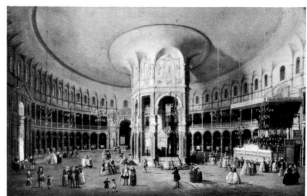

CANALETTO
*London: Interior of the Rotunda at Ranelagh*

CANALETTO
*Venice: A Regatta on the Grand Canal* 4454

**75**

JAN VAN DE CAPPELLE
*A Small Dutch Vessel before a
Light Breeze* 2588

AGOSTINO CARRACCI
*A Woman Borne off by a Sea God* (?)

ANNIBALE CARRACCI
*Christ and S. Peter*

ANNIBALE CARRACCI
*Christ and S. Anthony*

LUDOVICO CARRACCI
*Susannah and the Elders*

ROSALBA CARRIERA
*Portrait of a Man*

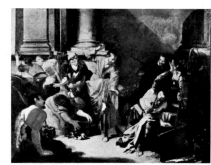

BERNARDO CAVALLINO
*Christ Driving the Money-Changers
from the Temple*

PAUL CÉZANNE
*Self-Portrait*

PAUL CÉZANNE
*Portrait of the Painter's
Father*

PHILIPPE DE CHAMPAIGNE
*Richelieu*

JEAN-BAPTISTE CHARDIN
*La Fontaine*

PETRUS CHRISTUS
*Portrait of a Young Man*

GIOVANNI BATTISTA CIMA
DA CONEGLIANO
*The Virgin and Child* 300

GIOVANNI BATTISTA CIMA
DA CONEGLIANO
*Christ Crowned with
Thorns*

PIETER CLAESZ.
*Still Life with Drinking Vessels*

PIETER CODDE
*A Seated Woman Holding a Mirror (?)*

COLOGNE SCHOOL
*Portrait of a Woman*

JOHN CONSTABLE
*The Cornfield*

JOHN CONSTABLE
*Salisbury Cathedral and Archdeacon Fisher's House from the River*

76

GONZALES COQUES
*A Family Group*

CORREGGIO
*The School of Love*

JEAN-BAPTISTE COROT
*Dardagny – un Chemin dans la Campagne, le Matin*

JEAN-BAPTISTE COROT
*A Horseman (M. Pivot) in a Wood*

LORENZO COSTA
*A Concert*

GUSTAVE COURBET
*Self-Portrait*

GIUSEPPE MARIA CRESPI
*S. Jerome*

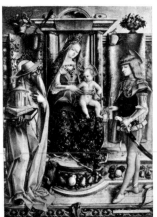

CARLO CRIVELLI
*Altarpiece: The Virgin and Child with SS. Jerome and Sebastian*

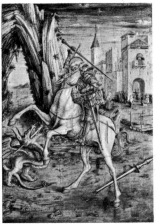

CARLO CRIVELLI
*S. George and the Dragon*

LUCAS CRANACH THE ELDER
*Charity*

LUCAS CRANACH THE ELDER
*The Close of the Silver Age (?)*

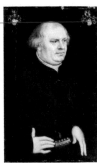

LUCAS CRANACH THE ELDER
*Portrait of a Man*

AELBERT CUYP
*Portrait of a Bearded Man; Bust*

AELBERT CUYP
*Ubbergen Castle*

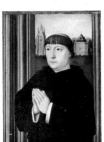

GERARD DAVID
*An Ecclesiastic Praying*

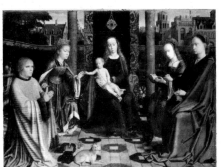

GERARD DAVID
*The Virgin and Child with Saints and Donor*

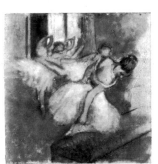

EDGAR DEGAS
*Les Danseuses*

EDGAR DEGAS
*Petites Filles Spartiates Provoquant des Garçons*

EUGÈNE DELACROIX
*Ovid Among the Scythians*

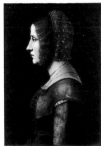

GIACOMO DE PREDIS
*Profile Portrait of a Lady*

NARCISSE-VIRGILIO DIAZ DE LA PEÑA
*The Storm*

CHRISTIAN DIETRICH
*Wandering Musicians*

DOMENICHINO (st)
*Apollo Killing the Cyclops*

DOMENICO VENEZIANO
*Fresco: Head of a
Beardless Saint* 766

DOSSO DOSSI
*Adoration of the Kings*

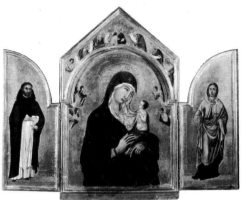

DUCCIO DI BUONINSEGNA
*The Virgin and Child with Saints*

ALBRECHT DÜRER (attr)
*The Painter's Father*

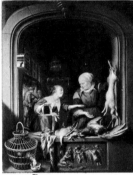

GERRIT DOU
*A Poulterer's Shop*

GASPARD DUGHET
*Ariccia*

DUCCIO DI BUONINSEGNA
*Jesus Opens the Eyes of a Blind Man*

WILLEM DUYSTER
*A Man and a Woman Playing Trick-Track,
and Three Other Men*

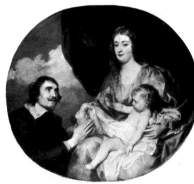

ANTHONY VAN DYCK
*The Virgin and Child Adored by the
Abbé Scaglia*

ANTHONY VAN DYCK (attr)
*Portrait of a Man*

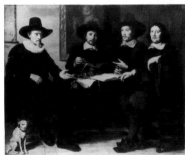

GERBRAND VAN DER EECKHOUT
*Four Officers of the Amsterdam Guild*

BARENT FABRITIUS
*The Naming of S. John the Baptist*

CAREL FABRITIUS
*A View in Delft, with a Musical Instrument Seller's Stall*

THÉODORE FANTIN-LATOUR
*The Rosy Wealth of June*

FLORENTINE SCHOOL
*Portrait of a Lady* 650

FLORENTINE SCHOOL
(attr)
*Portrait of a Boy*

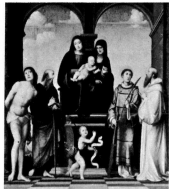

FRANCESCO FRANCIA
*The Virgin and Child with S. Anne
and Other Saints*

FRENCH SCHOOL (attr)
*Richard II Presented to the Virgin and Child
by His Patron Saints*

THOMAS GAINSBOROUGH
*Gainsborough's Forest*

DOMENICO GARGIULO (attr)
*The Finding of Moses*

PAUL GAUGUIN
*Flower piece*

GAROFALO
*The Agony in the Garden*

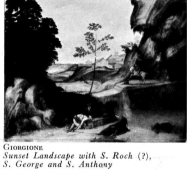

THOMAS GAINSBOROUGH
*John Plampin*

GIOVANNI DA MILANO
*The Almighty, the Virgin and Isaiah*

DOMENICO
GHIRLANDAIO (st)
*Portrait of a Girl*

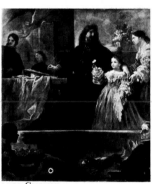

LUCA GIORDANO
*A Homage to Velázquez*

GIORGIONE
*Sunset Landscape with S. Roch (?),
S. George and S. Anthony*

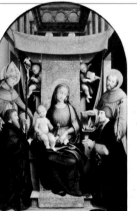

GIOVANNI DI PAOLO
*The Birth of S. John the Baptist*

GIUSTO DE' MENABUOI
*The Coronation of the Virgin*

GEROLAMO GIOVENONE
*The Virgin and Child with
Saints and Donors*

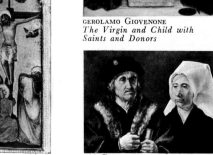

JAN GOSSAERT
*An Elderly Couple*

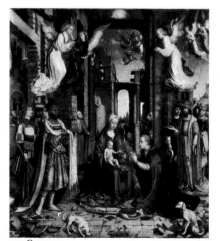

JAN GOSSAERT
*The Adoration of the Kings*

78

GOYA
*A Scene from
"El Hechizado por Fuerza"*

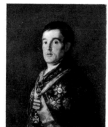

GOYA
*The Duke of Wellington*

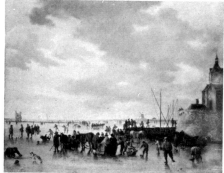

JAN VAN GOYEN
*A Scene on the Ice Outside Dordrecht*

JEAN-BAPTISTE GREUZE
*A Child with an Apple*

EL GRECO
*The Adoration of Jesus' Name*

FRANCESCO GUARDI
*Venice: Piazza San Marco* 2525

FRANCESCO GUARDI
*A View Near Venice* (?)

FRANS HALS
*Portrait of a Man
in His Thirties*

BARTHOLOMEUS VAN DER
HELST
*Portrait of a Lady*

JAN VAN DER HEYDEN
*The Huis ten Bosch at the Hague*

MEYNDERT HOBBEMA
*A View of the Haarlem Lock and the
Herring-Packers' Tower, Amsterdam*

GERRIT HEDA
*Still Life with a Lobster*

KATHARINA VAN HEMESSEN
*Portrait of a Man*

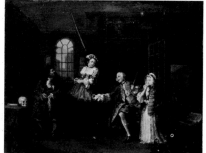

WILLIAM HOGARTH
*The Visit to the Quack Doctor*

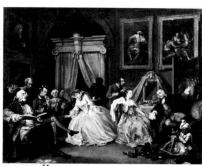

WILLIAM HOGARTH
*The Countess's Morning Levée*

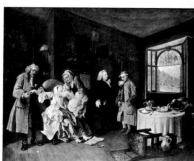

WILLIAM HOGARTH
*The Suicide of the Countess*

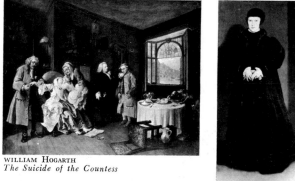

HANS HOLBEIN
THE YOUNGER
*Christina of
Denmark, Duchess
of Milan*

MELCHIOR DE HONDECOETER
*Geese and Ducks*

GERRIT VAN HONTHORST
*Christ before the High
Priest*

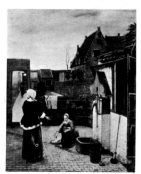

PIETER DE HOOGH
*A Woman and her Maid
in a Courtyard*

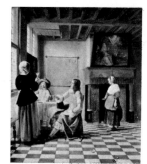

PIETER DE HOOGH
*An Interior, with a Woman,
two Men and a Maidservant*

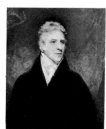

JOHN HOPPNER
*Portrait of Sir George
Beaumont*

79

JAN VAN HUIJSUM
*Flowers in a Terracotta
Vase, and Fruit*

DOMINIQUE INGRES
*Angelica Saved by Ruggiero*

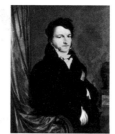

DOMINIQUE INGRES
*M. de Norvins*

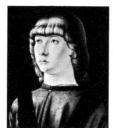

VENEZIANO JACOMETTO
(attr)
*Portrait of a Boy*

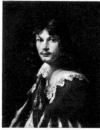

KAREL DU JARDIN
*Portrait of a Man*

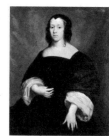

CORNELIUS JOHNSON
*Portrait of a Lady*

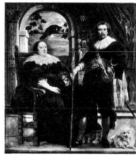

JACOB JORDAENS
*Portrait of a Man and His Wife*

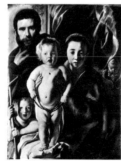

JACOB JORDAENS
*The Holy Family with
S. John*

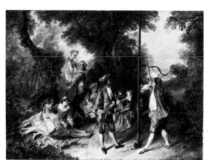

NICOLAS LANCRET
*Maturity*

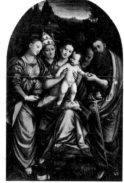

BERNARDINO LANINO
*Madonna and Child with
Saints*

NICOLAS DE LARGILLIÈRE
*Portrait of a Man*

MAURICE-QUENTIN DE
LA TOUR
*Henry Dawkins*

THOMAS LAWRENCE
*John Julius
Angerstein*  6370

BERNARDINO LICINIO
*Portrait of Stefano Nani*

ANTOINE LENAIN
*A Woman and Five Children*

JAN LIEVENSZ.
*Self-Portrait*

JEAN-ÉTIENNE LIOTARD
*A Grand Vizir* (?)

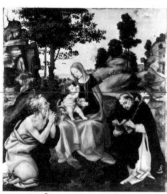

FILIPPINO LIPPI
*The Virgin and Child with SS. Jerome
and Dominic*

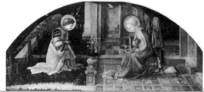

FILIPPO LIPPI
*The Annunciation*

LORENZO MONACO
*Incidents in the Life of S. Benedict*

AMBROGIO LORENZETTI
*A Group of Poor Clares*

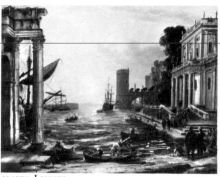

CLAUDE LORRAIN
*Seaport: The Embarcation of the Queen of Sheba*

PIETRO LONGHI
*A Fortune-Teller at Venice*

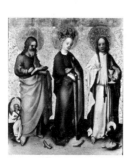

STEPHAN LOCHNER
*SS. Matthew, Catherine
and John the Evangelist*

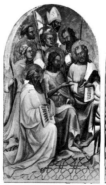
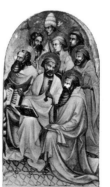

LORENZO MONACO
*Adoring Saints*

CLAUDE LORRAIN
*Landscape: Aeneas at Delos*

80

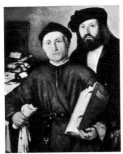

LORENZO LOTTO
*The Physician
della Torre and His Son*

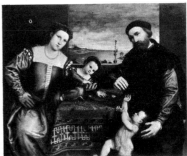

LORENZO LOTTO
*Family Group*

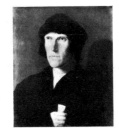

LUCAS VAN LEYDEN
*A Man Aged 38*

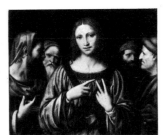

BERNARDINO LUINI
*Christ Among the Doctors*

NICOLAES MAES
*Interior with a Sleeping
Maid and Her Mistress*

ÉDOUARD MANET
*La Musique aux Tuileries*

ÉDOUARD MANET
*A Non-Commissioned
Officer Holding
his Rifle*

ANDREA MANTEGNA
*The Introduction of the Cult of Cybele at Rome*

ANDREA MANTEGNA
*Samson and Delilah*

MARGARITO D'AREZZO
*The Virgin and Child with Scenes of Nativity and the Lives of the Saints*

MARINUS VAN REYMERSWAELE
*Two Tax-Gatherers*

MARCO MARZIALE
*The Circumcision*

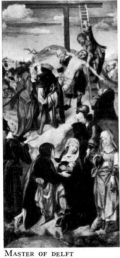

MASTER OF DELFT
*The Deposition*

MASOLINO (attr)
*A Pope and
S. Matthias*

MASTER OF LIESBORN
*Head of Christ Crucified*

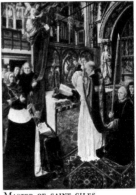

MASTER OF SAINT GILES
*The Mass of S. Giles*

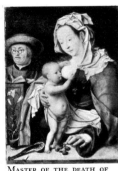

MASTER OF THE DEATH OF
THE VIRGIN
*The Holy Family*

MASTER OF THE
BRUGES PASSION
SCENES
*Ecce Homo*

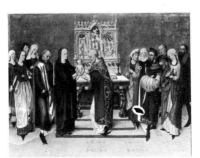

MASTER OF THE LIFE OF THE VIRGIN
*The Presentation in the Temple*

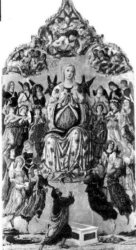

MATTEO DI GIOVANNI
*The Assumption*

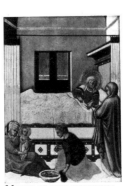

MASTER OF THE OSSERVANZA
*The Birth of the Virgin*

MASTER OF THE VIEW
OF SAINTE GUDULE
*Portrait of a Young Man*

JUAN BAUTISTA DEL MAZO
*Queen Mariana of Spain*

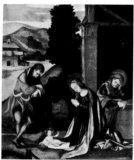

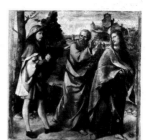

ALTOBELLO MELONE
*The Walk to Emmaus*

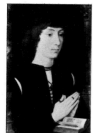

HANS MEMLINC
*A Young Man at
Prayer*

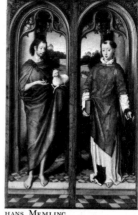

LODOVICO MAZZOLINO
*The Nativity*

LODOVICO MAZZOLINO
*Christ and the Adulteress*

HANS MEMLINC
*SS. John the Baptist and
Lawrence*

82

JAN MOLENAER
*A Young Man Playing a Theorbo
and a Young Woman Playing
a Cittern*

GABRIEL METSU
*Two Men with a Sleeping
Woman*

MICHELANGELO BUONARROTI
*The Entombment*

MICHELANGELO BUONARROTI
(attr)
*Madonna and Child with
S. John and Angels*

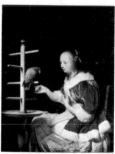

FRANS VAN MIERIS THE ELDER
*A Woman with a Parrot*

JEAN-FRANÇOIS MILLET
*The Whisper*

CLAUDE-OSCAR MONET
*La plage de Trouville*

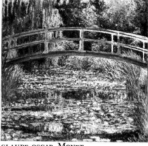

CLAUDE-OSCAR MONET
*Le bassin aux nymphéas*

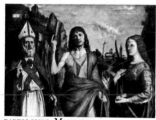

BARTOLOMEO MONTAGNA
*Three Saints*

ANTHONIS MOR
*A Man*

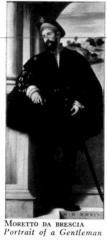

MORETTO DA BRESCIA
*Portrait of a Gentleman*

GIOVAN BATTISTA MORONI
*Portrait of a Gentleman*
1022

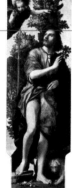

PAOLO MORANDO
*S. Roch*

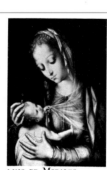

LUIS DE MORALES
*The Virgin and Child*

JEAN-MARC NATTIER
*Manon Balletti*

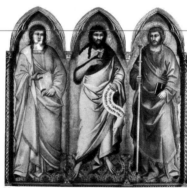

NARDO DI CIONE
*Three Saints*

GIOVAN BATTISTA MORONI
*Portrait Said to
Represent a Count Lupi*

GIOVAN BATTISTA MORONI
*Portrait of a Man
Holding a Letter*

MURILLO
*Self-Portrait*

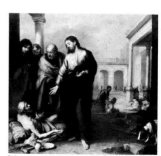

MURILLO
*Christ Healing the Paralytic
at the Pool of Bethesda*

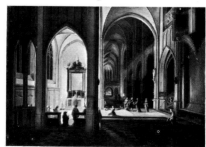

PEETER NEEFS THE ELDER
*Vespers*

AERNOUT VAN DER NEER
*A View Along a River Near a Village at Evening*

CASPAR NETSCHER
*Portrait of a Lady and a Girl with Oranges*

NICOLAS DE NEUFCHÂTEL
*Portrait of a Young Lady*

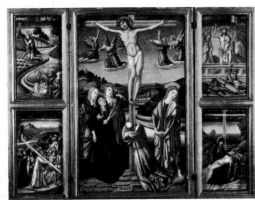

NICCOLÒ DI LIBERATORE
*Christ on the Cross and Other Scenes*

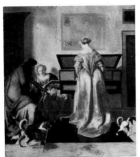

JACOB OCHTERVELT
*Concert Trio*

JACOB VAN OOST THE ELDER
*Portrait of a Boy*

LELIO ORSI (attr)
*The Walk to Emmaus*

ADRIAEN VAN OSTADE
*A Peasant Holding a Jug and a Pipe*

ISACK VAN OSTADE
*A Winter Scene, with an Inn by a Frozen Stream*

ORTOLANO
*SS. Sebastian, Roch and Demetrius*

MICHAEL PACHER (circle)
*The Virgin and Child Enthroned with Angels and Saints*

PALMA THE ELDER
*A Blonde Woman*

GIOVANNI PELLEGRINI
*Rebecca at the Well*

JEAN-BAPTISTE PERRONNEAU
*A Girl with a Kitten*

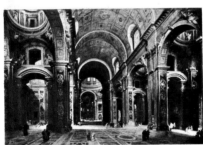

GIOVANNI PANINI
*Rome: The Interior of S. Peter's*

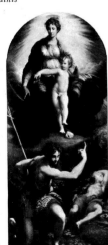

PARMIGIANINO
*The Madonna and Child with SS. John the Baptist and Jerome*

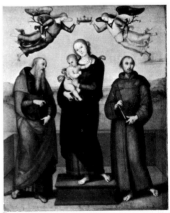

PERUGINO
*The Virgin and Child with SS. Francis and Jerome*

PERUGINO
*The Virgin and Child* and *S. Raphael*

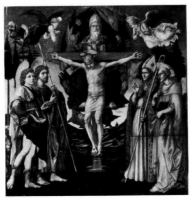

PESELLINO
*The Trinity with Saints*

PESELLINO
*S. Mamas in Prison Thrown to the Lions*

PESELLINO
*S. Jerome and the Lion*

PIERO DELLA FRANCESCA
*S. Michael*

PIERO DELLA FRANCESCA
*The Nativity*

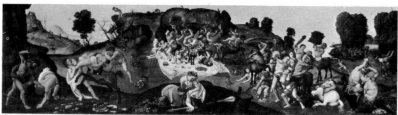

PIERO DI COSIMO
*The Fight between the Lapiths and the Centaurs*

PINTORICCHIO
*The Virgin and Child*

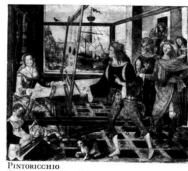

PINTORICCHIO
*Scenes from the Odyssey*

CAMILLE PISSARRO
*Lower Norwood, Londres, effet de neige*

CORNELIS VAN POELENBURGH
*A Landscape with an Italian Hill Town*

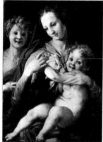

PONTORMO
*Madonna and Child
with the Infant S. John
the Baptist*

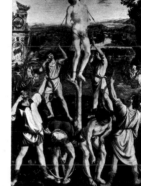

ANTONIO AND PIERO DEL
POLLAIUOLO (attr)
*The Martyrdom of S. Sebastian*

HENDRICK POT
*A Merry Company at Table*

NICOLAS POUSSIN
*Landscape with a Snake*

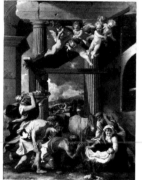

NICOLAS POUSSIN
*The Adoration of the
Shepherds  6277*

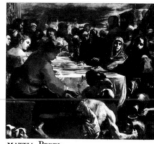

MATTIA PRETI
*The Marriage at Cana*

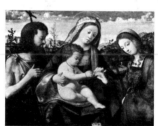

ANDREA PREVITALI
*The Virgin and Child with
SS. John the Baptist and Catherine*

ANDREA PREVITALI
*Salvator Mundi  3087*

SCIPIONE PULZONE
*Portrait of a Cardinal*

RAFFAELLINO DEL
GARBO (attr)
*Portrait of a Man*

RAPHAEL
*Pope Julius II*

RAPHAEL
*Madonna and Child with
the Infant Baptist*

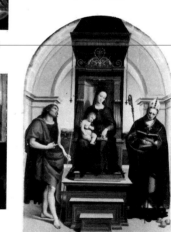

RAPHAEL
*Madonna and Child with S. John
the Baptist and S. Nicholas of Bari*

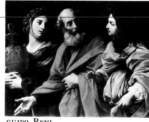

GUIDO RENI
*Lot and His Daughters
Leaving Sodom*

REMBRANDT
*Bust of a Bearded Man
in a Cap*

REMBRANDT
*Self-Portrait at the Age
of 34*

PIERRE-AUGUSTE RENOIR
*Portrait of Misia*

PIERRE-AUGUSTE RENOIR
*La Nymphe à la Source*

PIERRE-AUGUSTE RENOIR
*La Danseuse au Tambourin* and *La
Danseuse aux Castagnettes*

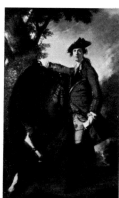

JOSHUA REYNOLDS
*Captain Robert Orme*

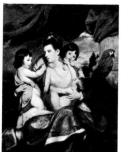

JOSHUA REYNOLDS
*Lady Cockburn and Her
Three Eldest Sons*

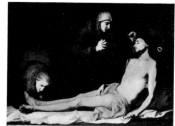

JUSEPE DE RIBERA
*The Lamentation Over the Dead Christ*

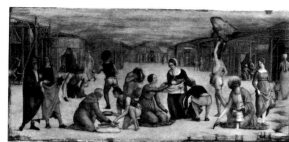

ERCOLE DE ROBERTI
*The Israelites Gathering Manna*

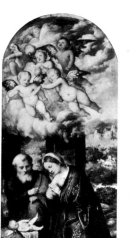

GEROLAMO ROMANINO
*The Nativity*

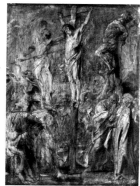

RUBENS
*The Crucifixion*

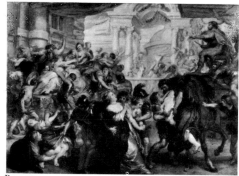

RUBENS
*The Rape of the Sabines*

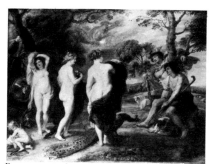

RUBENS
*The Judgment of Paris* 194

**85**

SALVATOR ROSA
*Self-Portrait*

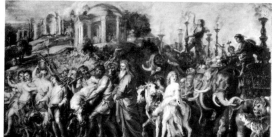

RUBENS
*A Roman Triumph*

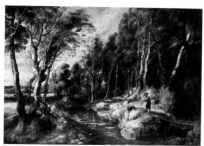

RUBENS
*A Shepherd with his Flock in a
Wooded Landscape*

RUBENS
*Thomas Howard,
Earl of Arundel*

JACOB VAN RUISDAEL
*An Extensive Landscape with a Ruined
Castle and a Village Church*

JACOB VAN RUISDAEL
*A Ruined Castle Gateway*

SASSETTA
*Young S. Francis' Whim to
Become a Soldier*

GIUSEPPE SALVIATI
*Justice*

SALOMON VAN RUYSDAEL
*A Landscape with a Carriage and
Horsemen at a Pool*

PIETER SAENREDAM
*The Interior of the Grote Kerk at Haarlem*

GABRIEL-JACQUES DE SAINT-AUBIN
*A Street Show in Paris*

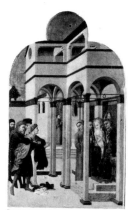

SASSETTA
*S. Francis Renounces his
Earthly Father*

SASSOFERRATO
*The Virgin and Child*

GODFRIED SCHALCKEN
*An Old Woman at a
Window Scouring a Pot*

SEBASTIANO DEL PIOMBO
*Madonna and Child with
SS. Joseph and John the Baptist
and a Donor*

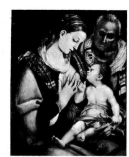

LUCA SIGNORELLI
*The Holy Family*

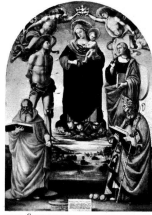

LUCA SIGNORELLI
*The Virgin and Child with Saints*

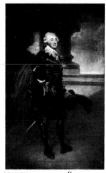

MARTIN ARCHER SHEE
*W.T. Lewis in
"The Midnight Hour"*

ALFRED SISLEY
*Abreuvoir à Marly*

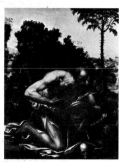

SODOMA
*S. Jerome in Penitence*

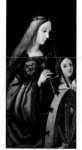

ANTONIO DE SOLARIO
*S. Catherine of Alexandria* and
*S. Ursula*

HENDRICK SORGH
*Two Lovers at Table Observed
by an Old Woman*

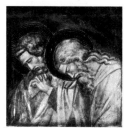

SPINELLO ARETINO
*Two Haloed Mourners*

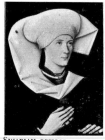

SWABIAN SCHOOL
*Portrait of a Woman
of the Hofer Family*

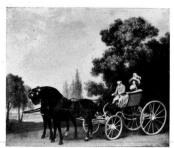

GEORGE STUBBS
*A Lady and Gentleman in a Carriage*

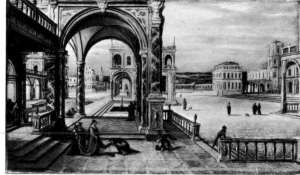

HENDRIK VAN STEENWYCK THE YOUNGER
*The Palace of Dido*

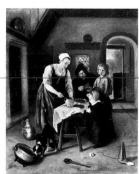

JAN STEEN
*A Peasant Family at Meal Time*

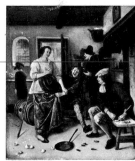

JAN STEEN
*"The Broken Eggs"*

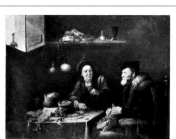

DAVID TENIERS THE YOUNGER
*The Covetous Man*

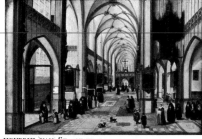

HENDRIK VAN STEENWYCK THE YOUNGER
*Interior of a Church* 1443

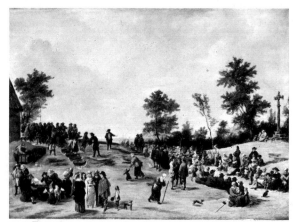

DAVID TENIERS THE YOUNGER (copy)
*A Village Festival*

DAVID TENIERS THE YOUNGER
*The Cardplayers*

GIOVANNI
BATTISTA
TIEPOLO
*Rinaldo and the
Magic Shield*

GIOVANNI DOMENICO TIEPOLO
*The Deposition from the Cross*
1333

TINTORETTO
*Christ Washing His Disciples' Feet*

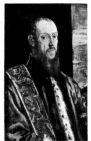

TINTORETTO
*Portrait of
Vincenzo Morosini*

TITIAN
*Noli me Tangere*

TITIAN
*Madonna and Child with SS. John the
Baptist and Catherine of Alexandria*

HENRI DE TOULOUSE-LAUTREC
*Femme assise dans le jardin*

JAN JANSZ. TRECK
*Still Life*

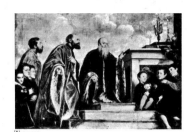

TITIAN
*The Vendramin Family*

TITIAN
*Allegory of Prudence*

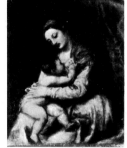

TITIAN
*Madonna and Child*

JOSEPH MALLORD TURNER
*Sun Rising through Vapour: Fishermen*

COSIMO TURA
*The Virgin and Child
Enthroned*

UGOLINO DI NERIO
*The Deposition*

UGOLINO DI NERIO
*Isaiah*

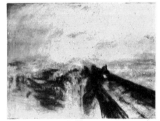

JOSEPH MALLORD TURNER
*The Great Western Railway*

COSIMO TURA
*S. Jerome*

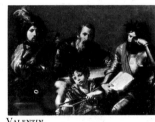

VALENTIN
*The Four Ages of Man*

VAN GOGH
*Long Grass with Butterflies*

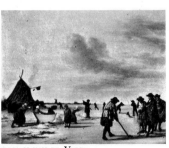

ADRIAEN VAN DE VELDE
*Golfers on the Ice Near Haarlem*

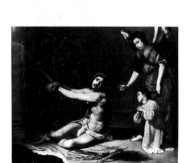

VELÁZQUEZ
*Christ after the Flagellation
Contemplated by the Christian Soul*

VELÁZQUEZ
*S. John the Evangelist*

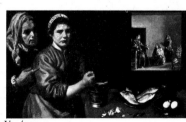

VELÁZQUEZ
*Interior of a Kitchen with Christ in
the House of Martha and Mary*

WILLEM VAN DE VELDE THE YOUNGER
*A Dutch Vessel in a Squall Reducing Sail
to Wait for a Boat*

WILLEM VAN DE VELDE THE YOUNGER
*Dutch Vessels Close Inshore at Low Tide
and Men Bathing*

JOHANNES VERMEER
*A Young Woman Standing
at the Virginal*

CLAUDE-JOSEPH VERNET
*A River with Fishermen*

VERONESE
*The Consecration of S. Nicholas*

VERONESE
*The Vision of S. Helena*

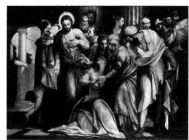

VERONESE
*The Magdalen Laying Aside her Jewels*

VERONESE
*Scorn*

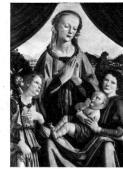

ANDREA DEL VERROCCHIO (attr)
*The Virgin and Child with Two Angels*

ALVISE VIVARINI
*The Virgin and Child*

BARTOLOMEO VIVARINI
*The Virgin and Child with SS. Paul and Jerome*

ANTONIO VIVARINI
*SS. Peter and Jerome and SS. Francis and Mark*

SIMON VOUET
*Ceres*

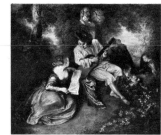

ANTOINE WATTEAU
*La Gamme d'Amour*

88

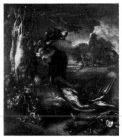

JAN WEENIX
*A Deerhound with Dead Game and Implements of the Chase*

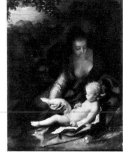

ADRIAEN VAN DER WERFF
*The Rest on the Flight into Egypt*

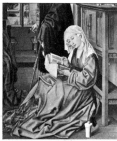

ROGIER VAN DER WEYDEN
*The Magdalen Reading*

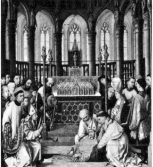

ROGIER VAN DER WEYDEN (follower)
*Exhumation of S. Hubert*

EMANUEL DE WITTE
*Adriana van Heusden and Her Daughter*

JAN WIJNANT
*A Track by a Dune with Peasants and a Horseman*

ADRIAEN YSENBRANDT
*The Magdalen in a Landscape*

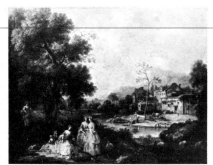

GIUSEPPE ZAIS
*Landscape with a Group of Figures*

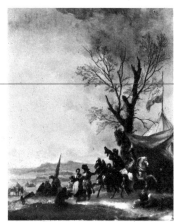

PHILIPS WOUWERMANS
*Cavalrymen Halted at a Sutler's Booth*

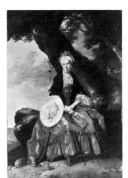

JOHANN ZOFFANY
*Mrs. Oswald*

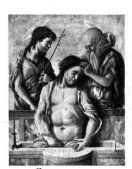

MARCO ZOPPO
*Pietà*

FRANCESCO ZUCCARELLI
*Landscape with Cattle and Figures*

FRANCISCO DE ZURBARÁN
*S. Francis in Meditation* 5655

FRANCISCO DE ZURBARÁN
*S. Margaret*

# Catalogue of the Paintings in the National Gallery

**AACK Johannes van der**
*Leyden 1635-6 – c 1680*
An old Woman seated sewing *
cv 42.9×31.9 (109×81 cm)
sg d 1655 ins

**Abate** see **NICCOLÒ DELL'ABATE**

**Agnolo di Cosimo** see **BRONZINO**

**Allegri Antonio** see **CORREGGIO**

**ALLORI Alessandro**
*Florence 1535 – 1607*
A Knight of S. Stefano
pn 82.3×47.6 (209×121 cm)

**ALTDORFER Albrecht**
*Regensburg (?) c 1480 – Regensburg 1538*
Landscape with a Footbridge *
parchment/pn 16.5×13.8
(42×35 cm)

**ANDREA DEL SARTO
(Andrea di Agnolo)**
*Florence 1486 – 1530*
Madonna and Child with SS. Elizabeth and John *
pn 41.7×31.9 (106×81 cm)
Portrait of a young Man → no 23
cv 28.3×22.4 (72×57 cm) sg

**ANDREA DI ALOIGI
(L'Ingegno)**
*act 1484-1516 Assisi*
The Virgin and Child
pn 25.6×16.9 (65×43 cm)
sg (?) attr

**ANDREA DI BONAIUTO
DA FIRENZE**
*act c 1343-77 Florence*
The Virgin and Child with ten Saints (Marcus, Peter, Thomas Aquinas, Dominic, Luke, John the Evangelist, Gregory, Catherine, Mary Magdalen, Thomas à Becket)
11 panels 11.0×41.7
(28×106 cm) (including original frame) attr

**ANDRIEU Pierre**
*Penouillet 1821 – Paris 1892*
Still life with Fruit and Flowers
cv 25.6×31.9 (65×81 cm) attr

**ANGELICO
(Fra Giovanni da Fiesole)**
*Vicchio di Mugello 1387 (?) – Rome 1455*
Christ glorified in the Court of Heaven * → no 9
pred; panels: centr pn 12.6×28.7 (32×73 cm);
the first and the fifth 12.6×8.7 (32×22 cm); the second and the fourth 12.6×25.2 (32×64 cm) ins
A Martyr Bishop or Abbot
pn; td 5.5 (14 cm) ins attr

**Follower of Fra ANGELICO**
The Adoration of the Kings
pred pn 7.5×18.5 (19×47 cm)
The Rape of Helen by Paris
pn 20.1×24.0 (51×61 cm)

The Annunciation
polyptych; pn 40.6×55.9 (103×142 cm)
The Vision of the Dominican Habit
pn 9.4×11.4 (24×29 cm)
The Virgin and Child with Angels
pn 11.4×8.3 (29×21 cm)

**ANGUISCIOLA Sofonisba**
*Cremona 1528 – Palermo 1625*
Portrait of a Lady
pn 33.1×26.8 (84×68 cm) attr

**ANTONELLO DA MESSINA**
*Messina c 1430 – 1479*
Salvator mundi *
pn 15.4×11.4 (39×29 cm)
sg d 1465
Portrait of a Man → no 39
pn 13.8×9.8 (35×25 cm)
mutilated c 1475
Christ crucified
pn 16.5×9.8 (42×25 cm)
sg d 1475
S. Jerome in his Study → no 38
pn 18.1×14.2 (46×36 cm)

**Follower of
ANTONELLO DA MESSINA**
The Virgin and Child
pn 16.9×13.4 (43×34 cm)

**ARENTSZ. Arent**
*Amsterdam (?) 1585-6 – ... 1635*
Fishermen near Muiden Castle
pn 9.1×15.0 (23×38 cm) sg

**AUGSBURG SCHOOL**
*Sixteenth Century*
Portrait of a Man *
pn 15.0×11.0 (38×28 cm) attr

**AUSTRIAN SCHOOL**
*Fifteenth Century*
The Trinity with Christ crucified
pn 46.5×45.3 (118×115 cm)

**AVERCAMP Hendrick**
*Amsterdam 1585 – Kampen 1634*
A Winter Scene with Skaters near a Castle *
pn; td 15.7 (40 cm) sg
A Scene on the Ice near a Town → no 95
pn 22.8×35.4 (58×90 cm) sg

**BACCHIACCA
(Francesco d'Ubertino)**
*Florence 1495 – 1557*
The History of Joseph I - II *
panels 14.2×55.5 (36×141 cm)
Marcus Curtius
pn 9.8×7.5 (25×19 cm) attr

**BADALOCCHIO Sisto**
*Parma 1585 – c 1621 (?)*
Christ carried to the Tomb
copper 16.9×13.0 (43×33 cm)
formerly attr to Ludovico Carracci

**BAKHUIZEN Ludolf**
*Emden 1631 – Amsterdam 1708*
Dutch Men-of-War and small Vessels in a stiff Breeze off Enkhuizen *
cv 39.4×53.5 (100×136 cm)
sg d 1683

The "Eendracht" and a Fleet of Dutch Men-of-War before the Wind
cv 29.5×41.3 (75×105 cm)
A Beach Scene with Fishermen
pn 13.4×18.9 (34×48 cm) sg
An English Vessel and a Man-of-War in a rough Sea off a Coast with tall Cliffs
cv 38.6×52.0 (98×132 cm)
A View across the River near Dordrecht (?)
pn 13.4×18.9 (34×48 cm)
Dutch Men-of-War entering a Mediterranean Port
cv 46.5×64.2 (118×163 cm)
sg d 1681

**BALDOVINETTI Alesso**
*Florence c 1426 – 1499*
Portrait of a Lady in yellow → no 12
pn 24.8×15.7 (63×40 cm)

**BALDUNG GRÜN Hans**
*Weyersheim (?) 1484-5 – Strasbourg 1545*
Portrait of a Man → no 80
pn 23.2×19.3 (59×49 cm)
d 1514
The Trinity and a mystic Pietà *
pn 44.1×35.0 (112×89 cm)
sg d 1512

**BALEN I Hendrick van**
*Antwerp 1575 (?) – 1632*
Pan pursuing Syrinx
copper 9.8×7.5 (25×19 cm)
in collaboration with a follower of Jan Brueghel the Elder

**BARBARI Jacopo de'**
*act 1500-16 (?) Venice*
A Sparrowhawk *
pn 6.7×4.3 (17×11 cm)

**Barbieri** see **GUERCINO**

**BARENDSZ. Dirck**
*Amsterdam 1534 – 1592*
Three Men and a little Girl
cv c 33.1×c 27.6
(c 84×c 70 cm) attr

**BARNABA DA MODENA**
*act 1361-83 Genoa and Tuscany*
Pentecost *
pn 21.3×19.7 (54×50 cm)
The Coronation of the Virgin; The Trinity; The Virgin and Child; The Twelve Apostles)
altarpiece; panels 13.4×10.6 (34×27 cm); pred 2.4×10.6 (6×27 cm); the third
sg d 1374 ins

**BAROCCIO Federigo**
*Urbino 1526-8 (?) – 1612*
Madonna and Child with S. Joseph and the Infant Baptist *
pn 44.5×36.6 (113×93 cm)

**BARTOLO DI FREDI**
*Siena c 1330 – c 1410*
S. Anthony Abbot
pn of an altarpiece 24.0×14.2 (61×36 cm) attr

**BARTOLOMEO VENETO**
*act 1502-46 Venice*
Portrait of Ludovico Martinengo *
pn 41.3×28.0 (105×71 cm)
false sg and d 1546
Portrait of a Lady
pn 21.6×17.3 (55×44 cm)

**BARTOLOMMEO Fra
(B. della Porta)**
*Florence 1472 (?) – 1517*
The Virgin adoring the Child, with S. Joseph
pn 54.3×41.3 (138×105 cm)
The Madonna and Child with S. John
pn/cv 34.6×28.0 (88×71 cm) attr

**BARYE Antoine-Louis**
*Paris 1796 – 1875*
Forest of Fontainebleau
cv 11.4×15.0 (29×38 cm) sg

**BASAITI Marco**
*act 1496-1530 Venice*
Portrait of a young Man *
pn 14.2×10.6 (36×27 cm) sg
The Virgin and Child
pn 24.8×18.5 (63×47 cm) sg

**BASSANO Jacopo
(J. da Ponte)**
*Bassano c 1510 – Venice 1592*
The Purification of the Temple → no 57
cv 63.0×104.3 (160×265 cm)
The good Samaritan *
cv 40.2×31.5 (102×80 cm)

**BASSANO Leandro
(L. da Ponte)**
*Bassano 1557 – Venice 1622*
The Tower of Babel
cv 54.7×74.4 (139×189 cm)

**Style of BASSANO Leandro**
Portrait of a Man
cv 25.2×20.9 (64×53 cm) ins

**Follower of the BASSANO**
Adoration of the Shepherds
cv 24.8×35.4 (63×90 cm)

**BASSEN Bartholomeus van**
*act 1613-52 Delft and The Hague*
The Interior of a Gothic Church 3164
pn 24.0×31.5 (61×80 cm)
sg d 1638
Interior of a Church 924
pn 26.8×38.6 (68×98 cm)
false sg and d 1644 attr

**BASTIANI Lazzaro**
*act 1449-1512 Venice*
The Virgin and Child
pn 32.7×25.2 (83×64 cm) sg

**BATONI Pompeo**
*Lucca 1708 – Rome 1787*
Mr. Scott (?) of Banks Fee
cv 39.8×29.1 (101×74 cm)
sg d 1774
Time orders Old Age to destroy Beauty *
cv 53.1×37.8 (135×96 cm)
sg d 1746

BAUGIN Lubin
*Pithiviers c 1610 – Paris 1663*
The Holy Family with SS. Elizabeth and John and Angels
pn 12.2×8.7 (31×22 cm)

BAZZANI Giuseppe
*Mantua 1690 – 1769*
S. Anthony of Padua with the Infant Christ
cv 33.5×27.2 (85×69 cm)

**Bazzi see SODOMA**

BECCAFUMI Domenico
*Montaperti 1486 (?) – Siena 1551*
An unidentified Scene
pn 29.1×54.3 (74×138 cm)
Tanaquil → no 31
Marcia *
panels 36.2×20.9 (92×53 cm)
ins

BEERSTRAATEN Jan
*Amsterdam 1622 – 1666*
The Castle of Muiden in Winter *
cv 37.8×50.8 (96×129 cm)
sg d 1658

BEGA Cornelis
*Haarlem (?) 1631-2 (?) – 1664*
An Astrologer *
pn 14.2×11.4 (36×29 cm)
sg d 1663

BEGEIJN Abraham
*Leyden 1637 (?) – Berlin 1697*
Peasants with Cattle by a Ruin
cv 21.3×26.0 (54×66 cm)
false sg
A River between rocky Cliffs, with a Waterfall on the left
cv 20.9×26.0 (53×66 cm)
false sg

BELLINI Gentile
*Venice c 1429 – 1507*
The Virgin and Child Enthroned *
ar pn 48.0×32.3 (122×82 cm)
sg
A Man with a Pair of Dividers (?)
cv 27.2×23.2 (69×59 cm) attr
The Sultan Mehmet II
pn(?)/cv 27.6×20.5 (70×52 cm)
false (?) d 1480 ins attr
The Doge Niccolò Marcello (?)
pn 24.4×17.7 (62×45 cm)
ins: on rv false (?) sg and d 1474 copy (?)

BELLINI Giovanni (Giambellino)
*Venice 1426 (?) – 1516*
The Doge Leonardo Loredan → no 41
pn 24.0×17.7 (61×45 cm) sg
The Virgin and Child (The Madonna of the Pomegranate [?]) 280
pn 35.8×25.6 (91×65 cm) sg
The Madonna of the Meadow → no 40
pn 26.4×33.9 (67×86 cm) damaged
The Agony in the Garden
pn 31.9×50.0 (81×127 cm)
The Blood of the Redeemer
pn 18.5×13.4 (47×34 cm) ins
S. Dominic
cv 24.8×19.3 (63×49) sg and false (?) d 1515 ins
Pietà *
pn 37.4×28.0 (95×71 cm) ins
The Virgin and Child 3913
pn 30.7×22.8 (78×58 cm) sg
The Assassination of S. Peter Martyr *
pn 39.4×65.0 (100×165 cm) false (?) sg attr
A Dominican with the Attributes of S. Peter Martyr added
pn 23.2×18.9 (59×48 cm) false (?) sg st
The Circumcision
pn 29.5×40.2 (75×102 cm) false (?) sg st
Madonna and Child 2901
pn 32.3×24.4 (82×62 cm) false sg st
The Virgin and Child 3078
pn 31.5×25.2 (80×64 cm) false (?) sg st

Follower of BELLINI Giovanni
S. Jerome reading in a Landscape
pn 18.5×13.4 (47×34 cm)
A Man in black
pn 12.2×9.8 (31×25 cm)

Style of BELLOTTO Bernardo
*Venice 1720 – Warsaw 1780*
A Caprice Landscape with Ruins
cv 21.3×29.1 (54×74 cm)

BENOZZO DI LESE (B. Gozzoli)
*Florence c 1421 – Pistoia 1497*
The Virgin and Child Enthroned among Angels and Saints 283
altarpiece; pn 63.8×66.9 (162×170 cm) c 1461-2 ins
The Virgin and Child Enthroned with Angels 2863
pn 53.9×35.0 (137×89 cm) copy

BENSON Ambrosius
*act 1519-50 Bruges*
The Magdalen reading
pn 16.1×14.2 (41×36 cm) st

**Benvenuti see ORTOLANO**

BENVENUTO DI GIOVANNI
*Siena 1436 – c 1509*
The Virgin and Child with SS. Peter and Nicholas
trp; centr pn 67.3×26.0 (171×66 cm) sg d 1479 ins; side panels 66.9×19.7 (170×50 cm) ins
The Virgin and Child
pn 20.5×13.4 (52×34 cm) ins

BERCHEM Nicolaes
*Haarlem 1620 – Amsterdam 1683*
Peasants with four Oxen and a Goat at a Ford by a ruined Aqueduct *
pn 18.5×15.0 (47×38 cm) sg
A mountainous Landscape with Muleteers
cv 42.9×49.6 (109×126 cm) sg d 1658
A Man and a Youth ploughing with Oxen
cv 42.9×20.1 (38×51 cm) sg
A Peasant playing a Hurdy-Gurdy to a Woman and Child in a woody Landscape
pn 13.4×15.0 (34×38 cm) sg d 1658
Peasants with Cattle fording a Stream
pn 11.4×17.7 (29×45 cm) false (?) sg attr
A Stag Hunt in a Forest
cv 39.4×48.0 (100×122 cm) sg ins
in collaboration with Johannes Hackaert (Amsterdam 1628-9 – Amsterdam [?] c 1685)

BERCKHEYDE Gerrit
*Haarlem 1638 – 1698*
The Market Place and the Grote Kerk at Haarlem *
cv 20.5×26.4 (52×67 cm) sg d 1674
The Interior of the Grote Kerk at Haarlem → no 90
pn 24.0×33.5 (61×85 cm) sg d 1673
The Market Place and the Town Hall: Haarlem
pn 12.6×15.7 (32×40 cm) sg

BERGOGNONE Ambrogio (A. da Fossano)
*act 1481-1528 Lombardy*
The Virgin and Child with SS. Catherine of Alexandria and Siena
altarpiece; pn 73.6×50.8 (187×129 cm) ins
The Virgin and Child with two Angels
pn 36.6×22.4 (93×57 cm) ins
The Agony in the Garden
Christ carrying the Cross *
panels of an altarpiece 39.4×17.7 (100×45 cm); the second false (?) d 1501
The Virgin and Child *
pn 21.6×13.8 (55×35 cm) ins
Members of a Confraternity (?)
fragments; silk or canvases/panels 25.2×16.5 (64×42 cm) attr

Style of BERGOGNONE
S. Paul
S. Ambrose (?)
panels of an altarpiece 43.3×16.5 (110×42 cm)

BERNINI Gian Lorenzo
*Naples 1598 – Rome 1680*
SS. Andrew and Thomas
cv 24.2×30.7 (61.5×78 cm)

**Berruguete see under Joos van Wassenhove**

**Bertucci see GIOVANNI BATTISTA DA FAENZA**

BIJLERT Jan van
*Utrecht 1603 (?) – 1671*
Portrait of an elderly Man and Woman, and a younger Woman, outside a House *
cv 50.0×39.8 (127×101 cm) sg

BILIVERT Giovanni
*Florence 1576 – 1644*
S. Zenobius revives a dead Boy
cv 80.7×64.6 (205×164 cm) formerly attr to Jacopo da Empoli (Florence c 1554-1640)

BISSOLO Francesco
*Venice (?) c 1470 – 1554*
The Virgin and Child with SS. Michael and Veronica and two Donors
pn 24.4×33.1 (62×84 cm) ins
The Virgin and Child with S. Paul and a Female Martyr
pn 30.7×46.1 (78×117 cm) repainted

BLANCOUR Marie
*Seventeenth Century, France*
A Bowl of Flowers
cv 25.6×20.1 (65×51 cm) sg

BOCCACCINO Boccaccio
*Ferrara 1467 – Cremona 1524-5*
The Way to Calvary
altarpiece; pn 52.0×51.6 (132×131 cm) attr

**Boel see under Coninck**

BOILLY Louis-Léopold
*Lille 1761 – Paris 1845*
A Girl at a Window
cv 21.6×17.7 (55×45 cm)
sg grisaille

BOL Ferdinand
*Dordrecht 1616 – Amsterdam 1680*
An Astronomer *
cv 50.0×53.1 (127×135 cm) sg d 1652
Portrait of a young Lady with a Fan
cv 32.7×27.2 (83×69 cm)

BOLTRAFFIO Giovanni Antonio
*Milan c 1466-7 – 1516*
The Virgin and Child
frm of an altarpiece (?); pn 36.2×26.4 (92×67 cm) ins
A Man in profile *
cv 22.0×16.5 (56×42 cm)

Follower of BOLTRAFFIO
The Virgin and Child
pn 20.1×14.6 (51×37 cm) ins
Narcissus
pn 9.1×10.2 (23×26 cm)

BONFIGLI Benedetto
*Perugia 1420 – 1496*
The Adoration of the Kings, and Christ on the Cross
frm of a pred (?); pn 14.6×19.3 (37×49 cm) attr

BONHEUR Rosa
*Bordeaux 1822 – By 1899*
The Horse Fair
cv 47.2×100.0 (120×254 cm) sg in collaboration with Nathalie Micas (Paris c 1824 – ... 1889)

BONIFACIO DI PITATI (B. Veronese)
*Verona 1487 – Venice 1553*
Madonna and Child with Saints 1202
cv 28.7×46.1 (73×117 cm)
A Huntsman
cv 46.1×25.6 (117×65 cm) st
Dives and Lazarus
pn 18.5×33.1 (47×84 cm) copy

Style of BONIFACIO DI PITATI
The Labours of the Months: January to June
The Labours of the Months: July to December
canvases/panels 5.1×3.9 (13×10 cm)
Madonna and Child with Saints 3536
cv 28.7×46.9 (73×119 cm)

BONO DA FERRARA
*act 1442 (?)-61 (?) Ferrara, Padua and Siena*
S. Jerome in a Landscape
pn 20.5×15.0 (52×38 cm) sg

BONSIGNORI Francesco
*Verona 1455 (?) – 1519 (?)*
Portrait of an elderly Man *
pn 16.5×11.4 (42×29 cm) sg d 1487
The Virgin and Child with four Saints
cv 18.9×42.1 (48×107 cm)

BONVIN François
*Paris 1817 – Saint-Germain-en-Laye 1887*
The Pasturage
cv 18.1×21.6 (46×55 cm) sg d 1869
Still Life
metal 14.2×18.9 (36×48 cm) sg d 1876

BORCH Gerard ter
*Zwolle 1617 – Deventer 1681*
A young Woman playing a Theorbo to two Men → no 98
cv 26.4×22.8 (67×58 cm)
The Swearing of the Oath of Ratification of the Treaty of Münster, 15 May 1648
copper 17.7×22.8 (45×58 cm) sg d 1648
Portrait of a young Man
cv 26.4×21.3 (67×54 cm)
Portrait of Hermanna van der Cruis
cv 28.3×22.4 (72×57 cm)
An Officer dictating a Letter while a Trumpeter waits *
cv c 29.1×c 20.1 (c 74×c 51 cm) sg

BORDONE Paris
*Treviso 1500 – Venice 1571*
Daphnis and Chloe
cv 53.5×47.2 (136×120 cm)
Portrait of a young Lady *
cv 41.7×33.5 (106×85 cm)
Christ as the Light of the World
cv 35.8×28.7 (91×73 cm) sg ins
Christ baptising S. John Martyr, Duke of Alexandria
cv 24.0×26.8 (61×68 cm)

Imitator of BORDONE
A young Woman with Carnations
cv 37.0×29.1 (94×74 cm)

BORSSOM Anthonie van
*Amsterdam 1629-30 – 1677*
A Garden Scene with Waterfowl
pn 13.0×17.7 (33×45 cm) sg

BOSBOOM Johannes
*The Hague 1817 – 1891*
The Interior of the Bakenesserkerk at Haarlem
pn 9.4×13.4 (24×34 cm) sg

BOSCH Hieronymus
*'s-Hertogenbosch c 1450 – 1516*
Christ mocked (The Crowning with Thorns) → no 72
pn 28.7×23.2 (73×59 cm)

BOSCH Pieter van den
*Amsterdam (?) c 1613-5 – c 1663*
A Woman scouring a Pan
pn 7.5×9.8 (19×25 cm) attr

BOTH Jan
*Utrecht c 1618 (?) – 1652*
A rocky Landscape with Peasants and Pack Mules
cv 46.9×63.0 (119×160 cm) sg
A rocky Italian Landscape with Herdsmen and Muleteers
cv 40.6×49.2 (103×125 cm) sg
Muleteers and a Herdsman with an Ox and Goats by a Pool
pn 22.4×27.2 (57×69 cm) sg
A View on the Tiber, near the Ripa Grande: Rome (?) *
pn 16.5×21.6 (42×55 cm) sg
Peasants with Mules and Oxen on a Track near a River
copper 15.4×22.8 (39×58 cm) sg
A rocky Landscape with an Ox-cart
cv 47.2×63.0 (120×160 cm) sg
A Landscape with the Judgment of Paris
cv 38.2×50.8 (97×129 cm) sg in collaboration with Cornelis van Poelenburgh

BOTTICELLI Sandro (Alessandro Filipepi)
*Florence c 1445 – 1510*
The Adoration of the Kings 592 *
pn 19.7×53.5 (50×136 cm)
The Adoration of the Kings 1033 *
pn; td 51.6 (131 cm)
Portrait of a young Man → no 16
pn 14.6×11.0 (37×28 cm)
Venus and Mars → no 18
pn 27.2×68.1 (69×173 cm)
Mystic Nativity → no 17
cv 42.5×29.5 (108×75 cm) false (?) sg and d 1500 ins
Four Scenes of the early Life of S. Zenobius
Three Miracles of S. Zenobius
panels 26.0×58.7 and 54.7 (66×149 and 139 cm)
The Virgin and Child with S. John and two Angels 226
oval pn 57.1×44.5 (145×113 cm) st
The Virgin and Child with S. John and an Angel 275
pn; td 33.1 (84 cm) ins st
The Virgin and Child 782
pn 32.7×25.6 (83×65 cm) st
The Virgin and Child with S. John the Baptist 2497
pn; td c 37.4 (c 95 cm) st
The Virgin and Child with a Pomegranate
pn 26.8×20.9 (68×53 cm) st

Follower of BOTTICELLI
The Virgin and Child with an Angel 589
pn 27.6×18.9 (70×48 cm)
S. Francis
pn 19.3×12.6 (49×32 cm)
An Allegory
pn 36.2×68.1 (92×173 cm)
A Lady in profile
pn 23.2×15.7 (59×40 cm)
The Virgin and Child 3082
pn 11.4×7.5 (29×19 cm)

BOTTICINI Francesco (F. di Giovanni)
*Florence c 1446 – 1497*
S. Jerome in Penitence with Saints and Donors
altarpiece; pn 59.8×68.1 (152×173 cm)
The Assumption of the Virgin
altarpiece; pn 89.8×148.4 (228×377 cm) attr

BOUCHER François
*Paris 1703 – 1770*
Pan and Syrinx *
cv 12.6×16.1 (32×41 cm) sg d 1759
The Billet-doux
cv 37.4×50.0 (95×127 cm) sg d 1754 st
Landscape with a Watermill
cv 22.4×28.3 (57×72 cm) sg d 1755

BOUDIN Louis-Eugène
*Honfleur 1824 – Paris 1898*
The Entrance to the Harbour of Trouville *
pn 12.6×16.1 (32×41 cm) sg d ...88
"A Squall from the West"
cv 13.8×22.8 (35×58 cm) ins
The Harbour of Deauville
pn 11.4×16.1 (29×41 cm) sg
The Beach at Tourgéville-les-Sablons, looking towards Trouville
cv 19.7×29.1 (50×74 cm) sg d ...93
"Scène de plage, Trouville" 6309
pn 8.3×18.1 (21×46 cm) sg
"Scène de plage, Trouville" 6310
pn 7.1×18.1 (18×46 cm)
"La plage de Trouville" 6312
pn 11.8×5.9 (30×15 cm) sg d 1873
"Village au bord d'une rivière"
pn 7.9×15.4 (20×39 cm) sg
"Laveuses au bord de l'eau"
pn 7.1×9.1 (18×23 cm) sg

BOURDON Sébastien
*Montpellier 1616 – Paris 1671*
The Return of the Ark
cv 42.5×52.8 (108×134 cm)

Style of BOUTS Aelbrecht
*Louvain 1460 – 1549*
Christ crowned with Thorns *
pn/cv 16.9×14.6 (43×37 cm)

BOUTS Dieric
*Haarlem ... – Louvain 1475*
The Entombment *
cv 35.4×29.1 (90×74 cm)

The Virgin and Child with S.
Peter and S. Paul
pn 26.8×20.1 (68×51 cm)
Portrait of a Man → no 69
pn 12.2×7.9 (31×20 cm)
d 1462
The Virgin and Child 2595 *
pn 14.6×10.6 (37×27 cm)
"Mater dolorosa"
Christ crowned with Thorns
panels 14.2×10.6 (36×27 cm)
st

**Follower of BOUTS Dieric**
The Virgin and Child 708
pn 7.9×5.5 (20×14 cm)

**BRAIJ Jan de**
*Haarlem 1626-7 (?) –1697*
Portrait of a Woman with a
black Cap
pn 26.0×19.7 (66×50 cm)
sg d 1657 ins

**BRAMANTINO
(Bartolomeo Suardi)**
*act 1465-1530 Milan and Rome*
The Adoration of the Kings
pn 22.4×21.6 (57×55 cm)

**BREENBERGH Bartholomeus**
*Deventer 1599-1600 –
Amsterdam 1657*
The Finding of the Infant Moses
by Pharaoh's Daughter
pn 16.1×22.0 (41×56 cm)
sg d 1636

**BREKELENKAM Quiringh van**
*Leyden c 1620 – 1667-8*
An Interior with a Man and a
Woman seated by a Fire
pn 20.1×27.6 (51×70 cm)
sg d 1653 ins
Interior of a Tailor's Shop
pn 16.5×19.7 (42×50 cm)
A Woman asleep by a Fire, an
open Bible (?) in her Lap
pn 16.9×12.6 (43×32 cm)

**BRESCIAN SCHOOL**
*Sixteenth Century*
"The Garden of Love"
cv 86.6×58.7 (220×149 cm)
Madonna and Child
pn 30.3×40.6 (77×103 cm)

**BRESCIANINO Andrea** and/or
**Raffaello**
*act c 1506-24 and 1506-45
Siena and Florence*
Madonna and Child with SS.
Paul and Catherine of Siena
and the Infant Baptist
pn 28.3×20.9 (72×53 cm)

**BRITISH SCHOOL**
*Nineteenth Century*
Portrait of a Man
Portrait of a Lady
panels 11.8×9.8 (30×25 cm)

**BRONZINO
(Agnolo di Cosimo)**
*Florence 1503 – 1572*
An Allegory → no 32
pn 57.5×45.7 (146×116 cm)
Portrait of Piero de' Medici,
"The Gouty"
pn 22.8×17.7 (58×45 cm)
Holy Family
pn 39.8×31.9 (101×81 cm)
Portrait of Cosimo I de' Medici,
Grand-Duke of Tuscany
pn 8.3×6.7 (21×17 cm) st

**Follower of BRONZINO**
Portrait of a Lady
pn 22.8×18.9 (58×48 cm)
repainted

**Style of BROUWER Adriaen**
*Oudenaerde 1605-6 –
Antwerp 1638*
Four Boors drinking
pn 11.0×8.7 (28×22 cm)

**BROWN John Lewis**
*Bordeaux 1829 – Paris 1890*
A Performing Dog
cv 14.2×17.3 (36×44 cm)

**BRUEGEL THE ELDER Pieter
(Peasant B. or B. the Droll)**
*act 1551-69 Antwerp and
Brussels*
The Adoration of the Kings →
no 74
pn 43.7×32.7 (111×83 cm)
sg d 1563

**BRUEGHEL THE ELDER Jan**
*Brussels 1568 – Antwerp 1625*
The Adoration of the Kings
crt 13.0×18.9 (33×48 cm)
sg d 1598
see also Balen, Steenwyck the
Younger

**Bruges Master of 1500** see
**MASTER OF BRUGES
PASSION SCENES**

**BRUGGHEN Hendrick ter**
*... 1588 (?) – Utrecht 1629*
Jacob reproaching Laban for
giving him Leah in place of
Rachel (?)
cv 38.2×44.9 (97×114 cm)
sg d 1627
The Singing Luteplayer
cv 39.4×31.1 (100×79 cm)

**BRUSSEL Paulus
Theodorus van**
*Zuid Polsbroek 1754 –
Amsterdam 1795*
Flowers in a Vase 3225
pn 31.9×23.2 (81×59 cm)
sg d 1792
Flowers in a Vase 5174
pn 30.7×24.0 (78×61 cm)
sg d 1789
Fruit and Flowers
pn 30.7×24.0 (78×61 cm)
sg d 1789

**BRUYN THE ELDER
Bartholomeus**
*Wesel or Cologne 1492-3 –
Cologne 1555*
A Man of the Strauss (?) Family
pn 14.2×9.4 (36×24 cm) ins
The Virgin, S. John, S. Mary
Magdalen and a holy Wom-
an *
pn of a dip (?) 26.8×18.9
(68×48 cm)

**Buonarroti** → see
**MICHELANGELO**

**BUONCONSIGLIO Giovanni
(Il Marescalco)**
*Vicenza c 1470 (?) –
Venice 1535-7*
S. John the Baptist
pn 18.5×16.5 (47×42 cm) ins

**BUSATI Andrea**
*act 1503-1528-9 (?) Venice*
The Entombment
pn 43.7×35.8 (111×91 cm) sg

**BUTINONE Bernardino**
*act 1484-1507 Lombardy*
The Adoration of the Shepherds
pn 9.4×8.3 (24×21 cm) attr

**BUYTEWEGH THE YOUNGER
Willem**
*Rotterdam 1625 – 1670*
A Dune Landscape
pn 9.8×13.4 (25×34 cm) sg

**CALAME Alexandre**
*Vevey 1810 – Menton 1864*
The Lake of Thun
cv 23.2×30.7 (59×78 cm)
sg d 1854

**CALRAET Abraham van**
*Dordrecht 1642 – 1722*
A brown and white skewbald
Horse with a Saddle beside it
pn 13.4×17.3 (34×44 cm) sg
The Interior of a Stable
pn 15.4×22.4 (39×57 cm) sg
A Scene on the Ice outside Dor-
drecht
pn 13.0×22.4 (33×57 cm) sg

**CAMPI Giulio**
*Cremona c 1502 – 1572*
A Musician
pn 26.4×21.6 (67×55 cm) attr

**CAMPIN Robert
(Master of Mérode or of
Flémalle [?])**
*... 1378-9 – ... 1444; act Tournai*
The Virgin and Child before a
Fire-screen → no 63
pn 24.8×19.3 (63×49 cm)
A Man holding a Scroll *
pn 9.1×5.9 (23×15 cm)
A Man
A Woman
panels 15.7×10.6 (40×27 cm)
attr
The Virgin and Child with two
Angels
pn 22.0×17.3 (56×44 cm)
copy (?)

**Imitator of CAMPIN**
The Death of the Virgin
pn 15.0×13.8 (38×35 cm)

**CANALETTO
(Giovanni Antonio Canal)**
*Venice 1697 – 1768*
Venice: Campo S. Vidal and S.
Maria della Carità ("The
Stonemason's Yard") → no 58
cv 48.8×64.2 (124×163 cm)
Venice: upper Reaches of the
Grand Canal with S. Simeone
Piccolo
cv 48.8×80.3 (124×204 cm)
Venice: the Feast Day of S.
Roch → no 59
cv 57.9×78.3 (147×199 cm)
Venice: a Regatta on the Grand
Canal 938
cv 46.1×73.2 (117×186 cm)
Venice: a Regatta on the Grand
Canal 4454 *
cv 48.0×72.0 (122×183 cm)
Eton College
cv 24.0×42.5 (61×108 cm)
London: Interior of the Rotunda
at Ranelagh *
cv 18.5×29.5 (47×75 cm);
on rv sg d
Venice: Piazza S. Marco
cv 18.1×15.0 (46×38 cm)
Venice: Piazza S. Marco and
the Colonnade of the Procu-
ratie Nuove
cv 18.1×15.0 (46×38 cm)
Venice: the Basin of S. Marco
on the Ascension Day
cv 47.6×72.0 (121×183 cm)
Venice: the Piazzetta from the
Molo
cv 39.4×42.1 (100×107 cm) st
Venice: the Doges Palace and
the Riva degli Schiavoni
cv 24.0×39.4 (61×100 cm) st
Venice: Palazzo Grimani
cv 11.8×15.4 (30×39 cm) st
Venice: Entrance to the Canna-
regio
cv 18.5×29.9 (47×76 cm) st
Venice: S. Pietro in Castello
cv 18.1×30.3 (46×77 cm) st

**Follower of CANALETTO**
Venice: S. Simeone Piccolo
cv 15.0×18.5 (38×47 cm)
Venice: upper Reaches of the
Grand Canal facing S. Croce
1885
cv 15.0×18.1 (38×46 cm)
Venice: upper Reaches of the
Grand Canal facing S. Croce
2514
cv 23.2×36.2 (59×92 cm)

**CAPPELLE Jan van de**
*Amsterdam 1623-5 – 1679*
A small Vessel in light Airs,
and another ashore
cv 13.8×18.9 (35×48 cm) sg
Vessels in light Airs on a River
near a Town
cv 14.6×18.9 (37×48 cm)
A Dutch Yacht firing a Salute as
a Barge pulls away, and many
small Vessels at Anchor
→ no 97
pn 33.5×44.9 (85×114 cm)
sg d 1650
A River Scene with a Dutch
Yacht firing a Salute as two
Barges pull away
cv 36.6×12.2 (93×31 cm)
sg d 1665 (?)
A River Scene with a large Fer-
ry and numerous Dutch Ves-
sels at Anchor
cv 48.0×60.6 (122×154 cm) sg
A Coast Scene with a small
Dutch Vessel landing Passen-
gers
pn 23.2×31.1 (59×79 cm)
A small Dutch Vessel, before a
light Breeze *
cv 17.3×21.6 (44×55 cm)
A River Scene with many Dutch
Vessels becalmed
cv 44.1×60.2 (112×153 cm) sg
Vessels moored off a Jetty
pn 13.8×16.5 (35×42 cm)

**CARAVAGGIO
(Michelangelo Merisi da)**
*Caravaggio 1573 –
Port'Ercole 1610*
The Supper at Emmaus → no 50
cv 55.5×77.2 (141×196 cm)
Salome receives the Head of S.
John the Baptist
cv 35.8×41.7 (91×106 cm)
attr

**CARIANI
(Giovanni Busi)**
*Venice 1485 – c 1547*
A Member of the Albani Family
cv 41.7×31.5 (106×80 cm)
Madonna and Child with Saints
cv 33.5×46.5 (85×118 cm)
repainted
Death of S. Peter Martyr
cv 39.8×57.1 (101×145 cm)
attr
Madonna and Child ("La Vierge
aux lauriers")
pn/cv 35.4×28.3 (90×72 cm)
attr

**CARMONTELLE
(Louis Carrogis)**
*Paris 1717 – 1806*
Mozart with his Father and Sis-
ter
wat 12.6×7.9 (32×20 cm)
d 1777 ins

**CARPACCIO Vittore**
*Venice 1455 – 1525-6*
S. Ursula taking leave of her
Father (?)
pn 29.5×34.6 (75×88 cm)
The Adoration of the Kings
cv 43.3×82.3 (110×209 cm)
attr

**CARRACCI Agostino**
*Bologna 1557 – Parma 1602*
Cephalus carried off by Aurora
in her chariot
pastel 79.9×157.0
(203×399 cm)
possibly in collaboration with
Annibale Carracci
A Woman borne off by a sea
god (?) *
pastel 79.9×161.4
(203×410 cm)
possibly in collaboration with
Annibale Carracci

**CARRACCI Annibale**
*Bologna 1560 – Rome 1609*
Christ appearing to S. Peter on
the Appian Way ("Domine,
quo vadis?") *
pn 30.3×22.0 (77×56 cm);
on rv ins
Silenus gathering Grapes
two fragments: panels
21.3×27.2 and 14.2×7.5
(54×69 cm and 36×19 cm)
Marsyas (?) and Olympus
pn 13.8×33.1 (35×84 cm)
Christ appearing to S. Anthony
Abbot during his Temptation *
copper 19.3×13.4 (49×34 cm)
The dead Christ mourned (The
three Maries) → no 52
cv 36.6×40.6 (93×103 cm)
see also Carracci Agostino

**Circle of CARRACCI Annibale**
S. John the Baptist seated in
the Wilderness
cv 52.4×37.8 (133×96 cm)
Erminia takes Refuge with the
Shepherds
cv 57.9×84.3 (147×214 cm)
Landscape with a hunting Party
cv 37.8×53.1 (96×135 cm)

**Style of CARRACCI Annibale**
Landscape with a River and
Boats
cv 37.4×52.0 (95×132 cm)

**CARRACCI Antonio**
*Venice (?) 1589 (?) – Rome 1618*
The Martyrdom of S. Stephen
cv 25.2×19.7 (64×50 cm) attr
formerly attr to Domenichino

**CARRACCI Ludovico**
*Bologna 1555 – 1619*
Susannah and the Elders *
cv 57.5×45.7 (146×116 cm)
sg d 1616
see also Badalocchio

**CARRIERA Rosalba**
*Venice 1675 – 1757*
Portrait of a Man *
pastel 22.8×18.5 (58×47 cm)
Rosalba Carriera
cv 22.8×15.4 (58×39 cm) copy

**CASTAGNO Andrea del**
*San Martino a Corella 1423 (?) –
Florence 1457*
The Crucifixion
pred pn 11.0×13.8 (28×35 cm)
attr

**CATENA Vincenzo**
*Venice 1470 – 1531*
A Warrior adoring the Infant
Christ and the Virgin
cv 61.0×103.5 (155×263 cm)
S. Jerome in his Study
cv 29.5×38.6 (75×98 cm)
Portrait of a young Man
pn 11.8×9.1 (30×23 cm)
Portrait of the Doge Andrea
Gritti
cv 38.2×31.1 (97×79 cm)
Madonna and Child with S.
John
pn 28.3×22.4 (72×57 cm) attr

**CAVALLINO Bernardo**
*Naples 1616 – 1654-6*
Christ driving the Traders from
the Temple *
cv 39.8×50.4 (101×128 cm)
see also Gargiulo

**Cavazzola** see **MORANDO**

**CERUTI Giacomo**
*First half of the Eighteenth
Century, Northern Italy*
Portrait of a Priest
cv 39.0×30.7 (99×78 cm) attr

**CESARE DA SESTO**
*Sesto Calende c 1477 –
Milan 1523*
Salome
pn 53.1×31.5 (135×80 cm) st

**CÉZANNE Paul**
*Aix-en-Provence 1839 – 1906*
Self-Portrait *
cv 13.4×10.2 (34×26 cm)
c 1880
Montagnes en Provence
cv 24.8×31.1 (63×79 cm)
"La vieille au chapelet"
→ no 131
pn 31.9×25.6 (81×65 cm)
Dans le parc du Château Noir
cv 35.8×28.0 (91×71 cm)
Les grandes baigneuses
→ no 132
cv 50.0×77.2 (127×196 cm)
c 1904
Portrait of the Painter's Father *
frs/cv 65.7×44.9 (167×114 cm)

**CHAMPAIGNE Philippe de**
*Brussels 1602 – Paris 1674*
Triple Portrait of Richelieu
→ no 119
cv 22.8×28.3 (58×72 cm) ins
Richelieu *
cv 102.0×70.1 (259×178 cm) sg
The Vision of S. Joseph
cv 81.9×61.0 (208×155 cm)
Cardinal de Retz
cv 28.0×22.4 (71×57 cm)
ins attr

**CHARDIN
Jean-Baptiste-Siméon**
*Paris 1699 – 1779*
"La fontaine" *
cv 14.6×17.3 (37×44 cm)
The young Schoolmistress
cv 24.0×26.0 (61×66 cm) sg
The House of Cards → no 122
cv 23.6×28.3 (60×72 cm) sg

**Imitator of CHARDIN**
Still Life
cv 15.0×17.7 (38×45 cm)
false sg and d 1754

**CHARLET Nicolas-Toussaint**
*Paris 1792 – 1845*
Children at a Church Door
cv 9.4×13.0 (24×33 cm)

**CHINTREUIL Antoine**
*Pont-de-Vaux 1814 –
Septeuil 1873*
Landscape
crt/cv 15.7×12.2 (40×31 cm)
sg

**CHRISTUS or CRISTUS
Petrus**
*Baerle ... – Bruges 1472-3*
Portrait of a young Man *
l wing of a trp (?);
pn 13.8×10.2 (35×26 cm) ins

**CIMA DA CONEGLIANO
Giovanni Battista**
*Conegliano c 1459 –
Venice c 1518*
The Virgin and Child 300 *
pn 27.2×22.4 (69×57 cm) sg
The Virgin and Child 2506
pn 25.6×20.5 (65×52 cm) sg

91

The Virgin and Child with a Goldfinch 634
pn 20.9×16.9 (53×43 cm) sg
The Incredulity of S. Thomas altarpiece; ar pn 115.7×78.3 (294×199 cm)
sg d 1504 ins
S. Jerome in a Landscape
pn 12.6×9.8 (32×25 cm)
Christ crowned with Thorns *
pn 14.6×11.4 (37×29 cm)
David and Jonathan
pn 15.7×15.4 (40×39 cm)
A Male Saint; S. Sebastian panels of an altarpiece
40.6×16.1 (103×41 cm)
The Virgin and Child with SS. John the Evangelist (?) and Nicholas
cv 20.1×27.6 (51×70 cm) attr
The Virgin and Child with SS. Paul and Francis (?)
pn 19.3×34.3 (49×87 cm) copy

**Style of CIPPER Giacomo**
*first half of the Eighteenth Century, Lombardy*
Head of a Man in blue
cv 18.5×14.2 (47×36 cm)
Head of a Man in red
cv 18.1×14.2 (46×36 cm)

**CLAESZ. Pieter**
*Burgsteinfurt 1596-7 – Haarlem 1661*
Still Life with drinking Vessels *
pn 24.8×20.5 (63×52 cm)
sg d 1649
Still Life
cv 33.9×39.8 (86×101 cm) attr

Claude see LORRAIN

**CLAYS Paul Jean**
*Bruges 1819 – Brussels 1900*
Ships lying off Flushing
pn 23.6×34.3 (60×87 cm)
sg d 1869
Ships lying near Dordrecht
cv 25.9×43.3 (75×110 cm)
sg d 1870

Cleve see MASTER OF THE DEATH OF THE VIRGIN

**CLOVIO Giorgio Giulio**
*Grizane 1498 – Rome 1578*
A Jesse Tree
crt 8.3×5.9 (21×15 cm)

**CODDE Pieter**
*Amsterdam 1599 – 1678*
Portrait of a Man, a Woman and a Boy in a Room
pn 18.9×25.6 (48×65 cm)
sg d 1640
A seated Woman holding a Mirror (?) *
pn 15.0×13.0 (38×33 cm)
sg d 1625

**COECKE VAN AELST Pieter**
*Aelst 1502 – Brussels 1550*
The Virgin and Child enthroned (r wing S. Louis [?], on rv S. Anthony of Padua; l wing A Bishop Saint, on rv S. James the Greater)
trp; panels; centr pn 10.2×7.1 (26×18 cm); wings 10.6×c 3.2 (c 27×c 8 cm); centr pn ins; attr st

**COLOGNE SCHOOL**
*Fifteenth Century*
Portrait of a Woman *
pn 15.0×11.0 (38×28 cm)

**CONINCK David de**
*Antwerp 1643-5 – Brussels c 1699*
A Still Life of dead Birds and Game with Gun Dogs and a little Owl
cv 37.8×52.4 (96×133 cm)
formerly attr to Peter Boel (Antwerp 1554 - Rome 1626)

**CONSTABLE John**
*East Bergholt 1776 – London 1837*
The Cornfield *
cv 56.3×48.0 (143×122 cm)
sg d 1826
The Hay-Wain → no 118
cv 51.2×72.8 (130×185 cm)
sg d 1821
The Cenotaph to Reynolds' Memory
cv 20.0×42.5 (132×108 cm)
addition to upper part
Salisbury Cathedral and Archdeacon Fisher's House, from the River *

sketch; cv 20.5×30.3 (52×77 cm)
Weymouth Bay → no 117
cv 20.9×29.5 (53×75 cm)
unfinished

**COQUES Gonzales**
*Antwerp 1614 (?) – 1684*
A Family Group *
cv 25.2×33.5 (64×85 cm)
Portrait of a Lady
silver 7.1×5.5 (18×14 cm)
Sight
Hearing
Touch
Smell
Taste
panels 9.8×7.5 (25×19 cm); the last is a copy
Portrait of a Man
copper; oval 6.3×4.7 (16×12 cm)

**Imitator of COQUES**
Portrait of a young Lady in black
pn 7.9×6.3 (20×16 cm)

**Style of CORNEILLE DE LYON**
*The Hague ... – Lyons 1574*
Portrait of a Man 2610
pn 7.5×5.9 (19×15 cm)
Portrait of a Man 2611
pn 6.3×5.1 (16×13 cm)
Portrait of a Man 6415
pn 6.3×5.5 (16×14 cm)
Portrait of a Lady
pn 7.9×6.3 (20×16 cm)

**CORNELIS VAN HAARLEM**
*Haarlem 1562– 1638*
Two Followers of Cadmus devoured by a Dragon
pn/cv 58.3×76.8 (148×195 cm) copy

**COROT Jean-Baptiste-Camille**
*Paris 1796 – 1875*
The Marsh of Arleux
cv 11.0×22.4 (28×57 cm)
The leaning Tree-Trunk ("L'arbre penché")
cv 19.7×24.0 (50×61 cm)
sg 1855-c 1860
The Wood (?) Gatherer
cv 18.5×25.2 (47×64 cm) sg
Evening on the Lake
cv 9.8×14.2 (25×36 cm) sg
A Wagon in the Plains of Artois
cv 10.6×13.8 (27×35 cm) sg
"A Flood"
cv 21.3×25.6 (54×65 cm)
sg (?) unfinished (?)
Cows standing in a Marsh
cv 9.7×13.8 (24×35 cm)
sg 1860-c 1870
"Souvenir d'un voyage à Coubron"
cv 12.6×18.1 (32×46 cm)
sg 1873
Avignon from the West → no 127
cv 13.4×28.7 (34×73 cm) sg
"Summer Morning"
pn 9.1×13.4 (23×34 cm) sg
The Roman Campagna, with the Claudian Aqueduct
cv 8.3×13.0 (21×33 cm)
sg c 1826-8
A Horseman (M. Pivot) in a Wood
cv 15.4×11.8 (39×30 cm) sg
The Seine near Rouen (?)
cv 7.9×13.4 (20×34 cm)
Sketch of a Woman in bridal (?) Dress
cv 14.2×10.2 (36×26 cm)
ins c 1860-70
"Dardagny: un chemin dans la campagne, le matin" *
cv 10.2×18.5 (26×47 cm)
La charrette, souvenir de Saintry
cv 18.5×22.4 (47×57 cm)
sg d 1874
An Italian (?) Peasant Woman
cv 12.6×11.4 (32×29 cm)
sg (?) attr

**CORREGGIO (Antonio Allegri)**
*Correggio 1489 – 1534*
Mercury instructing Cupid before Venus ("The School of Love") *
cv 61.0×35.8 (155×91 cm)
"Ecce Homo" → no 29
pn 39.0×31.5 (99×80 cm)
The Madonna of the Basket → no 30
pn 13.0×9.8 (33×25 cm)
The Magdalen
cv 15.0×11.8 (38×30 cm)

Christ taking Leave of His Mother
cv 34.3×30.3 (87×77 cm)
Head of an Angel 4076
frs 14.6×20.9 (37×53 cm)
Heads of two Angels
frm; frs 17.3×24.0 (44×61 cm)
Group of Heads 7 and 37
canvases 53.9×c 41.7 (137×c 106 cm) copies
The Agony in the Garden
pn 15.0×16.5 (38×42 cm) copy
"Ecce Homo"
cv 39.4×30.7 (100×78 cm) copy

**COSSA Francesco del**
*Ferrara 1435 (?) – Bologna 1477*
S. Vincent Ferreri (?) → no 36
centr pn of an altarpiece;
ar pn 60.2×23.6 (153×60 cm)

**COSTA Lorenzo**
*Ferrara 1459-60 – Mantua 1535*
The Virgin and Child with SS. Peter, Philip, John the Evangelist and John the Baptist polyptych; five panels/canvases; ar centr pn 65.7×28.3 (167×72 cm); the first and the fifth 21.6×22.4 (55×57 cm); the second and the fourth 43.3×22.4 (110×57 cm)
sg d 1505
Portrait of Battista Fiera
pn 20.1×15.0 (51×38 cm)
A Concert *
pn 37.4×29.5 (95×75 cm)
The Nativity
pn 20.5×14.6 (52×37 cm)
The Virgin and Child enthroned between (?) S. William of Aquitaine and S. John the Baptist (Strozzi Altarpiece) altarpiece; pn 97.2×64.2 (247×163 cm)
in collaboration (?) with Gian Francesco de' Maineri (act 1484-1506, Parma)

**Follower of COSTA**
The Story of Moses 3103 and 3104 (The Israelits gathering Manna; The Dance of Miriam)
canvases 46.5×30.7 (118×78 cm)

**COURBET Jean-Désiré-Gustave**
*Ornans 1819 – Vevey 1877*
The Sea near Palavas
cv 16.9×23.6 (43×60 cm) sg
Self-Portrait ("L'homme à la ceinture de cuir") *
crt 17.7×15.0 (45×38 cm) sg
In the Forest
cv 31.5×39.0 (80×99 cm) sg
"La diligence dans la neige"
cv 53.9×78.7 (137×200 cm)
sg d ...60
The Pool
cv 28.3×22.8 (72×58 cm) sg
Still Life: Apples and Pomegranate → no 126
cv 17.3×24.0 (44×61 cm)
sg d ...71
"Les demoiselles des bords de la Seine" → no 125
sketch: cv 37.8×51.2 (96×130 cm)
Landscape
cv 32.7×41.3 (83×105 cm)
sg(?) attr
Beach Scene
cv 14.6×21.3 (37×54 cm)
sg d 1874

**COUTURE Thomas**
*Senlis 1815 – Villers-le-Bel 1879*
Caught by the Tide
cv 25.2×31.9 (64×81 cm) attr

**CRANACH THE ELDER Lucas**
*Kronach 1472 – Weimar 1553*
Portrait of a Woman
pn 14.2×9.8 (36×25 cm) sg
Portrait of a Man *
pn 15.7×10.2 (40×26 cm) sg d 1524
Charity*
pn 22.0×14.2 (56×36 cm) ins
The Close of the Silver Age (?) *
pn 19.7×13.8 (50×35 cm)
Cupid complaining to Venus → no 79
pn 31.9×21.3 (81×54 cm)

Credi see LORENZO DI CREDI

**CRESPI Giuseppe Maria**
*Bologna 1665 – Rome 1747*
S. Jerome in the Desert*
cv 34.3×26.0 (87×66 cm)

Cristus see CHRISTUS

**CRIVELLI Carlo**
*Venice 1430-5 – 1495*
Pietà
pn of a polyptych
pn 28.3×21.6 (72×55 cm) false(?) sg
The Vision of the blessed Gabriele
pn 55.5×34.3 (141×87 cm) sg
The Virgin and Child with SS. Jerome and Sebastian** (The "Madonna della Rondine") (pred S. Catherine of Alexandria; S. Jerome; The Nativity; The Martyrdom of S. Sebastian; S. George and the Dragon) altarpiece; pn 59.1×42.1 (150×107 cm); pred panels 11.4×8.3, 13.0, 14.6 and 12.6 (29×21, 33, 37 and 32 cm); the last 11.0×8.3 (28×21 cm) sg
The Annunciation with S. Emidius → no 34
altarpiece; pn/cv 81.5×57.5 (207×146 cm) sg d 1486
"The Demidoff Altarpiece" (lower panels S. John the Baptist; S. Peter; The Virgin and Child; S. Catherine of Alexandria; S. Dominic; centr panels S. Francis; S. Andrew; S. Stephen; S. Thomas Aquinas; upper panels: S. Jerome; S. Michael; S. Lucy; S. Peter Martyr) panels; lower panels c 54.3×c 15.7 (c 138×c 40 cm), the third 58.3×15.7 (148×40 cm) sg d 1476; centr panels 24.0×c 15.7 (61×c 40 cm); upper panels c 35.8×c 10.2 (c 91×c 26 cm)
The Virgin and Child with SS. Francis and Sebastian altarpiece; pn 68.9×59.4 (175×151 cm) sq d 1491 ins
The Immaculate Conception
pn 76.4×36.6 (194×93 cm) sq d 1492 ins
S. Catherine of Alexandria
S. Mary Magdalen panels 15.0×7.5 (38×19 cm)
SS. Peter and Paul pn of an altarpiece 36.6×18.5 (93×47 cm) attr

**CUYP Aelbert**
*Dordrecht 1620 – 1691*
A hilly River Landscape with a Horseman talking to a Shepherdess
cv 53.1×79.1 (135×201 cm) sg
Portrait of a bearded Man*
pn 27.2×23.6 (69×60 cm) sg d 1649 ins
A Horseman with a Cowherd and two Boys in a Meadow, and seven Cows
cv c 31.5×c 41.7 (c 80×c 106 cm) sg
A Herdsman with five Cows by a River
pn 17.7×27.6 (45×70 cm) sg
Ubbergen Castle*
pn 12.6×21.3 (32×54 cm)
A distant View of Dordrecht with a Milkmaid and four Cows, and other Figures (The large Dort)
cv 61.8×77.6 (157×197 cm) sg
A distant View of Dordrecht, with sleeping Herdsman and five Cows (The small Dort)
pn 26.0×39.4 (66×100 cm) sg
Peasants with four Cows by the River Merwede → no 96
pn 15.0×19.7 (38×50 cm) sg
A River Scene with distant Windmills
pn 13.8×20.5 (35×52 cm) sg
A Boy holding a grey Horse
pn 14.2×12.6 (36×32 cm) false sg attr
The Maas at Dordrecht in a Storm
pn 19.7×29.1 (50×74 cm) sg

**Imitator of CUYP**
A Herdsman with seven Cows by a River
pn 24.0×35.8 (61×91 cm) false sg

**DAUBIGNY Charles-François**
*Paris 1817 – 1878*
Willows
cv 21.6×31.5 (55×80 cm) sg d 1874(?)

River Scene with Ducks
pn 7.9×15.7 (20×40 cm) sg d 1859
Alders
pn 13.0×22.4 (33×57 cm) sg d 1872
The Garden Wall
pn 7.5×14.2 (19×36 cm) sg
St. Paul's from the Surrey Side
cv 17.3×31.9 (44×81 cm) sg d 1873
Portrait of Honoré Daumier
cv 29.9×24.8 (76×63 cm) unfinished
View on the Oise, with Boat and Laundress
cv 15.4×26.0 (39×66 cm) sg d 1873
Landscape with Cattle by a Stream
cv 13.8×26.0 (35×66 cm) sg d 1872

**DAUMIER Honoré-Victorin**
*Marseilles 1808 – Valmondois 1879*
Don Quixote and Sancho Panza
sketch; pn 15.7×25.2 (40×64 cm)

**DAVID Gerard**
*Oudewater 1450-60 – Bruges 1523*
An Ecclesiastic praying*
r wing of a dip(?);
pn 13.4×10.2 (34×26 cm)
Canon Bernardinus de Salviatis and three Saints
l wing of an altarpiece;
pn 40.6×37.0 (103×94 cm)
The Deposition
pn 24.8×24.4 (63×62 cm)
The Adoration of the Kings → no 70
pn 23.2×22.8 (59×58 cm)
The Virgin and Child with Saints and Donor*
pn 41.7×56.7 (106×144 cm) ins
Christ nailed to the Cross
pn 18.9×37.0 (48×94 cm)
S. Jerome in a Landscape
pn 13.8×9.1 (35×23 cm) st
The Virgin and Child polyptych; centr pn 12.6×8.3 (32×21 cm); side panels 15.7×4.7 (40×12 cm) ins st

**Follower of DAVID**
Wings of an Altarpiece (r wing S. Peter and a Male Donor, on rv S. Jerome grisaille, l wing S. Paul and a Female Donor, on rv S. Nicholas grisaille)
panels 31.9×10.2 (81×26 cm)

**DECKER Cornelis**
*act 1640-78 Haarlem*
A cottage among Trees on the Bank of a Stream
cv 25.6×30.3 (65×77 cm) sg d 1669

**DEGAS Hilaire-Germain-Edgar**
*Paris 1834 – 1917*
"Bains de mer; Petite fille peignée par sa bonne"
crt/cv 18.5×32.3 (47×82 cm) (3 pieces) sg c 1876-7
Princess Pauline de Metternich
cv 15.7×11.4 (40×29 cm) unfinished
"Petites filles Spartiates provoquant des garçons"*
cv 42.9×60.6 (109×154 cm) unfinished
La La at the Cirque Fernando, Paris → no 130
cv 46.1×30.3 (117×77 cm) sg
Elena Carafa
cv 27.6×21.3 (70×54 cm) unfinished(?)
Danseuses*
cv 28.3×28.7 (72×73 cm) sg unfinished(?)
Combing the Hair → no 129
cv 44.9×57.5 (114×146 cm) unfinished
"Après le bain: femme s'essuyant"
pastel 40.6×39.0 (103×99 cm)

**DELACROIX Ferdinand-Victor-Eugène**
*Charenton St. Maurice 1798 – Paris 1863*
Baron Schwiter → no 124
cv 85.8×56.3 (218×143 cm) sg
landscape partially by Paul Huet (Paris 1803 – 1869)

92

Abel Widmer
oval cv 23.2×18.9 (59×48 cm)
Ovid among the Scythians*
cv 34.6×51.2 (88×130 cm)
sg d 1859
An Allegory
cv 69.7×53.9 (177×137 cm)
false(?) sg and d 1855 attr
Victor Considérant
cv 11.0×8.7 (28×22 cm)
unfinished(?) attr

**DELEN Dirck van**
*Heusden 1604-5 –*
*Arnemuiden 1671*
An architectural Fantasy
pn 18.1×23.6 (46×60 cm)

**DELFT SCHOOL**
*1650-5(?)*
An Interior, with a Woman re-
fusing a Glass of Wine offer-
ed by a Man
cv 46.1×36.2 (117×92 cm)

**DE PREDIS or PREDA**
**Giacomo Ambrogio**
*Milan c 1455 – c 1508*
Francesco di Bartolomeo Ar-
chinto(?)
pn 20.9×15.0 (53×38 cm)
sg d 1494
Profile Portrait of a Lady*
pn 20.5×14.6 (52×37 cm)
see also Associate of Leo-
nardo

**DETROY Jean-François**
*Paris 1679 – Rome 1752*
Jason swearing eternal Affec-
tion to Medea
cv 22.0×20.5 (56×52 cm)
"Le jeu du pied de bœuf"
pn 13.4×10.6 (34×27 cm)
ins copy

**DIANA Benedetto**
*act 1482-1525 Venice*
"Salvator Mundi"
pn 29.9×23.2 (76×59 cm) sg

**DIAZ DE LA PEÑA**
**Narcisse-Virgilio**
*Bordeaux 1807 – Menton 1876*
"Sunny Days in the Forest"
cv 15.0×22.0 (38×56 cm) sg
The Storm*
pn 24.0×29.9 (61×76 cm)
sg d … 71
Common, with stormy Sunset
pn 14.6×21.3 (37×54 cm)
sg d … 50
Venus and two Cupids
cv/pn 13.0×8.3 (33×21 cm)
sg d … 47
Cows at a Pool
pn 9.4×13.8 (24×35 cm) attr

**DIEPRAEM Arent (?)**
*Rotterdam(?) 1622(?) – 1670(?)*
A Peasant seated smoking
pn 11.0×9.1 (28×23 cm) sg

**DIETRICH Christian**
**Wilhelm Ernst**
*Weimar 1712 – Dresden 1774*
The wandering Musicians *
pn 16.9×13.0 (43×33 cm)
sg d 1745

**DOLCI Carlo**
*Florence 1616 – 1686*
The Virgin and Child with Flow-
ers
oval cv 30.7×24.8 (78×63 cm)

**DOMENICHINO**
**(Domenico Zampieri)**
*Bologna 1581 – Naples 1641*
Landscape with Tobias laying
hold of the Fish
copper 17.7×13.0 (45×33 cm)
S. George killing the dragon
pn 20.5×24.4 (52×62 cm)
The Vision of S. Jerome
cv 20.1×15.4 (51×39 cm)
Apollo slaying Coronis
frs/pn 78.3×35.0 (199×89 cm)
in collaboration with st
assistants
The Judgment of Midas
frs/cv 105.1×88.2
(267×224 cm)
in collaboration with st
assistants
The Transformation of Cypa-
rissus
frm; frs/cv 47.2×34.6
(120×88 cm)
in collaboration with st
assistants

Apollo pursuing Daphne
frs/cv 122.8×74.4 (312×189 cm)
in collaboration with st
assistants
The Flaying of Marsyas
frs/cv 82.7×130.3 (210×331 cm)
in collaboration with st
assistants
Apollo and Neptune advising
Laomedon on the Building of
Troy
frs/cv 120.5×72.0 (306×183 cm)
in collaboration with st
assistants
Apollo killing the Cyclops*
frs/cv 124.4×74.8 (316×190 cm)
in collaboration with st
assistants
Mercury stealing the Herds of
Admetus guarded by Apollo
frs/cv 102.8×79.1 (261×201 cm)
in collaboration with st
assistants
see also Carracci Antonio

**DOMENICO VENEZIANO**
*act 1438-61 Florence*
*and Perugia*
Head of a beardless Saint 766*
and 767
fragments; frescoes
c 16.9×13.8 (c 43×35 cm)
The Virgin and Child En-
throned
frm; frs/cv 94.9×47.2
(241×120 cm) sg

**DONCK G.**
*act 1627-40 Amsterdam (?)*
Jan van Hensbeeck and his
Wife, Maria Koeck, with an
Infant (?)
pn 29.9×41.7 (76×106 cm) sg

**DOSSI Battista**
**(Giambattista Luteri)**
*Ferrara (?) … – 1548*
The Conversion of S. Paul
pn 22.8×26.8 (58×68 cm)

**DOSSI Dosso**
**(Giovanni Luteri)**
*Ferrara … – 1542*
A Man embracing a Woman
pn 20.9×29.5 (53×75 cm)
The Adoration of the Kings*
pn 33.1×42.1 (84×107 cm)
Pietà
pn 14.2×11.8 (36×30 cm)
A Bacchanal
cv 55.5×66.1 (141×168 cm)

**DOU Gerrit**
*Leyden 1613 – 1675*
A Man with a Pipe
oval pn 74.8×57.9
(190×147 cm) sg
A Poulterer's Shop*
pn 22.8×18.1 (58×46 cm) sg
Portrait of a young Woman in
a dark green Jacket and black
Veil
oval pn 57.1×46.1
(145×117 cm) sg
see also Rembrandt

**DROST Willem**
*act 1652-4 Rotterdam (?)*
Portrait of a young Woman with
her Hands folded on a Book
cv 26.0×22.8 (66×58 cm)
false sg and d
1666 attr

**DROUAIS François-Hubert**
*Paris 1727 – 1775*
Le comte de Vaudreuil
cv 88.6×63.4 (225×161 cm)
sg d 1758 ins

**DUBBELS Hendrick**
*Amsterdam 1621 (?) – 1676 (?)*
A Dutch Yacht and other Ves-
sels becalmed near the Shore
cv 18.9×18.9 (48×48 cm)

**DUBUFE Claude-Marie**
*Paris 1790 – 1864*
"The Surprise"
cv 25.6×21.3 (65×54 cm) sg

**DUCCIO DI BUONINSEGNA**
*act 1278-1319 Siena*
The Virgin and Child with
Saints*
trp; ar panels; centr pn
16.5×13.4 (42×34 cm) ins;
wings 16.5×6.3 (42×16 cm) ins
The Annunciation
Jesus opens the Eyes of a Man
born blind*

The Transfiguration → no 1
panels c 17.3× c 17.7
(c 44× c 45 cm)
possibly pred panels from the
"Maestà" (Siena, Museo del-
l'Opera del Duomo)
The Virgin and Child with four
Angels
pn 14.2×9.3 (36×23,5 cm)

**Follower of**
**DUCCIO DI BUONINSEGNA**
The Virgin and Child with six
Angels
frm; cusped pn 74.0×65.0
(188×165 cm)

Duchatel see under
**Flemish School**

**DUCREUX Joseph**
*Nancy 1735 – Paris 1802*
Portrait of a Man
cv 21.6×17.7 (55×45 cm) attr

**DUGHET Gaspard**
**(G. Poussin)**
*Rome 1615 – 1675*
Landscape: Abraham and Isaac
approach the Place of Sacri-
fice
cv 59.8×76.8 (152×195 cm)
Landscape: Storm
cv 53.5×72.8 (136×185 cm)
Landscape near Albano (?)
cv 18.9×26.0 (48×66 cm)
Storm: the Union of Dido and
Aeneas
cv 59.8×88.2 (152×224 cm)
Ariccia*
cv 19.3×26.0 (49×66 cm)
Tivoli (?)
cv 28.0×65.4 (71×166 cm)
Storm: Moses and the Angel (?)
cv 79.1×60.2 (201×153 cm)

**Style of DUGHET**
Landscape with Figures 2723
and 2724
canvases 67.3× c 96.1
(171× c 244 cm)

Dujardin see **JARDIN**

**DUPRÉ Jules-Louis**
*Nantes 1811 – Isle-Adam 1889*
Willows, with a Man fishing
cv 8.3×10.6 (21×27 cm) sg

**DÜRER Albrecht**
*Nuremberg 1471 – 1528*
The Painter's Father*
pn 20.1×15.4 (51×39 cm) sg
d 1497 attr

**Style of DÜRER**
The Virgin and Child ("The Ma-
donna with the Iris")
pn 58.7×46.1 (149×117 cm)
false sg and d 1508

**DUTCH SCHOOL**
*Seventeenth Century*
Portrait of a Lady with a Fan
pn 33.5×27.6 (85×70 cm) d
1647 ins
Portrait of a Man
pn 12.2×9.4 (31×24 cm)
c 1640-5
A Landscape with a View of
Dordrecht
cv 53.1×76.8 (135×195 cm)
sg (?) c 1650-5
Portrait of a seated Woman and
a Child in a Landscape
cv 36.2×26.8 (92×68 cm)
c 1640-5
Portrait of a young Man in black
cv 28.7×22.8 (73×58 cm)
c 1635-40

**DUYSTER Willem**
*Amsterdam (?) c 1599 - Amster-*
*dam 1635*
Soldiers fighting over Booty in
a Barn
pn 14.6×22.4 (37×57 cm) sg
A Man and a Woman playing
Trick-track, and three other
Men*
pn 16.1×26.4 (41×67 cm) sg

**DYCK Anthony van**
*Antwerp 1599 – London 1641*
The Emperor Theodosius is for-
bidden by S. Ambrosius to
enter Milan Cathedral
cv 58.7×44.5 (149×113 cm)

Cornelis van der Geest
pn 14.6×12.6 (37×32 cm)
Carlo and Ubaldo see Rinaldo
conquered by love for Armida
pn 22.4×16.1 (57×41 cm)
Equestrian portrait of Charles I
→ no 78
pn 144.5×115.0 (367×292 cm)
ins
Portrait of a Woman and Child
cv 51.6×41.7 (131×106 cm)
The Abbot Scaglia adoring the
Virgin and Child*
cv 42.1×47.2 (107×120 cm)
Portrait of William Fielding, 1st
Earl of Denbigh
cv 97.2×58.3 (247×148 cm)
Portrait of a Man*
cv 29.1×24.0 (74×61 cm)
ins attr
Portrait of a Lady
cv 29.1×24.0 (74×61 cm) attr
Portraits of three Men
cv 45.7×44.5 (116×113 cm)
copy (?)
Portrait of Robert Rick, 2nd Earl
of Warwick
cv 24.0×13.4 (61×34 cm) copy
see also Rubens

**Style of van DYCK**
The Horses of Achilles
cv 41.7×36.2 (106×92 cm) ins
Portrait of a Woman
copper, oval 23.6×18.5
(60×47 cm)
Portraits of two young English-
men
cv 86.6×50.4 (220×128 cm)

**DYCKMANS Joseph Laurens**
*Antwerp 1811 – 1888*
The blind Beggar
pn 19.7×18.1 (50×46 cm)
sg d 1853 ins

**EECKHOUT Gerbrand van der**
*Amsterdam 1621 – 1674*
Four Officers of the Amsterdam
Coopers' and Wine-Rackers'
Guild*
cv 64.2×77.6 (163×197 cm) sg
d 1657

**ELSHEIMER Adam**
*Frankfort 1578 – Rome 1610*
S. Lawrence prepared for Mar-
tyrdom
copper 10.2×7.9 (26×20 cm)
ins
Tobias and the Archangel
Raphael with the Fish
copper 7.5×10.6 (19×27 cm)
S. Paul on Malta
copper 6.7×8.3 (17×21 cm)
The Baptism of Christ
copper 11.0×8.3 (28×21 cm)

**EMILIAN (?) SCHOOL**
*Seventeenth Century*
Portrait of a Painter
cv 25.2×20.1 (64×51 cm) attr
formerly attr to Benedetto
Gennari (Cento 1663 – Bolo-
gna 1715)
A Mathematician (?)
cv 44.5×32.7 (113×83 cm)
ins attr
formerly attr to Domenico
Cresti called "Il Passignano"
(Florence 1560 – … 1636)

Empoli see under **Bilivert**

**EVERDINGEN Allart van**
*Alkmaar 1621 – Amsterdam 1675*
A rocky Landscape with a Saw-
Mill by a Torrent
pn 17.7×23.6 (45×60 cm)

**EVERDINGEN Cesar van**
*Alkmaar 1616-7 (?) – 1678*
Portrait of a Dutch Comman-
der (?)
cv 47.2×33.9 (120×86 cm)
false sg and d 1651 attr

**EYCK Jan van**
*Maaseyck (?) … – Bruges 1441*
The Marriage of Giovanni (?)
Arnolfini and Giovanna Ce-
nami (?) → no 64
pn 31.9×23.2 (81×59 cm) sg
d 1434
A Man in a Turban → no 66
pn 9.8×7.5 (25×19 cm) sg d
1433 ins
Portrait of a young Man → no 65
pn 13.0×7.5 (33×19 cm) sg d
1432 ins

**Follower of van EYCK**
Marco Barbarigo
pn 9.4×6.3 (24×16 cm) ins

**FABRITIUS Barent**
*Midden-Beemster 1624 –*
*Amsterdam 1673*
The Adoration of the Shepherds
cv 26.0×24.0 (66×61 cm) sg d
1667
The Naming of S. John the Bap-
tist*
cv 14.2×18.9 (36×48 cm)

**FABRITIUS Carel**
*Midden-Beemster 1622 – Delft*
*1654*
A View in Delft, with a musical
Instrument Seller's Stall*
cv 5.9×12.2 (15×31 cm) sg d
1652
A young Man in a Fur Cap and
a Cuirass → no 88
cv 27.6×24.0 (70×61 cm) sg d
1654
self-portrait (?)

**FANTIN-LATOUR**
**Ignace-Henri-Jean-Théodore**
*Grenoble 1836 – Buré 1904*
"The rosy Wealth of June" *
cv 27.6×24.0 (70×61 cm) sg
1886
Still Life
cv 18.1×18.5 (46×47 cm) sg
d … 61
Roses
cv 19.3×23.6 (49×60 cm) sg
d … 90

**FERRARESE SCHOOL**
*Fifteenth Century*
Mystic Figure of Christ
pn 20.1×13.0 (51×33 cm) attr

*Sixteenth Century*
The Conversion of S. Paul
pn 22.8×27.6 (58×70 cm)
The Virgin and Child with SS.
Dominic and Catherine of
Siena
pn 18.1×13.8 (46×35 cm)

**Style of FERRARI Defendente**
*act 1511-35 Piedmont*
S. Peter Martyr and Bishop
Saint
SS. Nicholas of Tolentino and
John the Baptist
panels of an altarpiece
29.9×20.5 (76×52 cm);
the second ins

**FERRARI Gaudenzio**
*act 1508-46 Lombardy and Pied-*
*mont*
Christ rising from the Tomb
pn 59.8×33.1 (152×84 cm)
The Annunciation
two panels 22.8×22.8
(58×58 cm) ins
S. Andrew (?)
pn 59.1×33.1 (150×84 cm)

**FIORENZO DI LORENZO**
*Perugia c 1440 (?) – 1522-5*
Part of an Altarpiece (centr pn
The Virgin and Child, SS.
Francis and Bernardino and
a donor; side panels S. Bar-
tholomew and S. John the
Baptist)
panels: centr pn 48.0×32.7
(122×83 cm); side panels
48.0×19.3 (122×49 cm);
the second ins
The Virgin and Child
pn 18.9×14.6 (48×37 cm) attr

**FLEMISH SCHOOL**
*Seventeenth Century*
Interior of an Art Gallery
pn 37.8×48.4 (96×123 cm)
Portrait of a Man 1700
cv 39.4×31.9 (100×81 cm)
Portrait of a Boy holding a Rose
cv 36.6×25.6 (93×65 cm)
formerly attr to François Du-
chatel (Brussels 1625 [?] –
1694 [?])
Portrait of a Man (Baron Waha
de Lintere?) 1895
cv 45.7×33.9 (116×86 cm) d
1626 ins
Portrait of a Man in black 5631
cv 53.5×40.2 (136×102 cm) d
1636 ins attr
Portrait of a Woman
cv 27.6×24.0 (70×61 cm) attr
The Raising of Lazarus
cv 42.9×63.0 (109×160 cm) attr

**FLINCK Govert**
*Cleves 1615 – Amsterdam 1660*
Portrait of Rembrandt aged about 33
pn 25.6×21.3 (65×54 cm) sg d 1639

**FLORENTINE SCHOOL**
*Fifteenth Century*
Portrait of a Lady in red
pn 16.5×11.4 (42×29 cm)
The Combat of Love and Chastity
pn 16.9×13.8 (43×35 cm)
The Virgin and Child, S. John and an Angel
pn; td 27.2 (69 cm)
The Holy Family with Angels
pn; td 49.6 (126 cm) ins
The Virgin and Child with two Angels
pn 27.2×19.7 (69×50 cm) ins
Head of a Male Saint
frm; frs 16.5×13.0 (42×33 cm)
God the Father
frm of a frame (?); pn; td 3.9 (10 cm)
Story of the Schoolmaster of Falerii
wedding-chest; panels; centr pn 15.0×50.4 (38×128 cm); side panels 15.4×18.9 (39×48 cm); upper pn c 13.4×59.8 (c 34×152 cm)
The dead Christ and the Virgin
wing of a dip; pn 22.8×15.0 (58×38 cm)
The Baptism of Christ
frm of an altarpiece (?); pn 12.2×8.3 (31×21 cm)
Tournament Scene see p 8
wedding-chest; panels; centr pn 15.0×51.2 (38×130 cm); side panels 14.6×17.7 (37×45 cm) ins
SS. Catherine and Bartholomew
wing of a dip; pn 32.7×20.1 (83×51 cm) ins
The Virgin and Child
pn 19.3×13.0 (49×33 cm)
Portrait of a young Man
pn 22.0×14.6 (56×37 cm) attr

*Sixteenth Century*
Portrait of a Lady 650*
cv 44.1×31.5 (112×80 cm)
Portrait of a Lady 21
pn 44.1×18.9 (59×48 cm) attr
A Knight of S. John
pn 38.2×29.9 (97×76 cm) attr
Portrait of a Boy*
pn 50.8×24.0 (129×61 cm) attr
A bearded Man
pn 24.8×19.7 (63×50 cm) attr
Portrait of Savonarola
pn 8.3×6.3 (21×16 cm) attr

**FONTAINEBLEAU SCHOOL**
*Sixteenth Century*
Cleopatra
pn; td 18.1 (46 cm)

**FOPPA Vincenzo**
*Brescia 1427-30 – 1515-6*
The Adoration of the Kings
→ no 35
altarpiece; pn 94.1×82.7 (239×210 cm)

**FORAIN Jean-Louis**
*Reims 1852 – Paris 1931*
"L'assistance judiciaire"
cv 24.0×28.7 (61×73 cm) sg

**FORTUNY Mariano**
*Reus 1838 – Rome 1874*
The Bull-Fighter's Salute
cv 24.0×19.7 (61×50 cm) sg

**FRAGONARD Jean-Honoré**
*Grasse 1732 – Paris 1806*
Interior Scene
sketch; cv 14.6×18.9 (37×48 cm) attr

**FRANCESCO DI ANTONIO**
*act c 1394-1433 Florence*
The Virgin and Child with six Angels and two Cherubim
pn 33.5×21.3 (85×54 cm) ins attr

**FRANCESCO DI GIORGIO MARTINI**
*Siena 1439 – 1502*
S. Dorothy and the Infant Christ
pn 13.0×7.9 (33×20 cm)

**FRANCHOIJS Peeter**
*Malines 1606 – 1654*
Portrait of Lucas Fayd'herbe (?)
cv 39.0×31.5 (99×80 cm)

**FRANCIA Francesco**
**(F. Raibolini)**
*Bologna c 1450 – 1517*
The Virgin and Child with S. Anne and other Saints* (lunette Pietà)
altarpiece; pn/cv 76.8×70.9 (195×180 cm) sg; lunette 37.0×72.4 (94×184 cm)
The Virgin and Child with two Saints
pn 30.7×24.4 (78×62 cm)
Bartolomeo Bianchini
pn 22.0×15.7 (56×40 cm) ins
Mourning over the dead Christ
frm of a pred (?); pn 11.8×13.4 (30×34 cm) attr
The Virgin and Child with an Angel
pn 22.8×17.3 (58×44 cm)
false (?) sg and d 1490 copy

**FRANCIABIGIO**
**(Francesco di Cristofano)**
*Florence c 1482-3 – 1525*
Portrait of a Knight of Rhodes
pn 23.6×17.7 (60×45 cm) ins

**FRENCH SCHOOL**
*Fourteenth Century (?)*
Richard II presented to the Virgin and Child by his patron Saints ("The Wilton Diptych")**
panels 18.1×11.4 (46×29 cm) c 1395 ins attr

*Fifteenth Century*
The Virgin
pn 13.8×10.2 (35×26 cm) imitation (?)

*Sixteenth Century*
Paul, Sire d'Andouins (?)
pn 12.2×9.1 (31×23 cm) d 1543
Portrait of a Lady 2617
pn 13.8×9.8 (35×25 cm)
Portrait of a Boy
pn (?)/cv 14.6×10.6 (37×27 cm) attr
Portrait of a Man 3539
pn 11.0×9.1 (28×23 cm) attr

*Sixteenth Century (?)*
Portrait of a Man 947
pn 15.4×11.0 (39×28 cm) attr
Portrait of a young Lady 3582
frm (?); pn 18.1×13.8 (46×35 cm) attr

*Seventeenth Century*
The Visitation
cv 44.9×85.8 (114×218 cm) attr

*Eighteenth Century*
Madame de Gléon (?)
pn 25.2×21.3 (64×54 cm)

*early Nineteenth Century*
Portrait of a Boy
cv 21.6×17.7 (55×45 cm)
An "Académie"
cv 31.5×25.6 (80×65 cm)
false sg and d 1805 attr

*Nineteenth Century*
A black Woman
cv 31.9×26.0 (81×66 cm) attr

**FROMENTIN Eugène**
*La Rochelle 1820 – Saint-Maurice 1876*
The Banks of the Nile
cv 21.3×31.1 (54×79 cm) sg d ... 74

**FUNGAI Bernardino**
*Siena 1460 – 1516*
The Virgin and Child with Cherubim
pn; td 46.9 (119 cm)

**FYT Jan**
*Antwerp 1611 – 1661*
Dead Birds in the Landscape
cv 16.5×22.4 (42×57 cm) sg
Still Life with Fruit and Game
cv 33.5×44.9 (85×114 cm) sg attr

**GADDI Agnolo**
*act 1369-96 Florence and Prato*
The Coronation of the Virgin
frm (?) of an altarpiece; ar pn 71.7×37.0 (182×94 cm) attr

**GAINSBOROUGH Thomas**
*Sudbury 1727 – London 1788*
The Watering-Place
cv 57.9×70.9 (147×180 cm)
Mrs. Siddons
cv 49.6×39.0 (126×99 cm) 1785
Dr. Ralph Schomberg
cv 91.7×60.2 (233×153 cm)
Gainsborough's Forest ("Cornard Wood")*
cv 48.0×61.0 (122×155 cm) 1748 (?)
The Painter's Daughters chasing a Butterfly
cv 44.5×40.6 (113×103 cm) unfinished c 1759
The Painter's Daughters teasing a Cat
cv 29.5×24.4 (75×62 cm) unfinished
John Plampin*
cv 19.7×23.6 (50×60 cm) c 1755
The Morning Walk → no 111
cv 92.9×70.5 (236×179 cm) c 1785
Mr. and Mrs. Andrews → no 112
cv 27.6×46.9 (70×119 cm)
Pomeranian Bitch and Puppy
cv 32.3×43.3 (82×110 cm)

Garbo see
**RAFFAELLINO DEL GARBO**

**GARGIULO Domenico**
*Naples 1612(?) – c 1675*
The Finding of Moses*
cv 35.8×51.6 (91×131 cm) attr formerly attr to Bernardo Cavallino

**GAROFALO**
**(Benvenuto Tisi)**
*Ferrara 1481(?) – 1559*
S. Augustine with the Holy Family and S. Catherine of Alexandria ("The Vision of S. Augustine")
pn 25.2×31.9 (64×81 cm)
The Holy Family with SS. John the Baptist, Elizabeth, Zacharias and (?) Francis
cv 23.6×18.9 (60×48 cm)
The Agony in the Garden*
pn/cv 19.3×15.0 (49×38 cm) attr
Madonna and Child, with SS. William of Aquitaine, Clare, Anthony of Padua and Francis
altarpiece; ar 94.1×81.9 (239×208 cm)
An Allegory of Love
cv 50.0×69.7 (127×177 cm)
A pagan Sacrifice
cv 50.4×68.9 (128×175 cm) d 1527
S. Catherine of Alexandria
pn 17.7×15.0 (45×38 cm)

Gaudenzio see **FERRARI**

**GAUGUIN Paul**
*Paris 1848 – Marquesas 1903*
Flower piece*
cv 25.2×29.1 (64×74 cm) sg d ... 96

**GEERTGEN TOT SINT JANS**
*Leyden (?) 1460-5 – Haarlem 1490-5*
The Nativity, at Night
pn 13.4×9.8 (34×25 cm) attr

Gellée see
**LORRAIN Claude**

Gennari see under
**Emilian School**

**GÉRICAULT**
**Jean-Louis-André-Théodore**
*Rouen 1791 – Paris 1824*
A Horse frightened by Lightning
cv 19.3×23.6 (49×60 cm)
Male nude (An "Académie")
cv 26.4×14.6 (67×37 cm) attr

**GERMAN SCHOOL**
*Fifteenth Century (?)*
Virgin and Child with an Angel in a Landscape
pn 9.4×6.7 (24×17 cm) attr

*Sixteenth Century*
Portrait of a Woman
pn 16.1×11.0 (41×28 cm)

*Seventeenth Century*
S. Christopher
copper 3.5×5.1 (9×13 cm) attr

**GEROLAMO DA CARPI**
*Ferrara c 1501 – 1556*
Cardinal Ippolito de' Medici conferring an Office on Monsignor Mario Braccio
pn 54.3×44.1 (138×112 cm) ins attr

**GEROLAMO DAI LIBRI**
*Verona 1474 – 1555(?)*
The Virgin and Child with S. Anne
centr pn of a trp; cv 62.2×37.0 (158×94 cm) sg ins

**GEROLAMO DA SANTACROCE**
*act 1516-56 (?) Venice*
A youthful Saint reading
A Saint with a Fortress and Banner
panels from an altarpiece; panels 46.5×18.5 (118×47 cm) attr

**GEROLAMO DA TREVISO**
*act 1524-44 Venetia and Bologna*
Madonna and Child with Angels, Saints and a Donor
altarpiece; pn 88.6×57.9 (225×147 cm) sg
The Adoration of the Kings
pn 56.7×49.2 (144×125 cm) attr copy by Baldassare Peruzzi

**GEROLAMO DA VICENZA**
*act 1488 Vicenza (?) and Venice*
The Death and Assumption of the Virgin
pn 13.0×8.7 (33×22 cm) sg d 1488

**GÉRÔME Jean-Léon**
*Vesoul 1824 – Paris 1904*
A Student of the École polytechnique
cv 19.7×16.9 (50×43 cm) sg

Ghent Justus of see
**JOOS VAN WASSENHOVE**

**GHEYN THE YOUNGER**
**Jacob de**
**(G. J. d. III)**
*Leyden or Amsterdam c 1596 – Utrecht 1641*
S. Paul seated reading
cv 47.6×38.2 (c 121×97 cm) copy

**GHIRLANDAIO Domenico**
**(D. Bigordi)**
*Florence c 1448 – 1494*
A Legend of SS. Justus and Clement of Volterra
pred pn 5.5×15.4 (14×39 cm)
Portrait of a Girl*
pn 17.3×11.4 (44×29 cm) st
The Virgin and Child
pn 35.0×22.6 (89×58 cm) st

**Follower of GHIRLANDAIO**
Portrait of a young Man in red
pn 15.4×10.6 (39×27 cm)
The Virgin and Child with S. John
ar pn 31.1×18.5 (79×47 cm)

**Style of GHIRLANDAIO**
Costanza Caetani
pn 22.4×14.6 (57×37 cm) ins

**GHIRLANDAIO Ridolfo**
**(R. Bigordi)**
*Florence 1483 – 1561*
The Procession to Calvary
pn/cv 65.4×63.8 (166×162 cm)
Portrait of a Man
pn 27.6×22.0 (70×56 cm)

**GIAMBONO (Michele Bono)**
*act 1420-62 Venice*
A Saint with a Book
pn from an altarpiece 15.0×11.0 (38×28 cm)

**GIAMPIETRINO**
**(Giovanni Pedrini [?])**
*act 1520-40 Lombardy*
Christ carrying the Cross
pn 23.2×18.5 (59×47 cm)
Salome
pn 26.8×22.4 (68×57 cm)

**GIANNICOLA DI PAOLO**
**(Smicca, Manni)**
*act 1484-1544 Perugia*
The Annunciation
pn 26.4×41.7 (67×106 cm) ins attr

**GIAQUINTO Corrado**
*Molfetta 1703 – Naples 1766*
Apotheosis of the Spanish (?) Monarchy (?)
cv 37.8×16.9 (96×43 cm)

**GIOLFINO Niccolò**
*Verona c 1476-7 – 1555*
Portraits of the Giusti Family of Verona (?)
two fragments from an altarpiece; canvases 22.0×30.7 (56×78 cm) attr

**GIORDANO Luca**
*Naples 1634 – 1705*
A Homage to Velázquez*
cv 80.7×71.7 (205×182 cm)
A Miracle of S. Anthony of Padua
cv 41.3×31.5 (105×80 cm) false ins
The Martyrdom of S. Januarius
cv 42.1×31.5 (107×80 cm) attr

**Style of GIORDANO**
The Toilet of Bathsheba
cv 19.7×24.8 (50×63 cm)

**GIORGIONE**
**(Giorgio da Castelfranco)**
*Castelfranco Veneto c 1477 – Venice 1510*
Adoration of the Magi → no 43
pn 11.4×31.9 (29×81 cm)
Sunset Landscape with S. Roch (?), S. George and S. Anthony*
cv 28.7×35.8 (73×91 cm)

**GIOTTO**
*Colle di Vespignano 1267 (?) – Florence 1337*
Pentecost
pn 17.7×17.3 (45×44 cm) attr

**GIOVANNI BATTISTA DA FAENZA**
**(Bertucci)**
*act 1495 (?)-1516 Faenza*
The Virgin and Child in Glory
centr pn from an altarpiece; ar pn 70.5×31.9 (179×81 cm)
The incredulity of S. Thomas
pn 40.6×65.4 (103×166 cm)

**GIOVANNI FRANCESCO DA RIMINI**
*act c 1441-70 Padua (?) and Bologna*
The Virgin and Child with two Angels
pn 25.2×18.5 (64×47 cm) sg d 1461

**GIOVANNI MARTINI DA UDINE**
*... c 1453 – ... 1535; act Udine*
The Virgin and Child with S. George, S. James the Greater and a Donor
altarpiece; pn 97.6×57.1 (248×145 cm) attr

**Giovanni d'Alemagna**
see under **Vivarini Antonio**

**GIOVANNI DA MILANO**
*act c 1346-69 (?) Florence and Rome*
The Almighty, the Virgin and Isaiah***
centr pn 25.2×9.8 (64×25 cm); side panels 22.4×9.8 (57×25 cm); the second ins

**Style of GIOVANNI DA MILANO**
Christ and the Virgin with Saints
pn 15.7×11.0 (40×28 cm)

**GIOVANNI DA ORIOLO**
*act 1439 – 80-8 Faenza*
Lionello d'Este
pn 21.3×15.4 (54×39 cm) sg ins

**GIOVANNI DEL PONTE**
**(G. di Marco)**
*Florence 1385 – 1437-42(?)*
The Ascension of S. John the Evangelist with Saints (centr pn, above: Descent into Hell; side pilasters: Three scenes from the life of S.J.t.B.; pinnacles: centre Trinity; l S. Gabriel; r The Virgin Annunciate)
trp; panels 65.4×98.4 (166×250 cm) pred 15.4×98.4 (39×250 cm) (including frames)

**GIOVANNI DI PAOLO**
*Siena 1403(?) – 1482*
SS. Fabian and Sebastian
  pn 33.1×21.3 (84×54 cm)
The Baptism of Christ
The Head of S. John the Baptist brought to Herod
The Birth of S. John the Baptist*
S. John the Baptist retiring to the Desert
  pred panels c 12.2×14.6
  (c 31×37 cm)

**GIOVENONE Gerolamo**
*act 1513-55 Vercelli*
The Virgin and Child with Saints and Donors*
  altarpiece; ar pn 81.1×48.4
  (206×123 cm)

**Girolamo** see **GEROLAMO**

**GIULIO ROMANO (G. Pippi)**
*Rome 1499(?) – Mantua 1546*
The Infancy of Jupiter
  pn 41.7×68.9 (106×175 cm) st
Vision of the Magdalen
  lunette; frs 65.0×91.7
  (165×233 cm)
  in collaboration with Giovan Francesco Penni
  (Florence [?] 1496 – 1528)

**GIUSTO DE' MENABUOI (G. Padovano)**
*act c 1363-87 or 1391 Padua*
The Coronation of the Virgin*
  (wings Nativity and Crucifixion; on rv Scenes from the life of the Virgin)
  trp; cusped panels; centr pn 17.3×8.3 (44×21 cm); wings 18.9×5.1 (48×13 cm)

**Follower of GOES Hugo van der**
*Gand (?) ... – ... 1482*
The Nativity, at Night
  pn 24.4×18.1 (62×46 cm)

**Gogh** see **VAN GOGH**

**GOSSAERT Jan (Mabuse)**
*act c 1503-33 Antwerp*
A Man with a Rosary
  r wing from a dip; pn 26.8×19.3 (68×49 cm)
Portrait of a Man
  pn 9.4×6.3 (24×16 cm)
An elderly Couple*
  parchment (?) 17.7×26.4
  (45×67 cm)
A little Girl (Jacqueline de Bourgogne?) → no 73
  pn 14.6×11.0 (37×28 cm) ins
The Adoration of the Kings*
  pn 69.7×63.4 (177×161 cm) sg ins
The Virgin and Child
  ar pn 11.8×9.1 (30×23 cm) ins copy

**Follower of GOSSAERT**
The Magdalen
  ar pn 8.7× 5.5 (22×14 cm)

**GOYA Y LUCIENTES Francisco José de**
*Fuendetodos 1746 – Bordeaux 1828*
A Picnic
  cv 16.1×10.2 (41×26 cm)
A Scene from "El hechizado por fuerza" *
  cv 16.5×12.2 (42×31 cm)
Doña Isabel Cobos de Porcel → no 107
  cv 32.3×21.3 (82×54 cm) 1806
Don Andrés del Peral → no 108
  pn 37.4×25.6 (95×65 cm)
The Duke of Wellington*
  pn 25.2×20.5 (64×52 cm) res in 1965

**GOYEN Jan van**
*Leyden 1596 – The Hague 1656*
A view of Overschie
  pn 26.0×37.8 (66×96 cm) sg d 1645
A Scene on the Ice outside Dordrecht*
  cv 46.1×59.4 (117×151 cm) sg d 1642
A Windmill by a River → no 93
  pn 11.4×14.2 (29×36 cm) sg d 1642

A Scene on the Ice by a drinking Booth, a Village in the Distance
  pn 9.8×13.4 (25×34 cm) sg d 1645
A River Scene, with Fishermen laying a Net
  pn 12.2×9.8 (31×25 cm) sg d 1638
A River Scene, with a Hut on an Island
  pn 14.6×13.0 (37×33 cm) sg
A River Scene, with a Fisherman hauling a Net
  pn 14.6×13.0 (37×33 cm) sg
A Cottage on a Heath
  pn 15.4×23.6 (39×60 cm) false sg attr

**Imitator of van GOYEN**
Dutch River Vessels in a light Breeze
  pn 14.6×20.9 (37×53 cm) false sg d 1651 (?)

**Gozzoli** see **BENOZZO DI LESE**

**GRECO (Domenikos Theotokopoulos)**
*Candia 1541 – Toledo 1614*
Christ driving the Traders from the Temple → no 103
  cv 41.7×50.8 (106×129 cm)
The Adoration of the Name of Jesus* (formerly known as 'The dream of Philip II')
  pn 22.8×13.4 (58×34 cm)
S. Jerome as Cardinal
  cv c 23.2×18.9 (c 59×48 cm) ins attr
The Agony in the Garden of Gethsemane
  cv 40.2×51.6 (102×131 cm) st
S. Peter (?)
  parchment (?) 7.9×6.3 (20×16 cm) attr copy

**GRECO-ROMAN**
*I-IV Centuries*
A Young Woman
  pn 16.1×8.7 (41×22 cm)
A Man with a Wreath
  pn 16.5×8.7 (42×22 cm)
A young Woman with a Wreath
  pn 11.0×7.5 (28×19 cm)

**GREUZE Jean-Baptiste**
*Tournus 1725 – Paris 1805*
A Girl
  frm (?); cv 18.5×15.4 (47×39 cm)
A Child with an Apple*
  cv 15.7×12.6 (40×32 cm) unfinished (?)
A Girl with a Lamp
  cv 21.3×17.3 (54×44 cm) unfinished

**Follower of GREUZE**
A Girl
  pn 18.1×15.0 (46×38 cm)

**GUARDI Francesco**
*Venice 1712 – 1793*
Venice: Piazza S. Marco 210
  cv 28.3×46.9 (72×119 cm)
Venice: Piazza S. Marco 2525*
  cv 13.8×20.9 (35×53 cm)
A Gondola on the Lagoon near Mestre
  cv 11.4×17.3 (29×44 cm)
Venice: the Punta della Dogana with Santa Maria della Salute
  cv 22.0×29.9 (56×76 cm)
The Doges' Palace and the Molo from the Basin of S. Marco
  cv 22.8×29.9 (58×76 cm)
An architectural Caprice with a Palladian Style Building
  cv 8.7×6.7 (22×17 cm);
  on rv sg
A Caprice with a ruined Arch
  pn 7.9×5.9 (20×15 cm);
  on rv sg
An architectural Caprice 2519
  cv 8.7×6.7 (22×17 cm)
An architectural Caprice 2523
  cv 21.3×14.2 (54×36 cm) sg
A View near Venice (?)*
  cv 8.3×12.2 (21×31 cm)
Caprice Views with Ruins
  three panels 3.9×2.8 (10×7 cm)
A Caprice with Ruins on the Seashore
  cv 14.6×10.2 (37×26 cm)
View on the Venetian Lagoon with the Tower of Malghera → no 60
  pn 8.3×16.1 (21×41 cm); on rv sg
Venice: the Arsenal
  cv 24.4×38.2 (62×97 cm) sg

Venice: the Punta della Dogana
  cv 7.1×9.4 (18×24 cm)
Venice: the Giudecca with the Zitelle
  cv 7.5×9.4 (19×24 cm)
Venice: the Grand Canal with Palazzo Pesaro
  cv 36.6×51.6 (93×131 cm)

**Imitator of GUARDI**
Venice: Entrance to the Cannaregio
  cv 14.2×20.9 (36×53 cm)
A Ruin Caprice 2904 and 2905
  canvases 5.1×7.5 (13×19 cm)

**GUERCINO (Giovanni Francesco Barbieri)**
*Cento 1591 – Bologna 1666*
Angels weeping over the dead Christ
  copper 14.2×17.3 (36×44 cm)
The Incredulity of S. Thomas
  cv 45.3×55.9 (115×142 cm)
A bearded Man holding a Lamp
  cv 46.9×33.5 (119×85 cm) copy

**HACCOU Johannes Cornelis**
*Middelburg 1798 – London 1839*
A Road by a Cottage
  pn 9.1×13.0 (23×33 cm) sg d 1819

**Hackaert** see under **Berchem**

**HAENSBERGEN Johan van**
*Gorinchem (?) 1642 – The Hague 1705*
A Landscape with classical Ruins and twelve Women Bathers
  cv 13.8×16.9 (35×43 cm) false sg attr

**HALS Dirck**
*Haarlem 1591 – 1656*
A Party of young Men and Women at Table
  pn 11.0×15.0 (28×38 cm) sg d 1626

**HALS Frans**
*Antwerp or Malines c 1580 (?) – Haarlem 1666*
Portrait of a Middle-aged Woman with Hands folded
  cv 24.0×18.5 (61×47 cm) sg
Portrait of a Man in his thirties*
  cv 25.6×19.7 (65×50 cm) sg d 1633
  mutilated ins
A Family Group in a Landscape → no 86
  cv 58.3×98.8 (148×251 cm)
Portrait of a Man holding Gloves
  cv 30.7×26.4 (78×67 cm)
Portrait of a Woman with a Fan
  cv 31.5×23.2 (80×59 cm)
Portrait of Jean de la Chambre
  pn 8.3×6.7 (21×17 cm) ins
Portrait of a Woman (Marie Larp ?)
  cv 32.7×26.8 (83×68 cm)

**HARPIGNIES Henri-Joseph**
*Valenciennes 1819 – Saint-Privé 1916*
The Painter's Garden at Saint-Privé
  cv 23.2×31.9 (59×81 cm) sg d ... 86
A River Scene
  cv 8.3×9.1 (21×23 cm) sg
"Les oliviers à Menton"
  cv 39.4×31.9 (100×81 cm)
River and Hills
  cv 10.6×17.3 (27×44 cm) sg
"Une soirée d'automne"
  cv 45.7×61.8 (116×157 cm) sg d 1894

**HEDA Gerrit**
*act 1642-c 1702 Haarlem*
Still Life: Pewter and Silver Vessels and a Crab
  pn 21.3×28.7 (54×73 cm) sg d 1644
Still Life with a Lobster*
  cv 44.9×40.6 (114×103 cm) sg d 165 ...

**HEEM David Davidsz. de**
*act 1668 Utrecht*
Still Life: a Glass of Wine, Oysters, Fruit and Flowers
  cv 13.0×9.4 (33×24 cm) sg attr

**HEIMBACH Wolfgang**
*act 1636-78 Germany*
Portrait of a young Man
  pn 19.3×13.8 (49×35 cm) sg(?) d 1662

**HELST Bartholomeus van der**
*Haarlem 1613(?) – Amsterdam 1670*
Portrait of a Girl in pale blue with an Ostrich Feather Fan
  cv 29.5×25.6 (75×65 cm) sg d 1645
Portrait of a Lady in black Satin with a Fan*
  pn 40.9×29.9 (104×76 cm)
Portrait of a Man in black holding a Glove
  cv 44.5×31.5 (113×80 cm) d 1641 attr

**HEMESSEN Katharina van**
*Antwerp 1527-8 – c 1566(?)*
Portrait of a Man*
  pn 14.2×11.4 (36×29 cm) sg d 1552
Portrait of a Lady
  pn 8.7×6.7 (22×17 cm) sg d 1551
A Lady with a Rosary
  pn 9.1×6.7 (23×17 cm) attr

**HENDRIKS Wybrand**
*Amsterdam 1744 – Haarlem 1831*
Fruit, Flowers and dead Birds
  cv 26.4×21.3 (67×54 cm) sg

**HERP THE ELDER Guilliam van**
*Antwerp 1614(?) – 1677*
Franciscans distributing Alms
  copper 31.5×44.9 (80×114 cm) sg

**HEYDEN Jan van der**
*Gorinchem 1637 – Amsterdam 1712*
A View in Cologne
  pn 13.0×16.9 (33×43 cm) sg
An architectural Fantasy
  pn 20.1×25.2 (51×64 cm) sg
A Farm among Trees
  pn 8.7×11.4 (22×29 cm)
An imaginary View of Nijenrode Castle and the Sacristy of Utrecht Cathedral
  pn 20.9×16.1 (53×41 cm)
The Huis ten Bosch at The Hague*
  pn 8.3×11.0 (21×28 cm)
A Square before a Church
  pn 8.7×11.4 (22×29 cm) sg d 1678

**HOBBEMA Meyndert**
*Amsterdam 1638 – 1709*
A woody Landscape with a Road by a Cottage
  pn 23.6×33.1 (60×84 cm) sg
The Avenue, Middelharnis → no 92
  cv 40.6×55.5 (103×141 cm) d 1668 (89?)
The Ruins of Brederode Castle
  cv 32.3×41.7 (82×106 cm) sg d 1671
A Landscape with a Stream and several Watermills
  pn 23.6×33.1 (60×84 cm) sg
A Stream by a Wood
  pn 16.1×15.7 (41×40 cm)
A Woody Landscape with a Cottage on the right
  cv 39.0×51.2 (99×130 cm)
Cottages in a Wood
  pn 20.5×26.8 (52×68 cm) sg
A Road winding past Cottages in a Wood
  pn 24.0×33.1 (61×84 cm)
A View of the Haarlem Lock and the Herring-Packers' Tower, Amsterdam*
  cv 30.3×38.6 (77×98 cm) sg

**HOGARTH William**
*London 1697 – 1764*
"Marriage à la mode":
The Marriage Contract
Shortly after the Marriage → no 109
The Visit to the quack Doctor*
The Countess's Morning Levée*
The Killing of the Earl
The Suicide of the Countess*
  canvases 27.6×35.8 (70×91 cm) ins
The Shrimp Girl → no 110
  sketch; cv 24.8×20.5 (63×52 cm)
Portrait of Thomas Pellet
  cv 29.5×24.4 (75×62 cm)

**HOLBEIN THE YOUNGER Hans**
*Augsburg 1497-8 – London 1543*
Jean de Dinteville and Georges de Selve ("The Ambassadors") → no 81
  pn 81.5×82.3 (207×209 cm) sg d 1533 ins

Christina of Denmark, Duchess of Milan*
  pn 70.5×32.3 (179×82 cm)

**HONDECOETER Melchior de**
*Utrecht 1636 – Amsterdam 1695*
A Cock, Hens and Chicks
  cv 33.5×43.3 (85×110 cm)
Geese and Ducks*
  cv 46.9×61.0 (119×155 cm)
Birds, Butterflies and a Frog
  cv 26.8×22.0 (68×56 cm) sg d 1668

**HONTHORST Gerrit van**
*Utrecht 1590 – 1656*
Christ before the high Priest*
  cv 107.1×72.0 (272×183 cm)
S. Sebastian
  cv 39.8×46.1 (101×117 cm) sg
The Queen of Bohemia
  cv 80.7×51.6 (205×131 cm) later ins

**HOOGH Pieter de**
*Rotterdam 1629 – ... 1684 (?)*
A Woman and her Maid in a Courtyard*
  cv 28.7×24.4 (73×62 cm) sg d 166 ...
An Interior, with a Woman drinking with two Men and a Maidservant*
  cv 28.7×25.2 (73×64 cm) ins
The Courtyard of a House in Delft → no 89
  cv 28.7×23.6 (73×60 cm) sg d 1658
A musical Party in a Courtyard
  cv 32.7×26.8 (83×68 cm) sg d 1677
A Man with dead Birds and other Figures, in a Stable
  pn 20.9×19.3 (53×49 cm)

**HOOGSTRATEN Samuel van**
*Dordrecht 1627 – 1678*
A Peepshow with Views of the Interior of a Dutch House see p 8
  panels; ext panels 22.8×34.6 and 24.8 (58×88 and 63 cm); int panels 21.3×31.5 and 20.9 (54×80 and 53 cm) sg

**HOPPNER John**
*Whitechapel 1758 – London 1810*
Portrait of Sir George Beaumont*
  cv 30.3×25.2 (77×64 cm)

**Huet** see under **Delacroix**

**HUGHTENBURGH Johan van**
*Haarlem 1647 – Amsterdam 1733*
A Battle
  cv/pn 16.9×22.8 (43×58 cm)

**HUIJSUM Jan van**
*Amsterdam 1682 – 1749*
Flowers in a terracotta Vase, and Fruit*
  cv 44.5×35.8 (113×91 cm) sg d 1736
Hollyhocks and other Flowers in a Vase
  cv 24.4×20.5 (62×52 cm)

**Style of HUIJSUM**
Flowers in a Stone Vase
  cv 34.6×30.3 (88×77 cm) false sg

**Huysmans Cornelis** see under **Huysmans Jan-Baptiste**

**HUYSMANS Jan-Baptiste**
*Antwerp 1654 – 1716*
A woody Landscape
  cv 26.0×33.5 (66×85 cm) formerly attr to Cornelis Huysmans (Antwerp 1648 – Malines 1727)

**Ingegno** see **ANDREA DI ALOIGI**

**INGRES Jean-Auguste-Dominique**
*Montauban 1780 – Paris 1867*
The Duc d'Orléans
  cv 21.3×17.7 (54×45 cm) sg
Oedipus and the Sphinx
  cv 7.1×5.5 (18×14 cm) sg
M. de Norvins*
  cv/pn 38.2×31.1 (97×79 cm) sg ins

**95**

Angelica saved by Ruggiero*
   cv 18.5×15.4 (47×39 cm) sg
Pindar and Ictinus
   cv/pn 13.8×11.0 (35×28 cm) sg
Madame Moitessier seated
   → no 123
   cv 47.2×36.2 (120×92 cm) sg d
   1856 ins

**INNESS George**
*Newburg 1825 – Bridge of Al-
lan 1894*
Delaware Water Gap
   cv 35.8×54.3 (91×138 cm)

**ISABEY Louis-Gabriel-Eugène**
*Paris 1803 – 1886*
"Grandfather's Birthday"
   pn 9.4×11.4 (24×29 cm) sg d
   1866
"Fish Market, Dieppe"
   pn 13.8×20.9 (35×53 cm) sg
   d 1845

Isenbrandt see **YSENBRANDT**

**ISRAËLS Jozef**
*Groningen 1824 – The Hague
1911*
An old Man writing by Candle-
light (The Philosopher)
   cv 25.6×21.3 (65×54 cm) sg
Fishermen carrying a drowned
Man (The Shipwrecked Man)
   cv 50.8×96.1 (129×244 cm) sg

**ITALIAN SCHOOL**
*Fifteenth Century*
Portrait of a young Man
   pn 22.0×16.9 (56×43 cm)
Portrait of an old Man
   cv 29.9×24.4 (76×62 cm)
Portrait Group
   pn 15.7×14.2 (40×36 cm)
The Virgin and Child with An-
gels
   pn 14.2×10.2 (36×26 cm) ins
*Sixteenth Century*
The Attack on Cartagena
The Continence of Scipio
The Rape of the Sabines
The Reconciliation of Romans
and Sabines
   panels/canvases 13.8×60.2
   (35×153 cm)
Portrait of a young Man 1052
   pn 25.2×19.3 (64×49 cm)
Portrait of a young Man 2510
   pn 10.2×8.3 (26×21 cm)
A Man and his Wife
   cv 25.6×28.7 (65×73 cm)
A Jesse-Tree
   parchment or crt 8.7×5.5
   (22×14 cm)
The Holy Family
   pn 19.3×15.0 (49×38 cm)
Portrait of a Lady with a Dog
   pn 32.7×27.6 (83×70 cm)
*Seventeenth Century*
Bust Portrait of a bearded Man
   pn; oval 10.2×7.1 (26×18 cm)
A dead Soldier
   cv 40.9×65.7 (104×167 cm) ins
   attr
Bust of a Man
   frs 19.7×13.8 (50×35 cm)
An old Man holding a Pilgrim-
Bottle
   cv 44.1×35.8 (112×91 cm) attr
*Eighteenth Century*
S. Catherine of Alexandria (?)
   pn 20.9×18.1 (53×46 cm)

**JACKSON John**
*Lastingham 1778 – London 1831*
The Rev. William Holwell Carr
   cv 29.5×24.4 (75×62 cm)
William Seguier
   cv 31.1×25.6 (79×65 cm) on
   rv sg d 1830

**JACOMETTO VENEZIANO**
*act c 1472-98 Venice*
Portrait of a Boy*
   pn 9.1×7.5 (23×19 cm) attr
Portrait of a Man
   pn 10.2×7.5 (26×19 cm) on rv
   ins attr

Jacopo da Empoli see
under **Bilivert**

**Follower of
JANSSENS Hieronymus**
*Antwerp 1624 – 1693*
"La main chaude"
   pn 10.6×15.4 (27×39 cm)

**JARDIN Karel du**
*Amsterdam (?) 1621-2 (?) –
Venice 1678*
Farm Animals in the Shade of
a Tree with a Boy and a
sleeping Herdswoman
   cv 13.4×15.4 (34×39 cm) sg
   d 1656
A Woman and a Boy with Ani-
mals at a Ford
   cv 14.6×16.9 (37×43 cm) sg
   d 1657
A Woman with Cattle and Sheep
in an Italian Landscape
   copper 8.7×11.4 (22×29 cm)
   sg
Sheep and Goats
   copper 7.1×8.3 (18×21 cm) sg
   d 1673
Portrait of a young Man*
   cv c 24.4×20.5 (c 62×52 cm)
   false (?) sg  self-portrait (?)
The Conversion of S. Paul
   cv 73.2×52.8 (186×134 cm) sg
   d 1662

**JOHNSON Cornelius**
*London 1593 – Utrecht 1661*
Portrait of a Lady*
   cv 39.4×31.9 (100×81 cm) sg
   d 1655

**JONGKIND Johan Barthold**
*Lattrop 1819 –
Côte-Saint-André 1891*
Skating in Holland
   cv 12.6×18.1 (32×46 cm) sg
River Scene
   cv 20.5×31.5 (52×80 cm) sg

**JOOS VAN WASSENHOVE**
*act c 1460 – 80-5 (?) Ghent and
Urbino*
Rhetoric (?)
Music
   from a series of Liberal Arts
   [?]) panels c 61.0×39.4
   (c 155×100 cm) ins recently
   attr also to Pedro Berruguete
   (Paredes de Nava [?] c 1450
   – ... 1504)

**JORDAENS Jacob**
*Antwerp 1593 – 1678*
The Holy Family with S. John*
   pn 48.4×37.0 (123×94 cm)
The Virgin and Child with SS.
Zacharias, John and Eliza-
beth
   cv 44.9×60.2 (114×153 cm)
Portrait of Govaert van Surpe-
le (?) and his Wife *
   cv 83.9×74.4 (213×189 cm)

**JUAN DE FLANDES**
*act 1496-1519 Salamanca and
Palencia*
Christ appearing to the Virgin
with the Redeemed of the Old
Testament
   pn 8.3×6.3 (21×16 cm) st

**JUEL Jens**
*Gamborg Figen 1745 – Copen-
hagen 1802*
Joseph Greenway
   cv 30.7×39.0 (78×99 cm) sg
   d 1788

**KENT Leslie**
*... (England) 1890 – ...*
H.M.S. Barham
   cv 13.8×17.3 (35×44 cm)

**KESSEL Johan van**
*Amsterdam 1641-2 – 1660*
A Torrent in a mountainous
Landscape
   cv 48.0×51.2 (122×130 cm)
   false sg attr

**KEYSER Thomas de**
*Amsterdam 1596-7 – 1667*
Portrait of Constantijn Huygens
and his (?) Clerk
   cv 36.2×27.2 (92×69 cm) sg
   d 1627
Portraits of a Man and a Woman
   pn 15.7×10.6 (40×27 cm) attr

**KONINCK Philips**
*Amsterdam 1619 – 1688*
An extensive Landscape with
a hawking Party → no 91
   cv 52.0×63.0 (132×160 cm)

An extensive Landscape with
Houses in a Wood and a dis-
tant Town
   cv 39.8×57.5 (101×146 cm)
An extensive Landscape with a
Town in the Middle Distance
   cv 17.3×20.9 (44×53 cm)
An extensive Landscape with a
Road by a Ruin
   cv 53.9×65.7 (137×167 cm)
   sg d 1655

**LA FARGUE
Paulus Constantijn**
*The Hague 1729 – 1782*
The Grote Markt at The Hague
   pn 22.4×29.9
   (57×76 cm) sg d 1760 ins

**LAGOOR Jan de**
*act 1645-59 Haarlem and Am-
sterdam*
A woody Landscape with a Stag
Hunt
   cv 44.1×58.3 (112×148 cm) sg

**LA HIRE Laurent de**
*Paris 1606 – 1656*
Allegorical Figure of Grammar
   cv 40.6×44.5
   (103×113 cm) sg d 1650 ins

**LANCRET Nicolas**
*Paris 1690 – 1743*
The Four Ages of Man:
Childhood
Youth
Maturity*
Old Age
   canvases 13.0×17.3
   (33×44 cm)
The four Times of the Day:
Le Matin
Le Midi
L'Après-dîner
La Soirée
   copper c 11.4×c 14.6
   (c 29×c 37 cm)

**LANINO Bernardino**
*act 1528 – 81-83 Piedmont and
Lombardy*
Madonna and Child with S. Ma-
ry Magdalen, a sainted Pope,
S. Joseph (?) and S. Paul*
   cv; ar pn 81.1×52.4
   (206×133 cm) sg d 1543 ins

**LARGILLIÈRE Nicolas de**
*Paris 1656 – 1746*
Portrait of a Man*
   cv 35.8×28.0 (91×71 cm)
Princess Rákóczi
   cv 53.5×40.9 (136×104 cm) attr

**LASTMAN Pieter**
*Amsterdam (?) 1583 – Amster-
dam 1633*
Juno discovering Jupiter with Io
   pn 21.3×30.7
   (54×78 cm) sg d 1618

**LA TOUR Maurice-Quentin de**
*Saint-Quentin 1704 – 1788*
Henry Dawkins*
   pastel/cv 26.0×20.9
   (66×53 cm)

**LAWRENCE Thomas**
*Bristol 1769 – London 1830*
John Julius Angerstein 129
   cv 35.8×28.0 (91×71 cm)
John Julius Angerstein 6370*
   cv 29.9×25.6 (76×65 cm)
Queen Charlotte → no 114
   cv 94.1×57.9
   (239×147 cm) 1789 (?)

**LAZZARINI Gregorio**
*Venice 1655 – Villa Bona  1730*
Antonio (?) Correr
   cv 49.2×38.2
   (125×97 cm) sg d 1685 ins

**LE BRUN
Elizabeth-Louise Vigée**
*Paris 1755 – 1842*
Mlle. Brongniart
   pn 25.6×20.9 (65×53 cm)
Painter's Self-Portrait in a
Straw Hat
   cv 38.6×27.6 (98×70 cm) copy

**LENAIN Antoine**
*Laon c 1588 – Paris 1648*
A Woman and five Children*
   copper 8.7×11.4
   (22×29 cm) sg d 1642

**LENAIN Louis**
*Laon c 1593 – Paris 1648*
The Adoration of the Shepherds
   cv 42.9×53.9 (109×137 cm)
Four Figures at Table
   cv 18.1×21.6 (46×55 cm) copy

**Follower of the Brothers
LENAIN**
A Trio of Geometers (?)
   cv 20.9×24.8 (53×63 cm)

**LEÓN Y ESCOSURA Ignacio de**
*Oviedo 1834 – Toledo 1901*
A Man in XVII Century Spanish
Costume
   cv 36.2×27.6 (92×70 cm) attr

**LEONARDO DA VINCI**
*Vinci 1452 – Amboise 1519*
"The Virgin of the Rocks"
   → no 21
   centr pn from a polyptych;
   ar pn 74.4×47.2
   (189×120 cm) ins
   wings by an associate (q. v.)
The Virgin and Child with S.
Anne and S. John the Baptist
   → no 22
   crt 55.5×40.9 (141×104 cm)

**Associate of LEONARDO
(Ambrogio or Evangelista
De Predis)**
An Angel in green with a Vielle
An Angel in red with a Lute
   panels 46.1 and 46.5×23.6
   (117 and 118×60 cm)
   wings of Leonardo's "Virgin
   of the Rocks" (q.v.)

**Follower of LEONARDO**
The Virgin and Child
   pn 23.6×17.3 (60×44 cm)
The Head of S. John the Baptist
   pn 17.7×15.0
   (45×38 cm) d 1511

**LÉPINE Stanislas-Victor-
Edmond (or Édouard)**
*Caen 1835 – Paris 1892*
A Gateway behind Trees
   cv 13.0×8.3 (33×21 cm) sg
The Pont de la Tournelle, Paris
   cv 5.1×9.4 (13×24 cm) sg
Nuns and School Girls walking
in the Tuileries Gardens,
Paris
   pn 5.9×9.1 (15×23 cm) sg

**LE PRINCE Jean-Baptiste**
*Metz 1734 – St. Denis du Port
1781*
The Necromancer
   cv 30.3×24.8 (77×63 cm) sg

**LE SUEUR Eustache**
*Paris 1616 – 1655*
S. Paul preaching at Ephesus
   cv 40.2×33.9 (102×86 cm)

Leyden see **LUCAS
VAN LEYDEN**

**LEYDEN SCHOOL**
*Second half of the Seventeenth
Century*
A young Astronomer
   pn 5.9×5.1 (15×13 cm)

**LEYSTER Judith**
*Haarlem 1609 – Heemstede 1660*
A Boy and a Girl with a Cat
and (?) an Eel
   pn 180.6×19.3 (459×49 cm) sg

**LIBERALE DA VERONA**
*Verona c 1445 – 1526*
The Virgin and Child with two
Angels
   pn 24.0×17.7 (61×45 cm)
Dido's Suicide
   wedding-chest (?);
   pn 16.5×48.4 (42×123 cm)

**Libri see GEROLAMO
DAI LIBRI**

**LICINIO Bernardino**
*Poscante (?) c 1491 – Venice (?)
c 1549*
Portrait of Stefano Nani*
   cv 35.8×30.3
   (91×77 cm) sg d 1528
Madonna and Child with S. Jo-
seph and a Female Martyr
   pn 26.8×18.9 (68×48 cm)

**LIEVENSZ. Jan**
*Leyden 1607 – Amsterdam 1674*
A Landscape with Tobias and
the Angel
   pn 22.4×34.6 (57×88 cm)
Portrait of Anna Maria van
Schurman
   cv 34.3×26.8 (87×68 cm) ins
Self-Portrait*
   cv 37.8×30.3 (96×77 cm) sg

**LINGELBACH Johannes**
*Frankfort 1622 – Amsterdam (?)
1674*
Peasants loading a Hay Cart
   cv 27.6×34.6
   (70×88 cm) sg d 1664

**LINNELL John**
*London 1792 – Redhill 1882*
Samuel Rogers
   pn 17.3×14.2 (44×36 cm)
   sketch or unfinished

**LIOTARD Jean-Étienne**
*Geneva 1702 – 1789*
A Grand Vizir (?)*
   pastel 24.4×18.5 (62×47 cm)

**LIPPI Filippino**
*Prato 1457 (?) – Florence 1504*
The Virgin and Child with SS.
Jerome and Dominic* (pred
The dead Christ; S. Francis;
S. Mary Magdalen; The arms
of the Rucellai family)
altarpiece;
   pn 79.9×73.2 (203×186 cm);
   pred 7.9×92.9 (20×236 cm)
Angel adoring
   frm ; pn 22.0×9.8 (56×25 cm)
The Adoration of the Kings
   → no 15
   pn 22.4×33.9 (57×86 cm)
The Virgin and Child with S.
John
   pn 23.2×16.9 (59×43 cm)
Moses brings forth Water out
of the Rock
The Worship of the Egyptian
Bull-God, Apis (The Worship
of the Golden Calf [?])
   panels/canvases 30.7×53.9
   (78×137 cm)

**LIPPI Fra Filippo**
*Florence 1406 (?) – 1469*
S. Bernard's Vision of the Virgin
   pn 38.6×41.7 (98×106 cm)
The Annunciation*
Seven Saints
   lunettes; panels 26.8×c 59.8
   (68×c 152 cm)
The Virgin and Child
   pn 29.9×24.0 (76×61 cm) attr

**LIPPO DI DALMASIO**
*Bologna c 1352 – c 1410*
"The Madonna of Humility"
   pn (?)/cv 43.3×34.3
   (110×87 cm) sg

**LISS Johann**
*Oldenburg 1595 (?) – Venice
1629-30*
Judith in the Tent of Holofernes
   cv 50.4×39.0 (128×99 cm)

**LOCHNER Stephan**
*act 1442-51 Cologne*
SS. Matthew, Catherine of Alex-
andria and John the Evan-
gelist* (on rv S. Jerome, S.
Gregory, a Female Saint and
a Donor)
   pn 26.8×22.8 (68×58 cm) sg

**LOMBARD Lambert**
*Liège c 1506 – 1566-7*
Pietà
   pn 42.5×26.8 (108×68 cm) sg

**LONGHI Alessandro**
*Venice 1733 – 1813*
Caterina Penza
   cv 23.6×18.9 (60×48 cm) sg

**LONGHI Pietro
(P. Falca)**
*Venice 1702 (?) – 1785*
An Interior with three Women
and a seated Man
   cv 24.0×19.3 (61×49 cm) ins
Exhibition of a Rhinoceros at
Venice → no 61
   cv 23.6×18.5 (60×47 cm)
A Fortune-Teller at Venice*
   cv 23.2×18.9
   (59×48 cm) sg d 1756 ins

96

A Lady receiving a Cavalier
cv 63.4×19.7 (161×50 cm)
A Nobleman kissing a Lady's
Hand
cv 24.0×19.3 (61×49 cm)

**LOOTEN Jan**
*Amsterdam c 1618 – York (?) or
London (?) c 1680 (?)*
A River Landscape
cv 42.9×50.8 (109×129 cm)

**LORENZETTI Ambrogio**
*act 1319-47 Siena*
A Group of poor Clares*
frm; frs c 22.8×c 20.5
(c 58×c 52 cm)

**LORENZETTI Pietro**
*act 1306 (?)-1345 Siena*
S. Sabinus before the Governor (?) → no 2
pred pn 11.8×10.6
(30×27 cm) 1335-42 (?)
A crowned Female Figure
frm; frs c 15.0×c 13.0
(c 38×c 33 cm) attr

**LORENZO D'ALESSANDRO
DA SANSEVERINO**
*act 1468-1503 Marches*
The Marriage of S. Catherine
of Siena
altarpiece; pn 56.7×57.1
(144×145 cm) sg ins

**LORENZO DI CREDI**
*Florence c 1458 – 1537*
The Virgin and Child
pn 28.0×19.3 (71×49 cm)
The Virgin adoring the Child
(on rv The Announcement to
the Shepherds)
pn 33.9×23.6 (86×60 cm)

**LORENZO MONACO**
*Siena (?) 1370-1 – Florence
c 1425*
The Coronation of the Virgin**
→ no 6
(side panels Adoring Saints)
altarpiece; ar panels; centr pn
85.4×45.3 (217×115 cm) ins;
side panels c 70.9×c 40.2
(c 180×c 102 cm) ins
S. Benedict admitting SS. Maurus and Placidus into the
Benedictine Order; Incidents
in the Life of S. Benedict *
frm from a pred;
panels 11.0×15.0 and 20.5
(28×38 and 52 cm)
Illuminated letter B; cut from a
choral Book
parchment 14.6×c 13.0
(37×c 33 cm)
S. Benedict in the Sacro Speco
at Subiaco
pn 14.2×11.0
(36×28 cm) false ins

**LORENZO Veneziano**
*act 1356 (?)-72 Venice*
The "Madonna of Humility"
with SS. Mark and John the
Baptist
pn from an altarpiece
12.2×22.4 (31×57 cm) ins attr

**LORRAIN Claude
(C. Gellée)**
*Chamagne 1600 – Rome 1682*
Landscape: Cephalus and Procris reunited by Diana
cv 40.2×52.0
(102×132 cm) sg d 1645
A Seaport
cv 39.0×50.8
(99×129 cm) sg d 1644
Landscape: David at the Cave
of Adullam (The Chigi Claude)
cv 44.1×72.8
(112×185 cm) sg d 1658
Landscape: the Marriage of
Isaac and Rebekah ("The
Mill")
cv 58.7×77.6
(149×197 cm) sg d 1648 ins
Seaport: the Embarcation of the
Queen of Sheba*
cv 58.3×76.4
(148×194 cm) sg d 1648 ins
Landscape: Narcissus
cv 37.0×46.5
(94×118 cm) sg d 1644
Seaport: the Embarcation of S.
Ursula → no 121
cv 44.5×58.7
(113×149 cm) sg d 1641 ins

Landscape, with a Goatherd
and Goats
cv 20.5×16.1 (52×41 cm)
Landscape: Hagar and the Angel
cv/pn 20.5×17.3 (52×44 cm)
Landscape: Aeneas at Delos*
cv 39.4×52.8
(100×134 cm) sg d 1672 ins
Landscape: the Death of Procris
cv 15.0×18.9 (38×48 cm) copy
A View in Rome
cv 23.2×33.1
(59×84 cm) sg (?) d 1632 attr

**LOSCHI Bernardino**
*Parma 1460 – Carpi 1540*
Portrait said to be of Alberto
Pio
pn 22.8×19.3 (58×49 cm) attr

**LOTH Johann Carl**
*Munich 1632 – Venice 1698*
Mercury piping to Argus
cv 45.7×39.0 (116×99 cm)

**LOTTO Lorenzo**
*Venice (?) c 1480 – Loreto 1556*
The Physician Giovanni Agostino della Torre, and his Son
Niccolò*
cv 33.1×26.8
(84×68 cm) sg d 1515
Family Group*
cv 45.3×54.7
(115×139 cm) sg
The Prothonotary Apostolic,
Giovanni Giuliano
cv 37.0×28.0 (94×71 cm) ins
Virgin and Child with SS. Jerome and Anthony of Padua
cv 35.0×29.1
(89×74 cm) sg d 1521
A Lady as Lucretia → no 48
cv 37.8×43.3 (96×110 cm) ins

**LUCAS VAN LEYDEN**
*act 1508-33 Leyden*
A Man aged 38*
pn 18.1×15.7 (46×40 cm)

**Style of LUCAS
VAN LEYDEN**
Lot's Daughters make their Father drink Wine
pn 12.6×9.1 (32×23 cm)

**Lucidel** see **NEUFCHÂTEL**

**LUINI Bernardino**
*act 1512-32 Milan*
Christ among the Doctors*
pn 28.3×33.5 (72×85 cm)
The Virgin and Child with S.
John
pn 34.6×26.0 (88×66 cm)
The Virgin and Child
pn 19.3×17.3 (49×44 cm) st
Christ
pn 28.7×22.8 (73×58 cm) copy
S. Catherine
pn 28.0×23.6 (71×60 cm) copy

**Mabuse** see **GOSSAERT**

**MACHIAVELLI Zanobi**
*Florence c 1418 – Pisa (?) 1479*
The Virgin and Child with Saints
trp; cusped panels;
centr pn 64.6×28.0
(164×71 cm); side panels
c 56.7×23.2 (c 144×59 cm)
SS. John the Baptist and Evangelist
SS. Mark and Augustine
wings from an altarpiece;
ar panels 52.0×22.8
(132×58 cm) the first ins

**MADRAZO Raimundo de**
*Rome 1841 – Versailles 1920*
Portrait of a Lady
cv 19.3×15.7 (49×40 cm)

**MAES Nicolaes**
*Dordrecht 1634 – Amsterdam
1693*
A little Girl rocking a Cradle
pn 15.7×12.6 (40×32 cm) sg
A Woman scraping Parsnips,
with a Child standing by her
pn 13.8×11.8
(35×30 cm) sg d 1655
Interior with a sleeping Maid
and her Mistress (The idle
Servant)*
pn 27.6×20.9
(70×53 cm) sg d 1655
Christ blessing Children
cv 81.1×60.6 (206×154 cm)

Portrait of an elderly Man in a
black Robe
cv 35.0×28.0
(89×71 cm) sg d 1666
Portrait of Jan de Reus
cv 31.1×24.4 (79×62 cm)
Portrait of a Man in a black Wig
cv 18.5×15.0 (47×38 cm)

**Maineri** see under **Costa**

**MANCINI Antonio**
*Rome 1852 – 1930*
La Douane
cv 30.3×25.2 (77×64 cm) sg
En voyage
cv 39.4×23.2 (100×59 cm) sg
The Marquis del Grillo
cv 83.1×44.5
(211×113 cm) sg d 1899
Amelia
cv 39.4×23.6 (100×60 cm) sg

**MANET Édouard**
*Paris 1832 – 1883*
Eva Gonzalès
cv 75.2×52.4
(191×133 cm) sg d 1870
"La musique aux Tuileries"
cv 29.9×46.5
(76×118 cm) sg d 1862
Fragments of the Execution of
Maximilian*
(The firing Party; A non-commissioned Officer holding his
Rifle; Two fragments of General Miramón)
canvases 74.8×63.0;
39.0×23.2; 13.8×10.2;
35.0×11.8 (190×160;
99×59; 35×26; 89×30 cm)
The Waitress ("La Servante de
Bocks") → no 128
cv 38.2×30.3 (97×77 cm)
sg d 1879 or 1878

**Manni** see **GIANNICOLA
DI PAOLO**

**MANSUETI Giovanni**
*act 1485-1527 (?) Venice*
Symbolic Representation of the
Crucifixion
cv 50.8×48.8 (129×124 cm)
false (?) sg and d 1492

**MANTEGNA Andrea**
*Isola di Carturo 1431 – Mantua
1506*
The Virgin and Child with the
Magdalen and S. John the
Baptist
altarpiece; cv 53.5×44.9
(136×114 cm) sg ins
The Introduction of the Cult of
Cybele at Rome ("The Triumph of Scipio")*
cv (?) 28.7×105.5
(73×268 cm) ins grisaille
Samson and Delilah*
cv 18.5×14.6
(47×37 cm) ins grisaille
The Agony in the Garden
→ no 42
cv 24.8×31.5 (63×80 cm) sg
The Holy Family with S. John
cv 28.0×19.7 (71×50 cm) ins
Illuminated Initial D
parchment 7.5×7.5
(19×19 cm) copy

**Imitator of MANTEGNA**
"Noli me tangere"
The Resurrection
The Maries at the Sepulchre
panels 16.5×c 12.2
(42×c 31 cm)

**Follower of MANTEGNA**
The Vestal Virgin Tuccia with
a Sieve (Summer)
Sophonisba drinking Poison (?)
(Autumn)
panels 28.3×9.1 (72×23 cm)

**Maratti** see under **Voet**

**MARCO D'OGGIONO**
*act c 1490-c 1524 Milan*
The Virgin and Child
pn 26.0×20.9 (66×53 cm)

**MARGARITO D'AREZZO
(Margaritone)**
*act 1262 (?) Arezzo (?)*
The Virgin and Child enthroned, with Scenes of Nativity
and the Lives of the Saints*
pn 29.9×66.5
(76×169 cm) sg ins

**MARIESCHI Michiel Giovanni**
*Venice 1710 – 1743*
Buildings and Figures near a
River with Shipping
cv 24.0×36.2 (61×92 cm)
Buildings and Figures near a
River with Rapids
cv 24.0×36.2 (61×92 cm)

**MARINUS VAN
REYMERSWAELE**
*act 1509(?)-67(?) Reymerswaele*
"Two Tax-Gatherers"*
pn 36.2×29.1 (92×74 cm) ins

**MARIS Jacobus Hendricus**
*The Hague 1837 – Carlsbad 1899*
A young Woman nursing a Baby
pn 11.4×9.1
(29×23 cm) sg d 1868
A Drawbridge in a Dutch Town
cv 11.8×8.7 (30×22 cm) sg
A Girl feeding a Bird in a Cage
pn 12.6×7.9 (32×20 cm) sg
A Beach
cv 16.5×21.3 (42×54 cm) sg
A Windmill and Houses beside
Water; stormy Sky
cv 18.9×23.2 (48×59 cm) sg
Three Windmills
cv 13.0×16.1
(33×41 cm) sg d 1880
A Girl seated outside a House
pn 12.6×8.3
(32×21 cm) sg d 1867

**MARIS Matthijs**
*The Hague 1839 – London 1917*
Men unloading Carts, Montmartre
cv 9.1×11.8
(23×30 cm) sg d 1870

**MARIS Willem**
*The Hague 1844 – 1910*
Ducks alighting on a Pool
cv 12.6×7.9 (32×20 cm) sg

**MARMION Simon**
*act 1449-89 Amiens, Valenciennes and Tournai*
The Soul of S. Bertin carried
up to God
A Choir of Angels
fragments; panels 22.4×7.9
(57×20 cm)

**Style of MARMION**
The Virgin and Chilld, with
Saints and Donor
pn 10.6×7.9 (27×20 cm)
S. Clement and a Donor
I wing from a trp;
pn 19.7×14.6 (50×37 cm)

**MARZIALE Marco**
*act 1493-1507 Venice and Cremona*
The Circumcision*
altarpiece; cv 8.7×59.4
(22×151 cm) sg d 1500 ins
The Virgin and Child with
Saints
altarpiece; ar pn 86.6×55.9
(220×142 cm) sg d 1507 ins

**MASACCIO
(Tommaso di Giovanni)**
*San Giovanni Valdarno 1401 –
Rome 1427-9*
The Virgin and Child → no 8
centr pn from an altarpiece;
pn 53.1×28.7 (135×73 cm)

**Follower of MASACCIO**
The Nativity
pred pn 8.3×25.6 (21×65 cm)

**MASOLINO**
*Panicale c 1383 – ... 1447 (?)*
SS. John the Baptist and Jerome → no 7
A Pope and SS. Matthias*
panels from an altarpiece
44.9×21.6 (114×55 cm) attr;
once formed a single
pn painted on both sides

**MASSYS Quinten**
*Louvain 1465-6 – Antwerp 1530*
The Virgin and Child with SS.
Barbara (?) and Catherine
cv 36.6×43.3 (93×110 cm)
The Virgin and Child Enthroned
with four Angels
ar pn 24.4×16.9 (62×43 cm)
The Crucifixion
pn 35.4×22.8 (90×58 cm) st

Christ
The Virgin
ar panels 22.8×13.0
(58×33 cm) copies
A grotesque old Woman
pn 25.2×17.7
(64×45 cm) copy (?)

**Follower of MASSYS**
A Donor
pn 26.8×13.0 (68×33 cm)
A Female Figure standing in a
Niche
wing from an altarpiece;
pn 44.9×13.8 (114×35 cm)
S. Luke painting the Virgin and
Child
pn 44.5×13.8 (113×35 cm)

**MASTER OF CAPPENBERG**
*Early Sixteenth Century, Westphalia*
The Coronation of the Virgin
pn 38.2×27.6 (97×70 cm) ins
Christ before Pilate
pn 39.0×27.2 (99×69 cm)

**MASTER OF DELFT**
*Early Sixteenth Century, Delft*
Scenes from the Passion* (l
wing: Christ presented to the
People; on rv The Virgin and
Child and S. Augustine grisaille; r wing: The Deposition; on rv S. Peter and the
Magdalen grisaille)
trp; centr pn 38.6×41.3
(98×105 cm) ins; side panels
40.2×19.3 (102×49 cm)

**MASTER OF 1518**
*Early Sixteenth Century, Antwerp (?)*
The Crucifixion
pn 37.0×26.4 (94×67 cm) st
The Visitation of the Virgin to
S. Elizabeth
The Flight into Egypt
panels from an altarpiece;
panels 31.5×27.2 (80×69 cm)
st

**Master of Flémalle** or of
**Mérode** see **CAMPIN**

**MASTER OF LIESBORN**
*Second half of the Fifteenth
Century, Westphalia*
The Annunciation
The Presentation in the Temple
The Adoration of the Kings
fragments of l wing from a
polyptych;
pn 37.8×27.6 (96×70 cm) ins;
pn/cv 38.6×27.6 (98×70 cm);
pn 9.1×15.0 (23×38 cm)
Head of Christ crucified*
SS. John the Evangelist, Scholastica and Benedict
SS. Cosma and Damian and the
Virgin
fragments of centr wing from
an altarpiece;
pn 12.6×11.4 (32×29 cm);
pn/cv 21.6×27.6 (55×70 cm);
pn/cv 21.6×28.3 (55×72 cm)

**Circle of the MASTER
OF LIESBORN**
SS. Ambrose, Exuperius and
Jerome
SS. Gregory, Maurice and Augustine
wings from an altarpiece;
panels/canvases 47.2×26.8
(120×68 cm) ins
The Crucifixion with Saints
pred pn 15.0×46.5
(38×118 cm)
The Virgin and Child with a
Donor
pn 46.5×20.1 (118×51 cm) ins
S. Dorothy
S. Margaret
fragments from an altarpiece;
panels 31.5×18.9 (80×48 cm)

**MASTER OF MOULINS**
*act c 1483-c 1500 Moulins*
Charlemagne, and the Meeting
of SS. Joachim and Anne at
the golden Gate
frm; pn 28.3×23.2
(72×59 cm) ins

**MASTER OF RIGLOS**
*Middle of Fifteenth Century,
Aragon*
The Crucifixion
pn 28.0×40.9 (71×104 cm)

**MASTER OF SAINT GILES**
*act c 1500 Paris*

S. Giles and the Hind (on rv
A Bishop)
The Mass of S. Giles* (on rv
S. Peter)
panels 24.0×c 17.7
(61×c 45 cm); the second ins;
reverses grisaille

**MASTER OF SAN FRANCESCO**
*End of the Thirteenth Century*

Crucifixion
pn 36.2×29.5 (92×75 cm)

**MASTER OF THE AACHEN
ALTARPIECE**
*End of the Fifteenth Century –
early Sixteenth Century, Colog-
ne*

The Crucifixion
pn 42.1×47.2 (107×120 cm) ins

**MASTER OF THE BAMBINO
VISPO**
*Early Fifteenth Century,
Florence*

The Beheading of a Female
Saint
pn from a pred (?) 15.7×24.8
(40×63 cm) attr

**98**

**MASTER OF THE BRUGES
PASSION SCENES**
*Early Sixteenth Century,
Bruges (?)*

Christ presented to the People
(Ecce Homo)*
I wing from an altarpiece;
pn 36.6×16.1 (93×41 cm)

**MASTER OF THE CASSONI**
*Middle of Fifteenth Century,
Florence*

The Triumph of Love
pn; td 24.0 (61 cm) attr

**MASTER OF THE DEATH
OF THE VIRGIN
(Joos van Cleve?)**
*act 1507-37 Antwerp*

The Holy Family*
pn 19.3×14.2 (49×36 cm)
The Adoration of the Kings
centr pn from a trp 26.0×21.6
(66×55 cm) copy

**Follower of the MASTER OF
THE DEATH OF THE VIRGIN**

The Crucifixion
centr pn from a trp
28.3×19.7 (72×50 cm)
The Annunciation
two panels 29.9×8.3
(76×21 cm) grisaille

**MASTER OF THE LIFE
OF THE VIRGIN**
*Second half of the Fifteenth
Century, Cologne*

The Presentation in the Tem-
ple*
pn 33.1×42.5 (84×108 cm) ins

**MASTER OF THE MANSI
MAGDALEN**
*Early Sixteenth Century, Ant-
werp (?)*

Judith (?) and the Infant Her-
cules
pn 35.0×20.5 (89×52 cm)

**MASTER
OF THE OSSERVANZA**
*act c 1436 Siena*

The Birth of the Virgin*
trp; centr pn 10.6×7.5
(27×19 cm);
side panels 11.0×c 3.5
(28×c 9 cm)

**MASTER OF THE PALA
SFORZESCA**
*act c 1495 Milan (?)*

S. Paul
pn 9.4×5.1 (24×13 cm) attr
The Virgin and Child with
Saints and Donors
pn 21.6×19.3 (55×49 cm) attr

**MASTER OF THE
S. BARTHOLOMEW
ALTARPIECE**
*Late Fifteenth Century to early
Sixteenth Century, Cologne*

SS. Peter and Dorothy
pn 49.2×28.0 (125×71 cm)

**MASTER OF THE STORY
OF GRISELDA**
*Sixteenth Century, Siena (?)*

The Story of patient Griselda
I, II, III
panels 24.0×60.6 (61×154 cm)

**MASTER OF THE VIEW
OF SAINTE GUDULE**
*End of the Fifteenth Century,
Brussels (?)*

Portrait of a young Man*
ar pn 8.7×5.5 (22×14 cm)

**MATTEO DI GIOVANNI**
*act 1452-95 Siena*

The Assumption of the Virgin*
centr pn from an altarpiece;
pn 130.3×68.1
(331×173 cm) ins 1474 (?)
S. Sebastian
ar pn 49.6×23.6 (126×60 cm)

**Imitator of
MATTEO DI GIOVANNI**

Christ crowned with Thorns
pn 8.3×8.3 (21×21 cm) ins

**MAZO Juan Bautista del**
*Cuenca c 1612-6 – Madrid 1667*

Queen Mariana of Spain in
Mourning*
cv 77.6×57.5
(197×146 cm) sg d 1666
Don Adrián Pulido Pareja
cv 80.3×44.9 (204×114 cm)
false d 1639 ins attr

**MAZZA Damiano**
*act 1573 Venetia*

The Rape of Ganymede
cv 69.7×73.2 (177×186 cm) attr

**MAZZOLA Filippo**
*Parma 1460 – 1505*

The Virgin and Child with S. Je-
rome (?) and the B. Bernar-
dino da Feltre (?)
pn 22.0×29.1 (56×74 cm) sg

**MAZZOLINO Lodovico**
*act 1504-24 Ferrara*

Madonna and Child with SS. Jo-
seph, Elizabeth, Francis and
the Infant John the Baptist
ar pn 20.9×15.4 (53×39 cm)
The Trinity with the Madonna,
SS. Joseph and Nicholas of
Tolentino and Angels
pn 32.7×23.6 (83×60 cm)
Christ and the Woman taken in
Adultery*
ar pn 18.1×11.8
(46×30 cm) d 1522
Christ disputing with the Doc-
tors
pn 12.2×8.7 (31×22 cm)
The Nativity*
pn 15.4×13.4 (39×34 cm)

**MELONE Altobello**
*act 1516-8 Cremona*

The Walk to Emmaus*
pn 57.1×56.7 (145×144 cm)

**MEMLINC or MEMLING Hans**
*Seligenstadt c 1433 – Bruges
1494*

SS. John the Baptist and Law-
rence*
wings from a polyptych;
panels 22.4×6.7 (57×17 cm)
A young Man at Prayer*
I wing from a trp (?);
pn 15.4×9.8 (39×25 cm)
The Virgin and Child with
Saints, Angels and Donors
("The Donne Triptych")
→ no 71
trp; panels; centr
pn 27.6×27.6 (70×70 cm);
wings 27.6×11.8 (70×30 cm)
The Virgin and Child with an
Angel, S. George and Donor
pn 21.3×14.6 (54×37 cm) st
The Virgin and Child
centr pn from a trp (?)
14.6×11.0 (37×28 cm) st

**MENGS Anton Raphael**
*Aussig 1728 – Rome 1779*

The Virgin and Child with the
Infant S. John
crt; td 26.8 (68 cm)

**MERCIER Philippe**
*Berlin 1689 – London 1760*

Portrait of a Man
cv 31.9×25.6 (81×65 cm)
sg (?) d 1740

**METSU Gabriel**
*Leyden 1629 – Amsterdam 1667*

A Woman seated at a Table and
a Man tuning a Violin → no 99
cv 16.9×14.6 (43×37 cm) sg
A Man and a Woman seated by
a Virginal
pn 15.0×12.6
(38×32 cm) sg ins
Two Men with a sleeping Wo-
man*
pn 14.6×12.6 (37×32 cm)
An old Woman with a Book at
a Window
cv 12.2×10.6
(31×27 cm) sg ins
The Interior of a Smithy
cv 25.6×28.7 (65×73 cm) sg
A young Woman seated drawing
pn 14.2×11.8 (36×30 cm)

**Micas see under Bonheur**

**MEULEN Adam Frans van der**
*Brussels 1632 – Paris 1690*

Philippe-François d'Arenberg
saluted by the Leader of a
Troop of Horsemen
cv 22.8×31.9
(58×81 cm) sg d 1662

**MICHEL Georges**
*Paris 1763 – 1843*

Landscape with Trees, Build-
ings and a Road
crt/cv 17.3×26.8
(44×68 cm) attr
Stormy Landscape: Ruins on a
Plain
crt/cv 21.6×31.5
(55×80 cm) attr

**MICHELANGELO BUONARROTI**
*Caprese (Florence) 1475 – Rome
1564*

The Entombment*
pn 63.4×58.7
(161×149 cm) unfinished
Madonna and Child with S.
John and Angels (The "Man-
chester Madonna")*
pn 41.3×29.9
(105×76 cm) unfinished attr
Leda and the Swan
cv 41.3×53.1
(105×135 cm) copy

**MICHELE DA VERONA**
*Verona c 1470 – 1536-44*

Coriolanus persuaded by his
Family to spare Rome
cv 36.6×47.2 (93×120 cm)

**MIEREVELD Michiel van**
*Delft 1567 – 1641*

Portrait of a Woman
pn 24.0×19.7
(61×50 cm) sg d 1618 ins

**MIERIS Willem van**
*Leyden 1662 – 1747*

A Woman and a Fish-Pedlar in
a Kitchen
pn 19.3×16.1
(49×41 cm) sg d 1713

**MIERIS THE ELDER Frans van**
*Leyden 1635 – 1681*

A Woman in a red Jacket feed-
ing a Parrot*
copper 8.7×6.7 (22×17 cm)
Portrait of the Artist's Wife, Cu-
rina van der Cock (?)
pn 6.3×5.1 (16×13 cm)
Self-Portrait of the Artist, with
a Cittern
cv 6.7×5.5
(17×14 cm) d 1674 ins
An old Fiddler at a Window
pn 11.4×9.1
(29×23 cm) d 1660 copy

**MIGNARD Pierre**
*Troyes 1612 – Paris 1695*

The Marquise de Seignelay and
two of the Children
cv 76.4×61.0
(194×155 cm) sg d 1691
Portrait of Descartes (?)
oval cv 44.1×37.8
(112×96 cm) false (?) sg and
d 1647 ins repainted attr

**MILANESE SCHOOL**
*Fifteenth Century*

The Virgin and Child
frm (?); frs 28.7×17.7
(73×45 cm)
Bona of Savoy (?)
cv 54.7×23.6 (139×60 cm)

**MILLET Francisque**
*Antwerp 1642 – Paris 1679*

Mountain Landscape, with
Lightning
cv 38.2×50.0 (97×127 cm)

**MILLET Jean-François**
*Grouchy 1814 – Barbizon 1875*

The Whisper*
cv 18.1×15.0
(46×38 cm) sg c 1846
Landscape with Buildings
cv 14.6×17.3 (37×44 cm)
false (?) sg attr

**MOCETTO Gerolamo**
*Murano (?) c 1458 – 1531*

The Massacre of the Innocents
1239 and 1240
frm (?); panels (?)/canvases
26.4×17.3 (67×44 cm);
the first sg

**MOLA Pier Francesco**
*Coldrerio 1612 – Rome 1666*

S. John preaching in the Wil-
derness
cv 20.9×26.0 (53×66 cm)
The Rest on the Flight into
Egypt
cv 11.8×18.1 (30×46 cm)

**Style of MOLA**

Leda and the Swan
cv 15.4×19.7 (39×50 cm)

**MOLENAER Jan**
*Haarlem 1609-10 – 1668*

A young Man playing a Theorbo
and a young Woman playing
a Cittern*
cv 26.8×33.1 (68×84 cm) sg
Two Boys and a Girl making
Music → no 101
cv 26.8×33.1
(68×84 cm) sg d 1629

**Follower of MOMPER
THE YOUNGER Joos de**
*Antwerp 1564 – Brussels 1635*

A Music Party before a Village
cv 55.9×71.7
(142×182 cm) sg d 1633

**MONET Claude-Oscar**
*Paris 1840 – 1926*

Lavacourt (?), Winter
cv 23.2×31.9
(59×81 cm) sg d 1881
La plage de Trouville*
cv 14.6×18.1
(37×46 cm) sg d 1870
Le bassin aux nymphéas*
cv 34.6×36.2
(88×92 cm) sg d 1899
"L'inondation"
cv 28.0×35.8 (71×91 cm)
Water-lilies
cv 78.7×58.7 (200×149 cm)
River Scene
cv 20.9×28.3 (53×72 cm) sg
The Thames below Westminster
cv 18.5×28.3 (47×72 cm) sg d
1871

**MONTAGNA Bartolomeo
(B. Cincani)**
*Orzinuovi 1450 – Vicenza 1523*

The Virgin and Child 802
pn 25.2×21.3 (64×54 cm)
Three Saints*
frm; pn/cv 40.6×55.5
(103×141 cm) sg ins
The Virgin and Child 1098
pn/cv 23.2×20.1
(59×51 cm) attr
The Virgin and Child 1696
frm; frs 33.1×22.8
(84×58 cm) attr

**MONTICELLI Adolphe**
*Marseilles 1824 – 1886*

The Hayfield
pn 8.3×17.3 (21×44 cm) sg
Sunrise
pn 11.0×16.1 (28×41 cm) sg
Sunset
pn 12.2×17.3 (31×44 cm) sg
Torchlight Procession
pn 11.8×19.3 (30×49 cm) sg
Subject Composition 5010
pn 7.5×16.5 (19×42 cm) sg;
painted on rv
Subject Composition 5018
pn 8.3×6.3 (21×16 cm) sg
Fountain in a Park
pn 7.5×18.5 (19×47 cm) sg
Meeting Place of the Hunt
pn 7.5×18.5 (19×47 cm) sg
Still Life: Oysters, Fish
pn 18.1×24.0 (46×61 cm) sg

Still Life: Fruit
pn 17.7×24.0 (45×61 cm) sg
Wild Flowers
pn 24.0×18.5 (61×47 cm) sg
Conversation Piece
pn 13.0×9.8 (33×25 cm) sg

**MOR VAN DASHORST Anthonis**
*Utrecht c 1519 – Antwerp 1576-7*

A Man*
pn 19.3×15.7
(49×40 cm) false sg

**MORALES Luis de**
*act 1546-86 (?) Badajoz*

The Virgin and Child*
pn 11.0×7.5 (28×19 cm)

**MORANDO Paolo (Cavazzola)**
*Verona c 1486 – 1522*

S. Roch*
I wing of a trp; cv 61.8×21.6
(157×55 cm) sg d 1518
The Virgin and Child, S. John
the Baptist and an Angel
cv 29.5×25.2 (75×64 cm) sg

**MORETTO DA BRESCIA
(Alessandro Bonvicino)**
*Brescia c 1498 – 1554*

Portrait of a young Man
→ no 46
cv 44.5×37.0 (113×94 cm) ins
Madonna and Child with S. Ber-
nardino and other Saints
altarpiece; cv 139.8×91.3
(355×232 cm) ins
Portrait of a Gentleman*
cv 79.1×36.2
(201×92 cm) d 1526
Madonna and Child with SS.
Hippolytus and Catherine of
Alexandria
cv 91.3×55.5 (232×141 cm) ins
Madonna and Child with Saints
pn 17.7×24.8 (45×63 cm) ins
Portrait of a Member of the
Averoldi Family (?)
cv 50.8×35.0 (129×89 cm)
Christ blessing S. John the
Baptist
cv 25.6×36.6 (65×93 cm)

**MORISOT Berthe**
*Bourges 1841 – Paris 1895*

"Jour d'été"
cv 18.1×29.5 (46×75 cm) sg

**MORONE Domenico**
*Verona c 1442 – c 1517*

Scene at a Tournament
1211 and 1212
panels 17.7×19.3 (45×49 cm)
c 1490

**MORONE Francesco**
*Verona c 1471 – 1529*

The Virgin and Child
pn 24.4×16.9 (62×43 cm)

**MORONI Giovan Battista**
*act 1546-7 – 78 Bergamo*

Portrait of a Man (The Tailor)
→ no 49
cv 38.2×29.1 (97×74 cm)
Portrait of a Man holding a
Letter*
cv 31.9×25.6 (81×65 cm)
Portrait of a Gentleman 1022*
cv 79.5×41.7 (202×106 cm) ins
Portrait of a Gentleman 1316
cv 72.8×39.0 (185×99 cm)
Portrait of a Gentleman 2094
cv 39.0×31.5 (99×80 cm)
Portrait of a Lady
cv 60.6×41.7 (154×106 cm)
Canon Ludovico di Terzi
cv 39.4×31.9 (100×81 cm) ins
Chastity
cv 60.2×34.3 (153×87 cm) ins
Leonardo Salvagno (?)
cv 38.6×28.0 (98×71 cm) ins
Portrait of a Man
cv 16.5×14.6 (42×37 cm)
Portrait said to represent a
Count Lupi*
cv 18.5×15.4 (47×39 cm) ins
An Angel 2090 and 2091
panels 59.4×20.9
(151×53 cm) ins attr
S. Jerome
pn 59.4×20.9
(151×53 cm) ins attr

**MOSTAERT Jan**
*Haarlem c 1475 – ... 1555-6*

The Head of S. John the
Baptist, with mourning
Angels and Putti
pn 10.2×6.7 (26×17 cm)

**Style of MOSTAERT**

Christ crowned with Thorns
pn 11.8×7.9 (30×20 cm)

**MOUCHERON Frederick de**
*Emden 1633 – Amsterdam 1686*

Figures in an Italian Garden
with Fountains and Statuary
cv 28.7×36.6 (73×93 cm) sg
A Landscape with classical
Ruins
cv 28.0×25.6 (71×65 cm) sg

**MURILLO Bartolomé Esteban**
*Seville 1617 – 1682*

The two Trinities ("The pedroso
Murillo") → no 106
cv 115.4×c 81.5
(293×c 207 cm)
A peasant Boy leaning on a Sill
cv 20.5×15.0 (52×38 cm)
The Infant S. John with
the Lamb
cv 65.0×41.7 (165×106 cm)
Christ healing the Paralytic at
the Pool of Bethesda*
cv 93.3×102.8 (237×261 cm)
Self-Portrait*
cv 48.0×41.7
(122×106 cm) sg ins
The Birth of the Virgin
cv 10.2×17.7 (26×45 cm) copy
The Adoration of the Shepherds
cv 89.8×64.6 (228×c 164 cm)
res attr

**Follower of MURILLO**

The Immaculate Conception of
the Virgin
cv 83.1×49.6 (211×126 cm)
S. John the Baptist in the
Wilderness
cv 47.2×41.3 (120×105 cm)

**Style of MURILLO**

A young Man drinking
cv 24.4×18.5 (62×47 cm)

**NARDO DI CIONE**
*act c 1343-c 65 Florence*

Three Saints*
altarpiece;
pn with triple ar top 53.5×57.1
(136×145 cm) ins

**NATTIER Jean-Marc**
*Paris 1685 – 1766*

Manon Balletti*
cv 21.3×17.7
(54×45 cm) sg d 1757
Portrait of a Man in Armour
cv 21.3×17.3 (54×44 cm)

**NAZARI Nazario**
*Venice (?) 1724 – c 1793*

Andrea Tron
cv 98.0×65.4 (249×166 cm)

**NEAPOLITAN SCHOOL**
*Seventeenth Century*

Christ disputing with Doctors
cv 47.2×63.4 (120×161 cm)

*Eighteenth Century*

Portrait of a Lady
cv 36.6×29.5 (93×75 cm)

**NEEFS THE ELDER Peeter**
*Antwerp 1578 (?) – 1656-61*

Interior of a Church
pn 10.6×8.7 (27×22 cm)
Vespers*
pn 10.6×15.0
(27×38 cm) sg d 1649
in collaboration with
Bonaventura Peeters
(Antwerp 1614 - Hoboken 1652)
see also Steenwyck the
Younger

**NEER Aernout (Aert) van der**
*Gorinchem (?) 1630-4 – Amsterdam 1677*

An Evening View near a Village,
with a Man and a Milkmaid
cv 47.6×63.8 (121×162 cm) sg
A River near a Town,
by Moonlight
pn 11.8×18.9 (30×48 cm) sg
A View along a River near a
Village at Evening*
cv 52.4×65.7 (133×167 cm) sg
A frozen River by a Town
pn 10.2×15.7 (26×40 cm) sg
A frozen River near a Village,
with Golfers and Skaters
cv 15.4×20.9 (39×53 cm) sg
A Landscape with a River
cv 31.1×25.6 (79×65 cm)

A River Landscape
with a Village
pn 11.0×16.9 (28×43 cm)
false (?) sg c 1645-50
A Village by a River in
Moonlight
pn 7.5×11.0 (19×28 cm)
false (?) sg 1645 (?)
Landscape with a Horse and a
Cart by a Stream
cv 20.5×24.8 (52×63 cm)

**NEER Eglon Hendrik van der**
*Amsterdam 1634 (?) – Düsseldorf 1703*

Judith
pn 12.6×9.4 (32×24 cm) sg

**NETHERLANDISH SCHOOL**
*Fifteenth Century*

A young Man holding a Ring
pn 7.1×4.7 (18×12 cm) ins
Philip the Fair and his Sister
Margaret of Austria
ar panels 9.1×5.9
(23×15 cm) ins
c 1493-5 (?)

*Sixteenth Century*

S. Ambrose with Ambrosius
van Engelen (?)
(on rv A Crozier)
r wing from a trp (?);
pn 28.3×13.0
(72×33 cm) on rv ins
The Virgin and Child
pn 27.6×20.1 (70×51 cm)
A Girl writing
pn 10.6×9.1 (27×23 cm)
The Magdalen
pn 20.5×13.8 (52×35 cm)
A Man with a Pansy and a Skull
pn 10.6×8.3 (27×21 cm)
A young Man praying
l wing from a trp (?)
pn 9.4×7.1 (24×18 cm)
The Virgin and Child with
Saints and Angels in a Garden (l wing S. John the
Baptist, SS. Agnes and Agatha; r wing S. John the Evangelist)
trp; panels;
centr pn 26.4×16.9
(67×43 cm);
side panels 26.4×6.7
(67×17 cm)
The Virgin and Child with S.
Anne
pn 15.7×11.8 (40×30 cm)
A Man
pn 23.6×19.3 (60×49 cm)
Landscape with a River among
Mountains
frm (?); pn 20.1×26.8
(51×68 cm)
Mevr. van der Goes, née van
Spangen
pn 18.1×16.1
(46×41 cm) d 1543
The Virgin and Child in a Landscape
oval pn 31.9×31.5 (81×80 cm)
Edzard the Great, Count of East
Friesland
pn 19.3×14.2 (49×36 cm) ins
Portrait of a bearded Man
pn 16.1×11.8 (41×30 cm)
The Magdalen (?)
ar pn 16.1×12.6 (41×32 cm)
The Virgin and Child Enthroned
ar pn 9.1×5.5 (23×14 cm)
The Magdalen weeping
pn 20.5×15.0 (52×38 cm)
The Virgin and Child with two
Angels
pn 18.5×13.4 (47×34 cm)
The Birth of the Virgin (?)
pn 28.0×17.7 (71×45 cm)
Acts of Charity (?)
pn 9.8×16.5 (25×42 cm)
A little Girl with a Basket of
Cherries
cv 31.1×20.5 (79×52 cm)

**NETSCHER Caspar**
*Heidelberg 1635-6 (?) – The Hague 1684*

Two Boys blowing Bubbles
pn 12.2×9.4
(31×24 cm) sg d 1670
A Lady teaching a Child to
read, and a Child playing
with a Dog ("La maîtresse
d'école")
pn 17.7×14.6 (45×37 cm)
A Lady seated at a Spinning-
Wheel
pn 8.7×6.7
(22×17 cm) sg d 1665
Portrait of a Lady and a Girl
with Oranges*
cv 18.5×15.0
(47×38 cm) sg d 1679

Portrait of a Lady in yellow
cv 18.5×24.4
(78×62 cm) sg d 1683
Portrait of a young Man
cv 18.5×15.0
(47×38 cm) false (?) sg d 1679
st
A musical Party
cv 21.6×17.7 (55×45 cm) copy

**NEUFCHÂTEL Nicolas de**
**(Lucidel)**
*act 1561-7 Nuremberg*

Portrait of a young Lady*
cv 31.5×25.6 (80×65 cm)

**Style of NEUFCHÂTEL**

A Man with a Skull
pn 37.8×29.5 (96×75 cm)

**NICCOLÒ DELL'ABATE**
*Modena c 1509-12 – Fontainebleau 1571*

The Story of Aristaeus
cv 74.0×92.9 (188×236 cm) attr

**NICCOLÒ DI BUONACCORSO**
*act 1372-88 Siena*

The Marriage of the Virgin
pn from a trp (?);
cusped pn 16.9×10.2
(43×26 cm) sg

**NICCOLÒ DI LIBERATORE**
*act 1456-1502 Umbria and Marches*

Christ on the Cross, and other
Scenes*
(l wing The Agony in the Garden and The Way to Calvary;
r wing The Resurrection and
The Mourning over the Dead
Christ)
trp; panels; centr
pn 36.2×22.4
(92×57 cm) sg d 1487;
side panels 39.4×13.0
(100×33 cm)

**NICCOLÒ DI PIETRO GERINI**
*act 1368-1415 Tuscany*

The Baptism of Christ with SS.
Peter and Paul
trp; panels;
cusped centr pn 63.0×29.9
(160×76 cm);
medallion, td 4.7 (12 cm);
cusped side panels 48.4×14.6
(123×37 cm);
pred 18.5×78.7
(47×200 cm) attr

**NOMÉ François de**
**(Monsù Desiderio)**
*Metz 1593 – ... c 1644 (?)*

Fantastic Ruins, with a Vision
of S. Augustine
cv 17.7×26.0
(45×66 cm) d 1623

**NORTH GERMAN SCHOOL**
*Sixteenth to Seventeenth Century*

Christ carrying the Cross
pn 16.5×11.4 (42×29 cm)

**NORTH ITALIAN SCHOOL**
*Sixteenth Century*

The Adoration of the Magi
ar pn 17.3×12.6 (44×32 cm)
S. Hugh
pn 16.1×12.6 (41×32 cm) ins
Portrait of a Musician
pn 26.0×22.0 (66×56 cm)
Portrait of a Man in a large
black Hat
pn 23.6×19.3 (60×49 cm)
Portrait of a Lady in a plumed
Hat
cart/cv 17.7×13.4 (45×34 cm)

*Seventeenth Century*

A Man holding an armless
Statuette
cv 29.5×24.8
(75×63 cm) retouched
The Adoration of the Shepherds
copper 12.2×9.4 (31×24 cm)
formerly attr to Ippolito Scarsella, called Scarsellino (Ferrara 1551 – 1620)

*Eighteenth Century*

The Interior of a Theatre
cv 41.3×44.1 (105×112 cm) attr

**NOUTS Michiel**
*act 1656 Amsterdam (?)*

Family Group
cv 53.5×42.1
(136×107 cm) mutilated attr

**OCHTERVELT Jacob**
*Amsterdam (?) 1652 – Rotterdam c 1710*

A Woman standing at a Harpsichord, a Man seated by her
cv 31.1×25.6 (79×65 cm)
A young Lady trimming her
Finger-Nails, attended by a
Maidservant
cv 29.1×23.2 (74×59 cm)
A Woman playing a Virginal,
another singing and a Man
playing a Violin (Concert
Trio)*
cv 33.1×29.5
(84×75 cm) sg ins (?)

**OLIS Jan**
*Gorinchem c 1610 (?) – Heusden 1676*

A musical Party
pn 14.2×20.5
(36×52 cm) sg d 1633

**OOST THE ELDER Jacob van**
*Bruges 1601 – 1671*

Portrait of a Boy*
pn 31.5×24.8
(80×63 cm) sg d 1650
Two Boys
cv 22.0×22.8
(56×58 cm) attr

**Style of ORCAGNA**
**(Andrea di Cione)**
*act 1343 – 68-9 Florence*

The Adoration of the Shepherds
The Adoration of the Kings
The Resurrection
The Maries at the Sepulchre
The Ascension
Pentecost
panels from an altarpiece
37.4×19.3 (95×49 cm)
Seraphim, Cherubim and Angels
adoring 571 and 572
panels from an altarpiece
34.3×14.6 (87×37 cm)
The Trinity
pn from an altarpiece
34.3×15.7 (87×40 cm)
The Coronation of the Virgin
with adoring Saints
altarpiece; cusped panels;
centr pn (206×113 cm);
side panels 81.1×44.5
(169×113 cm)
The Crucifixion
(l and r of the main part,
Saints; pred The Virgin and
Child with Saints)
altarpiece; panels;
cusped centr pn 42.5×33.1
(108×84 cm);
side panels c 39.4×c 5.1
(c 100×c 13 cm);
pred medallion,
td 5.9 (15 cm) ins
"Noli me tangere"
pn 21.6×15.0 (55×38 cm)

**Oriolo see GIOVANNI**
**DA ORIOLO**

**Style of ORLEY Bernaert van**
*Brussels c 1488 (?) – 1541*

The Virgin and Child in a Landscape
pn 13.4×10.2 (34×26 cm)

**ORSI Lelio**
*Novellara 1511 – 1587*

The Walk to Emmaus*
cv 27.6×22.0 (70×56 cm) attr

**ORTOLANO**
**(Giovanni Battista Benvenuti)**
*act 1512-24 Ferrara*

SS. Sebastian, Roch and Demetrius*
altarpiece; ar pn/cv 90.6×61.0
(230×155 cm) ins

**OS Georgius Jacobus**
**Johannes van**
*The Hague 1782 – Paris 1861*

Fruit, Flowers and Game
pn 31.5×24.0 (80×61 cm) sg

**OS Jan van**
*Middelharnis 1744 – The Hague 1808*

Fruit, Flowers and a Fish
pn 28.3×22.0
(72×56 cm) sg d 1772
Dutch Vessels in calm Water
pn 12.6×16.5 (32×42 cm) sg

**OSTADE Adriaen van**
*Haarlem 1610 – 1685*

An Alchemist → no 100
pn 13.4×17.7 (34×45 cm)
sg d 1661 ins
The Interior of an Inn with nine
Peasants and a Hurdy-Gurdy
Player
pn 15.7×21.6
(40×55 cm) sg d 1653
A Peasant courting an elderly
Woman
pn 10.6×8.7
(27×22 cm) sg d 1653
A Peasant holding a Jug and a
Pipe*
pn 10.6×8.7
(27×22 cm) sg 1650-5
A Cobbler at his Stall
pn 8.7×7.1 (22×18 cm)
false sg and d 1671 copy

**OSTADE Isack van**
*Haarlem 1621 – 1649*

The Outskirts of a Village, with
a Horseman
pn 22.0×19.3 (56×49 cm)
A Winter Scene, with an Inn by
a frozen Stream*
pn 19.3×15.7 (49×40 cm) sg
A Farmyard
pn 15.7×16.1 (40×41 cm) sg
A Landscape with Peasants and
a Cart
pn 20.9×17.7
(53×45 cm) sg d 1645
An Inn by a frozen River
pn 16.1×21.6
(41×55 cm) false sg attr
The Interior of a Barn with two
Peasants
pn 11.8×15.7 (30×40 cm)

**PACCHIA Gerolamo**
*Siena 1477 – 1535*

Madonna and Child
pn 28.7×24.0 (73×61 cm)

**PACCHIAROTTO Giacomo**
*Siena 1474 – Viterbo c 1540*

The Nativity with Saints (pred
The Agony in the Garden;
The Betrayal; Christ on the
Cross; The Entombment; The
Resurrection)
altarpiece; pn 92.5×76.8
(235×195 cm) including
the frame

**Circle of PACHER Michael**
*act 1465 (?)-98 Tirol*

The Virgin and Child enthroned
with Angels and Saints*
metal 15.7×15.4 (40×39 cm)

**PADOVANINO**
**(Alessandro Varotari)**
*Padua 1588 – Venice 1648*

Cornelia and her Sons
cv 55.9×71.3
(142×181 cm) copy

**PALMA GIOVANE**
**(Jacopo Negretti)**
*Venice 1544 – 1628*

Mars and Venus
cv 51.6×65.0 (131×165 cm)

**PALMA VECCHIO**
**(Jacopo Negretti)**
*Serinalta ... – Venice 1528*

Portrait of a Poet, probably
Ariosto
cv/pn 32.7×24.8 (83×63 cm)
A blonde Woman*
pn 30.3×25.2 (77×64 cm)
S. George and a Female Saint
pn/cv 40.2×28.7 (102×73 cm)
repainted attr

**PALMEZZANO Marco**
*Forlì 1458-63 – 1539*

The dead Christ in the Tomb,
with the Virgin Mary and
Saints
pn 38.6×65.7 (98×167 cm)

**PANINI Giovanni Paolo**
*Piacenza c 1692 – Rome 1765 (?)*

Roman Ruins with Figures
cv 19.3×24.8 (49×63 cm)
Rome: The Interior of S. Peter's*
cv 59.1×87.8
(150×223 cm) sg ins

**PAOLO DA SAN LEOCADIO**
*act 1472-1520 Valencia*

The Virgin and Child with
Saints
pn 16.9×9.1 (43×23 cm) ins

PAPE Abraham
Leyden c 1621 (?) – 1666
Tobit and Anna (?)
pn 15.7×22.0
(40×56 cm) sg d 1658-9 (?)

PARMIGIANINO
(Girolamo Francesco
Maria Mazzola)
Parma 1503 – Casalmaggiore
1540
The Madonna and Child with
SS. John the Baptist and Je-
rome*
altarpiece; ar pn 135.0×58.7
(343×149 cm)

Passignano see under
Emilian School

PATENIER Joachim
Bouvigne or Dinant ... –
Antwerp c 1524
Landscape with the Rest on the
Flight into Egypt
pn 13.0×19.3 (33×49 cm) attr
S. Jerome in a rocky Landscape
pn 14.2×13.4 (36×34 cm) attr

Style of PATENIER
The Virgin and Child with a Cis-
tercian Nun (the donatrix?)
pn 13.0×9.4 (33×24 cm)

Imitator of
PATER Jean-Baptiste
Valenciennes 1695 – Paris 1736
"La danse"
cv 29.5×44.9 (75×114 cm)

Pedrini see GIAMPIETRINO

Peeters see under Neefs

PELLEGRINI Giovanni Antonio
Venice 1675 – 1741
An Allegory of the Marriage of
the Elector Palatine and An-
na Maria Luisa de' Medici
sketch; cv 16.9×24.8
(43×63 cm)
Rebecca at the Well*
cv 50.0×40.9 (127×104 cm)

Penni see under Giulio Romano

PERRONNEAU Jean-Baptiste
Paris 1715 (?) – Amsterdam 1783
A Girl with a Kitten*
pastel 23.2×19.7
(59×50 cm) sg d 1745
Madame Legrix (?)
pastel 24.0×18.9 (61×48 cm)

PERUGINO Pietro
(P. Vannucci)
Città della Pieve c 1448 –
Pontignano 1523
The Virgin and Child with S.
John
pn 26.8×17.3 (68×44 cm) sg
The Virgin and Child with SS.
Raphael and Michael**
→ no 19
panels from an altarpiece;
ar pn centr pn 50.0×25.2
(127×64 cm);
side panels 49.6×19.7
(126×50 cm); l pn sg
The Virgin and Child with SS.
Francis and Jerome*
altarpiece;
pn 72.8×59.8 (185×152 cm)
The Nativity
frs/cv 100.0×234.4
(254×598 cm) (in three pieces)
damaged repainted
The Baptism of Christ
pn 12.6×23.2 (32×59 cm) copy

Follower of PERUGINO
The Virgin and Child in a Man-
dorla with Cherubim
pn 18.1×12.6 (46×32 cm)
The Virgin and Child with SS.
Dominic and Catherine of
Siena, and two Donors
pn 13.8×12.2 (35×31 cm)

PERUZZI Baldassare
Siena 1481 – Rome 1536
The Adoration of the Magi
crt 44.1×42.1
(112×107 cm) sg 1522-3
see also Gerolamo da Treviso

PESELLINO
(Francesco di Stefano)
Florence c 1422 – 1457

The Trinity with Saints***
(pred S. Mamas in prison
thrown to the lions; The Be-
heading of S. James the
Great; S. Zeno exorcizing the
daughter of the emperor Gal-
lienus; S. Jerome and the
lion)
altarpiece; panels 72.4×71.3
(184×181 cm);
pred c 10.6×15.4 (c 27×39 cm)

PIAZZA Martino
(M. de' Toccagni)
act c 1513-22 Lodi
S. John the Baptist in the Des-
ert
pn 27.2×20.5
(69×52 cm) sg attr

PIAZZA DA LODI Calisto
act 1514-62 Lodi and Brescia
Portrait of a Man
pn 29.5×23.2 (75×59 cm) attr

PIAZZETTA Giovanni Battista
Venice 1683 – 1754
The Sacrifice of Isaac
cv 79.1×52.4 (201×133 cm)

PIERO DELLA FRANCESCA
Borgo San Sepolcro 1415-20 –
1492
The Baptism of Christ → no 13
pn (?) from an altarpiece;
ar pn 65.7×45.7 (167×116 cm)
S. Michael*
pn from a polyptych;
ar pn 52.4×23.2
(133×59 cm) ins.
The Nativity
pn 48.8×48.4 (124×123 cm)
A Battle
pn 28.0×37.0
(71×94 cm) copy (?)

PIERO DI COSIMO
Florence c 1462 – c 1515
A Mythological Subject
→ no 14 (The Death of Pro-
cris?)
pn 25.6×72.0 (65×183 cm);
on rv drw
The Fight between the Lapiths
and the Centaurs*
pn 28.0×102.4 (71×260 cm)
Portrait of a Man in Armour
pn 27.6×20.1 (70×51 cm) attr

PINTORICCHIO
(Bernardino di Betto)
Perugia c 1454 – Siena 1513
S. Catherine of Alexandria with
an ecclesiastical Donor
pn 22.0×15.0 (56×38 cm)
The Virgin and Child*
pn 22.4×15.7 (57×40 cm)
Scenes from the Odyssey*
frs/cv 49.2×59.8 (125×152 cm)

PISANELLO
(Antonio di Puccio Pisano)
Pisa (?) c 1395 – Rome (?)
1455 (?)
The Virgin and Child with SS.
George and Anthony Abbot
→ no 4
pn 18.5×11.4 (47×29 cm) sg
The Vision of S. Eustace (?)
→ no 5
pn 21.3×25.6 (54×65 cm)

PISSARRO Camille
St. Thomas 1830 – Paris 1903
View from Louveciennes
cv 20.5×32.3 (52×82 cm) sg
Paris, the Boulevard Montmar-
tre at Night
cv 20.9×25.6 (53×65 cm) 1897
The Côte des Bœufs at l'Hermi-
tage, near Pontoise → no 133
cv 45.3×34.3
(115×87 cm) sg d 1877
Le Louvre, matin, effet de
neige, 2e série → no 134
cv 25.6×31.9
(65×81 cm) sg d 1902
Lower Norwood, Londres, effet
de neige*
cv 13.8×18.1
(35×46 cm) sg d 1870

PITTONI Giovanni Battista
Venice 1687 – 1767
The Nativity with God the Fa-
ther and the Holy Ghost
cv 87.8×60.2
(223×153 cm) repainted

PLAS Peeter van der
Brussels or Haarlem c 1595 –
Brussels c 1647
Portrait of a Preacher (?)
cv 28.0×23.2
(71×59 cm) sg attr

POEL Egbert van der
Delft 1621 – Rotterdam 1664
A view of Delft after the Explo-
sion of 1654
pn 14.2×19.3
(36×49 cm) sg d 1654

POELENBURGH Cornelis van
Utrecht or Houbraken 1586 (?) –
Utrecht 1667
A Landscape with an Italian Hill
Town*
cv 8.7×13.4 (22×34 cm)
see also Both

POLLAIUOLO
Antonio and Piero del
Florence c 1432 – Rome 1498;
Florence c 1441 – Rome c 1496
The Martyrdom of S. Sebastian*
altarpiece; pn 114.6×79.5
(291×202 cm) attr
Apollo and Daphne
pn 11.4×7.9 (29×20 cm) attr

PONTORMO
(Jacopo Carucci)
Pontormo 1494 – Florence 1557
Joseph in Egypt
pn 37.8×42.9 (96×109 cm)
A Discussion (Herod and the
Three Magi)
pn/cv 13.8×9.1 (35×23 cm)
Madonna and Child with the
Infant S. John the Baptist*
pn 13.8×22.8 (81×58 cm)

POORTER Willem de
Haarlem (?) 1608 – ... c 1648
An allegorical Subject
pn 19.7×14.6 (50×37 cm) sg

PORDENONE Giovanni Antonio
(G. A. de' Sacchis or
de' Lodesanis)
Pordenone c 1483 – Ferrara 1539
S. Bonaventure
octagonal pn 28.3×27.6
(72×70 cm)
S. Louis of Toulouse
octagonal pn 28.3×28.0
(72×71 cm)
Portrait of a Lady
pn 20.1×16.1 (51×41 cm) attr

PORTUGUESE SCHOOL
Sixteenth Century
The mystic Marriage of S. Cath-
erine
pn 13.0×9.8 (33×25 cm)

POT Hendrick
Haarlem (?) c 1585 – Amster-
dam 1657
A merry Company at Table*
pn 12.6×19.3 (32×49 cm) sg

POTTER Paulus
Enkhuizen 1625 – Amsterdam
1654
A Landscape with Cows, Sheep
and Horses by a Barn
pn 22.4×13.0
(57×33 cm) sg d 1651
Cattle and Sheep in a stormy
Landscape
pn 18.1×15.0
(46×38 cm) sg d 1647

Poussin Gaspard see DUGHET

POUSSIN Nicolas
Les Andelys 1594 (?) – Rome
1665
Bacchanal
cv 29.5×38.2
(75×97 cm) unfinished
Bacchanalian Revel before a
Term of Pan
cv 39.4×55.9
(100×142 cm) 1630
Cephalus and Aurora
cv 37.8×51.2 (96×130 cm)
The Annunciation
cv 41.3×40.6
(105×103 cm) sg d 1657
The Adoration of the golden
Calf → no 120
cv 60.6×84.3 (154×214 cm)
Landscape with a Snake*
cv 46.9×78.0 (119×198 cm)

The Adoration of the Shep-
herds*
cv 37.8×28.7 (96×73 cm) sg
Landscape in the Roman Cam-
pagna with a Man scooping
Water
cv 24.8×30.3 (63×77 cm)
Landscape in the Roman Cam-
pagna
cv 24.4×29.1 (62×74 cm)
Landscape: a Man washing his
Feet at a Fountain
cv 29.1×39.4
(74×100 cm) copy
Sleeping Nymph surprised by
Satyrs
cv 26.0×19.7 (66×50 cm) copy
The Plague at Ashwood
cv 50.8×80.3
(129×204 cm) copy
The Holy Family with SS. Eliz-
abeth and John
cv 26.8×20.1 (68×51 cm) copy
Bacchanalian Festival
cv 56.3×47.6
(143×121 cm) copy (?)

Follower of POUSSIN Nicolas
Italian Landscape
cv 21.3×16.9 (54×43 cm)
Phineus and his followers turn-
ed to stone
cv 56.3×47.6 (143×121 cm)

POUSSIN Pierre-Charles
Paris 1819 – 1904
"Pardon Day in Brittany"
cv 57.5×129.1
(146×328 cm) sg d 1851

POZZOSERRATO Ludovico
act 1581-1603-5 Treviso
Landscape with mythological
Figures
cv 72.4×81.1
(184×206 cm) attr
The Sons of Boreas pursuing
the Harpies
cv 72.4×80.7 (184×205 cm) attr

Preda see DE PREDIS

PRETI Mattia
Taverna 1613 – Valletta 1699
The Marriage at Cana*
cv 79.9×89.0 (203×226 cm)

PREVITALI Andrea
act 1502-28 Bergamo and Ven-
ice (?)
The Virgin and Child with a
Donor
pn 20.9×27.2 (53×69 cm)
The Virgin and Child with SS.
John the Baptist and Cath-
erine*
pn 25.6×33.5
(65×85 cm) sg d 1504
The Virgin and Child
pn 19.7×26.0 (50×66 cm)
Salvator Mundi 3087*
cv 18.5×15.0 (47×38 cm)
The Virgin and Child with two
Angels
pn/cv 26.4×36.2
(67×92 cm) attr
Scenes from an Eclogue of Te-
baldeo
two panels 7.9×7.1
(20×18 cm) attr

PROCACCINI Giulio Cesare
Bologna 1574 – Milan 1625
The dead Christ supported by
Angels
pn 24.4×18.1 (62×46 cm) attr

PROVOOST Jan
Mons 1465 – Bruges 1529
The Virgin and Child in a Land-
scape
pn 23.6×19.7 (60×50 cm) attr

PULZONE Scipione
Gaeta c 1550 – Rome 1598
Portrait of a Cardinal*
copper 37.0×28.0 (94×71 cm)

PUVIS DE CHAVANNES
Pierre-Cécile
Lyons 1824 – Paris 1898
The Beheading of S. John the
Baptist
cv 94.5×124.4
(240×316 cm) unfinished
"La toilette"
crt 12.6×9.4
(32×24 cm) sg unfinished
Death and the Maidens
sketch; crt 15.7×12.2
(40×31 cm) c 1872

Summer
sketch; cv 16.9×24.4
(43×62 cm) c 1873

QUAST Pieter
Amsterdam 1605-6 – 1647
A Man and a Woman in a Sta-
bleyard
pn 17.7×22.4 (45×57 cm) sg
A Standing Man
pn 13.8×9.1 (35×23 cm) sg

RAFFAELLINO DEL GARBO
act c 1479 (?)-1527 (?) Florence
Portrait of a Man*
pn 20.1×13.8 (51×35 cm) attr
The Virgin and Child with two
Angels
pn/cv, td 33.1 (84 cm) attr
The Virgin and Child with the
Magdalen and S. Catherine of
Alexandria
pn/cv, td 50.4 (128 cm) attr

RAGUINEAU Abraham
London 1623 – ... c 1681
Portrait of a young Man in grey
oval pn 29.1×23.6
(74×60 cm) sg d 1657

RAPHAEL (Raffaello Santi)
Urbino 1483 – Rome 1520
S. Catherine of Alexandria
→ no 28
pn 28.0×21.6 (71×55 cm)
An Allegory ("Vision of a
Knight") 213 → no 26
pn 6.7×6.7 (17×17 cm)
An Allegory 213 A → no 27
crt 7.1×8.3 (18×21 cm)
Madonna and Child with the
Infant Baptist ("The Aldobran-
dini Madonna" or "The Gar-
vagh Madonna")*
pn 15.0×12.6 (38×32 cm)
Madonna and Child with S.
John the Baptist and S. Nich-
olas of Bari ("The Ansidei
Madonna")*
altarpiece; ar pn 93.7×61.4
(238×156 cm) ins
Madonna and Child ("The
Mackintosh Madonna") 2069
pn/cv 30.7×25.2 (78×64 cm)
The Procession to Calvary
pn 9.4×33.5 (24×85 cm)
The crucified Christ with the
Virgin Mary, Saints and An-
gels → no 25 (The Mond Cru-
cifixion)
altarpiece; ar pn 110.2×65.0
(280×165 cm) sg
Pope Julius II*
pn 42.5×31.5 (108×80 cm)
Madonna and Child ("The Sis-
tine Madonna") 661
crt/cv 101.2×79.9
(257×203 cm) copy
Madonna and Child 929
pn 34.3×24.0 (87×61 cm) copy

REMBRANDT HARMENSZ.
VAN RIJN
Leyden 1606 – Amsterdam 1669
The Deposition
crt and cv/pn 12.6×10.6
(32×27 cm)
The Woman taken in Adultery
→ no 82
pn 33.1×25.6 (84×65 cm)
sg d 1644 multilated (?)
The Adoration of the Shepherds
cv 25.6×21.6
(65×55 cm) sg d 1646
A Woman bathing in a Stream
(Hendrickje Stoffels [?])
→ no 83
pn 24.4×18.5
(62×47 cm) sg d 1655
A Franciscan Monk
cv 35.0×26.0
(89×66 cm) sg d 165...
Bust of a bearded Man in a
Cap*
cv 30.7×26.0
(78×66 cm) sg d 165...
Portrait of the Painter in old
Age; in a red Jacket with a
Fur Collar, his hands clasped
cv 33.9×27.6
(86×70 cm) c 1659-60
An elderly Man as S. Paul
cv 40.2×33.5
(102×85 cm) sg d 1659 (?)
in the top r corner Abraham's
Sacrifice
Self-Portrait at the Age of 34*
cv 40.2×31.5
(102×80 cm) sg d 1640 ins

Portrait of an 83-year-old Woman → no 85
oval pn 26.8×20.9 (68×53 cm) sg d 1634 ins
Portrait of Philips Lucasz. (?)
pn 31.1×23.2 (79×59 cm) sg d 1635
Christ presented to the People ("Ecce Homo")
crt/cv 21.3×17.3 (54×44 cm) grisaille sg d 1634
Jacob Trip
Margaretha de Geer 1675 Husband and wife portraits
canvases 51.2×38.2 (130×97 cm); the first sg
A Man seated reading at a Table in a lofty Room
pn 21.6×18.1 (55×46 cm) false sg
Saskia van Ulenborch in Arcadian Costume
cv 48.4×38.2 (123×97 cm) false sg d 1635 mutilated (?)
Portrait of Margaretha de Geer, Wife of Jacob Trip 5282
cv 29.5×25.2 (75×64 cm) sg d 1661
An old Man in an Armchair, leaning his Head on his right Hand
cv 43.7×34.6 (111×88 cm) sg d 1652
Equestrian Portrait
cv 115.7×94.5 (294×240 cm) sg d 1663
Anna and the blind Tobit
pn 24.8×18.5 (63×47 cm) false sg in collaboration with Gerrit Dou
A seated Man with a Stick ("A Jew Merchant")
cv 53.9×41.3 (137×105 cm) false (?) sg attr
The Militia Company of Captain Banning Cocq (The "Night Watch")
pn 26.0×26.4 (66×67 cm) copy
Belshazzar's Feast → no 84
cv 65.7×82.3 (167×209 cm) sg d 163... ins

**Follower of REMBRANDT**
A young Man and a Girl playing Cards
cv 48.4×40.9 (123×104 cm)
Diana bathing surprised by a Satyr (?)
pn 18.1×13.8 (46×35 cm) false sg

**Imitator of REMBRANDT**
A Study of an elderly Man in a Cap
cv 26.4×20.9 (67×53 cm) sg false d 1648 (?)

**RENI Guido**
*Bologna 1575 – 1642*
Christ embracing S. John the Baptist
cv 18.9×26.8 (48×68 cm)
Lot and his Daughters leaving Sodom*
cv 43.7×58.7 (111×149 cm)
The Coronation of the Virgin
copper 26.0×18.9 (66×48 cm)
The Adoration of the Shepherds
cv 188.9×126.4 (480×321 cm) ins
The Toilet of Venus
cv 111.0×81.1 (282×206 cm) st (?)
Christ with the Crown of Thorns
oval cv 21.3×15.7 (54×40 cm) copy
Susannah and the Elders
cv 45.7×59.1 (116×150 cm) copy
Perseus and Andromeda
cv 110.2×81.1 (280×206 cm) copy
S. Jerome
cv 43.7×33.9 (111×86 cm) copy

**Style of RENI**
S. Mary Magdalen
cv 31.1×26.8 (79×68 cm)

**RENOIR Pierre-Auguste**
*Limoges 1841 – Cagnes 1919*
"Les parapluies" → no 135
cv 70.9×45.3 (180×115 cm) sg
"Le Café-concert" ("La première Sortie") → no 137
cv 25.6×20.1 (65×51 cm) sg
"La nymphe à la source"*
cv 26.0×48.8 (66×124 cm) sg
Moulin Huet Bay, Guernesey
cv 11.4×21.3 (29×54 cm) sg

Portrait of Misia*
cv 36.2×28.7 (92×73 cm) sg d 1904
"La danseuse au tambourin"*
"La danseuse aux castagnettes"*
canvases 61.0×25.6 (155×65 cm) sg d ... 09
"Baigneuse se coiffant" → no 136
cv 15.4×11.4 (39×29 cm) sg

Reymerswaele see **MARINUS VAN REYMERSWAELE**

**REYNOLDS Joshua**
*Plympton 1723 – London 1792*
Lord Heathfield, Governor of Gibraltar
cv 55.9×53.1 (142×135 cm)
Captain Robert Orme*
cv 94.5×57.9 (240×147 cm) sg d 1756
Anne, Countess of Albemarle
cv 49.6×39.8 (126×101 cm)
Lady Cockburn, and her three eldest Sons*
cv 55.5×44.5 (141×113 cm) sg d 1773
Mr. Huddesford and Mr. Bampfylde
cv 49.6×39.4 (126×100 cm)
General Sir Banastre Tarleton → no 113
cv 92.9×57.1 (236×145 cm) 1782

**RIBALTA Francisco**
*Solsona 1565 – Valencia 1628*
The Vision of Father Simón
cv 83.1× 43.3 (211×110 cm) sg d 1612

**RIBERA Jusepe de (Lo Spagnoletto)**
*Játiva 1591 (?) – Naples 1662*
The Lamentation over the dead Christ*
cv 50.8×71.3 (129×181 cm)
Jacob with the Flock of Laban
cv 52.0×46.5 (132×118 cm) sg d 1638 (?)

**RICARD Louis-Gustave**
*Marseilles 1823 – Paris 1873*
Portrait of a Man
cv 25.2×21.3 (64×54 cm) 1866
The Countess of Desart as a Child
oval pn 21.3×17.7 (54×45 cm) sg

**RICCI Sebastiano**
*Belluno 1659 – Venice 1734*
Bacchus and Ariadne
cv 29.9×24.8 (76×63 cm)
Esther before Ahasuerus
cv 18.5×13.0 (47×33 cm)

**RIGAUD Hyacinthe**
*Perpignan 1659 – Paris 1743*
Cardinal Fleury
cv 31.5×25.6 (80×65 cm) st

Rimini see **GIOVANNI FRANCESCO DA RIMINI**

**ROBERTI Ercole de'**
*act 1479-96 Ferrara and Bologna (?)*
The Israelites gathering Manna*
pn/cv 11.4×24.8 (29×63 cm)
The Adoration of the Shepherds and the dead Christ
two panels 6.7×5.1 (17×13 cm) attr
The Last Supper
pn 11.8×8.3 (30×21 cm) attr

**ROGHMAN Roelant**
*act c 1646-86 Amsterdam (?)*
A mountainous Landscape
cv 24.8×29.1 (63×74 cm)

**ROMAN SCHOOL**
*I to II Century (?)*
Crane, Python and Lizard
frm from a mosaic 9.1×11.4 (23×29 cm) attr
*II Century (?)*
"The Water of Life"
frm from a mosaic 19.7×20.1 (50×51 cm)
*Seventeenth Century*
S. Cecilia
cv 56.3×42.5 (143×108 cm)

**ROMANINO Gerolamo (G. da Romano)**
*Brescia c 1484-7 – c 1559*
The Nativity with SS. Alessandro, Jerome, Gaudiosa and Filippo Benizzi*
polyptych; ar centr
pn 102.4×45.3 (260×115 cm); lower wings 62.2×25.2 (158×64 cm); upper wings 29.1×25.2 (74×64 cm)
Pegasus and the Muses
pn 15.0×45.3 (38×115 cm) attr

Romano see **GIULIO ROMANO**

**ROSA Salvator**
*Naples 1615 – Rome 1673*
Landscape with Mercury and the Dishonest Woodman
cv 49.2×79.5 (125×202 cm)
Self-Portrait*
cv 45.7×37.0 (116×94 cm) ins
Landscape with Tobias and the Angel
cv 57.9×88.2 (147×224 cm)
"The Philosophers' Wood"
cv 58.3×86.6 (148×220 cm) copy
Hagar and Ishmael in the Desert
cv 52.0×37.4 (132×95 cm) copy

**Style of ROSA**
Forest Scene, with Tobias and the Angel
cv 92.9×133.5 (236×339 cm)
A coastal Scene
cv 34.6×46.5 (88×118 cm)
Landscape with Figures
cv 29.9×43.7 (76×111 cm)

**ROSLIN Alexandre**
*Malmö 1718 – Paris 1793*
The Dauphin, Son of Louis XV
cv 31.5×25.2 (80×64 cm)

Rossi see **SALVIATI**

**ROUSSEAU Henri ('Le Douanier')**
*Laval 1844 – Paris 1910*
Tropical Storm, with a Tiger
cv 51.2×63.8 (130×162 cm) sg d 1891

**ROUSSEAU Philippe**
*Paris 1816 – Acquigny 1887*
The Fish Market
pn 9.4×13.4 (24×34 cm) sg
Still Life, with Oysters
cv 16.5×24.4 (42×62 cm) sg
A Valley
cv 31.9×39.0 (81×99 cm) sg

**ROUSSEAU Pierre-Étienne-Théodore**
*Paris 1812 – Barbizon 1867*
River (?) Scene
pn 12.2×15.7 (31×40 cm) sg
Sunset in the Auvergne (?)
pn 7.9×9.4 (20×24 cm) sg
Moonlight: the Bathers
cv 20.5×26.4 (52×67 cm)
The Valley of Saint-Vincent (?)
cv 7.1×12.6 (18×32 cm) sg (?)
Rocks
crt 11.0×16.9 (28×43 cm)
Landscape
crt 19.7×26.4 (50×67 cm) sg

**RUBENS Peter Paul**
*Siegen 1577 – Antwerp 1640*
The Rape of the Sabine Women*
pn 66.9×92.9 (170×236 cm)
Minerva protects Pax from Mars (Peace and War) → no 76
cv 79.9×117.3 (203×298 cm)
S. Bavo is about to receive the monastic habit at Ghent
(l wing Three Female Saints; r wing Dispute of Clotaire and Dagobert with an Ambassador of Emperor Maurice)
trp; panels; centr pn 42.1×32.3 (107×82 cm)
wings 42.5×16.1 (108×41 cm)
The brazen Serpent
cv 74.0×104.7 (188×266 cm)
An Autumn Landscape with a View of Hit Steen in early Morning → no 75
pn 53.9×90.9 (137×231 cm)
A Landscape with a Shepherd and his Flock
pn 19.3×32.7 (49×83 cm)
Minerva and Mercury conduct the Duke of Buckingham to the Temple of Virtus (?)
pn 25.2×25.2 (64×64 cm)

Paris awards the golden Apple to Venus (The Judgment of Paris) 194*
pn 57.1×76.4 (145×194 cm)
Paris awards the golden Apple to Venus (The Judgment of Paris) 6379
pn 54.7×68.5 (139×174 cm)
A Roman Triumph*
cv 34.3×64.6 (87×164 cm)
The miraculous Draught of Fishes
crt/cv 21.6×33.5 (55×85 cm)
Susanna Fourment (?) ("Le chapeau de paille") → no 77
pn 31.1×21.3 (79×54 cm)
A Lion Hunt
pn 29.1×41.3 (74×105 cm) grisaille
The Birth of Venus
pn 24.0×30.7 (61×78 cm) grisaille
The Crucifixion (The "Coup de lance")*
pn 25.6×19.7 (65×50 cm) grisaille formerly attr to van Dyck
Aurora abducting Cephalus (Diana and Endymion?)
pn 12.2×18.9 (31×48 cm)
A Shepherd with his Flock in a woody Landscape*
pn 25.2×37.0 (64×94 cm)
Thomas Howard, 2nd Earl of Arundel*
cv 26.4×21.3 (67×54 cm)
Peasants with Cattle by a Stream in a woody Landscape ("The Watering Place")
pn 39.0×53.1 (99×135 cm)
Portrait of Ludovicus Nonnius
pn 48.8×36.2 (124×92 cm) ins
A Wagon fording a Stream
crt/cv 18.5×27.6 (47×70 cm) attr
Drunken Silenus supported by Satyrs
cv 52.4×77.6 (133×197 cm) st formerly attr to van Dyck
The Holy Family with Saints in a Landscape
cv 46.9×62.2 (119×158 cm) attr st
Archduke Albert
cv 48.0×35.0 (122×89 cm) attr st
Infanta Isabella Clara Eugenia
cv 47.2×35.0 (120×89 cm) attr st
An Allegory showing the Effects of War ("The Horrors of War")
crt/cv 18.9×29.9 (48×76 cm) copy

**RUISDAEL Jacob van**
*Haarlem 1628-9 – Amsterdam (?) 1682*
A bleaching Ground in a Hollow by a Cottage
pn 20.5×26.8 (52×68 cm) sg ins 1650 (?)
A Waterfall in a rocky Landscape
cv 38.6×33.5 (98×85 cm) false sg
A Landscape with a Waterfall and a Castle on a Hill
cv 39.8×33.9 (101×86 cm) sg
Ruins in a Dune Landscape
pn 16.1×22.4 (41×57 cm) false (?) sg false d 1673
A Pool surrounded by Trees, and two Sportsmen coursing a Hare
cv 42.1×56.3 (107×143 cm) sg 1660 (?)
A Waterfall at the Foot of a Hill, near a Village
cv 33.5×39.4 (85×100 cm) sg c 1660
Two Watermills
cv 34.3×43.7 (87×111 cm) sg
A Road winding between Trees towards a distant Cottage
pn 12.6×11.8 (32×30 cm) sg c 1649
An extensive Landscape with a ruined Castle and a Village Church*
cv 42.9×57.5 (109×146 cm) sg
The Shore at Egmond-aan-Zee → no 94
cv 20.9×26.0 (53×66 cm) sg c 1675
An extensive Landscape with Ruins
cv 13.4×15.7 (34×40 cm) sg
A ruined Castle Gateway*
crt/cv 18.1×25.2 (46×64 cm) sg
A Cottage and a Hayrick by a River
pn 10.2×13.0 (26×33 cm) false sg

Vessels in a fresh Breeze
cv 17.3×21.3 (44×54 cm) sg
A Landscape with a ruined Building at the Foot of a Hill by a River
pn 9.1×11.4 (23×29 cm) false (?) sg attr
A rocky Hill with three Cottages, a Stream at its Foot
cv 21.6×26.0 (55×66 cm) false (?) sg attr

**Follower of RUISDAEL**
Three Watermills at the Foot of a steep Hill; Washer-Women in the foreground
cv 23.6×29.1 (60×74 cm) false ins
A Road leading into a Wood
cv 21.3×28.0 (54×71 cm) false sg
The Skirts of a Forest
cv 22.4×27.6 (57×70 cm) false sg

**Imitator of RUISDAEL**
A Castle on a Hill by a River
cv 55.1×69.3 (140×176 cm) false sg ("M. Hobbem... ")

**101**

**RUYSDAEL Jacob Salomonsz. van**
*Haarlem 1629-30 (?) – 1681*
A Waterfall by a Cottage in a hilly Landscape
cv 40.6×34.3 (103×87 cm) sg

**RUYSDAEL Salomon van**
*Naarden 1600-3 (?) – Haarlem 1670*
A Landscape with a Carriage and Horsemen at a Pool*
pn 19.7×24.8 (50×63 cm) sg d 1659
A River Landscape with Fishermen
pn 14.2×25.6 (36×65 cm) sg d 1631
A River with Fishermen drawing a Net
pn 18.1×24.8 (46×63 cm)
A View of Rhenen from the West
pn 11.8×16.1 (30×41 cm)
A View of Deventer
cv 20.5×29.9 (52×76 cm) sg d 1657
River Scene
pn 20.1×37.8 (51×96 cm) sg d 1632

**RYCKAERT Marten**
*Antwerp 1587 – 1631*
Landscape with Satyrs
pn 3.9×7.9 (10×20 cm) attr

**SACCHI Andrea**
*Nettuno (Rome) 1599 (?) – Rome 1661*
SS. Anthony Abbot and Francis of Assisi
cv 24.0×30.7 (61×78 cm) additions at each side

**SACCHI Pier Francesco**
*Pavia c 1485 – Genova 1528*
S. Paul writing
pn 41.7×32.3 (106×82 cm) ins

**SAENREDAM Pieter**
*Assendelft 1597 – Haarlem 1665*
The Interior of the Buurkerk at Utrecht
pn 23.6×19.7 (60×50 cm) sg ins
The Interior of the Grote Kerk at Haarlem*
pn 23.2×31.9 (59×81 cm) 1636-7

**SAFTLEVEN Herman**
*Rotterdam 1609 – Utrecht 1685*
Christ teaching out of S. Peter's Boat on the Lake of Gennesaret
pn 18.1×24.4 (46×62 cm) sg d 1667

**SAINT-AUBIN Gabriel-Jacques de**
*Paris 1724 – 1780*
A Street Show in Paris ("La parade du boulevard")*
cv 31.5×25.2 (80×64 cm)

Salvi see **SASSOFERRATO**

**Follower of SALVIATI Francesco or Cecchino (F. de' Rossi)**
*Florence 1510 – Rome 1563*
Charity
pn 9.4×6.7 (24×17 cm)

**SALVIATI Giuseppe (G. Porta)**
*act 1535-73 Venice*
Justice*
cv 34.3×40.9 (87×104 cm)

Santacroce see **GEROLAMO DA SANTACROCE**

**SANTI Giovanni**
*act 1469-94 Urbino*
The Virgin and Child
pn 26.8×19.3 (68×49 cm)

Santi Raffaello see **RAPHAEL**

**SANTVOORT Dirck**
*Amsterdam 1610-1 – 1680*
Portrait of a Girl with a Finch
pn 24.4×19.7 (62×50 cm) sg d 1631 (?) mutilated

**SANTVOORT Philipp van**
*act c 1711-21 Antwerp*
The Rape of Tamar by Ammon
pn 23.6×19.3 (60×49 cm) sg d 17...

Sarto see **ANDREA DEL SARTO**

**SASSETTA (Stefano di Giovanni)**
*Siena 1392 (?) – 1450*
The Whim of the young S. Francis to become a Soldier*
S. Francis renounces his earthly Father*
The Pope accords Recognition to the Franciscan Order
The Stigmatization of S. Francis
S. Francis bears Witness to the Christian Faith before the Sultan
The Legend of the Wolf of Gubbio → no 3
The Funeral of S. Francis
panels from an altarpiece; panels with triple ar tops
c 34.3×c 20.5 (c 87×c 52 cm) 1437-44

**SASSOFERRATO (Giovanni Battista Salvi)**
*Sassoferrato 1609 – Rome (?) 1685*
The Virgin in Prayer
cv 28.7×22.4 (73×57 cm)
The Virgin and Child*
cv 38.2×29.1 (97×74 cm)

**SAVERY Roelandt**
*Courtrai 1576 (?) – Utrecht (?) 1639*
Orpheus
pn 20.9×31.9 (53×81 cm) sg d 1628

**SAVOLDO Gian Gerolamo**
*Brescia c 1480 – c 1548*
S. Mary Magdalen approaching the Sepulchre → no 47
cv 33.9×31.1 (86×79 cm)
S. Jerome
cv 47.2×62.2 (120×158 cm) sg

Scarsellino see under **North Italian School**

**SCHALCKE Cornelis van der**
*Haarlem 1611 – 1671*
An extensive River Landscape, with two Sportsmen and their Greyhounds
cv 39.4×58.7 (100×149 cm)

**SCHALCKEN Godfried**
*Made 1643 – The Hague 1706*
Lesbia weighing her Sparrow against Jewels
copper 6.7×5.1 (17×13 cm)
An old Woman at a Window scouring a Pot*
pn 11.0×8.7 (28×22 cm) sg
A Woman singing and a Man with a Cittern
pn 10.2×7.9 (26×20 cm) sg
A Candle-Light Scene; a Man offering a gold Chain and Coins to a Girl
copper 5.9×7.5 (15×19 cm) sg

**SCHEFFER Ary**
*Dordrecht 1795 – Paris 1858*
Mrs. Robert Hollond
cv 32.3×23.6 (82×60 cm) sg d 1851
SS. Augustine and Monica
cv 53.1×40.9 (135×104 cm) sg d 1854

**SCHIAVONE (Andrea Meldolla)**
*Zadar ... – Venice 1563*
A mythological Figure
cv 7.1×7.1 (18×18 cm) attr
Two mythological Figures
cv 7.1×7.1 (18×18 cm) attr

**SCHIAVONE Giorgio (G. Chiulinovich)**
*Scodrin 1436-7 – Sebenico 1504*
Polyptych of ten Panels (lower row S. Anthony of Padua; S. Bernardino; The Virgin and Child Enthroned; S. John the Baptist; S. Peter Martyr; upper row S. Jerome; S. Catherine; Pietà; S. Sebastian; A Female Saint)
panels 26.0×9.1; 28.3×9.8; 35.8×13.8 sg; 28.3×9.1; 26.0×9.1; 12.6×9.8; 11.8×9.1; 14.6×10.2; 11.8×9.1; 12.6×9.8 (66×23 cm; 72×25 cm; 91×35 cm; 72×25 cm; 66×23 cm; 32×25 cm; 30×23 cm; 37×26 cm; 30×23 cm; 32×25 cm)
The Virgin and Child
pn 22.0×16.1 (56×41 cm) ins attr

**SCHOLDERER Otto Franz**
*Frankfort 1834 – 1902*
Portrait of the Artist's Wife
cv 12.6×16.1 (32×41 cm) sg
Lilac
cv 19.7×14.6 (50×37 cm) sg

**Style of SCHONGAUER Martin**
*act 1469-91 Cologne*
The Virgin and Child in a Garden
pn 11.8×8.3 (30×21 cm)

**SCHWEICKHARDT Heinrich Wilhelm**
*Brandenburg 1746 – London 1797*
Cattle
pn 18.1×24.0 (46×61 cm) sg d 1794

**SEBASTIANO DEL PIOMBO (S. Luciani)**
*Venice c 1485 – Rome 1547*
The Raising of Lazarus → no 33
pn/cv 150.0×113.8 (381×289 cm) sg
A Lady as S. Agatha
cv 36.2×29.5 (92×75 cm) sg
Madonna and Child with SS. Joseph and John the Baptist and a Donor*
pn 38.6×41.7 (98×106 cm)
The Daughter of Herodias
pn 21.6×17.3 (55×44 cm)

**Style of SEGHERS Hercules**
*Haarlem 1589-90 – The Hague c 1633*
A Mountain Landscape
pn 22.4×32.3 (57×82 cm)

**Style of SEGNA DI BONAVENTURA**
*act 1298-1326-31 Siena*
Crucifix
pn 83.9×72.4 (213×184 cm) ins

**SEISENEGGER Jacob**
*... 1504-5 – Linz 1567*
Portrait of a Girl
pn 11.0×8.3 (28×21 cm)

**SEURAT Georges-Pierre**
*Paris 1859 – 1891*
"Une baignade, Asnières" → no 140
cv 79.1×118.5 (201×301 cm) sg

**SHEE Martin Archer**
*Dublin 1769 – Brighton 1850*
W. T. Lewis as the Marquis in "The Midnight Hour"*
cv 94.1×57.9 (239×147 cm)

**SIBERECHTS Jan**
*Antwerp 1627 – London 1700-3*
A Cowherd passing a Horse and a Cart in a Stream (The Water Lane)
cv 25.2×21.3 (64×54 cm) sg d 1658 (?)

**SIENESE SCHOOL**
*Fourteenth Century*
S. Mary Magdalen
S. Peter
panels from a polyptych; cusped panels
23.2×13.0 (59×33 cm)

*Fifteenth Century*
The Marriage of the Virgin
pn 16.1×13.0 (41×33 cm)

**SIGNORELLI Luca**
*Cortona 1441 (?) – 1523*
The Triumph of Chastity: Love disarmed and bound
frs/cv 49.2×52.4 (125×133 cm) sg
The Circumcision → no 20
altarpiece: pn 101.6×70.9 (258×180 cm) sg
The Adoration of the Shepherds 1133
altarpiece; pn 84.6×66.9 (215×170 cm) sg
The Adoration of the Shepherds 1776
pred pn 6.7×25.6 (17×65 cm)
The Virgin and Child with Saints*
altarpiece: ar pn 104.3×76.0 (265×193 cm) sg d 1515 ins
The Holy Family*
pn 31.9×25.6 (81×65 cm)
Coriolanus persuaded by his Family to spare Rome
frs/pn 49.2×49.2 (125×125 cm) sg
Esther before Ahasuerus and three Visions of the Triumph of S. Jerome
pred; pn 11.4×83.5 (29×212 cm)

**SISLEY Alfred**
*Paris 1839 – Moret-sur-Loing 1899*
L'abreuvoir de Marly*
cv 19.3×25.6 (49×65 cm) sg c 1875

**Follower of SNYDERS Frans**
*Antwerp 1579 – 1657*
A Monkey with Fruit on a Table
cv 40.6×53.1 (103×135 cm)

**SNYERS Peeter**
*Antwerp 1681 – 1752*
Still Life
cv 46.9×39.4 (119×100 cm) sg

**SODOMA (Giovanni Antonio Bazzi)**
*Vercelli 1477 – Siena 1549*
Madonna and Child with SS. Peter, Catherine of Siena and a Carthusian Donor
pn 19.3×14.6 (49×37 cm)
S. Jerome in Penitence*
pn 55.5×44.1 (141×112 cm)
Head of Christ crowned with Thorns bearing his Cross
pn 15.0×12.2 (38×31 cm) attr
Madonna and Child
cv 31.1×25.6 (79×65 cm) attr

**Follower of SODOMA**
The Nativity with the Infant Baptist and Shepherds
pn 46.9×37.8 (119×96 cm)

**SOGLIANI Giovanni Antonio**
*Florence 1492 – 1544*
Madonna and Child
pn 6.7×3.9 (17×10 cm)

**SOLARIO Andrea**
*act c 1495-1524 Milan and Venice (?)*
Giovanni Cristoforo Longoni
pn 31.1×23.6 (79×60 cm) sg d 1505 ins
A Man with a Pink → no 24
pn 20.1×16.1 (51×41 cm)
The Virgin and Child with S. John
pn/cv 14.2×11.4 (36×29 cm) sg ins
The Virgin and Child
pn 24.0×18.1 (61×46 cm) st

**SOLARIO Antonio de (Lo Zingaro)**
*act 1502-18 (?) Marches and Naples*

S. Catherine of Alexandria*
S. Ursula*
wings from a trp; panels
33.1×15.7 (84×40 cm) ins

**SOLIMENA Francesco**
*Canale di Serino 1657 – Barra 1747*
Dido receiving Aeneas and Cupid disguised as Ascanius
cv 81.5×122.0 (207×310 cm)

**SORGH Hendrick**
*Rotterdam 1610-1 – 1670*
A Woman playing Cards with two Boors
oval pn 10.2×14.2 (26×36 cm)
Two Lovers at Table, observed by an old Woman*
oval pn 10.2×14.2 (26×36 cm)

**SOUTH GERMAN SCHOOL**
*Fifteenth Century*
S. John on Patmos
pn 16.5×16.9 (42×43 cm)

*Sixteenth Century*
Portrait of a Man
pn 19.3×15.4 (49×39 cm)

**SPAGNA (Giovanni di Pietro)**
*act 1504-28 Umbria*
Christ crowned with Thorns
pn 15.7×12.6 (40×32 cm) attr
The Agony in the Garden 1032
pn 23.6×26.4 (60×67 cm) attr ins
Christ at Gethsemane 1812
pn 13.4×10.2 (34×26 cm) attr

Spagnoletto see **RIBERA**

**SPANISH SCHOOL**
*Seventeenth Century*
Landscape with Figures
cv 35.8×49.6 (91×126 cm)
A Man and a Child eating Grapes
cv 28.7×22.8 (73×58 cm) attr

**SPINELLI Giovanni Battista**
*Naples (?) ... – ... c 1647*
The Nativity
cv 60.2×52.8 (153×134 cm) repainted attr

**SPINELLO Aretino**
*act 1373-1410-1 Umbria and Tuscany*
Two haloed Mourners*
frm; frs 19.7×19.7 (50×50 cm)
S. Michael and other Angels
Decorative Borders 1216 A-B
fragments; frescoes/canvases
45.7×66.9 (116×170 cm);
22.0×60.6 and 50.0 (56×154 and 127 cm) ins

**SPRANGER Bartholomaeus**
*Antwerp 1546 – Prague 1611*
The Adoration of the Magi
ar cv 78.7×56.3 (200×43 cm) sg

**STANZIONE Massimo**
*Orta di Atella 1585 (?) – Naples 1656*
The Mourning over the dead Christ
slate 16.9×20.5 (43×52 cm) copy

**STEEN Jan**
*Leyden 1625-6 – 1679*
A young Woman playing a Harpsichord to a young Man
pn 16.5×13.0 (sg d 16 [... 9] (?) ins
Two Men and a young Woman making Music on a Terrace
cv 16.9×23.6 (43×60 cm) sg
A Man blowing Smoke at a drunken Woman, and another Man with a Wine-Pot
pn 11.8×9.8 (30×25 cm) sg
A Pedlar selling Spectacles outside a Cottage
pn 9.4×7.9 (24×20 cm) sg
Peasants merry-making outside an Inn, and a seated Woman taking the Hand of an old Man
pn 9.4×7.9 (24×20 cm) sg
A Peasant Family at Meal-Time: "Grace before Meat"*
cv 17.3×14.6 (44×37 cm) sg
An Interior with a Man offering an Oyster to a Woman
pn 15.0×12.2 (38×31 cm) sg
Skittle Players outside an Inn → no 102
pn 13.0×10.6 (33×27 cm)

The Interior of an Inn, with a Man seizing a Woman's Skirt, and other Figures: "The broken Eggs"*
cv 16.9×15.0 (43×38 cm) sg 1665-70
An itinerant Musician saluting two Women in a Kitchen
crt/cv 18.1×14.6 (46×37 cm) false sg and d 1670 grisaille copy

**STEENWYCK Harmen**
*Delft 1612 – c 1656*
Still Life: an Allegory of the Vanities of human Life
pn 15.4×19.7 (39×50 cm) sg

**STEENWYCK THE YOUNGER Hendrik van**
*... c 1580 – London c 1649*
The Palace of Dido*
copper 15.7×27.6 (40×70 cm) sg d 1610
Interior of a Church 4040
copper 3.9×5.9 (10×15 cm)
Interior of a Church 1443*
copper 14.6×21.6 (37×55 cm) sg d 1603 and 1607 (?) in collaboration with Jan Brueghel the Elder
Interior of a Church 2204
copper 9.8×11.4 (25×29 cm) sg d 1615 in collaboration with Jan Brueghel the Elder
Croesus and Solon
copper 12.2×9.1 (31×23 cm) in collaboration with a follower of Jan Brueghel the Elder

**Imitator of STEENWYCK THE YOUNGER Hendrik van**
Interior of the Church at night 2205
pn 18.5×26.0 (47×66 cm) sg d (?) 1632 formerly attr to Neefs the Elder

Stefano di Giovanni see **SASSETTA**

**STEVENS Alfred**
*Brussels 1823 – Paris 1906*
The Present ("Le cadeau")
cv 14.6×18.1 (37×46 cm) sg
Seascape ("Effet d'orage à Honfleur")
cv 26.0×31.9 (66×81 cm) sg

**STORCK Abraham**
*Amsterdam 1644 – c 1704*
A View on the Maas at Rotterdam (?)
cv 22.8×28.7 (58×73 cm) sg

**STROZZI Bernardo**
*Genoa 1581 – Venice 1644*
A Personification of Fame → no 51
cv 42.1×59.8 (107×152 cm)

**STUBBS George**
*Liverpool 1724 – London 1806*
A Lady and a Gentleman in a Carriage*
pn 32.3×39.8 (82×101 cm) sg d 1787

Suardi see **BRAMANTINO**

**SUBLEYRAS Pierre**
*Saint-Gilles-du-Gard 1699 – Rome 1749*
The Bark of Charon
cv 52.8×32.7 (134×83 cm) copy

**SUTTERMANS Justus**
*Antwerp 1597 – Florence 1681*
Ferdinand II of Tuscany and his Wife Vittoria della Rovere
cv 63.4×57.9 (161×147 cm)
Portrait of a Man
cv 47.2×36.6 (120×93 cm) attr

**SWABIAN SCHOOL**
*Fifteenth Century*
Portrait of a Woman of the Hofer Family*
metal 20.9×15.7 (53×40 cm) ins

**TACCONI Francesco**
*act 1458-1500 Cremona and Venice*
The Virgin and Child
pn 39.4×20.9 (100×53 cm) sg d 1489

**TASSI (?) Agostino**
*Rome c 1580 – 1644*
Diana and Callisto
pn 19.3×28.3 (49×72 cm) attr

**TENIERS THE YOUNGER**
**David**
*Antwerp 1610 – Brussels 1690*
The Covetous Man*
cv 24.4×33.5 (62×85 cm) sg
A Man holding a Glass and an old Woman lighting a Pipe (The Companions)
pn 9.4×13.4 (24×34 cm) sg
A View of Het Sterckshof near Antwerp
cv 32.3×46.5 (82×118 cm) sg
Spring
Summer
Autumn
Winter
copper 8.7×6.3 (22×16 cm) sg
A Cottage before a River with a distant view of a Castle
pn 19.3×26.4 (49×67 cm) sg
The Surprise ("La surprise fâcheuse")
pn 19.3×25.6 (49×65 cm) sg
Dives in Hell ("Le mauvais riche")
pn 18.9×27.2 (48×69 cm) sg
A View of a Village with three Peasants (The Conversation)
cv 44.1×65.7 (112×167 cm) sg
Peasants playing Bowls
cv 47.2×75.2 (120×191 cm) sg
A Village Festival: "La fête aux Chaudrons"*
cv 35.4×49.2 (90×125 cm) sg d 1643 copy
The Cardplayers*
pn 21.6×29.9 (55×76 cm) sg
Landscape with Peasants at Archery
cv 46.9×114.2 (119×290 cm) sg
A Music Party
pn 10.6×13.8 (27×35 cm) sg ins attr
Trick-Track Players
pn 14.6×22.4 (37×57 cm) sg
A Gipsy telling a Peasant his Fortune in a hilly Landscape
cv 64.2×84.6 (163×215 cm) sg attr
see also Uden

**Follower of TENIERS**
An old Woman peeling Pears
cv 19.3×26.0 (49×66 cm) false sg ins

**Imitator of TENIERS**
Personification of Autumn (?) (The Toper)
pn 6.3×4.7 (16×12 cm) false sg
The Visit to the Doctor
pn 15.4×24.0 (39×61 cm) false sg
An old Woman reading
pn 6.7×5.5 (17×14 cm) false sg

**Terborch** see **BORCH**

**Terbrugghen** see **BRUGGHEN**

**Theotokopoulos** see **GRECO**

**TIEPOLO Giovanni Battista**
*Venice 1696 – Madrid 1770*
SS. Maximus and Oswald (?) → no 62
cv 22.8×12.6 (58×32 cm)
SS. Augustine, Louis of France, John the Evangelist and a Bishop Saint
cv 22.8×13.0 (58×33 cm)
The Virgin and Child appearing to a Group of Saints
cv 20.5×12.6 (52×32 cm)
The Trinity appearing to S. Clement (?)
cv 27.2×21.6 (69×55 cm)
Two Men in oriental Costume
Rinaldo looking in the magic Shield*
A seated Man and a Girl with a Pitcher
Two Orientals under a Pine-Tree
canvases 63.0×21.3 (160×54 cm)
An Allegory with Venus and Time
ceiling; shaped cv 115.0×74.8 (292×190 cm)
The Banquet of Cleopatra
sketch; cv 17.3×26.0 (44×66 cm)

**TIEPOLO Giovanni Domenico**
*Venice 1727 – 1804*

The Deposition from the Cross 1333*
cv 25.2×16.5 (64×42 cm)
The Deposition from the Cross 5589
cv 31.5×35.0 (80×89 cm)
The Marriage of Frederick Barbarossa and Beatrice of Burgundy
cv 28.3×20.9 (72×53 cm)
The Building of the Trojan Horse
The Procession of the Trojan Horse into Troy
canvases 15.4×26.4 (39×67 cm); the second ins

**TINTORETTO Jacopo**
**(J. Robusti)**
*Venice 1518 – 1594*
S. George and the Dragon → no 55
cv 61.8×39.4 (157×100 cm)
Christ washing his Disciples' Feet*
cv 78.7×160.6 (200×408 cm)
The Origin of the Milky Way → no 56
cv 58.3×65.0 (148×165 cm)
Portrait of Vincenzo Morosini*
cv 33.1×20.1 (84×51 cm)
Jupiter and Semele
pn 8.7×25.6 (22×65 cm) attr
The Miracle of S. Mark
cv 15.7×23.2 (40×59 cm) copy

**Style of TINTORETTO**
Portrait of a Cardinal
cv 25.2×20.9 (64×53 cm)

**Follower of TINTORETTO**
Portrait of a Lady
cv 38.6×35.4 (98×90 cm)

**Tisi** see **GAROFALO**

**TITIAN (Tiziano Vecellio)**
*Pieve di Cadore 1488-90 – Venice 1576*
The Holy Family and a Shepherd
cv 39.0×53.9 (99×137 cm)
Venus and Adonis
cv 69.7×73.6 (177×187 cm)
Bacchus and Ariadne
cv 68.9×74.8 (175×190 cm) sg
The Tribute Money
cv 42.9×39.8 (109×101 cm) sg
"Noli me tangere"*
cv 42.9×35.8 (109×91 cm)
Madonna and Child with SS. John the Baptist and Catherine of Alexandria*
cv 39.8×55.9 (101×142 cm)
Portrait of a Man 1944 → no 45
cv 31.9×26.0 (81×66 cm) sg
Madonna and Child*
cv 29.5×24.8 (75×63 cm)
The Vendramin Family*
cv 81.1×118.5 (206×301 cm)
Portrait of a Lady ('La Schiavona') → no 44
cv 46.5×38.2 (118×97 cm) sg
Allegory of Prudence*
cv 29.9×26.8 (76×68 cm) ins
A Boy with a Bird
cv 13.8×19.3 (35×49 cm) copy
Portrait of a Man (Gerolamo Fracastoro [?]) 3949
cv 36.2×28.3 (92×72 cm) copy
The Trinity
cv 51.6×38.6 (131×98 cm) copy
The Death of Actaeon
cv 70.5×76.0 (179×193 cm)

**Follower of TITIAN**
Mythological Scene
pn 29.9×52.0 (76×132 cm)

**Imitator of TITIAN**
A Concert
cv 39.0×49.2 (99×125 cm)

**TOCQUÉ Louis**
*Paris 1696 – 1772*
Portrait of a Man
cv 39.4×31.5 (100×80 cm) sg d 1747
Mlle. de Coislin (?)
cv 31.1×24.8 (79×63 cm)
Jean Michel de Grilleau
cv 31.9×26.0 (81×66 cm) attr

**TORO or TURREAU**
**Jean (?)-Bernard-Honoré**
*Toulon 1672 – 1731*
The Entrance to Hell (?)
crt/cv 35.0×49.2 (89×125 cm) attr

**TOULOUSE-LAUTREC Henri de**
*Albi 1864 – Malromé 1901*
"Femme assise dans un jardin"*
crt 26.4×20.9 (67×53 cm) sg d 1891

**TOURNIÈRES Robert**
**(R. Levrac)**
*Caen 1667 – 1752*
La Barre and other Musicians
cv 63.0×50.0 (160×127 cm) ins attr

**TRECK Jan Jansz.**
*Amsterdam c 1606 – 1652 (?)*
Still Life with a Pewter Flagon and two Ming Bowls *
cv 29.9×24.8 (76×63 cm) sg d 1649

**Troy** see **DETROY**

**TSCHAGGENY**
**Charles-Philogène**
*Brussels 1815 – St. Josse-ten-Node 1894*
An Incident in a Battle
cv 57.1×76.8 (145×195 cm) sg d 1848

**TURA Cosimo or Cosmè**
*Ferrara c 1431 – 1495*
The Virgin and Child Enthroned*
centr pn from a polyptych; ar pn 94.1×40.2 (239×102 cm) ins
S. Jerome*
frm; pn 39.8×22.4 (101×57 cm)
The Virgin
pn 17.7×13.4 (45×34 cm)
frm of an Annunciation
An allegorical Figure (Summer [?]) → no 37
pn 45.7×28.0 (116×71 cm)

**TURNER**
**Joseph Mallord William**
*London 1775 – 1851*
Calais Pier: an English Packet arriving
cv 67.7×94.5 (172×240 cm)
Sun rising through Vapour: Fishermen cleaning and selling Fish*
cv 52.8×70.5 (134×179 cm)
Dido building Carthage, or the Rise of the Carthaginian Empire
cv 61.0×91.3 (155×232 cm) sg d 1815 ins
Ulysses deriding Polyphemus → no 116
cv 52.0×79.9 (132×203 cm)
The "Fighthing Téméraire" tugged to her last Berth to be broken up, 1838 → no 115
cv 35.8×48.0 (91×122 cm)
Rain, Steam and Speed: The great western Railway*
cv 35.8×48.0 (91×122 cm)
The Parting of Hero and Leander
cv 57.5×92.9 (146×236 cm)
Margate (?) from the Sea
cv 35.4×47.2 (90×120 cm)
The evening Star
cv 36.2×48.4 (92×123 cm) unfinished c 1840

**TUSCAN SCHOOL**
*Fifteenth Century*
Side Parts of an Altarpiece (l SS. Michael and John the Baptist; r A Bishop and a Female Martyr)
panels 37.0×19.3 (94×49 cm)

*Sixteenth Century*
Portrait of fra Gerolamo Savonarola
His Execution (on rv)
pn 8.3×6.3 (21×16 cm)
Heads of Angels
frm; oval frs 11.0×15.0 (28×38 cm) attr

**TYROLESE SCHOOL**
*Fifteenth Century*
The Dormition of the Virgin
pn 34.6×28.0 (88×71 cm)

**UCCELLO Paolo (P. di Dono)**
*Florence 1397 – 1475*
Niccolò Mauruzi da Tolentino at the Battle of San Romano → no 10
pn 71.7×126.0 (182×320 cm)
S. George and the Dragon → no 11
cv 22.0×29.1 (56×74 cm)

**UDEN Lucas van**
*Antwerp 1595 – 1672*
Peasants merrymaking before a Countryhouse
cv 70.1×103.9 (178×264 cm) sg (D. Teniers) in collaboration with David Teniers the Younger

**UGOLINO DI NERIO**
*act 1317-27 Siena and Florence (?)*
The Betrayal
The Way to Calvary
The Deposition*
The Resurrection
pred panels 13.4×20.9 (34×53 cm)
Isaiah*
pinnacle from an altarpiece; pn 13.4×9.8 (34×25 cm) ins
SS. Simon and Thaddeus (Jude)
frm from an altarpiece; pn 26.0×22.4 (66×57 cm) ins
Two Angels
frm from an altarpiece; pn 9.8×20.9 (25×53 cm)
SS. Bartholomew and Andrew
frm of an altarpiece; pn 16.9×8.7 (43×22 cm) ins

**UMBRIAN SCHOOL**
*Late Fourteenth Century*
A Saint 4143
frm; frs/cv 31.5×25.6 (80×65 cm) attr
A Saint 4144
frm; frs/cv 30.3×24.0 (77×61 cm) attr
A Bishop Saint
frm; frs/cv 30.7×25.6 (78×65 cm) attr

**UNKNOWN**
The young Pretender (?)
oval pn (?) 2.8×2.4 (7×6 cm)
Eighteenth Century (?)
Portrait of a Lady
cv 12.6×9.8 (32×25 cm) c 1850

**VAILLANT Wallerant**
*Lille 1623 – Amsterdam 1677*
A Boy seated drawing
cv 50.0×39.0 (127×99 cm) attr

**VALDÉS LEAL Juan de**
*Seville 1622 – 1690*
The Immaculate Conception of the Virgin, with two Donors
cv 74.8×80.3 (190×204 cm) sg d 1661

**VALENTIN**
**(Jean de Boulogne)**
*Coulommiers 1591-4 (?) – Rome 1632*
The four Ages of Man*
cv 37.8×52.8 (96×134 cm)

**VALLIN Jacques-Antoine**
*Paris c 1760 – ... c 1831*
Dr. Forlenze
cv 82.7×50.4 (210×128 cm) sg d 1807

**VANDERLYN John**
*Kingston (N. Y.) 1776 – 1852*
Portrait of a Lady
cv 10.6×8.3 (27×21 cm) attr

**VAN GOGH Vincent**
*Groot-Zundert 1853 – Auvers-sur-Oise 1890*
A Cornfield, with Cypresses → no 138
cv 28.3×35.8 (72×91 cm)
The Chair and the Pipe
cv 36.2×28.7 (92×73 cm) sg at present deposited on loan at the Tate Gallery
Sunflowers → no 139
cv 36.2×28.7 (92×73 cm) sg
Long Grass with Butterflies*
cv 25.2×31.9 (64×81 cm)

**Varotari Alessandro** see **PADOVANINO**

**Vecellio** see **TITIAN**

**VELÁZQUEZ**
**Diego Rodríguez de Silva**
*Seville 1599 – Madrid 1660*
Philip IV of Spain 745
cv 25.2×21.3 (64×54 cm)
Philip IV of Spain in brown and silver 1129 → no 104
cv 78.3×44.5 (199×113 cm) sg

Christ after the Flagellation contemplated by the Christian Soul*
cv 65.0×81.1 (165×206 cm)
Kitchen Scene with Christ in the House of Martha and Mary*
cv 23.6×40.6 (60×103 cm)
The Toilet of Venus ("The Rokeby Venus") → no 105
cv 48.0×69.7 (122×177 cm)
S. John the Evangelist on the Island of Patmos*
cv 53.1×40.2 (135×102 cm)
Philip IV Hunting wild Boar ("La tela real")
cv 50.4×118.9 (182×302 cm) in collaboration with st assistants
Archbishop Fernando de Valdés y Llanos
frm; cv 26.8×23.2 (68×59 cm)

**VELDE Adriaen van de**
*Amsterdam 1636 – 1672*
A Farm with a dead Tree
cv 21.3×24.4 (54×62 cm) sg d 1658
Peasants with a Bullock and Sheep fording a Stream
cv 12.6×14.6 (32×37 cm)
Golfers on the Ice near Haarlem*
pn 11.8×14.2 (30×36 cm) sg d 1668
The Edge of a Wood, with a sleeping Shepherd, Sheep and Goats
pn 10.6×15.0 (27×38 cm) sg d 1658
A bay Horse, a Cow, a Goat and three Sheep near a Building
cv 12.2×14.6 (31×37 cm) sg d 1663
A Goat and a Kid
cv 16.5×19.7 (42×50 cm) 1663 (?)
A Landscape with a Farm by a Stream
cv 12.6×13.8 (32×35 cm) sg d 1661
Two Calves, a Sheep and a dun Horse by a Ruin
pn 9.1×11.8 (23×30 cm) attr

**VELDE Esaias van de**
*Amsterdam c 1590 (?) – The Hague 1630*
A Winter Landscape
pn 10.2×11.8 (26×30 cm) sg d 1623

**VELDE Jan van de**
*Haarlem 1619-20 – ... c 1663*
Still Life: a Goblet of Wine, Oysters and Lemons
pn 15.7×12.6 (40×32 cm) sg d 1656

**VELDE THE YOUNGER**
**Willem van de**
*Leyden 1633 – Westminster 1707*
Two small Dutch Vessels inshore in a Calm
pn 8.3×11.0 (21×28 cm) sg
A Dutch Vessel in a Squall reducing Sail to wait for a Boat*
cv 9.1×13.0 (23×33 cm) sg
Dutch Men-of-War and small Vessels in a Calm
cv 21.6×24.4 (55×62 cm) sg d 1657
Dutch Vessels close inshore at low Tide, and Men bathing*
cv 24.8×28.3 (63×72 cm) sg d 1661
Dutch Men-of-War and small Vessels offshore in a Breeze
pn 16.1×22.8 (41×58 cm) sg
The Shore at Scheveningen
cv 16.5×22.0 (42×56 cm)
An English Vessel and Dutch Men-of-War becalmed
pn 8.7×10.6 (22×27 cm) false (?) sg
Two small Vessels and a Dutch Man-of-War in a Breeze
pn 9.4×11.4 (24×29 cm) sg
A small Dutch Vessel closehauled in a Strong Breeze, and Men-of-War in the Distance
cv 12.6×15.7 (32×40 cm) sg
Small Dutch Vessels in a Breeze and a Dutch Ship at Anchor
pn 8.3×11.4 (21×29 cm) sg
A Dutch Yacht, surrounded by many small Vessels, saluting as two Barges pull alongside
cv 35.4×49.6 (90×126 cm) sg d 1661
A Dutch Man-of-War, a Yacht and smaller Vessels in a Breeze
cv 13.0×14.2 (33×36 cm) sg

**103**

Boats pulling out to a Yacht in a Calm, with Men-of-War saluting
cv 16.9×19.7 (43×50 cm) sg
Three Ships in a Gale
cv 29.1×37.0
(74×94 cm) sg d 1673
A Dutch Man-of-War and small Vessels off a Coast in a strong Breeze
cv 21.6×27.6
(55×70 cm) sg d 1658
Small Dutch Vessels ashore, and other Shipping in a Calm
cv 13.0×14.6 (33×37 cm) sg
Dutch Vessels lying inshore in a calm, one saluting
cv 22.0×27.6 (56×70 cm) sg d 1660

**VELSEN Jacob van**
*act 1625-56 Delft*
A musical Party
pn 15.7×21.6
(40×55 cm) sg d 1631

**VENETIAN SCHOOL**
*Fourteenth Century*
S. Jerome in a Landscape
pn 13.4×10.6 (34×27 cm) ins

*Fifteenth Century*
The Virgin and Child with SS. Christopher and John the Baptist and doge Giovanni Mocenigo
cv 72.4×116.5
(184×296 cm) ins
traditionally attr to Carpaccio
Augustus and the Sibyl
pn 6.7×15.0 (17×38 cm)
Pietà
cusped pn 16.9×10.6
(43×27 cm)
Altarpiece of the Virgin Mary (centr pn The Virgin and Child; l panels The Birth of the Virgin; r panels Miracles of the Virgin Connected with the Feast of the Conception; pred Christ and the Twelve Apostles)
panels; centr pn 28.7×17.7
(73×45 cm)
ins; eight side panels
11.8×c 10.2 (30×c 26 cm); pred three scenes
5.1×9.4 and 9.8 and 10.6 (13×124 cm and 25 and 27 cm)

*Sixteenth Century*
Portrait of a Lady 631
pn 14.6×11.8
(37×30 cm) c 1510-20 (?)
Portrait of a Lady 595
cv 28.7×22.4 (73×57 cm)
Portrait of a Man
cv 46.9×38.2 (119×97 cm)
A colossal decorative Figure
cv 59.8×45.3 (152×115 cm)
Adoration of the Shepherds
cv 42.9×63.0 (109×160 cm)
A naval Battle
pn 6.7×15.0 (17×38 cm)
The Story of Cimon and Efigenia
pn 26.4×47.2 (67×120 cm)
A Concert
pn/cv 35.4×48.4
(90×123 cm) attr
Solomon and the Queen of Sheba
cv 30.7×72.8 (78×185 cm) attr

*Seventeenth Century*
The Nativity
cv 36.2×45.7 (92×116 cm) attr

*Eighteenth Century*
Portrait of a Man
cv 29.5×25.2 (75×64 cm) attr

**VERBEECQ Pieter**
*Haarlem c 1610-5 (?) – 1652-4*
A white Horse standing by a sleeping Man
pn 12.2×10.6 (31×27 cm) sg

**VERMEER Johannes**
*Delft 1632 – 1675*
A young Woman standing at the Virginal*
cv 20.1×17.7 (51×45 cm) sg
A young Woman seated at a Virginal →no 87
cv 20.1×17.7 (51×45 cm) sg

**VERMEULEN Andries**
*Dordrecht 1763 – Amsterdam 1814*
A Scene on the Ice
pn 15.4×19.3 (39×49 cm) sg

**Style of VERMEYEN Jan Cornelisz.**
*Beverwijck 1500 – Brussels 1559*
A Man holding a coloured Medal
pn 16.5×13.0
(42×33 cm) ins school

**VERNET Claude-Joseph**
*Avignon 1714 – Paris 1789*
A Sea-Shore
copper 24.4×33.5
(62×85 cm) sg d 1776
A sporting Contest on the Tiber at Rome
cv 39.0×53.5
(99×136 cm) sg d 1750
A River with Fishermen*
cv 23.2×29.1 (59×74 cm) false (?) sg and d 1751
An imaginary (?) Seaport
cv 38.2×52.8
(97×134 cm) ins attr

**VERNET Emile-Jean-Horace**
*Paris 1789 – 1863*
Portrait of Napoleon
oval cv 28.3×23.2
(72×59 cm) sg d 1815
The Battle of Jemappes (1792)
cv 69.7×113.4
(177×288 cm) sg d 1821
The Battle of Valmy (1792)
cv 68.9×113.0
(175×287 cm) sg d 1826
The Battle of Montmirail (1814)
cv 70.1×114.2
(178×290 cm) sg d 1822
The Battle of Hanau (1813)
cv 68.5×113.8
(174×289 cm) sg d 1824

**VERONESE Paolo (P. Caliari)**
*Verona 1528 – Venice 1588*
The Consecration of S. Nicholas*
cv 111.0×67.3 (282×171 cm)
Adoration of the Kings
cv 139.8×126.0
(355×320 cm) d 1573
The Family of Darius before Alexander → no 54
cv 92.9×186.5 (236×474 cm)
The Magdalen laying aside her Jewels*
cv 46.1×64.2 (117×163 cm)
The Vision of S. Helena*
cv 77.6×45.3 (197×115 cm)
Allegory of Love
Unfaithfulness → no 53
Scorn*
Respect
Happy Union
canvases c 73.6×c 74.0
(c 187×c 188 cm)
The Rape of Europe
cv/pn 23.6×27.2
(59×69 cm) copy

**VERROCCHIO Andrea del**
*Florence c 1435 – Venice 1488*
The Virgin and Child with two Angels*
pn 37.8×27.6 (96×70 cm) attr

**Follower of VERROCCHIO**
Tobias and the Angel
pn 33.1×26.0 (84×66 cm)

**VERSCHURING Hendrick**
*Gorkum 1627 – 1690*
Cavalry attacking a fortified Place
cv 35.8×44.5 (91×113 cm) sg

**VICTORS Jan**
*Amsterdam 1619-20 – c 1676*
A Village Scene with a Cobbler
cv 24.8×30.7 (63×78 cm) sg

**VIVARINI Alvise**
*act 1457–1503-5 Venice*
The Virgin and Child*
pn 24.4×18.5
(62×47 cm) sg d 1497

**VIVARINI Antonio**
*act 1440 (?) – 76-84 (?) Venice and Padua*
SS. Peter and Jerome*
SS. Francis and Mark*
panels from a polyptych
c 55.1×c 17.7
(c 140×c 45 cm) ins
in collaboration with Giovanni d'Alemagna (act 1440-50 Venice and Padua)

**VIVARINI Bartolomeo**
*Murano c 1432 (?) – ... c 1499 (?)*
The Virgin and Child with SS. Paul and Jerome*
pn 37.4×24.8 (95×63 cm) sg

**VLIEGER Simon de**
*Rotterdam c 1600 (?) – Weesp 1654*
A Dutch Man-of-War and various Vessels in a Breeze
pn 16.1×21.3
(41×54 cm) sg c 1640-45
A View of an Estuary, with Dutch Vessels at a Jetty and a Dutch Man-of-War at Anchor
pn 34.6×48.0
(88×122 cm) sg c 1645-50

**VLIET Willem van der**
*Delft 1583-4 (?) – 1642*
Portrait of Suitbertus Purmerent
pn 44.5×33.5
(113×85 cm) sg d 1631

**VOET Jakob Ferdinand**
*Antwerp (?) 1639 – 1700 (?)*
Cardinal Carlo Cerri
cv 47.6×38.2 (121×97 cm) ins
formerly attr to Carlo Maratti
(Camerano 1625 – Rome 1713)

**VOUET Simon**
*Paris 1590 – 1649*
Ceres*
cv 57.9×74.4 (147×189 cm)

**VRIES Roelof van**
*Haarlem 1630-1 – ... c 1681*
A View of a Village
pn 25.2×19.3 (64×49 cm)

**VROOM Cornelis**
*... 1590-1 – Haarlem 1661*
A Landscape with a River by a Wood
pn 12.2×17.3
(31×44 cm) sg d 1626

**VUILLARD Édouard**
*Cuisseaux 1868 – Le Baule 1940*
"La Cheminée"
cv 20.1×30.3
(51×77 cm) sg 1905
"Le déjeuner à Villeneuve-sur-Yonne" → no 141 and 142
canvases 85.8×74.8 and 71.7 (218×190 and 182 cm) sg

**WALSCAPPELLE Jacob van**
*Dordrecht 1644 – Amsterdam 1727*
Flowers in a Glass Vase
cv 23.2×18.5
(59×47 cm) sg mutilated

**Wassenhove** see
**JOOS VAN WASSENHOVE**

**WATTEAU Antoine**
*Valenciennes 1684 – Nogent-sur-Marne 1721*
"La gamme d'amour"*
cv 20.1×23.6 (51×60 cm)
"L'accord parfait"
cv 10.6×9.1 (27×23 cm) copy

**WEENIX Jan**
*Amsterdam 1642 (?) – 1719*
A Deerhound with dead Game and Implements of the Chase*
cv 68.1×61.8
(173×157 cm) sg d 1708

**WEENIX Jan Baptist**
*Amsterdam 1621 – Huister Mey 1660-1 (?)*
A Huntsman cutting up a dead Deer, with two Deerhounds
cv 77.2×104.3
(196×265 cm) sg mutilated

**WEIER Jacob**
*act 1645-70 Hamburg (?)*
Cavalry attacked by Infantry
pn 15.0×23.6
(38×60 cm) sg d 1645

**WERFF Adriaen van der**
*Kralingen 1659 – Rotterdam 1722*
Portrait of a Man in a quilted Gown
cv 18.5×15.0
(47×38 cm) sg d 1685
A Boy with a Mousetrap
pn 7.5×5.1 (19×13 cm) sg

The Rest on the Flight into Egypt*
pn 21.3×16.9
(54×43 cm) sg d 1706

**WET THE ELDER Jacob de**
*Haarlem (?) c 1610 (?) – c 1675*
A Landscape with a River at the Foot of a Hill
pn 20.9×28.3 (53×72 cm) sg

**WEYDEN Rogier van der**
*Tournai c 1399 – Brussels 1464*
The Magdalen reading*
frm from an altarpiece
pn 24.0×21.3 (61×54 cm)
Portrait of a Lady → no 68 (on rv Christ Crowned with Thorns)
pn 14.2×10.6 (36×27 cm)
Pietà → no 67
pn 13.8×17.7 (35×45 cm)
S. Ivol (?)
pn 17.7×13.8 (45×35 cm) false ins

**Follower of van der WEYDEN**
The Exhumation of S. Hubert*
pn 34.6×31.5 (88×80 cm)
Christ appearing to the Virgin r wing from a trp (?);
pn/cv 48.8×28.0 (124×71 cm)

**WHISTLER James Abbott McNeill**
*Lowell 1843 – London 1903*
Nocturne in Blue Green ("Nocturne en Bleu vert")
pn 19.7×23.2 (50×59 cm) sg d 1871

**WIJNANT Jan**
*Haarlem (?) 1620-5 – Amsterdam 1684*
A Landscape with a dead Tree, and a Peasant driving Oxen and Sheep along a Road
cv 31.5×39.0 (80×99 cm) sg
Peasants driving Cattle and Sheep by a Sand-Hill and two Sportsmen with Dogs
pn 11.0×15.0
(28×38 cm) false (?) sg
A Landscape with a high Dune and Peasants on a Road
cv 16.1×20.9 (41×53 cm) sg
A Landscape with two dead Trees, and two Sportsmen with Dogs on a sandy Road
pn 11.4×14.2
(29×36 cm) false (?) sg
A Landscape with a Woman driving Sheep through a ruined Archway
cv 13.8×16.9
(35×43 cm) sg d 1667
A Track by a Dune, with Peasants and a Horseman*
pn 11.4×14.2
(29×36 cm) sg d 1665

**WITTE Emanuel de**
*Alkmaar 1615-7 – Amsterdam 1691-2*
The Interior of the Oude Kerk, Amsterdam, during a Sermon 1503
cv 20.1×22.0 (51×56 cm)
The Interior of the Oudekerk, Amsterdam, during a Sermon 6402
cv 31.1×24.8 (79×63 cm) sg
Adriana van Heusden and her Daughter at the New Fishmarket in Amsterdam (?)*
cv 22.4×25.2 (57×64 cm)

**WOUTERS Frans**
*Lierre 1612 – Antwerp 1659-60*
Nymphs and Satyrs
pn 16.9×22.8 (43×58 cm) sg

**WOUWERMANS Jan**
*Haarlem 1629 – 1666*
A Landscape with a Farm on the Bank of a River
pn 15.7×21.6 (40×55 cm) sg

**WOUWERMANS Philips**
*Haarlem 1619 – 1668*
Cavalrymen halted at a Sutler's Booth*
pn 20.1×16.1 (51×41 cm) sg
The Interior of a Stable
cv 18.5×26.4 (47×67 cm) sg
A View of a Seashore, with Fishwives offering Fish to a Horseman
pn 13.8×16.1 (35×41 cm) sg
A white Horse, and an old Man binding Faggots
pn 12.2×10.2 (31×26 cm) sg

A Dune Landscape with a River and many Figures
pn 9.1×11.8 (23×30 cm) sg
A Stream in the Dunes with two Bathers
pn 10.6×13.0 (27×33 cm)
A Stag Hunt
cv 29.5×40.9 (75×104 cm) sg
Two Vedettes on the Watch by a Stream
pn 12.2×13.8 (31×35 cm) sg
A Horse being shod outside a Village Smithy
pn 18.1×24.4 (46×62 cm) sg
Cavalry making a Sortie from a Fort on a Hill
cv 54.7×74.8
(139×190 cm) sg d 1646
Cavalry attacking Infantry
pn 13.0×24.8
(33×63 cm) sg attr
Two Horsemen at a Gipsy Encampment, one having his Fortune told
pn 12.6×13.8
(32×35 cm) sg attr

**WTEWAEL Joachim**
*Utrecht c 1566 – 1638*
The Judgment of Paris
pn 23.6×31.1
(60×79 cm) sg d 1615

**Wynant** see **WIJNANT**

**YSENBRANDT or ISENBRANDT Adriaen**
*act 1510-51 Bruges*
The Magdalen in a Landscape*
pn 15.7×12.2 (40×31 cm)

**Style of YSENBRANDT**
The Entombment
pn 6.7×4.7 (17×12 cm)

**ZAGANELLI Bernardino**
*act 1499-c 1509*
S. Sebastian
ar pn 46.9×17.3
(119×44 cm) sg

**ZAGANELLI Francesco**
*act 1499–1531-2*
The Baptism of Christ (on lunette Dead Christ with Angels)
altarpiece; panels 78.7×74.8
(200×190 cm) sg d 1514 ins; lunette 40.2×81.1
(102×206 cm)

**ZAIS Giuseppe**
*Canale d'Agordo (Belluno) 1709 – Treviso 1784*
Landscape with a Group of Figures*
cv 19.3×25.6 (49×65 cm) sg
Landscape with a Group of Figures fishing
cv 19.3×25.6 (49×65 cm)
Landscape with a ruined Tower
cv 27.6×37.8 (70×96 cm)

**Zampieri** see **DOMENICHINO**

**ZOFFANY Johann**
*Frankfort on the Main 1733 (?) – Strand-on-the-Green 1810*
Mrs. Oswald
cv 89.0×62.6 (226×159 cm)

**ZOPPO Marco (M. di Ruggero)**
*Cento c 1432 – Venice c 1478*
Pietà*
pn 10.2×8.3 (26×21 cm)
A Bishop Saint
pn from an altarpiece
ar pn 19.3×11.0 (49×28 cm)

**ZUCCARELLI Francesco**
*Pitigliano 1702 – Florence 1788*
Landscape with Cattle and Figures*
cv 36.6×52.0
(93×132 cm) repainted

**ZUGNO Francesco**
*Venice 1709 – 1787*
The Finding of Moses
cv 21.3×31.9 (54×81 cm) attr

**ZURBARÁN Francisco de**
*Fuente de Cantos 1598 – Madrid 1664*
S. Francis in Meditation 230
cv 59.8×39.0 (152×99 cm)
S. Francis in Meditation 5655*
cv 63.8×53.9
(162×137 cm) sg d 1639
S. Margaret*
cv 76.4×44.1 (194×112 cm)